THE
PHOTOGRAPHER
AND THE
PRESIDENT

ALSO BY RICHARD S. LOWRY

"Littery Man": Mark Twain and Modern Authorship

THE
PHOTOGRAPHER
AND THE
PRESIDENT

Abraham Lincoln, Alexander Gardner,
and the Images That Made a Presidency

RICHARD S. LOWRY

Rizzoli
ex libris

Published in the United States of America in 2015
by Rizzoli Ex Libris, an imprint of
Rizzoli International Publications, Inc.
300 Park Avenue South
New York, NY 10010
www.rizzoliusa.com

2015 2016 2017 2018 / 10 9 8 7 6 5 4 3 2 1

Distributed in the U.S. trade by Random House, New York
Printed in U.S.A.

ISBN-13: 978-0-8478-4541-5
Library of Congress Catalog Control Number: 2014944524

For Joyce and Eleanor

CONTENTS

LIST OF ILLUSTRATIONS

A PORTFOLIO OF PHOTOGRAPHS
BY ALEXANDER GARDNER AND HIS OPERATORS

ILLUSTRATIONS

22. Daniel Webster, by Mathew Brady, daguerreotype, between 1851 and 1860. Prints and Photographs Division, Library of Congress.

23. Daniel Webster, by Albert Southworth and Joseph Hawes, daguerreotype, circa 1850. Image copyright © The Metropolitan Museum of Art. Image source: Art Resource, New York.

26. "M. B. Brady's New Photographic Gallery, Corner of Broadway and Tenth Street, New York," *Frank Leslie's Illustrated Newspaper*, January 5, 1861, p. 108. Prints and Photographs Division, Library of Congress.

34. Mathew Brady (self-portrait), M. B. Brady Gallery, circa 1860s. Culver Pictures/ The Art Archive at Art Resource, New York.

38. Confederate Dead, Antietam Battlefield, by Alexander Gardner, September 1862. Prints and Photographs Division, Library of Congress.

38. Confederate Dead along Hagerstown Pike, Antietam Battlefield, by Alexander Gardner, September 1862. Prints and Photographs Division, Library of Congress.

38. Single Confederate Dead, Antietam Battlefield, by Alexander Gardner, September 1862. Prints and Photographs Division, Library of Congress.

38. Dead in front of Dunker Church, Antietam Battlefield, by Alexander Gardner, September 1862. Prints and Photographs Division, Library of Congress.

40. Burial Party, Antietam Battlefield, by Alexander Gardner, September 1862. Prints and Photographs Division, Library of Congress.

63. Two Confederate Dead, Antietam Battlefield, by Alexander Gardner, September 1862. Prints and Photographs Division, Library of Congress.

64. "The Battle of Antietam, Fought September 17, 1862—Burnside Holding the Hill," *Harper's Weekly*, October 4, 1862, pp. 632–33. HarpWeek.

64. "Scenes on the Battlefield of Antietam—from Photographs by Mr. M. B. Brady [Alexander Gardner]," *Harper's Weekly*, October 18, 1862, pp. 664–65. HarpWeek.

66. Detail, "Scenes on the Battlefield of Antietam," *Harper's Weekly*, October 18, 1862, pp. 664–65. HarpWeek.

72. Abraham Lincoln, by Alexander Gardner, November 8, 1863. Prints and Photographs Division, Library of Congress.

75. Abraham Lincoln with Secretaries John Nicolay and John Hay, by Alexander Gardner, November 8, 1863. Prints and Photographs Division, Library of Congress.

77. Abraham Lincoln, by Alexander Gardner, November 8, 1863. Prints and Photographs Division, Library of Congress.

81. Abraham Lincoln, by Sarah Fisher Clampitt Ames. Courtesy of U.S. Senate Collection.

82. Abraham Lincoln, by Alexander Gardner, November 8, 1863. Copyright Moses P. Rice. Prints and Photographs Division, Library of Congress.

INTRODUCTION

I BEGAN this book as an effort to understand Alexander Gardner's photograph of Abraham Lincoln that appears as plate 15. I am sure I had seen copies of the portrait many times before I saw the original at the National Portrait Gallery several years ago, but none of them had impressed me like the actual photograph. It is very large—nearly a foot and a half tall and more than fifteen inches wide—with deep sepia tones and an almost holographic intensity to the details. A fracture line, caused by the breaking of the delicate glass-plate negative, veers from the upper left corner, across the top of Lincoln's head, all the way to the right edge, giving the picture its nickname, the cracked-plate portrait. Lincoln looks frail, even vulnerable, but the photograph itself possesses an uncanny power. The picture invites us close to Lincoln—his wan smile suggests he shares something with us—but it also insists on our distance from him. He looks past us, not at us, which makes his expression inscrutable. It is as if he visits us from another world.

At the time, I was more interested in the photographer than his subject. I knew him for *Gardner's Photographic Sketch Book of the War,* an album of one hundred images by more than a dozen photographers that follows the Army of the Potomac during its four years of fighting. Some of these, including those of the battlefield dead at Gettysburg, have become icons of the human cost of war, though one of them is notorious for Gardner's perhaps having moved a corpse to get the shot. When I visited the gallery I didn't know that he was also an accomplished portrait photographer who took more pictures of Lincoln than anyone else. Nor was I prepared for his artistry, which seems as experimental and provocative as that of his English contemporary Julia Margaret Cameron and anticipates the great portraitists Walker Evans and Diane Arbus.

As I went deeper into my investigation, I came to realize that Gardner brought to his subject the same sophisticated understanding he did to his

medium. He shows Lincoln as his contemporaries saw him in early 1865: a man worn down by the burdens of leading the Union through four years of unprecedented strife and heartbreak. In his faint smile, they would have recognized the Westerner of humble origins whose seemingly endless reservoir of anecdotes, sympathetic attention, and self-deprecating humor could disarm the most ardent opponent and charm his supporters into calling him Father Abraham, a name that mingled the stern authority of Old Testament patriarchs with domestic comfort. They would also have recognized in Lincoln's distant stare a man of deep reserve—a natural politician, with all the calculation and veiled intentions that the term implies, but someone whose dedication to democratic ideals thrived alongside an appreciation of the absurdity of human aspiration.

Gardner's photograph led me in other directions, as well. During his lifetime, Lincoln was the subject of more than 130 photographs, more than virtually any other person of his generation. About half of these were taken during the four and a half years between his nomination as the Republican presidential candidate and his death. Clearly Lincoln understood the new medium—photography had become commercially viable only in the early 1840s—as an emerging force in politics, capable of bringing the face of the president to the electorate with unprecedented objectivity and variety.

Gardner took some thirty-eight photographs of Lincoln during their time together in Washington. The image that first caught my eye was one of the last anyone made of him. Most of the pictures were done in the studio, but other portraits were taken on the Antietam battlefield, at the second inauguration, and at the ceremonies that included the Gettysburg Address. Add these to the dozens of images he took documenting Lincoln's assassination, including the hanging of four of the conspirators, and it becomes clear that Gardner followed Lincoln's presidency with the same attention as he did the Army of the Potomac. By the end of his career, Gardner's pictures, reproduced as engravings in national magazines and sold as prints large enough to frame and small enough to fit in family albums, helped make Lincoln's not only the most recognizable face in the country, but also the face of the nation.

The Photographer and the President tells the story of the partnership between these two remarkable men who, in very different but complementary ways, changed the way their generation *saw*, and thus ultimately how they *experienced* the Civil War. As president, Lincoln endured personal loss, negotiated social turmoil, and mastered the demands of being both commander in chief and the political leader of a country he fought to restore. In time he

framed a new vision for the nation, born of the upheaval of war, grounded in ideals of equality, and guided by a pragmatic commitment to bettering the life of all its citizens. Gardner documented for the public the unprecedented carnage and destruction on the dead-strewn battlefields of Antietam and Gettysburg and in the ruins of Richmond. He portrayed the president with an increasingly sophisticated subtlety both as a leader indelibly immersed in the challenges of the moment and as a figure who was worthy of memorializing for history.

I place Gardner's artistry and Lincoln's political genius at the heart of my story by building each chapter around Gardner's portraits, using them as a doorway into the historical circumstances that brought the two men together. The first session, in early 1861, introduced the president-elect to a nation that was already splitting apart. The second recorded the intrigue and high drama of Lincoln's meeting with General George McClellan on the Antietam battlefield in October 1862, weeks after Gardner had braved the flies and stench to document the grim aftermath of fighting and weeks before Lincoln would change the course of the war by announcing the Emancipation Proclamation.

Gardner photographed Lincoln twice in 1863. They first met in August in Gardner's newly opened studio, a month after Gardner had again photographed battlefield dead, this time at Gettysburg. The second took place just eleven days before Lincoln delivered the Gettysburg Address, his brief rhetorical masterpiece that would come to keynote the nation's understanding of freedom. Their final session, in February 1865, came with the end of the war in sight and the hopes and fears for the future looming large; there the president posed for the cracked-plate portrait. The last chapter follows Gardner and Lincoln on their separate visits to the newly fallen Confederate capital, Richmond. Only days after photographing the somber beauty of the city ruins, Gardner took up the challenge of translating into pictures the grief, rage, shock, and fascination that followed Lincoln's assassination.

When he made them, Gardner's photographs allowed people to see for the first time in history the crisis they lived through and the president who led them through it. Since then they have played an important role in shaping our national memory of those events. Even for the millions of people who visit the battlefields, the Civil War lives on most persistently in the thousands of pictures produced by Gardner and his fellow photographers. The same holds true for Lincoln. For all the sculptures of and memorials to our sixteenth president, from Mount Rushmore to the National Mall in Washington, D.C., for all the countless representations of him on the penny, on the five-dollar bill, and in the exuberantly

corrosive nonsense of a popular culture that makes him into a square-bearded, stovepipe-hatted salesman for anything from sleep aids to auto insurance, Lincoln lives in our contemporary public imagination through photographs.

We cannot avoid this double vision of who Lincoln was at the time and what he is to us now when we look at Gardner's portraits. This is certainly the product of the power of myth to obscure the past, but it is also an effect of the photographs themselves as they evoke the uncanny experience of time's passing. Anyone who has looked at photographs has experienced the wavering dislocation that comes when we first respond to a picture's realism by feeling we are *there* when the picture was taken, only to then realize that *there* or *then* is no longer *now* or *here*. (Can one even imagine looking at a picture of the present?) That poignant mix of loss and pleasure, distance and presence, lies at the heart of photography's power to fascinate us. It also defines the dynamic that led the two men to understand making pictures as making history. We make Lincoln's story our story, because he and Gardner made their story ours.

CHAPTER 1

1861: President-Elect

Alexander gardner and Abraham Lincoln first met at Mathew Brady's National Photographic Art Gallery in Washington, D.C., Sunday, February 24, 1861. Brady was near the height of his fame as the country's preeminent portrait photographer; he had been commissioned to supply a photograph for *Harper's Weekly*, which wanted to introduce the world to the newly bearded president-elect. Working through back channels, Brady had managed to secure Lincoln's agreement. After notifying Gardner, he returned to New York.

This was likely a big moment for Gardner. He had worked for Brady for nearly five years, first in the famous New York gallery and for the past three managing the new D.C. gallery, where he and his assistants did a tidy business photographing Washington's politicians, celebrities, and landmarks. In May the year before, he had assisted his employer in producing portraits of the Japanese delegation to Washington: in the artist's rendering of the scene at the exclusive Willard Hotel for *Frank Leslie's Illustrated Newspaper*, that is Gardner peering over the large camera while next to him Brady points to what he wants in the frame (see page 6). This time, however, Gardner was on his own, not only with the president, but with responsibility for fulfilling the commission for a national outlet like *Harper's*. As part of his preparations, he asked the artist George Henry Story, who rented studio space from Brady, to stop by and help pose his sitter. The painter had just turned twenty-six. He would go on to distinguish himself as a portraitist and later as curator of painting at the New York Metropolitan Museum of Art, but that morning was as big a moment for him as it was for Gardner. Together they would be expected to capture the chief stylistic signature of the well-known Brady brand—the natural way sitters related to the camera even when they didn't look at it—on a subject famously disinclined to engage with the aperture.

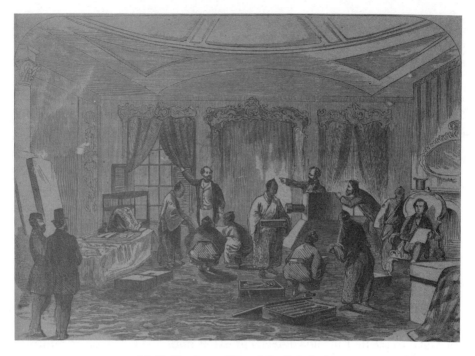

M. B. Brady and Frank Leslie's Artists

Lincoln showed up looking, in Story's words, like "a man who was overwhelmed with anxiety and care and fatigue." He had arrived in Washington at dawn the day before, having just completed a grueling twelve-day railway journey from his home in Springfield, Illinois, punctuated by dozens of whistle-stops, ceremonies, brief speeches, and endless handshaking. In Philadelphia Lincoln had been alerted about a possible plot to assassinate him as he changed trains in Baltimore. The threat seemed plausible to many in his party, including the renowned detective Allan Pinkerton and his friend and self-appointed bodyguard, Ward Hill Lamon, who traveled armed with two revolvers, two derringers, brass knuckles, and a bowie knife. Baltimore had earned its nickname, Mobtown, because of its history of political violence and murder. Ever since Lincoln had won the presidency in November without a single electoral vote from the South, passions had been running high all over the country. Divided as Maryland was—it would choose to remain in the Union as a slave state—Baltimore seemed as likely a place as any for the tinderbox of national crisis to explode. Lincoln was skeptical about the danger, but out of his trust in Pinkerton, whom he knew from his law days, he

agreed to adjust his plans and travel to Washington on a furtive overnight trip. Arriving in Washington worn out from changing trains in the middle of the night and trying to jackknife his six-four frame into a standard sleeping berth, Lincoln nonetheless plunged into his agenda, breakfasting with his soon-to-be secretary of state, William Seward, at the Willard Hotel, where Lincoln was to spend the next several weeks, then walking the few blocks to the White House to meet the outgoing president, James Buchanan. The afternoon included calls and visits with a host of notables, including a warm meeting with his rival Stephen Douglas, before settling his newly arrived family in the hotel and dining again with Seward. The day did not end until he and his wife, Mary, held an impromptu reception for the many people thronging the halls of the hotel—including the members of Buchanan's Cabinet, who stopped by at ten p.m. Lincoln went to bed Saturday night with his right hand swollen from handshaking.

Though Sunday's schedule was slower, even including the visit to Brady's, it still included time with the ubiquitous Seward, an afternoon of meet and greet, an evening call from Vice President John C. Breckinridge, and a late-night serenade by the Marine Band. But the chaos of high-stakes political life in the capital city was the least of Lincoln's worries. He had been elected in November as president of a bitterly divided but still intact nation. By the time he'd departed from Springfield to take office in Washington, seven Southern states, led by South Carolina, had seceded from the Union and inaugurated Jefferson Davis as the provisional president of the Confederacy. Without a cabinet, with virtually no administrative experience, with only one term as an Illinois Congressman and four terms in the Illinois General Assembly on his political résumé, with few Washington friends and fewer people he could trust, Lincoln was a man, according to Horace Greeley, as "honest as the sun" about to enter "a web of very cunning spiders." So sometime that Sunday, he went to get his picture taken.

The Brady National Photographic Art Gallery, as the banner on the balcony proclaimed its name, was just a few blocks up Pennsylvania Avenue from the White House. It was closed on Sundays, but Gardner was happy to accommodate an important visitor who wanted convenience and discretion. Other days of the week, the gallery was busy in the mornings, when the sunlight was best, with patrons eager to have their portraits stamped with the biggest name in photography, and all day with "idlers," who could while away the hours in the "charming lounge" on the second floor (the first was occupied by a bank and a pharmacy) with its "mellowed light" and "luxurious divans," perusing

Brady's impressive collection of pictures. Brady had installed his gallery on the same plan as his successful New York establishments. The main floor functioned as a cross between a museum and a parlor, where the public was invited to visit at leisure and take in his impressive collection of oil portraits of national figures like Daniel Webster, John C. Calhoun, and Washington Irving based on Brady pictures, and retouched photographs of local personalities like the banker William Wilson Corcoran, who would endow one of Washington's landmark art museums, and Amos Kendall, a member of Andrew Jackson's "kitchen cabinet" and cofounder of Gallaudet University for the deaf, as well as celebrities, theater people, and views of Europe and Niagara Falls. Stairs led patrons up past the finishing and mounting rooms on the third floor to the top-floor studio, installed beneath skylights outfitted with baffles, mattes, and reflectors to control the light, and cluttered with cameras, headrests, chairs, tables, and props that included a French mirror, draperies, a stove, and a gold clock always at 11:52.

With assistance from his brother James, Gardner had ably run the Washington studio since it opened. The burly and genial Scottish émigré managed the daily portrait traffic, established distribution contracts, minded and upgraded the equipment, and developed relationships with people in the federal government and local society. His photographic work was accomplished enough to hang on the gallery walls: both Corcoran and Kendall had sat for him. In fact, given that his employer made only occasional visits to the capital, Gardner would have had plenty of opportunity to further develop his skills with the camera, if not to make his name as a portrait photographer. As was the custom of the time, credit for any work by a cameraman—known as an "operator"—went to the owner of the studio. Still, by and large it was a good situation for him.

Lincoln would have arrived some time in the late morning, perhaps after church, to take advantage of the light. Gardner likely greeted him in his long dust jacket, which he wore to protect himself from chemicals and dirt, and ushered him upstairs to the studio. Story, the portrait painter, showed up a little later and found Lincoln "carelessly seated at the table waiting to be posed. He did not utter a word and he seemed absolutely unconscious of all that was going on about him." When asked to help pose him in a "natural way," Story simply said, "'bring the camera at once.' I saw that in this unconscious pose a great picture might be taken." Gardner, who according to Story cared little about posing his sitters in any but the most conventional stances, heeded the artist's advice, taking, in fact, five different exposures—four with a three-lens camera, and one

with a stereoscopic camera with two lenses, for a total of fourteen images (see pages 10 and 11). Without a word, Lincoln left to return to his duties.

Story's eye notwithstanding, Gardner's photographs are a dreary lot. Lincoln appears as abstracted as Story described him. Only once in the sequence of exposures do his eyes rise from the floor; in all but one his face seems masklike in its slackness. In all of them, his swollen right hand remains curled and partially hidden by the arm of the chair he sits in. In one exposure, his open pocket watch sits in his lap, suggesting a man with other things to do.

In an interview some sixty years later, Story would imbue the moment with the aura of inspiration: at least Lincoln's pose broke with the "laughable" custom of posing a statesman standing "bolt upright, with one hand on a table and the other thrust into the breast of his coat." But what to Story seemed innovative (the headline to the interview reads "Chance Created Best Photo Ever Taken of 'Abe' Lincoln") on a number of levels suggests failure (see plate 1). A photo that upheld the Brady studio brand would have connected Lincoln to the camera even if he wasn't looking at it. Gardner's pictures, on the other hand, show a man closed in on himself, almost to the point of lifelessness. The artist who later rendered the engraving for *Harper's Weekly* stayed true to the pose, but he slightly rounded the face and added lines defining Lincoln's cheeks, thereby imparting a feeling of animation that is absent from the photographs. The *Harper's* image looks something more like the candid shot Story saw in his mind's eye: Lincoln weighing the great issues of the day (see page 12).

There is no evidence that anyone at the time was dissatisfied with the photographs. Brady made copies of the images available for sale. Gardner remained Brady's most trusted employee and continued to manage the Washington gallery. When Lincoln visited Brady's for another sitting two months later, Gardner was almost certainly in the studio again, and likely again on his own (and this time with much more successful results). And *Harper's* got what it wanted: the magazine continued for years to commission work for its illustrations by both Brady and, once he was on his own, Gardner.

And yet, to our eyes, it is difficult to find another set of photographs by either photographer as lifeless as these. Their "failure," however, lies at least as much in our contemporary eyes as it does in Gardner's efforts. We consider photographs to be final products, no matter their content. But it is probable that Gardner and Lincoln saw the images as simply a good-enough record of Lincoln's new face that would anyway be adapted by the engraver to fit *Harper's* interests. Gardner's pictures worked in effect as an artist's sketch in preparation for a finished product. This assumption explains Story's

ABOVE AND OPPOSITE:
Abraham Lincoln, by Alexander Gardner, February 24, 1861

"President Lincoln," Harper's Weekly, *April 27, 1861*

enthusiasm: he saw Lincoln not as he appeared through a camera lens, but as he would look in a painting (or engraving), interpreted by the eye and hand of the artist.

Lincoln may have been thinking along these lines as well. He had already posed for dozens of photographs—some of them quite good (his best early photographer was Alexander Hesler), quite a few of them stiff and dull. He offered much the same face to painters and sculptors. Months earlier in Springfield, the artist Albert Jasper Conant met with an experience similar to Gardner's when he managed a sitting with the new president-elect. "Promptly on the hour" of their appointment, Lincoln rose from his writing desk "and without a word threw his angular form into the chair, crossing his legs and settling back with a sigh, as though to a disagreeable ordeal. Immediately his countenance relapsed into impenetrable abstraction; the hard, sinister lines deepened into an expression of utter melancholy, almost despair. It was not the Lincoln I had resolved to paint." The sculptor Thomas Jones found similar challenges in rendering a bust of the president-elect. Lincoln, he wrote a friend soon after settling into his task, "reminds me of a rough block, of the

old red primitive sand-stone....I have a severe task before me. He is by far the most difficult subject that I have ever encountered." Both made do with what was offered; with a little more observation and some imagination Conant delivered a finished painting titled *Smiling Lincoln*.

At Brady's Washington studio, Lincoln, of course, had every reason to be distracted and anxious. Over the past thirty hours, the urgency of the crisis of secession and the magnitude of his responsibilities as president had been brought home by all he had encountered. At that moment, he simply may not have cared how he looked to the camera—or to Gardner standing behind it.

If this was the case that Sunday morning in February 1861, it would never be again. Over the next four years, Lincoln would pose for nearly seventy photographs—most of them in studios, but others on location at crucial moments in his presidency: his two inaugurations, his visit with General George McClellan after the battle of Antietam, and on the occasion of his Gettysburg Address. He would come to understand photography as one of the crucial media of office—not in the way presidents today understand media as an arena for controlling a "message" (he would never have much control over his image), but as that space that humanized him for the public. He would present himself variously as commander in chief, as a citizen, as the leader of a democratic republic, and as a "careworn" face of the Union, embodying the harrowing grief and resolve he shared with those who elected him. In the end, photographs were for Lincoln in all senses of the word political. They proved effective tools in the rough-and-tumble of partisanship, sectional loyalty, and powermongering. But they also offered the president's craggy face and long, gangly body as a symbolic image of the body politic and the ideals of democracy and equality on which it was founded.

Gardner would take more of those photographs than anyone else, working in the studio, amid the crowds at his inaugurations, and at Gettysburg and Antietam. Many of them would be taken at the request of other artists, but over time he would develop a distinctive visual style of his own that was rooted in a sophisticated understanding of the medium of photography. Working with his bulky cameras and chemicals that stained his fingers, Gardner would find in Lincoln the face of a nation in crisis. The terms of this crisis were for him largely shaped by the same understanding of politics as Lincoln's. But Gardner would be of his own mind about what was happening. Traveling as a photographer with the Army of the Potomac, walking the clotted battlefields of Antietam and Gettysburg, or amid the burned-out ruins of Richmond, he would produce powerful and enduring images that not only reflected his own

vision of the war and the times they lived through, but also influenced how he photographed the president.

Little of the ambition and achievements of either man is visible in the picture they made that day in Washington. But their relative failure opens a historical door onto the changing place of photography in our cultural perception. Over a century and a half of technological and aesthetic ferment has replaced the formal intensity of daguerreotypes with the digital carnival of social media snapshots. We have internalized expectations for what a proper portrait should be. It is not enough for us to simply see what someone looks like—consider the emptiness of ID photos. Instead, we value a kind of expressive contact with the sitter that makes us as viewers feel like privileged, if virtual, participants in the moment of exposure. But the kind of looking that comes naturally to us today was still under construction in 1861. That Lincoln fit a visit to Brady's in his hectic schedule points to his respect for the growing presence of photography in political life: no matter the distractions, no matter the crisis—indeed *because* of the crisis—*Harper's*, Brady, and the public must have their pictures. At the same time, the fact that Lincoln, Gardner, and Brady were satisfied with the photograph suggests that none of them was quite sure what photography could do. All three were in their way very experienced with the medium, but all of them came of age in a world without photographs. Certainly a host of rubrics and conventions were already coalescing around the practice—many of them put in place by Brady himself—but what photographs meant, how they were used, and what they represented in a broadly cultural sense, was still open. Culture had yet to bring photographs into focus.

FROM the vantage point of the twenty-first century, where media and image are at least as important as the message, Lincoln's posing for photographs makes perfect sense. But in the context of 1861, long before the twenty-four-hour news cycle, his decision to cram a studio session into such a fraught weekend seems almost eccentric. Until the 1860 election, politicians paid little attention to how they were pictured. They made their reputations oratorically, as Lincoln had done in his famous debates with Stephen Douglas during the 1858 campaign for an Illinois Senate seat. Even after he was elected president, Lincoln well understood the power of rhetoric: he worked on his inaugural address for months. In fact, the very same day he posed for Gardner in Brady's shop, he gave a copy of his speech to Seward, who would respond with pages of criticism and suggested changes. Both men knew that Lincoln's every word

would be eagerly parsed by an expectant public—with more scrutiny than would the details of the president-elect's studio portrait.

Lincoln's unlikely route to the presidency had been opened by a major speech against slavery delivered on a snowy evening in February 1860 at the Cooper Union Institute in New York City. His performance electrified his audience; reprinted in newspapers across the country, the speech impressed readers with its vision, balance, and erudition, making it a kind of unofficial policy statement for the party as a whole. Leading up to the Republican convention in Chicago in May, Lincoln saw his speech published in numerous pamphlet editions in Detroit, Chicago, Washington, New York, and even in his hometown by the *Springfield Journal*, which offered it at a penny a copy in hopes of profiting from bulk orders from Republican clubs nationwide. Immediately after his nomination, in the words of one Lincoln scholar, "the avalanche of Cooper Union reprints resumed."

But the political landscape was changing; the same presses churning out thousands of copies of his speech could also produce abundant low-cost illustrations of each of the men running for office. Tradition imposed a cloak of modesty on candidates by keeping them out of their party's nominating conventions and off the campaign trail (Stephen Douglas, this time Democratic candidate for president, would be the first to break decorum by traveling after his nomination). But a confluence of innovations in graphic publishing and photography helped make it possible to bring Lincoln's image to the electorate without his leaving Springfield. Chief among these pictures was a photograph taken by Brady at his posh gallery on New York's Broadway the afternoon before Lincoln delivered his famous speech (see page 16). In a full-length pose that flirts with the "laughable" conventions derided by Story, Lincoln stands next to a classical column on his right, while resting his left hand on books piled on a table—both a symbol of wisdom and learning and a prop to help steady him during the seconds-long exposure. Lincoln's stern but approachable face and his statesmanlike stance give weight to his political aspirations: he may be a Westerner, but he's no hick.

Soon after Lincoln's nomination, Brady's image of him was everywhere, marketed by the gallery, copied and sold by other photographers (in an era before copyright), and reproduced in engravings and on campaign buttons, posters, and pamphlets. It even appeared in *Harper's Weekly* twice, once cropped tight to his head and shoulders, then again on the cover with Lincoln fronting drapes revealing a prairiescape with buffalo—an effort to blend Lincoln's frontier origins with Brady's classicism. So popular was Brady's image that by the time Lincoln arrived

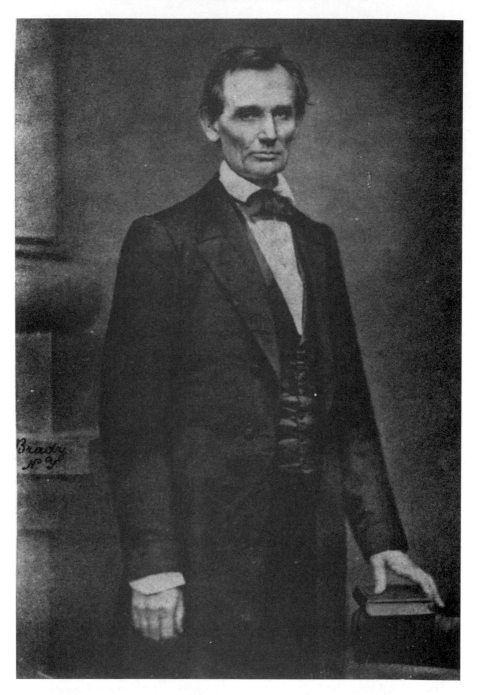

Abraham Lincoln, by Mathew Brady, February 27, 1860

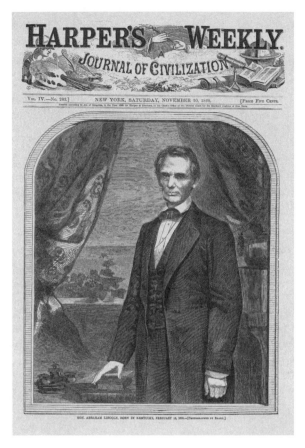

"Honorable Abraham Lincoln": Harper's Weekly, *November 10, 1860*

in Washington a year later, the fillip of hair on top of his head in the photograph had become recognizable much as his top hat and beard are today.

Brady's, of course, was not the only image in circulation—Chicago photographer Alexander Hesler alone sold ten thousand copies of two portraits. Between his nomination for president in mid-May 1860 and his boarding the train as president-elect in January 1861, Lincoln sat for seven different painters, seven photographers, and one sculptor, most of whom traveled to Springfield commissioned by others, all hoping to exploit the new public interest in the candidate from Illinois. These images, as well as earlier photographs, were copied, edited, and freely interpreted, appearing on the covers of campaign biographies and sheet music (such as the "Lincoln Quick Step"), in engravings by Currier and Ives (who would feature Lincoln in more that seventy-five

prints over the course of his administration), and in the burgeoning world of political cartoons and caricature.

All of this went a long way toward making Lincoln virtually present even as he stayed put and guided his representatives' pursuit of the messy work of campaigning. The power of these images in the American household can be gauged by the well-known letter Lincoln received from eleven-year-old Grace Bedell, who wrote to the candidate urging him to grow a beard: "You would look a great deal better for your face is so thin. All the ladies like whiskers and they would tease their husbands to vote for you and then you would be President." Lincoln was charmed enough by the letter to reply, and then after his election, and after indeed growing a beard, to call her to his makeshift podium at his whistle-stop visit to her home village in upstate New York. "You see," he said after kissing her, "I let these whiskers grow for you, Grace." Her advice was provoked by an unflattering poster of the candidate—one of a host of caricatures in circulation that Brady's photograph helped to defuse. Particularly but not exclusively in the South, Lincoln was portrayed as the devil, as simian, and as African. Of course, photographs couldn't stop such partisanship then any more than they can today, but they did carry the weight of accuracy, if not giving a candidate and his supporters control over his public image, at least giving the public a realistic point of reference. And in a society that so valued a person's face as a reflection of inner character, a fair representation could only help. Even when cartoonists simply grafted Lincoln's head from Brady's photograph onto their often grotesque pictures, his face retained some of the level gaze from the image.

That said, it would overstate the case to say that Lincoln had control over his image. Once he sat for a picture, its use was out of his hands. In fact, given the copyright laws of the period, not even photographers or painters had much luck controlling the rights to their work. Brady, of course, was paid for his studios' sessions with Lincoln, and he made more money selling copies. But he could do little to prevent other photographers from copying the images themselves and distributing them for profit, much less control their use by engravers.

Some thirty years later, Brady told a reporter that Lincoln had credited his Cooper Union picture with winning the election for him—an overstatement either of Brady's memory or Lincoln's flattery. But Brady's anecdote does point to a larger truth: Lincoln's election was the first in which photographs played a role in shaping the public's perception of a candidate. It also rightly suggests that when Lincoln visited Brady's studio in Washington, he acted out

of a dawning respect both for the abilities of the man and the political influence of the medium.

Even so, political calculation does not fully explain Lincoln's decision: the campaign, after all, was over; the public no longer needed to be convinced of Lincoln's "presidentability." He was due to deliver his inaugural address in several weeks: that, he well knew, would establish the public contours of his leadership. Instead, there were other, less conscious, and more culturally precipitated motives drawing Lincoln and Gardner together.

PHOTOGRAPHY had been introduced in the country only in the late 1830s, but in a mere two decades it had saturated American culture. Police adopted photography to identify criminals; artists used photographs as they would sketches to model paintings and sculpture; travelers brought back pictures of pyramids and the temples of Siam; and scientists began training a lens on everything from the smallest leaves to the moon. The most explosive growth in the new industry came from the millions who flocked to studios to have their portraits made. Virtually anyone could have likenesses recorded for the ages and displayed with those of their loved ones in albums, on mantels, or in cabinets. Alongside this democratic explosion of portraiture arose a burgeoning celebrity culture, fueled by photographers' ability to reproduce thousands of inexpensive pictures of the famous—like the actor Junius Booth or the adventurer-general and presidential candidate John C. Frémont.

Americans in 1861 wanted to see and be seen—in part to enjoy a vicarious brush with fame (or its cheaper cousin, notoriety)—but also because they widely believed that appearance revealed truth about inner character. Urban dwellers in particular were sensitive to cues to social standing implicit in one's dress, posture, grooming, and general deportment. Of even greater interest were people's faces and heads. The set of the eyes, the height of the forehead, the prominence of the chin, and the shape of the cranium: bodily features such as these gave shrewd viewers a vocabulary of moral traits, widely codified and popularized by the "science" of phrenology. Photographic portraits brought the face alive with compelling dramas of psychological and social identity.

No single man had more to do with photography's cultural ascendancy than Mathew Brady, whose remarkable success both rode the wave of enthusiasm for all things photographic and helped chart its direction. Born to Irish immigrants on a farm in upstate New York sometime around 1823 (late in life,

Brady admonished a reporter never to ask the age "of a lady or a photographer; they are sensitive"), by the age of twenty-one, he owned a gallery on lower Broadway in New York City and had walked away with a national prize for his daguerreotypes—the first of many. The process he used had been refined by the Frenchman Louis Daguerre in 1839 and introduced shortly afterward to the United States by Samuel Morse. A respected portrait painter, Morse had been visiting France to secure financial backing for his own device, the telegraph, but had been so impressed by Daguerre's invention that he returned to New York with a camera apparatus. Brady recalled years later finding in Morse's loft at Beekman and Nassau streets "a telegraph stretched and an embryo camera also at work."

Morse offered public lectures and private lessons on the new technique, which Brady may have attended. But he need not have—the technique quickly captured the imagination of a motley network of polymaths, chemists, mechanics, tinkerers, and gentlemen inventors who soon made daguerreotyping commercially viable. The attraction was twofold. As Brady's memory suggests, photography at bottom was a technological wonder: it magically harnessed the sun to produce enduring images just as telegraphy converted the mysterious power of electricity into messages. At the same time, it was a do-it-yourselfer's dream. For something under $300 (around $7,000 in today's money), anyone could acquire a camera and lens, some supplies and chemicals, and—with time—master, even improve, the process and open for business. Daguerreotyping served as a lucrative sideline for jewelers, watchmakers, even blacksmiths and cobblers. Those who took up photography full-time established galleries and studios virtually anywhere good sunlight could be had, while still others traveled by horse and wagon and even boat, offering portraits all through the land.

Few if any of the early enthusiasts could have foreseen the growing demand for mechanical portraits over the next decade. Painted portraits had long been expensive status symbols—even miniatures and shadow profiles, or those done by itinerant painters who would offer to fill in a sitter's head on a prepainted torso and background. When they first appeared, daguerreotypes were much cheaper, and they saved sitters from suffering at the hands of indifferently talented painters. Still, they cost a relatively dear five dollars for a single picture, and more for special jewel cases or frames or for touching up with color. Prices dropped through the 1840s until by 1850 pictures cost half that, while the average exposure times in the studio made having one's picture taken almost casual. In 1853 the *New York Daily Tribune* estimated that the industry

employed more than seventeen thousand people who produced three million daguerreotypes a year.

Much of this demand was met by low-budget portrait mills, which could usher patrons in and out "as fast as coining, for the small charge of twenty-five cents a head." Customers essentially moved through on an assembly line—buying a ticket at the door, scooting spot by spot along a bench in the waiting room until called, entering a room where they were told to sit and look "thar" before the operator exposed the plate, exiting by another door, and picking up the finished copy a few minutes later at a desk on the way out. The final pictures were claimed to be "as fine Daguerreotypes as could be produced anywhere."

Brady begged to differ about quality and chose a different route to success, charging more for a superior product. Daguerreotypes were made by exposing a copper plate coated with light-sensitive chemicals, then bathing that plate in hot mercury and salt water. The copper picture was then covered with glass and mounted in a frame or in a smaller, card-size jewel case. Because there was no negative, each picture was unique (it could be rephotographed, but it lost something in quality). At its best, the smooth copper facing allowed for uncanny detail that took on an almost holographic luminosity under glass. But the process demanded great care and judgment; it was easy to botch coating the copper, the exposure (accomplished simply by removing a lens cap, counting, and replacing it), or developing the plate.

Brady mastered these processes; he also paid careful attention to lighting (which came only from the sun; he was among the first to install skylights in his studio) and to posing his subjects comfortably. The result was a style that remained remarkably consistent over the three and a half decades he was active. There are, of course, exceptions among the thousands of images he produced, but in general his portraits offered up a sitter with sharp focus, few props, a blank background, and a generous space between the sitter and the picture's frame. He also bathed his subjects in a rich, diffuse light that softened tones and lent delicacy to the image. Whatever the pose—sitting, standing, turned to one side, or (less often) facing the camera—Brady emphasized his sitter's face. These were the qualities that earned Brady a string of prizes that culminated in 1851, when a collection of his portraits received a medal at Prince Albert's Crystal Palace Exhibition in London, an international world's fair showcasing accomplishments in science, industry, and the arts that drew six million people.

Quality, of course, was expensive, as Brady made clear in his marketing. "It has been my constant labor," he announced to the newspapers in the early

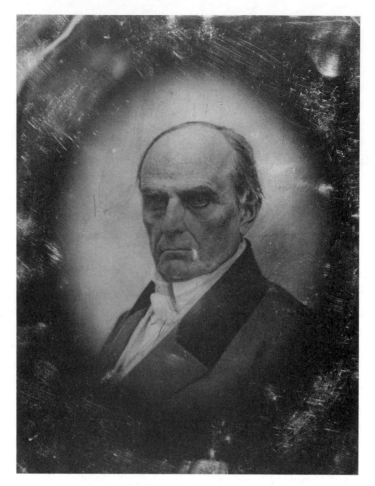

Daniel Webster, by Mathew Brady, between 1851 and 1860

1850s, "to perfect and elevate…The Daguerrean Art." The public can acquire "cheap pictures" if it wants, made with "little science, experience, or taste," or they can pay more for the confidence that their likenesses were recorded by well-remunerated professionals—"men of talent, science, and application."

The "Art" Brady laid claim to in his pictures resided to a large extent in their meticulous production, not in personal style. Even for his era, he worked with a relatively small and conventional visual vocabulary. Take, for instance, his portrait of the great orator and senator from Massachusetts Daniel Webster, made sometime in the early 1850s. Brady's image emphasizes the senator's eyes, deep-set and limpid beneath what can only be described

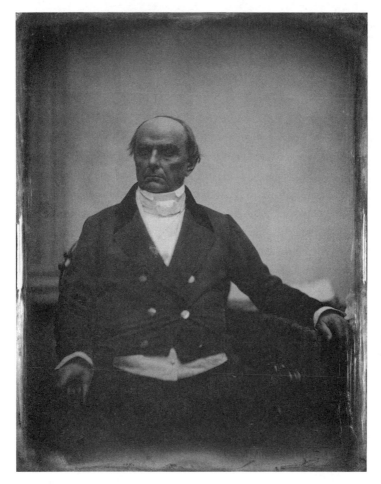

Daniel Webster, by Albert Southworth and Joseph Hawes, circa 1850

as fierce, almost eaglelike eyebrows. The eyes are framed by an expanse of forehead (emphasized by the diffuse lighting from above), cheekbones, and a stern mouth. The result is a remarkably unified image of will and profundity. We are meant to see Webster as embodying his office. Contrast this with a portrait of Webster taken a few years earlier by the Boston studio run by Albert Southworth and Joseph Hawes. Like Brady, they light Webster from above, but with a harsher contrast that picks out the wrinkles on his forehead, deepens his glare, shadows the left side of his face, and highlights the creases pulling across the tightly buttoned jacket. His hair is disheveled in both pictures, but it stands out against the white background in the latter. Like Brady,

Southworth and Hawes imbue Webster with a public purpose. But the lighting and posture add a stylized drama to the image: Webster appears as a force of nature, held in place by will but ready to burst with the pop of a button in unbounded directions.

While it is difficult to characterize an entire career with one image, the comparison highlights the more stylized repertoire of Southworth and Hawes, how willing they were to use their technology for expressive purposes, and finally, how much more modern their images look to contemporary eyes. The differences between the two studios may have been of talent or temperament, but they also stemmed from divergent intentions. For Southworth and Hawes, the photograph was a final product of their labor and vision; they are notable for taking, either singly or together, all of their own images. Brady, on the other hand, after mastering his craft, hired other operators to work the cameras (a common practice). In fact, when he received his medal in London in 1851, it was widely known that because of degenerating eyesight he had largely ceased to operate a camera, a situation that likely changed but rarely for the rest of his career.

This is not to dismiss his skills as an operator: his early work is that of a man in control of his medium. Even when he stopped operating the camera, the consistent quality of his galleries' output attests to how carefully he trained his large, well-paid staff. Nor did his extensive use of assistants and camera operators diminish his reputation. As the *Photographic Art Journal* put it generously in 1854, Brady's "failing eyesight" may have precluded "the possibility of his using the camera with any certainty, but he is an excellent artist, nevertheless."

It is probably best to follow the *Art Journal*'s lead and appreciate Brady's artistry as something closer to that of a film director and producer than a lone artist with a camera. Brady saw daguerreotypes as potentially but one stage of an ensemble production of the broader "Daguerrean Art" of image making. Take his pictures of Webster: he may well have displayed the daguerreotype in his gallery, but at the time he was likely more interested in how one like it would look as one of twelve lithographs by Francis D'Avignon published in 1850 in an lavishly produced (and expensive) volume entitled *The Gallery of Illustrious Americans*. The photograph also served as the basis for a large painting done by Richard Francis Nagle in 1858 that Brady did hang in his gallery alongside paintings by Henry Darby of Henry Clay and John C. Calhoun, holding a place of honor until he sold all three to the United States government in 1881 for $4,000.

Webster was but one trophy in Brady's relentless quest to capture images of the country's most noteworthy figures. It was an ambition inspired by a fundamentally didactic vision: his images would offer portraits of men of distinction for the edification of the citizenry. Thus his great pride in acquiring photographs of every president but one (Harrison died too early) from John Quincy Adams to McKinley. His subjects also included Dolley Madison, Elizabeth Schuyler Hamilton (the ninety-one-year-old widow of Alexander Hamilton), James Fenimore Cooper ("daguerreotypers were afraid of him"), and Robert E. Lee, whose portrait Brady secured days after Appomattox, even though "it was supposed that after his defeat it would be preposterous to ask him to sit." He also went after celebrities, like Jenny Lind, "The Swedish Nightingale," managed by Brady's Broadway neighbor P. T. Barnum, and most famously, Edward, Duke of Wales, who while in New York in 1860 visited no sights except Barnum's American Museum of curiosities and Brady's gallery, which he could enter only after negotiating the throng clogging the streets outside the building.

Once he had them in his studio, Brady worked his charm on sitters like Washington Irving—"a delicate person to handle"—in order to get his picture. This was no easy task; getting a patron to relax in front of a camera could take all of a photographer's attention. Along with articles and letters on the fine points of refraction and emulsions, the photography journals that sprang to life in the 1850s—like *Humphrey's Journal of the Daguerreotype and Photographic Arts* and the *Photographic Art Journal*—also ran articles on how to best manage nervous sitters. Many customers take their place in front of the camera with "a sort of dread, or uncomfortable feeling," wrote the Connecticut photographer H. J. Rodgers in his memoir *Twenty-Three Years Under a Sky-Light*. In part this grew out of a superstitious fear that allowed "the operating and darkroom" where pictures were fixed and developed "to be connected with something mystical, magical, and conjural." Equally disturbing was the headrest, a device designed to hold the subject steady for the length of the exposure that looked like a clamp on top of a pole—sitters expressed "a great aversion to having their heads 'placed in a vice.'"

The key to success was diverting patrons in a comfortably furnished waiting room with books (nothing "bulky, grave, or abstract"), pictures, and curiosities. Marcus Root, a Philadelphia photographer whose book *The Camera and the Pencil* emerged as the era's most authoritative guide, advised hanging "several cages of singing-birds" because "they tend to awaken emotions and call up recollections and associations which impart to the face an amiable,

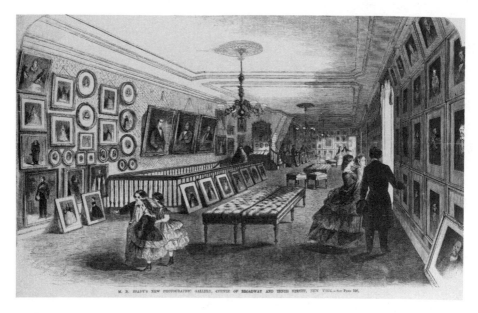

"M. B. Brady's New Photographic Gallery": Frank Leslie's Illustrated Newspaper, *January 5, 1861*

genial expression." Brady needed no birds, though, of course, he made his galleries marvels of comfort. His strongest resource was his demeanor: as he put it in retrospect, "I never had an excess of confidence, and perhaps my diffidence helped me out with genuine men." Part of Brady's talent lay in what we can call his tenacious tact, a trait that one contemporary characterized as an "urbanity and geniality of manners, and an untiring attention to the feelings and happiness of those with whom he comes in contact."

Brady saw photography as a tool for the largely Romantic project of rendering exemplary figures visible to the public. In practice, this meant, as he put it later in life, directing his best effort at "getting the subjects to come to me, [and] in posing them well." After that, it is just a matter of "completing the likeness." And, of course, displaying it as beautifully as possible, either in publications like *Illustrious Americans* (which, at thirty dollars, sold poorly), or in his lavish galleries, which functioned as national portrait museums. And yet, as integral as didactic uplift was to Brady's aesthetic, at least as many who came to admire Webster stayed to marvel at Brady's talent and the way his subjects "seem almost to stand out of the plate, like sculpture, so perfectly distinct is every line and feature of their countenances."

Brady strove to create a pantheon of fame, and his galleries were successful at staging fantasies of celebrity and prestige. While he moved his New York gallery three times, Brady never left lower Broadway, which kept him at the heart of the city's most fashionable public life. "Find the photographic emporium of our friend Brady," wrote celebrity writer Nathaniel Parker Willis in 1859, "and you find the spot where the city of New York is liveliest." Within blocks of his gallery stood Barnum's, the fashionable Astor Hotel, A. T. Stewart's famous department store, and an array of showrooms for carpet, furniture, dresses, and hats that attracted fashionable promenaders. Brady's gallery (as well as those of his best competitors) fit right in. As one New York woman explained in the newspaper in 1858, after shopping, she and her friends liked to seek out "those delicious lounging-places on Broadway...where we drop in to look at pretty things and pick up new ideas." What better place to rest than Brady's Gallery, located in "the great throbbing heart of Broadway," with its "cool emerald light through its spacious length and breadth, which is marvelously refreshing in the glow of an August noon."

Brady's Romantic vision of representing the faces of the nation fit well into a society growing entranced with the allures of commercial display, leisure, and status, and his galleries helped to make photographic portraiture into a medium that mixed cultural celebrity with political distinction. His pursuit of famous sitters, often enticed with free sittings and copies of flattering retouched images, not only secured his reputation as a photographer, but also helped transform him into a celebrity himself. As he put it later, "In those days, a photographer ran his career upon the celebrities who came to him." When he opened his final New York gallery on the corner of Tenth and Broadway (just after photographing Lincoln before his 1860 Cooper Union address), the event was so newsworthy that it was covered by the nationally distributed *Frank Leslie's Illustrated Newspaper*, complete with picture. Members of the public could dip into this celebrity by visiting what one paper called his "Broadway Valhalla"—or his gallery on Pennsylvania Avenue in Washington—and having their own pictures made by the photographer of statesmen and presidents. Brady was not alone in linking photography with celebrity and prestige, but his knack for self-promotion, as well as the consistent quality of his images, made him a leading figure in establishing its status.

*

MATHEW BRADY not only recruited the world's most illustrious subjects; he also paid some of the best wages in the industry, which likely made a job in his gallery very attractive to Alexander Gardner, who had just moved to the United States from his native Scotland with his wife, two children, and a deaf mother. New York was not the original destination, nor was a career in photography what Gardner had in mind when he emigrated. Instead, he had planned to join his brother, his sister's family, and friends in Iowa, where they had originally moved to start a small cooperative community that he had helped organize and finance. The cooperative had failed, but the community continued with good enough prospects to convince the Scotsman to emigrate. Before arriving, however, they received news that many in the community had succumbed to "galloping consumption" (tuberculosis), which had taken his sister, laid low her husband, who would soon die, and left their two-year-old daughter in the care of friends.

When Gardner showed up for work at Brady's sometime during the summer of 1856, he was just back from visiting survivors and settling a permanent place for his niece but apparently still determined to make his living in the United States. It is not clear either why Gardner chose New York or why he left Glasgow when he did and not, for instance, with the community six years earlier. But whatever the circumstances leading up to it, the hiring was fortunate for both parties. Gardner landed a position with the most enterprising photographer in the country at a moment when the industry was undergoing changes that were opening new opportunities. For his part, Brady had brought in a man whose expansive beard, long hair, and bulky frame belied a cosmopolitan energy and keen sense for business.

Although he was just a few years older than Brady, Gardner already had an impressively wide-ranging résumé. Born in 1821 in Paisley, Scotland (best known for the Kashmir weaving pattern produced by the mills there), he moved to just outside Glasgow as a boy around the time of his father's death. There he was apprenticed to a jeweler for his teenage years and completed his training at the age of twenty-one. But he did not stay in the trade long: by 1847 he was working in the heart of the Glasgow business finance community managing the Clydesdale Discount and Loan Company— essentially a brokerage for bills of exchange and promissory notes. He was restless intellectually as well. He studied such topics as astronomy, botany, and chemistry at the Gorbals Popular Institution for the Diffusion of Science and joined the Glasgow Athenaeum, an educational center that sponsored public lectures and offered members a library and a selection

of periodicals, as well as classes in English grammar and literature, math, logic, languages, and business.

At some time, maybe even in childhood, given how popular they were, Gardner was introduced to Robert Owen's ideas of cooperative socialism, which inspired the Iowa settlement. Owen was a liberal philanthropist whose own efforts at reforming the mill town of New Lanark in Scotland, some thirty miles southeast of Glasgow, and founding the utopian community of New Harmony, Indiana, had inspired many progressives on both sides of the Atlantic with the dream of building a society from scratch based on the just distribution of wealth and labor. Such a prospect would have appealed to many inhabitants of Glasgow during this period. Already one of Britain's key ports, over the past few decades its size had swelled with immigrants from the Highlands and Ireland seeking work in its cotton and textile mills or chemical and paper industries, which made Glasgow one of the wealthiest cities in Europe. It was also home to some of Europe's worst living conditions: the same industrialism that brought prosperity to the few left the many ravaged by poverty and disease so appalling that its tenements and slums became internationally notorious.

Gardner and a few associates responded by chartering the Clydesdale Joint Stock Agricultural and Commercial Company in 1849 with the express goal of purchasing land in the United States where they might establish, "by means of the united capital and industry of its partners, a comfortable home for themselves and families" by following "a more simple useful rational mode of life than is found practicable in the complex and competitive state of society from which they have become anxious to retire." It was a heady dream, much like that of the millions of emigrants who sought new lives in the Americas but animated with an idealistic vision of the harmonious marriage of capital and labor.

Gardner apparently traveled to Iowa in 1849 to help establish the community, outside the hamlet of McGregor along the Mississippi River. (He would visit once more before emigrating.) On his return to Scotland, he busied himself with yet another enterprise by purchasing the *Glasgow Sentinel*, a freethinking reformist weekly paper for working-class readers. Again, his motives for running the paper were filled with idealism, touched with just a dash of paternalism. He did not acquire the *Sentinel*, he assured his readers in an early issue, "as mere speculation in the usual sense of the term[,] but as a means of enlightening the public on the great political, educational and social questions of the times and of guiding right the popular mind of this country on all matters of state policy." Acting as publisher and business manager, Gardner worked with

his Owenite editor, Robert Buchanan, out of a tiny office above a radical book-seller run by one of his partners in the Iowa project, located "up a dingy street" in "the darkest slums and dens of the city." Together they were able to make the paper, according to one source, "the principle [*sic*] working-class paper in the west of Scotland in its day." The paper featured extensive coverage of reform politics, paying particular attention to Chartism and universal male suffrage, and offered articles on such topics as "the necessity of improving dwellings of the poor." It also reprinted national and international news from other papers, as well as shipping and commercial news; it carried reports on commodities like wood, lard, cotton, grain, and flour and even printed poetry exhorting the laborer's "right of soil / And the right to toil." Letters from America complained about the "ill-paved streets" and "narrow pavements" of New York, praised its political institutions and standard of living, and described the drama of resistance in Massachusetts to the capture of fugitive slaves.

Gardner remained with the paper only two years, leaving perhaps to settle financial matters in Iowa when the cooperative broke apart. After that, he apparently drops out of the historical record until the end of 1855, when a notice in the *Dumbarton Herald* in Scotland announced that "Mr. Gardner is practicing among us as a photographic artist." It was a curious turn for someone with such big ideas. Perhaps he was inspired by seeing Brady's daguerreotypes at the Crystal Palace Exhibition in London, which the *Sentinel* covered. Or perhaps it was a show of Roger Fenton's photographs of the Crimean War, or meetings of the Glasgow Photographic Society, or the regularly exhibited work of Edinburgh photographers David Octavius Hill and Robert Adamson that led Gardner to try his hand at the new art. Maybe he saw the opportunity to once again pursue a craft that required the same steady hand, attention to method, and care for detail as jewelry.

Whatever led him into the business, as with all of his enterprises during this period, he was very soon out of it and on his way to the United States, never to return to Scotland. By the summer he was working for Brady, no doubt pleased that five months' experience in photography had landed him a good position.

Brady must have been pleased as well. Gardner arrived just as the industry standard was changing from daguerreotypes to wet-plate, or collodion, photography. Instead of producing one-of-a-kind images on relatively small and expensive copper sheets, operators could now expose chemically coated glass plates to produce negative images—backward, upside down, with reversed lights and darks—which could then be used to print on treated paper as many

identical pictures as were needed. The prints lacked the uncanny detail of daguerreotypes, but they were sharp enough, flexible and easily mounted, and could be enlarged.

The new technology required new investments in equipment and skills but also opened new markets and new uses for pictures. While the decade had opened with millions of daguerreotypes being produced, these unique images remained where they were, exhibited in the environment that made them meaningful. With wet-plate photography, patrons could now procure multiple copies of images of themselves from a single sitting, which they could distribute to family, friends, and sweethearts. On a more public scale, photography's reproductive capacity coincided with the emergence of the national pictorial weeklies, like *Leslie's Illustrated* and *Harper's Weekly*, to set images in circulation through the whole social body. Faces and poses traveled far from their home contexts. Just as on city streets, it became possible to see strangers without ever knowing who they were. This curiously modern expansion of anonymity was met by the equally modern phenomenon of virtual celebrity: people could recognize the faces of public figures they had never met in person.

This proliferation of images would accelerate toward the end of the decade and into the 1860s with the introduction of the *carte de visite* format, "calling card"–size photographs, which traveled easily in the mail and fit well in the family albums that were increasingly common on the country's parlor tables. Even as consumers assembled their own private galleries, they also came to include pictures of the very celebrities—statesmen, actors and singers, national heroes—who made Brady's gallery such an attraction. Over the course of the decade following Gardner's emigration, the demand for such photographs, as well as for the double-imaged stereoscopes that rendered the world in three dimensions, far exceeded what a business like Brady's could meet, leading to the emergence of a photographic reproduction industry. Integrated mass-production firms like E. & H. T. Anthony could print thousands of negatives of people in the news, like Lincoln, and distribute them to booksellers, stationery stores, and tobacconists.

Much of this change was just starting when Gardner began work. Brady was already rephotographing his extensive collection of daguerreotypes so they could be copied, and he was experimenting with the larger formats made possible by negatives. Gardner brought with him experience in printing to paper and enlarging that likely yielded an immediate benefit for Brady. Like many artistically inclined photographers, Brady was not enthusiastic about smaller formats and more softly detailed printing techniques, which allowed

little space for the clarity he so valued. In effect Brady wanted his photographs to have the aura of paintings. Coincidence or not, soon after Gardner arrived, Brady offered a new product that carried just the visual authority he wanted: massive-size, "imperial" prints (up to 20" × 24") that allowed full-figure poses or nearly full-size head shots that could be retouched with color or ink enough to look painterly. Prices matched the new scale: Brady could ask from $50 to $750 for each print, depending on how much handwork was done on the images.

Gardner also brought, by most accounts, other skills that may have helped Brady even more. Brady ran his business with energy, ambition, and commitment to high production values, but he apparently had only the most casual interest in, or understanding of, financial management. When Gardner arrived, Brady's finances were in such disarray that the credit-rating agency R. G. Dun (later half of Dun & Bradstreet) was warning creditors to be wary. Gardner's background in finance may not have been enough to rectify Brady's problems in New York—three years later, the agency was even more forceful in its critique: "He makes money fast, but does not lay up." But it is easy to imagine Gardner, described in his eulogy as "a man of great system, and much firmness in maintaining and carrying forward his plans," making known his disapproval of Brady's bookkeeping. And it likely helps account for Brady's appointing the Scotsman manager of the Washington gallery when he opened it in early 1858.

In Washington, Gardner by and large faithfully fulfilled Brady's aesthetic vision while putting his personal stamp on how things were managed. The gallery was not as lavish as Brady's original, but then again, the marshy, pestilent half-built capital city was hardly New York. Pennsylvania Avenue was certainly no Broadway: the north side, where Brady set up shop, had its share of good hotels, upstanding businesses, and residences, but facing it across the expanse of mud or gagging dust (depending on the season) were blocks of seedy saloons, gambling clubs, and bawdy houses. At one end rose the Capitol's half-finished dome, surrounded by the detritus of seemingly endless construction. Near the other end, on the rise south of the White House, stood the 156-foot stub (about a quarter of the finished height) of the Washington Monument. Running between the monument and the White House toward the Capitol was the Washington City Canal, which had become the city's open sewer and storm-water drain.

Still, Gardner filled the second-floor gallery with Brady's (and his own) pictures, hired an able staff, including his brother, and ran a studio that soon

emerged as the finest in the city, attracting the kind of patrons and walk-in traffic worthy of the biggest name in studio photography. As the crisis of the Union intensified and the country lurched toward open conflict, Gardner rightly anticipated the flood of soldiers and other visitors eager to send home pictures of themselves in uniform when he purchased a four-lens cameras that could expose simultaneously four *cartes de visite* on a single half-plate negative. He also arranged a contract that gave the Anthony Company exclusive reproduction rights to publish Brady images of popular figures—and later, scenes from the war—in exchange for a cut of the sales profits. All in all, under Gardner's management the business earned a regular income of $12,000 per year on top of the walk-in trade. He was also active in acquiring negatives from other photographers, which he passed on to Anthony. Anthony did retain ownership of the negatives, but each print carried Brady's imprint.

As he built the reputation and expanded the business of Brady's gallery, Gardner also settled into a lifelong residency in Washington. At thirty-seven, the restless socialist utopian reformer ex-publisher ex-jeweler photographer immigrant found a home. Shortly after the gallery opened, he moved his family to a small community on the rural northeast edge of Washington City called Kendall Green, named for the nearby farm owned by Amos Kendall, whose portrait by Gardner would hang on the gallery wall.

GARDNER remained in Brady's employ for at least another year before leaving the studio to serve with General George McClellan's staff as a civilian volunteer for the Topographical Engineers. While at large, Gardner continued to supply Brady with photographs of military life, though it's unclear whether he did so as an employee or as a freelance photographer. After McClellan was relieved of command in November 1862, Gardner returned to Washington but not to Brady's; the next summer he opened his own gallery just around the corner.

Their break has invited speculation about what precipitated it—tension over money, over Gardner's wanting credit for his work as an operator, over Brady's casual business practices—but there really is no way to know why Gardner left, beyond the obvious thought that the former newspaper publisher wanted his own business. Neither photographer left much of a personal record. For all his fame, Brady in particular wrote very little (this may be in part due to his poor eyesight; Gardner, who knew shorthand, wrote Brady's letters for him to sign). After death, Gardner's name sank into relative obscurity for three

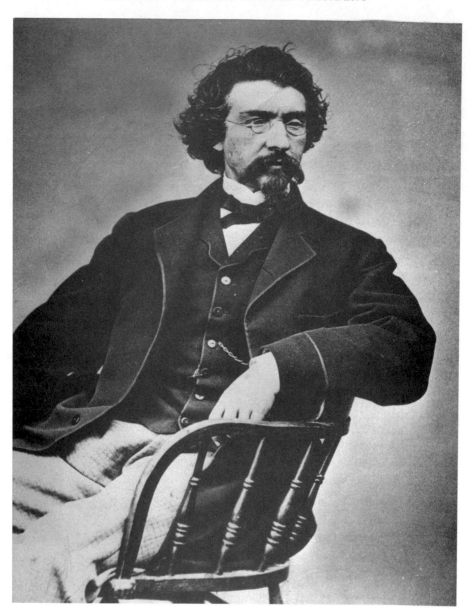

Mathew Brady, by M. B. Brady Gallery, circa 1860–65

quarters of a century. Many of his negatives and whatever personal papers he may have left were destroyed or disappeared; many of his published photographs were attributed to Brady. As a consequence, there are scant records of a full life: a few notes and telegrams, some newspaper pieces, several eulogies, brief reminiscences, advertisements, and public records.

Still, there are the photographs: if they can tell us anything, they certainly suggest two men of different sensibilities. In life, as in his portraits, Brady cut a dashing figure, sporting fashionable clothing with silk scarves, handkerchiefs of linen, and a walking cane. In a self-portrait taken sometime during the war, he displays his fashion sense as he leans back and turns past the camera with his left arm jauntily resting on the chair back. While the pose is blatantly theatrical, Brady's graceful balance makes it seem natural. His delicate features are obscured by the long Van Dyke, which echoes the wavy hair framing his face, giving his head a classically sculptural feel.

Cutting against this suavity is Brady's expression of serious, almost severe, concentration, marked on the forehead by the muscles straining his eyebrows straight as if in concentration. At the same time, however, his gaze is obscured by his glasses; the right frame even cuts across his iris. Brady here poses, as he was careful to in virtually all of his pictures, as a visionary artist of obscure genius who himself is a worthy subject of the very serious art he practices—a notable member of the select society that he himself had the vision to recognize.

Judging from pictures, Gardner's features were not what we call delicate, though the hair that swept from forehead to collar and his exuberant beard make any conclusion conditional (see plates 2 and 3). Nor did he pose gracefully or dress fashionably. In his best portrait, taken around the time he first met Lincoln, Gardner sits in a posture of solid ease—his worn studio coat even bulges open below a button at his stomach. He does share with Brady a studied look to the side, but his expansive forehead is smooth. The overall disheveled look of his beard, hair, and coat contrasts with the ornately carved chair, suggesting he may not belong in it.

At first glance, the two seem as different from each other as they could be. Brady's salon-ready demeanor speaks to a world of taste and fashion that the rough figure in the lab coat has nothing to do with. Gardner's prominent hands and thick wrists suggest a laborer—an "operator"—who has momentarily come from behind the camera, out of the workroom into public view. And yet it may be more useful to see them as two sides of the same coin of artistry. Brady may be the aesthete, and Gardner the hirsute man of passion, but both

of them pose with a knowing theatricality—Gardner's right eye narrows with a hint of a half-smile that betrays an amused self-consciousness every bit as studied as Brady's scowl. Taken together, they hint at both how much Gardner learned from his employer and how fully he stepped out from beneath his influence to form ideas of his own about what the "mystical, magical, and conjural" art was about.

Lincoln offers a different problem for inquiry. American history is replete with biographies, histories, documents, novels, films, memorials, and artifacts of, about, and from his life. Within weeks of his death, the advice-book writer and former editor Josiah Gilbert Holland was in Springfield to interview those who had known the president, and those who had known Lincoln while he was in the White House rushed to print their memories. The reporter Noah Brooks's "Personal Recollections of Abraham Lincoln" appeared in *Harper's Monthly Magazine* that very summer. The flood of writing and documentation has continued unabated for a century and a half. That said, there remains as much a blank about Lincoln's inner life as there is about Gardner's. Surprisingly for a man whose memory is so tied to his words, Lincoln kept no diaries or journals and wrote very few personal letters. This core of inscrutability has inspired some remarkable and imaginative scholarship; it may well lie at the heart of our culture's ongoing fascination with him. "Lincoln is like the Bible," declared Walt Whitman—among his most imaginative and enduring admirers. "You can read anything in him. One man will say, 'Here, here, Uncle Abe was so and so—I have the text for it,' and another with an opposite notion will say, 'See, he was with *us*: I have the text for it.'"

There is little in the photographs Gardner took of Lincoln that February morning in 1861 that anticipates the probing intelligence with which he would turn his camera on the quick and the dead, on the famous and the anonymous, the mighty and the humble. Nor is there much trace in the image of the man who sat for those pictures of the political genius, personal tenacity, and steady vision that would guide the Union through Civil War and make his the single most recognized visage in our history. But in his dull expression and heavy posture we see exactly the enigmatic figure he was to his contemporaries and remains for us today. We see him because Gardner, through inexperience or maybe because he trusted his camera to deliver more to our eyes than either he or Lincoln intended, took the picture.

Maybe it was simply an accident of history that a Scottish immigrant was the most imaginative visual interpreter of our most American president and most American war. But if we attend to the images they made together,

holding them alongside others made of Lincoln, others made by Gardner, and a small sample of the flood of images that flowed from the expanding photographic industry, we find rich documentation of Gardner's studio as a crossroads where the worlds of politics, enterprise, art, and celebrity met. In Lincoln's case, looking critically opens a sepia-tinted window into the reserved self-consciousness that so provokes and tantalizes us. We glimpse from a different angle the ambition, even the hubris, that informed Lincoln's sense of himself as an actor on history's stage and his deep investment in how he was perceived, not only by the time he lived in, but by the future as well. In Gardner's case, looking closely allows us, as it were, to stand in his shoes and see with his eyes the president and the conflict that was never far from either one of them. It lets us share his sense of discovery as he turned his camera from well-known statesmen and generals to the anonymous battlefield dead, from the great public buildings of the nation's capital to the ruins of Richmond, from the face of Lincoln to the hooded forms of his assassins at the end of a rope. And we can follow the growing sophistication with which he came to see the young technology of photography as a medium for imagining a national community through the shared vision of a common past. As Lincoln did in his Gettysburg Address, Gardner took hold of our national memory.

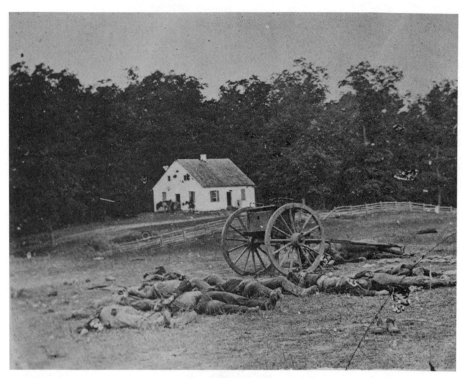

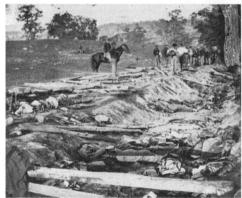

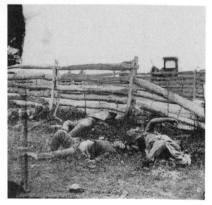

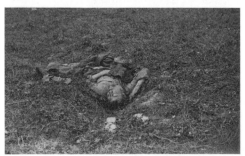

Battle Dead, Antietam Battlefield, by Alexander Gardner, September 1862

CHAPTER 2

1862: Antietam

O N the Friday morning of September 19, 1862, Alexander Gardner, along with James Gibson, a fellow Scotsman and Brady operator, ventured with their portable darkroom wagon and cameras onto the fields just north of the western Maryland town of Sharpsburg and just across the Antietam River, where two days earlier some one hundred thousand troops of the Army of the Potomac and the Army of Virginia had fought one of the most memorable battles in American history. Gardner and Gibson had formed a partnership to distribute pictures taken while in the field with the Army of the Potomac. Although it ended in litigation, their arrangement suggests that Gardner was starting to make strides toward independence from Brady. The men took twenty-eight photographs of the battlefield where the most violent fighting had occurred, sixteen of which pictured the unburied dead that still littered the ground, waiting to be interred in hastily dug and casually marked mass graves.

During the following days, the two men worked their way south, documenting such sights as the soon-to-be-iconic Burnside Bridge, named for the Union commander whose troops crossed it under enemy fire. They finished up Monday with pictures of General George McClellan's field headquarters and the village of Sharpsburg before shipping all of their negatives, carefully packed in boxes to protect the glass, to Mathew Brady's Washington gallery, where they would be printed. All in all, they produced seventy views, sixty-three of which Gardner would later credit as his own, many of which have become among the best-known images of the war.

Two weeks later, on October 3, Gardner was again at work around Antietam, this time without Gibson, taking pictures of President Lincoln's

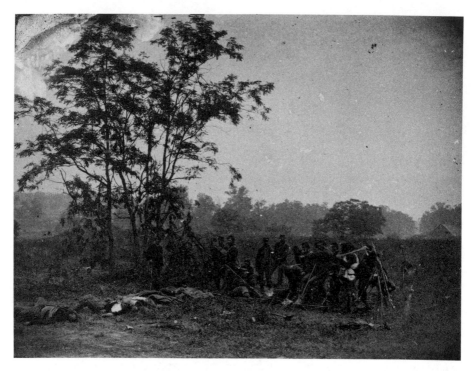

Burial Party, Antietam Battlefield, by Alexander Gardner, September 1862

visit to the Army of the Potomac. The visit was a busy one for both men. Gardner took two pairs of pictures of Lincoln with McClellan; one pair shows the president and his general seated together at a table inside a tent, another shows the two standing in more formal poses with various military men and civilian officials (see plate 5). Gardner also photographed the president with Allan Pinkerton—by now appointed McClellan's head of military intelligence—as well as civilian groups and military staffs around the area. Lincoln, followed by reporters, reviewed the troops, toured the battlefield, visited hospitals, including one with Confederate soldiers, and, above all, spent time consulting with McClellan before returning to Washington on October 4.

Taken together, Gardner's Antietam pictures make a strange collection. His views of dead men and horses, broken caissons amid the litter of military destruction, and rude graves in barren landscapes contrast sharply with the more or less formal group portraits of generals, staff officers, scouts, and civilians, standing, seated, or sprawled on the ground in front of tents or arranged on the steps of houses commandeered for the Union cause. It is as if one world has nothing to do with the other.

But of course they had everything to do with each other. Lincoln traveled from Washington to visit the army in part to raise morale after a battle that much of the Northern press, as well as McClellan himself, had declared a great victory. He also wanted to gauge for himself the army's fitness for combat after fighting a monthlong campaign. Lincoln was meeting with McClellan less to congratulate him than to urge him to pursue the badly damaged Rebel army and fight again. Over the course of the year that McClellan had led the Army of the Potomac, he had shown himself a superb organizer, transforming a demoralized citizen army into the greatest fighting machine in the world, but he had also manifested a maddening hesitancy about using that machine for its purpose. For his part, Lincoln had come to the conclusion that the best use of the North's superior forces was to fight the Army of Virginia at every opportunity, to grind down the enemy by killing, wounding, and capturing as many soldiers as possible.

The conflict between the president and his general ran deeper and wider than questions of strategy. It was professional (when does the judgment of a military professional trump that of his civilian commander?); it was political (McClellan was a Democrat); after months of mutual irritability, it had become personal; and by the time of Antietam, it was very public. Gardner's photographs resonate with these tensions. But they also mark a key moment in the president's decision to wage the kind of war that produced the death and mayhem Gardner had recorded two weeks earlier. It is as if the unburied dead haunt the leaders' summit.

Nevertheless, there are fundamental differences, other than subject, between the battlefield images and those taken at headquarters. Today the former are among the best-known battlefield photographs from the war. Like those that Gardner and his team of operators were to take after the battle of Gettysburg the next year, despite their aura of stark documentary, they have taken on a powerfully metaphorical meaning that has lifted them out of their historical moment and made them symbols of the violence of the Civil War and modern warfare in general. The photographs of Lincoln and McClellan, too, are well known—Gardner included one of them as the only image of the president in his *Photographic Sketch Book of the War*, his final artistic statement about the conflict—but they are more timely than timeless; their interest for us today lies in how they fix a particular moment in the past.

Spend more time comparing the two sets of images, and other differences emerge. Those taken during Lincoln's visit project a world of almost domestic order. The tents are crisply white, the ground is clear, generals dress

smartly for their photographs while the staff officers lounge together with an easy bonhomie that comes to those working and living together. In a number of them Gardner was careful to identify people in his pictures (George Armstrong Custer stands at the far right of the group; see plate 4). Subsequent researchers have been able to fill out even more names. These are men (and some women) posing for a public eager to put faces to the names in the news articles from the correspondents who followed the armies from campaign to campaign. Gardner's photographs are in some senses the wartime version of Brady's *Illustrious Americans*, and as with Brady's portraits, we are invited to read character and intention and speculate on relationships based on the details of posture, expression, positioning, and lighting.

Gardner generally called his battlefield photographs "views"—the nineteenth century's word for landscapes. The word is apt: part of their shock comes from seeing exposed bodies on the terrain of everyday life—arable land, in front a church, along a road. Formally Gardner uses the land as his canvas: fences, trees, horizon lines, ditches, and the contour of the ground frame the bodies and the detritus of battle in space. But really, especially when held alongside the camp-life portraits he made in October, the images of the dead work more like "antiportraits." A number of images present the dead simply as objects scattered across the ground or in a ditch, at times barely distinguishable from each other or from the clothing, shoes, slabs of wood, tangled rope, and broken fences that litter the battle-scarred ground. At times details seem to overwhelm the image as whole: in one photograph a crooked arm rises from the ground as if in an embrace; another pictures a body as if caught—horizontally, it is true—in the midst of a pirouetting *danse macabre* (see page 63).

The differences attest to both Gardner's eye for composition and his ability to adapt the camera to different situations. The two sets of photographs work best in dialogue with each other. While the battlefield scenes invite us to contemplate the anonymity of violent death outside of questions of military policy or social morality, the group portraits of dramatic but bloodless politics solicit our interest in what the press called "the two most popular men in America." Only together do they illustrate how such wanton death made generals, officers, and politicians into the household names whose faces the public, and history, wants to see.

Of course no one was more aware of such ironies than McClellan and Lincoln. And there is good reason to think that Gardner, too, shared their awareness. Weeks earlier, while working on the battlefield with Gibson, Gardner had telegraphed the Washington gallery urgently requesting more

glass negative plates, and then added he had already taken "forty fine negatives of Battle." He was right to think he had something special: his photographs would bring viewers closer to the battle than any others on record. Brady agreed: he quickly arranged for them to be published as woodcuts in *Harper's Weekly* and to be displayed in his New York gallery, attracting visitors with a simple handmade sign: "The Dead of Antietam." A thoughtful reporter from the *New York Times* wrote on October 20 that it was as if the exhibit had set a "few dripping bodies, fresh from the field," in front of the sauntering crowds of Broadway. "Mr. Brady," he or she wrote, "has done something to bring home to us the terrible reality and earnestness of war."

Brady's exhibit very likely opened in October, after Gardner photographed Lincoln. In keeping with custom, owner Brady, not operator Gardner, received all the credit for the pictures in the gallery and in *Harper's*, which appeared a week after the *Times* article. Still, Gardner must have known that his pictures would be exhibited in New York with all the fanfare that Brady, the master publicist, could muster. And it is very likely that the public success of those photographs played a large role in Gardner's decision, made sometime later that fall, to leave Brady and step out on his own, taking with him both sets of Antietam photographs and billing himself as "Photographer to the Army of the Potomac." How clear these plans were in his head when he photographed the president and McClellan, we can't know. What is certain is that Gardner's image of Lincoln standing tall with his general and his staff documents a moment when the president, McClellan, and their photographer were assessing the fearful costs and myriad opportunities inherent in a scale of warfare that, only a few months before, had been unimaginable. Each man would respond in his own way to the responsibility of such recognition.

The power of Gardner's battlefield photographs to arrest our eyes even today derives at least in part from Antietam's infamous place in history—a reputation his images helped create. With its three days of high drama and higher stakes, Gettysburg remains the battle most identified as the turning point of the Civil War, but Antietam has its own claims to importance. Technically, the two armies fought to a standstill that continued the next day before the Army of Virginia withdrew. Strategically, however, it stood as a Union victory—a significant turn after August's resounding defeat of Union forces at the second battle of Bull Run, which had thrown Washington into a panic over fears of a Rebel occupation of the city and spurred General Robert E. Lee on to press his advantage by invading Maryland. Lee had hoped to galvanize support in the border state for the Confederate cause and strike at the heart of the Union.

There was also thought in Richmond that such a bold strike would help legit-
imize the Confederacy in England and France, perhaps leading to formal rec-
ognition and aid. By halting the invaders, General George McClellan's Army
of the Potomac not only saved the North, but provided a deterrent strong
enough to take the air out of foreign interest in supporting the Confederacy.
He also gave Lincoln enough of a victory for him to issue the Emancipation
Proclamation, a decree that, for all of its limitations, established the end of
slavery as a key goal of the war.

But Antietam's place in our national memory has less to do with strategy
than it does with the ferocity of the fighting and the scale of carnage. At some
point, most accounts of the battle, like that in James McPherson's *Battle Cry
of Freedom*, simply turn to statistics to convey its character. Together, he tells
us, Union and Confederate forces suffered almost 6,000 deaths and 17,000
wounded; of the wounded something like another 2,500 would later die. This
was four times as many casualties as suffered by Allied forces on D-day in 1944
and again more than half the American casualty totals of the War of 1812, the
Mexican War, and the Spanish-American War combined. Contemporaries
lacked the same historical perspective, but they too resorted to numbers to
describe what had happened. The reliable McPherson, this time in his book
on Antietam, gives some of the most vivid examples. A Union colonel notes "in
the space of less than ten acres, lay the bodies of a thousand dead men and as
many more wounded." Another officer counts 200 bodies "in one small field,"
while an enlisted man on burial detail at the Sunken Road counts 264 bodies in
55 yards. An exhausted Massachusetts captain noted 20 bodies around where
he slept. Witnesses claimed you could walk a mile across the battlefield with-
out touching the ground; others told of whole ranks of Confederates killed so
suddenly their bodies lay in perfect battle formation.

Numbers convey the scale of violence but none of the emotion. For that,
accounts today tend to reach for a single word, repeated like a Homeric epi-
thet: Antietam, we are told, was "the bloodiest single day in American military
history." "In the bloodiest war in American history, the battle of Antietam
stands out as the bloodiest single day." The National Park Service website
puts it all together: "The Bloodiest One Day Battle in American History," it
proclaims, "23,000 soldiers were killed, wounded or missing after twelve hours
of savage combat on September 17, 1862."

Nineteenth-century observers used a more richly Gothic vocabulary,
easily visible in the material McPherson gathers in his book on Antietam,
Crossroads of Freedom. "No tongue can tell, no mind can conceive, no pen

portray the horrible sights I witnessed." "Hundreds of dead bodies lying in rows and in piles...looking the picture of all that is sickening, harrowing, horrible. O what a terrible sight!" "No words can convey...[the] utter devastation and ruin." "The real horror can better be imagined than described." "But few persons can form even the faintest conception of the horrors presented by a battle-field," wrote a local paper at the time. "The eye beholds but the lips can but faintly express the misery here exhibited—the soul is sickened, the heart grows faint." Fragments and details of the whole seemed to speak most clearly. A burial detail officer found bodies "in every state of mutilation, sans arms, sans legs, heads, and intestines." For miles, noted another witness, "the ground is strewn with...hats, caps, clothing, canteens, knapsacks, shells and shot."

What happened at Antietam, these accounts tell us, was beyond the limits of ordinary language, even somehow beyond imagination. For those who could find words, the horrors shook to the core their faith in the Union cause, even in God. "To the feeling man this war is truly a tragedy," wrote a surgeon of a New Hampshire regiment, "but to the thinking man it must appear a madness." He went on: "When I think of the battle of Antietam it seems so strange. Who permits it? To see or feel that a power is in existence that can and will hurl masses of men against each other in deadly conflict—slaying each other by the thousands—mangling and deforming their fellow men—is almost impossible. But it is so— and why we cannot know." Robert Gould Shaw (who would later perish leading his African American brigade storming Fort Wagner) wrote to his father days after the battle that "it seems almost nothing could justify a battle like that of the 17th, and the horrors inseparable from it." As one observer put it with darkly sardonic bravado, "Visit a battle-field and see what a victory costs!"

Provoked by similar accounts in the national press, the "hushed, reverend [sic]" visitors to Brady's gallery leaned in to see for themselves in Gardner's photographs—each about the size of a postcard—what words had failed to capture. If Brady, wrote the *Times* correspondent, "has not brought bodies and laid them in our dooryards and along the streets, he has done something very like it." Such realism provoked in viewers responses similar to those of eyewitnesses. Even as *Harper's* published woodcuts of the images, the editors felt compelled to describe the photographs themselves, in one "of which are a number of dead bodies grouped in every imaginal [sic] position, the stiffened limbs preserving the same attitude as that maintained by the sufferers in their last agonies." Later, the well-known essayist Oliver Wendell Holmes, who had traveled to Antietam in search of his wounded son, visited Brady's and found

the photographs so powerful "that all the emotions excited by the actual sight of the stained and sordid scene…came back to us."

Strikingly, the *Times* writer makes virtually no reference to the battle itself beyond noting Brady's handwritten sign on the street. None in this admittedly small sample of responses to Gardner's images tries to tie what is visible to what happened in the battle, even as all acknowledge their power to evoke a visceral "reality." In part this is a response to Gardner's images themselves. He may have thought he had "fine pictures of [the] Battle," but what he delivered spoke less about flanking maneuvers and attacks and campaigns and the fate of the Union, than about death—not a "good death" redeemed by noble causes and last words to the family, but a sudden, anonymous, and profoundly violent end of life. Gardner's "weird copies of carnage" left viewers at Brady's "chained by the strange spell that dwells in dead men's eyes."

But there was another reason these pictures did not speak specifically about Antietam. For all of the carnage, the engagement was less a startlingly unique battle than a heightened instance of a distressing trend. Previous battles, like that at Shiloh in Tennessee in April 1862 and the Union debacle at the second Bull Run just weeks before Antietam, had evoked their own stunned accounts of unparalleled death and destruction. To a large extent, this escalation in violence was the result of the collision between old battlefield tactics, which organized attacking troops into closely packed units, and technological innovation, which drastically increased the range, accuracy, and firepower of rifles and artillery. The results were such firestorms as that at Antietam, which reduced Union General John Sedgwick's division of 5,000 men by nearly half in twenty minutes of fighting, and produced in forty-five minutes 186 casualties out of 236 members of a Texas regiment. Antietam's exceptional casualty rates and Gardner's pictures became symbols for the soul-numbing violence of Civil War battles even for the veterans who fought in them.

Only months earlier, no one had foretold this escalation in warfare. But as each side committed more of its material and economic resources to the conflict, as more men were called to service, and as more of them were killed, lost, or maimed, the fighting came to cast an increasingly dark shadow over the civilians of the North. The war reached past the battlefield. Contemplating the photographs in Brady's gallery, the *Times* correspondent saw "Union soldier and Confederate, side by side…the red light of battle faded from their eyes." On one hand, they are brought together by their willingness "to seal and stamp their convictions with their blood." On the other, they attest to the "widows and orphans" they leave behind to fend for themselves. "Homes have been

made desolate, and the light of life in thousands of hearts has been quenched forever. All of this desolation imagination must paint—broken hearts cannot be photographed."

Gardner's photographs were taken and displayed in a society growing uneasy about the scale of conflict and increasingly attentive to questions about the nature and value of the war. These questions rightfully accompany any war, but by late 1862, they had taken on a special urgency as anxieties about this war's rising costs in material and human lives provoked widespread dissatisfaction with its management. Why couldn't the North, with its superior resources and righteous cause, bring the fighting to an end and restore the Union to its rightful wholeness? As president, Lincoln was the lightning rod for much of this unrest, but so too was his brilliant but sluggish general, George McClellan. It was in this hothouse of violence and anxiety that their relationship unfolded. These circumstances were very much on Lincoln's mind when he consulted with his general on October 3 and 4.

GARDNER photographed the general and president twice, each time in two poses—one in a small format designed for viewing with the popular stereoscope, the other with a negative large enough to fill a full album page. In one image (see plate 5, second figure)—a marvel of composition and shrewd use of reflective light—they sit just inside a tent at a small table covered with papers, seemingly in the midst of talking strategy. On another table to Lincoln's left, the Stars and Stripes lies draped above a captured Confederate flag on the ground, presumably foretelling victories to come. This photograph was taken on the second day of Lincoln's visit—presumably a short time before his return to Washington—and Gardner masterfully manages the high contrast to allow us to see the two men lock eyes across the table while, below, their tightly tucked knees almost touch.

The more compelling shot of Lincoln was captured by Gardner the day before (see plate 4). At first glance the scene seems undistinguished, even awkward. Lincoln and McClellan stand vaguely facing each other in front of a ragged line of mainly uniformed figures arrayed across the middle ground of the image. Each man poses for the camera, but the group itself seems hardly composed; Custer on the far right could be standing for his own portrait. Behind the group rise a number of tents, which obscure a house visible in the deep background only by its roof and chimney. Beyond the branches of a tree in the right foreground and a splayed tuft of blurred foliage to the left, there

are no references to any specific place. Like the October 4 image of Lincoln and McClellan in the tent, this image could almost be a staged studio shot with a backdrop.

The light that day must have been very bright; none of the men need to brace themselves for a long exposure except, apparently, Lincoln, who must use a chair to steady himself. And judging by another photograph, of the president standing with Pinkerton, the prop was a good idea: in that image, Lincoln's blurred head suggests something like a skyscraper in a windstorm. With McClellan the president stands still enough, but the chair back is so low he must slouch to reach it. Nevertheless, he towers almost a full head above the rest (the one figure who might approach Lincoln's height stands at the far left of the image), and his stovepipe hat only accentuates the disparity in height. The general, on the other hand, has no problem with swaying, both because of his stout posture and because, as the photograph makes clear, he is the shortest figure in the group.

Clearly Gardner built his picture around the difference in height between Lincoln and his general—going so far as to use the linear spread of officers as a kind of ruler to measure the two main figures. Both of them, and likely everyone in the image, were well aware of how important stature was to the public images of both the president and the general. Lincoln's outsize hands and feet and his lanky stature had made him the object of particularly robust and harsh caricature. It was to defuse such imagery that Brady had raised Lincoln's collar in order to soften the stretch of his neck when he photographed the candidate before his Cooper Union speech two years earlier. Even the relatively sympathetic reporter for the *New York Herald* covering the Antietam visit relished the contrast between Lincoln's "gigantic stature" and the "fine physique and natural soldierly appearance" of "Little Mac.... The contrast in their personal appearance was strikingly perceptible—McClellan, under the ordinary size, as was the great Napoléon; Lincoln, as he says himself, six feet four in his stockings."

In the photograph, neither Gardner nor Lincoln makes any effort to disguise their relative heights, but the image goes further than simply offering a crude Laurel and Hardy joke. Facing each other as they do, McClellan and Lincoln seem engaged in some sort of confrontation. McClellan's posture certainly suggests this: while his gaze up at the president's face could imply respect, even devotion, the slight tilt of his head away from us, and most of all the thrust of his left leg suggest perhaps a challenge, or at least a refusal to give ground to the taller man. In this context, Lincoln's slouch could suggest

weakness or perhaps the condescending stoop of an adult to hear a child. But his deliberate stare above and beyond his diminutive general suggests more that he has his eyes and attention elsewhere.

While it is impossible to say for certain what Gardner was up to in these photographs, there are clues that he sought to provoke a physical discomfort between his illustrious subjects by posing them so close to each other. In general, Gardner was a master at harmoniously composing group photographs to reflect both the individuality of each sitter and the character of the group as a whole. Here the character of the group is decidedly one of awkward tension, as the two leaders negotiate their shared space with unease.

Later, when he captioned the photograph in his *Photographic Sketch Book of the War*, Gardner described how during his visit Lincoln toured "scenes of the recent battle," reviewed the troops, and occupied "much of the time in private conversation" with McClellan. "In this conversation," continues Gardner, "it is said, that when the President alluded to the complaints that were being made of the slowness of the General's movements, General McClellan replied, 'You may find those who will go faster than I, Mr. President, but it is very doubtful if you will find many who will go further.'" Whether or not this represents a revision of Gardner's original intent with the photograph, it is clear that a couple of years later, he saw the physical disparity between the two men as a metaphor for a power struggle over the conduct of the war.

On the surface, Lee's withdrawal from Antietam and return to Virginia should have settled many of these issues, yet Lincoln could not shake the feeling that the battle was more a lost opportunity than a victory. Just days before it was fought, Union scouts had come upon secret orders, wrapped around cigars, detailing Lee's risky gambit of dividing his army as it moved north. Had McClellan acted quickly enough, he may well have been able to overwhelm each half in succession, destroy the army, and all but end the war. He missed other chances for decisive victory during the battle by withholding nearly a third of his forces in reserve, and by not using them to renew his attack the next day. Nor did he, to Lincoln's great frustration, follow up whatever advantage he may have won by pursuing the badly damaged Confederate army into Virginia.

Lincoln's visit to the front allowed him to assert himself to the troops as commander in chief and to personally spur his general to give up his dawdling ways and pursue the enemy. For McClellan, this could hardly have been a welcome visit. He was exasperated by what he saw as the amateur meddling of a politician in the affairs of a professional military man. His caution, he

insisted, was grounded on the kind of knowledge no civilian could understand of the capabilities and strength of his troops and the enemy. After Antietam his army was disorganized and exhausted, unable to move forward without risking defeat. But military matters were only part of his beef. He had been appalled by news of Lincoln's intentions to emancipate all slaves in any state that refused to put down arms by the end of the year. McClellan, like many Democrats, feared this would lead to uncontrolled insurrection and civilian suffering all through the South. Taken together, Lincoln's policies and military plans threatened to transform a civil conflict into total war.

Gardner's photograph stages these tensions with characteristic economy by contrasting Lincoln's civilian cloak and top hat with the military dress of most of the men in the picture, most stylishly worn by McClellan himself, with his open coat, buttoned vest, and elaborately embossed cavalry boots. Does the president's visit mark a civilian intrusion that McClellan must defend against? Or must the general confront what are ultimately political questions of warfare?

For Lincoln, of course, there was no choice in the matter: war was always and rightfully political. Certainly war was political in how its fortunes shaped the struggle between Republicans and Democrats for ascendancy with the electorate. It was political too in how it intensified the individual intrigue for power that has always characterized life in Washington. But it was also polit-ical in a higher sense. In Lincoln's eyes, this war expressed the duty of people to adhere to their vision of a nation founded on principles ultimately moral.

The president had held these convictions from the beginning of his term, but the experience of the last year had taught him hard lessons in what it meant to hew to such principles in the face of a war that was metastasizing in front of him. When the conflict had opened, Lincoln had hopes, like many in North and South, that it would end quickly. He had wanted a decisive military victory that would bring both sides to the negotiation table with the Union holding an advantage. By the time he met McClellan at Antietam, however, he had formulated a very different vision: the war, he told an associate, "will be one of subjugation.... The [old] South is to be destroyed and replaced by new propositions and ideas." Lincoln well knew that urging his general not just to fight but to destroy the Confederate army was to guarantee more bat-tlefields like the one he toured in western Maryland, more scenes like those in Gardner's photographs that would hush New York's sophisticates.

During the ordeal of managing his general over the past year, Lincoln came to a clear vision of what the war was about, how it should be waged, and

how to lead the Union to realize those aims. In capturing the tensions between the president and his general, Gardner photographed the beginning of the end of one of the war's great dramas of leadership. This was the moment when Lincoln assumed full responsibility for a conflict he never wanted to happen.

THERE were a lot of reasons for Lincoln and McClellan not to get along. For all of his political genius, for all of his genuine sympathy and delight in other people, Lincoln moved east as president against a stiff social headwind. Observers noted his ill-fitting suits, his propensity for laughing at his own stories, even his angular lankiness, as signs of bad breeding and hardscrabble roots. Add to this an intellectual intensity that bordered on arrogance—one of his White House secretaries, John Hay, felt it came from Lincoln's knowing he was the smartest person in the room—and it was inevitable that he should offend those who valued social etiquette. The vastly influential minister Henry Ward Beecher—whose sister Harriet, on her visit to the White House in 1862, may or may not have been greeted by Lincoln's asking, "Is this the little woman who made the great war?"—spoke for many when he remarked, "It would be difficult for a man to be born lower than he was.... He is a man that bears evidence of not having been educated in schools or in circles of refinement."

Like virtually all written descriptions of the president, Beecher's said as much about his politics as it did about Lincoln's deportment. Supporters tended to emphasize his expression "of care and anxiety" on a face "prematurely aged by public labors and private grief." The writer Nathaniel Hawthorne, author of (besides *The Scarlet Letter*) the campaign biography of his Bowdoin classmate, Democrat Franklin Pierce, signaled his political leanings when he described Lincoln's "physiognomy...as coarse a one as you would meet anywhere in the length and breadth of the States." (Too much the iconoclast to follow the party line, in the end he admitted to liking "this sallow, queer, sagacious visage," enough to "have Uncle Abe for a ruler as any man.") The English journalist William Howard Russell introduced the president for his skeptical readers in London with a caricature of Lincoln's "strange quaint face and head," its "flapping and wide projecting ears," "prodigious" mouth, and lips "straggling and extending almost from one line of black beard to the other." Lincoln, pronounced Russell, was no gentleman.

The dashing Philadelphia-born McClellan, on the other hand, was among the best and brightest of eastern refined circles, capping an elite education by entering West Point at the age of fifteen and graduating second in

his class. McClellan served with distinction in the Mexican War (a war that Illinois Congressman Lincoln had opposed) alongside many of the generals he would face in the Civil War. He enjoyed a series of plum appointments, translated from the French a handbook on strategy, designed a new saddle for the cavalry, and wrote a textbook on cavalry tactics. At the age of thirty-one, he resigned his commission to take up a lucrative position as a railroad executive, only to return to active service with the outbreak of the war as major general of Ohio volunteers.

Relations between the two of them began well enough. McClellan arrived in Washington in July 1861, charged with taking command of the defense of Washington after the humiliating rout at the first battle of Bull Run. Despite his relatively modest military success in driving a disorganized rebel force out of West Virginia, his self-possession and social polish soon stormed the capital. "By some strange operation of magic," he marveled to his wife, "I seem to have become *the* power in the land....I almost think that were I to win some small success now I could become Dictator or anything else that might please me." Within three months, McClellan's success at restoring morale and discipline to the troops and organizing the newly created Army of the Potomac into the largest fighting force in the world—as well his considerable genius at self-promotion—had not brought him a dictatorship but did lead to his supplanting the venerable Winfield Scott (hero of the Mexican War) as general in chief of all Union forces. When Lincoln offered a sympathetic caution to the young prodigy about his new responsibilities—"In addition to your present command, the supreme command of the Army will entail a vast labor upon you," he warned—McClellan replied simply, "I can do it all."

Initially such bravura inspired remarkable loyalty from his troops and raised the spirits of the North. As McClellan wrote Lincoln in early August, he planned to "crush the rebellion at one blow, terminate the war in one campaign" using "such an overwhelming strength as will convince all our antagonists...of the utter impossibility of resistance." Lincoln, very much aware of his ignorance of military matters, not only deferred to his younger subordinate's professional knowledge but sought out opportunities to confer with him—dropping in on McClellan's headquarters, and even his fashionable home in the evenings, to pore over maps and talk strategy.

It did not take long, however, for their partnership to become strained. McClellan, who shared with many career military men a disdain for politicians who meddled in war, found Lincoln's comments amateurish and his visits annoying. However, instead of enduring them professionally, over the next

months he asserted his independence by "forgetting" White House meetings, and leaving Lincoln to cool his heels when the president came to meet with him. Once, to the outrage of Hay, he even went to bed while the president waited in his parlor for a late-night consultation.

McClellan's petty snubs also grew from a profound, almost narcissistic arrogance that distrusted any authority not his own. Even as he had promised to "crush" his enemies, he was ranting to his wife about the "idiot" president. Over the fall of 1861, the epithets grew more savage: "his Excellency," as McClellan liked to call the president, was "nothing more than a well meaning baboon" or, in reference to the so-called missing link of evolution, "the original gorilla." The simian imagery was common in the political press, but it also expressed a class revulsion similar to Beecher's. As the general put it years later, Lincoln "was destitute of refinement—certainly in no sense a gentleman— he was easily wrought upon by coarse associates whose style of conversation agreed so well with his own."

McClellan was not the only presumptuous snob Lincoln had to deal with. As Doris Kearns Goodwin has made so brilliantly clear, he filled his cabinet with, and came to command the loyalty of, schemers and rivals who had initially harbored thoughts much like the general's. In fact, McClellan likely learned "the original gorilla" from his friend Edwin Stanton, who would later become Lincoln's secretary of war and one of the president's most devoted allies. With his general, Lincoln exercised the same patience and pragmatism as he used with his cabinet. Left sitting in the parlor after McClellan had gone to bed, he responded to the insult by saying, "I will hold McClellan's horse if he will only bring us success."

But McClellan did not bring success. It was not from lack of ability. Instead, McClellan suffered from what Lincoln diagnosed just before Antietam as "the slows." Over the first ten months of his command, despite the rising clamor of the public for military action, despite the formation of an angry ad hoc Congressional meeting to investigate the conduct of the war (a meeting McClellan missed), despite open challenges in the press and even Congress of McClellan's loyalty to the cause, despite even the increasingly pointed urging, and finally despite orders from his commander in chief, McClellan buried himself in a flurry of organization and preparation without making any move to go on the offensive. Always he needed more men, more supplies, more training to face an enemy he compulsively overestimated. While the Army of Virginia never mustered more than 60,000 troops in battle during the eighteen months between Bull Run and Antietam,

McClellan regularly claimed to be facing 150,000, even 200,000 troops capable of overwhelming his relatively meager army of 130,000. How could anyone ask him to risk his troops and the fate of the Union against such odds? Lincoln's frustration with his commander comes through clearly in his correspondence with him. "It is indispensable to *you* that you strike a blow," the president insisted at one point. "The country will not fail to note—is now noting—that the present hesitation to move upon an intrenched enemy, is but the story of Manassas repeated." Lincoln then changes his tone, turning solicitous, almost fatherly. "I beg to assure you that I have never written you, or spoken to you, in greater kindness of feeling than now, nor with a fuller purpose to sustain you, so far as in my most anxious judgment, I consistently can. *But you must act.*"

In the context of the letter, Lincoln's claim to "kindness of feeling" here has the earmarks of a rhetorical ploy as he searches for any appeal that will yield success. But there is evidence that he, in fact, as McClellan put it in his autobiography, "liked me personally." Still, McClellan's arrogance left him tone-deaf to Lincoln's overtures, and drove the president, if not to epithets, then at times to sarcasm. After one particularly galling failure of nerve on McClellan's part, Lincoln quipped that he may be a great military engineer, but "he seems to have a special talent for developing a '*stationary*' engine." In the spring of 1862, in response to McClellan's lament about how a lack of troops hamstrung him on the Virginia Peninsula, Lincoln responded that if McClellan felt he could not defend his position, then he had "better remove as soon as possible." To this he added a sly postscript: "If, at any time, you feel able to take the offensive, you are not restrained from doing so."

By most accounts, it was this failure of the Peninsula Campaign that led Lincoln to conclude that McClellan was not his man. In fact, months before the battle at Antietam, the president had reapportioned much of McClellan's authority, including removing him as general in chief of all forces. Only when John Pope's Army of Virginia suffered the Union's second major defeat at Bull Run and Lee turned his eyes northward did Lincoln restore McClellan's full command of Union forces in the East. The move was made despite much criticism inside the government and out, but Lincoln found his general "too useful just now to sacrifice."

After his good-enough victory at Antietam, McClellan once again felt the confidence in his command expressed by his stance in Gardner's photograph. After all, throughout the several days of his visit, McClellan found the president's manner disarmingly solicitous. "He was very affable," he wrote his

wife, "& I really think that he does feel very kindly towards me personally." Later he would recall Lincoln's telling him "that he was entirely satisfied with me and with all that I had done." Perhaps he yet again misread his commander in chief, or perhaps he fell victim to Lincoln's politic duplicity. One early morning during the visit, Lincoln stood with a friend on a hill above the Army of the Potomac sprawled at their feet. What did he see? Lincoln asked. Part of the grand army, answered his puzzled companion. No, responded Lincoln, "That is General McClellan's bodyguard." It is difficult to imagine Lincoln's keeping McClellan after such a comment. Several weeks later, with McClellan once again sluggishly resisting all prods of urgency as he moved his army into Virginia, Lincoln relieved his general of command.

MCCLELLAN'S curious blend of blind arrogance, professional polish, charisma, and almost pathological caution makes his rise and fall a compelling melodrama of hubris and personality clashes. But perhaps the touchiest issue in the conflict between him and Lincoln was not the president's exertion of his military authority but the commander's uninvited forays into the realm of politics. In early July 1862, with the Army of the Potomac idle at Harrison's Landing on the banks of the James River after its defeat outside Richmond, Lincoln traveled down the Chesapeake Bay to visit his general and appraise his army. When he arrived, McClellan presented Lincoln with a position paper on "civil and military policy, covering the whole ground of our national trouble." In it, McClellan argued that the Union had the responsibility to operate on "the highest principles known to Christian Civilization," seeking not "the subjugation of the people of any state," but directing attacks only "against armed forces and political organizations." Thus, "all private property and unarmed persons should be strictly protected; subject only to the necessities of military operations."

Lincoln read the paper right then, thanked the general, and put it away. He never mentioned it to him again, though he voiced dismay to others about its author's presumption. He understood his general's point clearly—"private property" meant more than livestock and barns; it also referred to slaves. A year, even months earlier, for all his personal abhorrence of slavery, Lincoln would have settled for a military victory that restored the Union as it had been with as little loss of life and economic disruption as possible. He had taken heat from his own party for remaining neutral on the question of abolition, largely because he felt he lacked the constitutional authority to do anything

about it, but also because he feared losing the border states Missouri, Kentucky, and Maryland to secession if he moved too strongly against slavery. Things, however, had changed. Refugee slaves, popularly known as contrabands, had been crossing Union lines seeking freedom, forcing military commanders to deal with them as best they could. Moreover, on an earlier visit to southeast Virginia, Lincoln had seen for himself the vast fortifications and engineering work that an enslaved labor force had performed for the Confederate army, not to mention the home-front labor of growing food and staples. Slavery had long been a moral issue with no political solution; now it was a military issue and thus the legitimate object of his power as a war president.

Five days after pocketing McClellan's paper, while sharing a carriage with his two most trusted Cabinet members, Secretary of State William Seward and Secretary of the Navy Gideon Welles, he raised the possibility of using his constitutional war powers as president to issue a proclamation freeing all slaves in those states in rebellion. Both men were surprised by Lincoln's apparent about-face but gave their support. Just over a week later, on July 22, Lincoln announced his intentions to his Cabinet, though he accepted Seward's suggestion that he delay making it public until the North had a military victory. He would, in fact, build in a double delay: first by waiting until after Antietam, and then by announcing his *intention* to put the proclamation into effect on January 1, 1863.

Much has been said and written about the racial politics of the Emancipation Proclamation, but Lincoln's slow pivot toward issuing it coincided with a growing decisiveness on his part about what kind of war he wanted his generals to wage. With his position paper at Harrison's Landing, McClellan thought he was drawing a line in the sand, but Lincoln had already stepped over it, at least in his own mind. Union armies would indeed confiscate personal property of Confederate civilians (including, of course, slaves). And Lincoln would find generals willing to aggressively seek out and engage enemy forces in all the theaters of the war, thereby taking advantage of the Union's superior resources and manpower. As General Henry Halleck would explain months later in a letter to General Grant, "The character of the war has very much changed within the last year. There is no possible hope of reconciliation.... We must conquer the rebels or be conquered by them."

Things would grow clear to McClellan over the summer as his authority diminished, his army was divided, and word leaked out about Lincoln's intentions. Pronouncing the president's moves "infamous," he even considered speaking publicly against it (he had been consulting with Democratic Party

leaders for a while about a possible run at the White House). In July McClellan had warned that, should the president make any "declaration of radical views, especially on slavery," the army itself would "rapidly disintegrate." His forecast, or threat, seemed borne out when a member of his very tight and loyal officer corps was called to the White House and summarily dismissed from service for suggesting that the army would not follow the president's orders. Even as Lee crossed into Maryland, tempers continued to run high both in the military and in Washington, where many, including Lincoln, thought that McClellan's refusal to reinforce Pope had led to the latter's ignominious defeat at the end of August.

Perhaps even then Lincoln was willing to give the younger man, for whom he felt genuine sympathy, another chance to prove himself in the new war Lincoln was shaping. But whatever hopes the two men entertained for their continuing partnership, as Gardner's photographs make clear, the strength of their convictions and ambitions had made even a formal closeness awkward and tense. In any case, Lincoln's gaze above and beyond McClellan's head as they stood for the camera seems an apt expression of his having moved on from his general. The general would soon retire from the military for good, leaving Lincoln, his incongruous civilian garb notwithstanding, as commander in chief.

LINCOLN began his tour of the battlefield under the late afternoon sun on the second day of his visit—October 4—after a long bumpy ride in the back of an ambulance wagon from Harper's Ferry, where he had spent the night as the guest of General Edwin Sumner. After a quick meal, McClellan first led the president to the hill where he had established his headquarters during the battle. Overlooking a "splendid" view of the countryside, the general regaled his guest with "a graphic description of the grand battle and our victory," explaining the "orders he issued" and "the movements of the army." The party then descended to the battlefield, working its way from the Union army's right to its left as the sun set, following the same direction as Gardner had followed weeks earlier. Reporters commented on Lincoln's "peculiar" interest in the scene as he moved among the scattered clothing of the dead that still littered the ground, passing hundreds of hastily mounded graves and dead horses—many burned, but others still rotting in the open air. After nightfall, they encountered a lone burial party of nuns and a priest; elsewhere in the moonlight they were able to make out the inscription of a rude mass grave: HERE LIES THE BODIES OF SIXTY REBELS. THE WAGES OF SIN IS DEATH!

Lincoln encountered other reminders of the fearful toll of the battle. He visited field hospitals, still burdened with men too wounded to move. At one treating Confederate soldiers, he asked to take their hands and then told them only "uncontrollable circumstances" made them enemies, and thus "he bore them no malice, and could take them by the hand with sympathy and good feeling." In reviewing the Union troops, he was most impressed by their fitness and morale (putting to rest McClellan's claim that they were too exhausted to press the fight), but he also noted the badly torn regimental flags and at least one regiment so reduced that he "thought they were merely a corporal's guard."

Just how affected the president was at the time by what he saw is hard to say. After the battlefield tour, he kept his dinner company "in the best of humors by his apt remarks and amusing stories." But it could only have added to the loss he had personally witnessed—and in some cases suffered him-self—over the past eighteen months of war. In May 1861, the young officer Elmer Ellsworth had been killed leading some of the first Union troops into Alexandria, just across the Potomac River from Washington. Lincoln had met Ellsworth in Springfield and taken such a liking to the young man that he invited him to study law in his office. They later grew so close that Ellsworth was practically made part of the family—he even contracted measles along with two of the Lincoln boys, Willie and Tad. In Alexandria Ellsworth impul-sively dashed up the stairs of a local hotel to take down a Confederate flag that had flown in sight of the White House, much to the irritation of Lincoln and his Cabinet. On his way down, he was shot and killed by the hotel owner. When Lincoln heard the news, he was staggered, and mourned him as a son. Looking at the body for the last time before it was laid in state in the East Wing, Lincoln was heard to mutter, "My boy! My boy! Was it necessary that this sacrifice should be made?" The death of the upright, patriotic Ellsworth became an emblem for the North, a rallying call for troop enlistments; for Lincoln, as he wrote in an eloquent and heartfelt note of condolence to Ellsworth's parents, the death brought "an affliction" to him, his family, and the close-knit White House staff, "scarcely less than your own."

Months later, he lost another dear friend in battle, Senator Edward Baker of Oregon, a charming Englishman of "impetuous daring," whom Lincoln had known since his early days as a lawyer. Together they had worked on cases and pursued their political ambitions in the Whig and later the Republican parties, sometimes as opponents, most often as allies. He too was unofficially inducted into the Lincoln family; their second son, Eddie, who died of con-sumption before his fourth birthday, was named after him. Baker had left

Illinois for the West Coast but had found his way back to Washington as senator from Oregon and had introduced Lincoln at his inauguration. When the war broke out, he raised a regiment from California and entered the army as a colonel so he could keep his Senate seat. When Lincoln heard the news of Baker's death in a meaningless and ineptly managed engagement just forty miles from Washington, he was crushed: "When will this terrible war be over? Is there no way of stopping this shedding of blood?" He wept uncontrollably at the funeral. Young Willie Lincoln wrote a poem about the family friend: "There was no patriot like Baker, / So noble and so true; / He fell as a soldier on the field, / His face to the blue."

But his most traumatic loss came in February 1862, when his beloved son Willie succumbed to "bilious fever," a catchall phrase that likely in this case referred to typhoid from the bad water at the White House. Lincoln called him simply "a gentle and amiable boy"; many saw him as a bright, charming, and handsome version of his father. Lincoln admitted that his death "overwhelmed" him: "It showed me my weakness as I had never felt it before." It was nearly two weeks before the president could resume a full schedule; for much longer he would excuse himself on Thursdays (the day Willie died) to go to a room and weep. Months later Lincoln was still affected enough to break into tears after reading a passage from Shakespeare's *King John* about meeting a son in the afterlife. Mary spiraled into severe mourning, halting all White House social events for months and refusing ever again to enter either Willie's bedroom or the Green Room, where he had been prepared for burial. Lincoln's youngest son, Tad, who had also suffered dangerously from the same illness, was left forlorn when Mary banished the playmates he had shared with Willie because they reminded her too much of her loss.

While Willie's death was not directly related to the war, for both Lincolns it became a touchstone of sympathy for the suffering of others affected by the conflict. Mary began addressing her grief by visiting the military hospitals that were spreading through Washington, bringing oranges for scurvy and writing letters home for the wounded soldiers. Lincoln suffered more quietly, but the black crepe band around his top hat—visible in Gardner's Antietam photographs—had been affixed there as a sign of mourning for his son.

McClellan likewise felt the loss of his troops. While his hilltop accounts of the battle seem to have focused on the drama of his command decisions, it was he who approached the burial party on the battlefield. Like Lincoln, McClellan found the sight of missing soldiers, made obvious by the short columns in the formations for review, "deeply affecting. He said it made him

feel sad to see the decimated regiments and their tattered colors." All politics and psychology aside, much of McClellan's caution stemmed from his commitment to minimizing casualties. During the Peninsula campaign, he sent one particularly irate telegram (Lincoln called it with typical equanimity "ungenerous") hectoring Washington for more reinforcements and blaming the administration for high casualties: "I have seen too many dead & wounded comrades to feel otherwise than that the Gov[ernmen]t has not sustained this Army." When he addressed his troops on stepping down as their commander, he said, "The glory you have achieved, our mutual perils & fatigues; the graves of our comrades fallen in battle & by disease, the broken forms of those whom wounds & sickness have disabled—the strongest associations which can exist among men, unite us still by an indissoluble tie."

It is difficult to say how Gardner's visit to the battlefield affected him. His telegrammed excitement over his "forty fine pictures" suggests that by the second day of shooting he was more intent on his craft than what he was looking at. Perhaps he had encountered similar sights before. While still listed in the city directory as manager of Brady's gallery, he had long since taken on his duties with the Army of the Potomac, by most accounts photographically copying maps and documents for the Topographical Engineers and McClellan's newly formed Secret Service, headed by none other than Lincoln's and McClellan's mutual friend Allan Pinkerton. Nearly a half century later, Pinkerton's son recalled traveling "around with Gardner a good deal while he was taking these views." How much traveling Gardner did is unclear, though he was deeply enough immersed in military life to call himself Captain, an honorary rank given to him as a civilian. Looking back, his eulogist—a friend from Gardner's Masonic lodge, in which he was very active—said "he was the photographer for the Union Army," and "a member of the military family of George B. McClellan, for whom [Gardner] ever had the highest regard." Gardner "remained with him during all of his campaigns in Virginia," returning to Washington only after McClellan was relieved of command.

That said, it is unlikely that Gardner had witnessed any major action until he stood with the press corps during the battle on the same hilltop Lincoln would visit in October for his overview. And it is doubtful anything he would have encountered thus far could have prepared him for the appalling experience of walking the field in the aftermath of Antietam. "We say of the great battle," intoned the *New York Herald*, "that there never has been anything like it seen upon this continent."

We can get some idea of what Gardner encountered from Oliver Wendell Holmes's account of visiting the battlefield on the same Sunday, four days after the battle, that Gardner telegraphed Brady for more supplies. Writing later for the esteemed literary magazine the *Atlantic Monthly*, Holmes kept his voice even and polished as he described what he saw. Virtually all of the burial work was done when he arrived, but the signs of battle were still vivid in the "fragments of clothing, haversacks, canteens, cap-boxes, bullets, cartridge-boxes, cartridges, scraps of paper, portions of bread and meat. I saw two soldiers' caps that looked as though their owners had been shot through the head. In several places I noticed dark red patches where a pool of blood had curdled and caked, as some poor fellow poured his life out on the sod." Holmes wanders for a while across the landscape, encountering at one point "a party, women among them, bringing off various trophies they had picked up on the battlefield." Wishing for "an intelligent guide" to explain the battle to him, he comes to the same area where Gardner took his first photographs. "The opposing tides of battle must have blended their waves at this point," muses Holmes as he moves across the ground. He picks up a canteen from each army, and then has a change of heart: "there was something repulsive about the trodden and stained relics of the stale battle-field," he writes. "It was like the table of some hideous orgy left uncleared, and one turned away disgusted from its broken fragments and muddy heeltaps." From curiosity to fascination strong enough to compel his picking up some "mementos of my visit" (he does leave with some bullets, a button, a brass belt plate, and an unread letter), Holmes leaves the field in disgust with what he has seen, and perhaps with his own need to see it.

Surely a similar mix of excitement, dismay, fascination, and repulsion must have gripped Gardner—who only a few years earlier had been looking forward to joining a utopian community founded for the betterment of humankind—as he lugged his camera across fields and over fences alongside burial details, scavengers, and souvenir hunters, doctors searching for wounded (found as late as Saturday), locals warily assessing their losses, and soldiers and relatives trying to locate their fallen comrades and loved ones. He would also have had to deal with one detail of the experience that Holmes did not mention in deference to his genteel audience: the "almost intolerable" stench from the rotting flesh of hastily buried humans and, in the early fall sun, the still exposed horses. One local resident recalled having to take a shot of whiskey the moment he rose from bed in the mornings following the battle. "If I didn't, I'd throw up before I got my clothes all on."

Most infuriating to the operators were the buzzing clouds of flies feasting on the battle's remains. Not only could they drive anyone to distraction, they also threatened to disrupt the elaborate procedures of glass-plate photography. While Gardner moved his camera into place, framing the shot and focusing, Gibson worked in the stuffy confines of their portable darkroom—known among the troops as a what-is-it wagon—to coat and bathe the glass plates with chemicals to sensitize them to light. It was a delicate job under the best of circumstances, made all the more demanding by the flies swarming to the smell of the collodion coating the negative. Once finished, Gibson rushed across the field, lest the chemicals dry, to Gardner and his camera, who inserted the plate and removed the lens cap to expose the picture in often variable light conditions (one scholar estimates exposures of up to fifteen seconds). Then it was back to the wagon, where the plate was developed and rinsed, once again amid the flies, before it was stored. Later that day, or maybe in the evening, the negatives would be fixed (made stable in another chemical bath) and dried, ready to be shipped to Washington.

Given the difficulties of their working conditions, it is easy to imagine both men immersing themselves in the labor of photographing. It takes no great leap to think of Gardner's stark images—perhaps a flurry of five pictures along the two hundred yards of the Hagerstown Pike, or the group taken around the Dunker Church (see page 38)—as photographic equivalents of Holmes's "mementos" or the women's "trophies." But even if they do represent the same kind of compulsive reaction to the power of what he saw, they also bear witness to Gardner's resolute dedication to his craft. Even as the two operators pushed their way across fields, gagging, fighting flies, and stepping around pools of blood and gore, Gardner brought an artistic eye to bear on the carnage in front of his camera.

Consider, for instance, how, in the photograph on the opposite page, Gardner frames the unsettled posture of the soldier in the foreground—evoking an uncanny air of life-in-death—in a hazy, almost ghostlike landscape of horizontal lines that impart an elegiac stillness to the scene. In plate 6, he develops this mood further, using nature to suggest a pastoral narrative of death and rebirth in the rich tracery of the tree branches—shorn of their leaves by battle—reaching into the sky from a single grave at the tree's roots. The soldiers stand guard as if at a monument; their rifles point in delicate balance away from the leftward lunge of the tree's crown. In photographs like these, Gardner clearly draws his visual vocabulary from the rich popular language of Victorian death and mourning, which included a

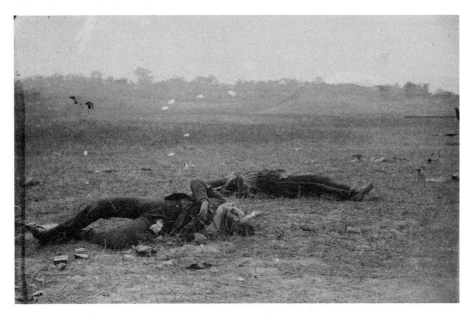

Two Confederate Dead, Antietam Battlefield, by Alexander Gardner, September 1862

robust demand for photographs of dead loved ones, often posed as if alive (sitting, say, in a favorite chair, or at least blissfully asleep). In this sense, the formal elegance of his images acts to mute the unspeakable quality of the battlefield.

There is another context for Gardner's pictorial response to what he encountered. When *Harper's Weekly* published woodcuts of his photographs in the October 18 issue, it was the magazine's third week of coverage of the momentous battle. The most detailed account of the battle, generously excerpted from the *New York Tribune*, appeared in the October 4 issue, accompanied by a two-page pictorial spread. The pictures show crucial scenes of the battle ("McClellan to the Rescue," "Burnside Holding the Hill"), each of which prominently features a dashing officer (three out of four on horseback, all with a sword) and disciplined troops moving into action. The images reflect the description of the battle: troops fight "unyielding in purpose, exhaustless in courage." The correspondent does describe "dead...strewn so thickly that as you ride over it you can not guide your horse's steps too carefully," but in watching General Burnside defend his position against the setting sun, he waxes poetic: "Four miles of battle, its glory all visible, its horrors all veiled, the fate of the Republic hanging on the hour—could any one be insensible of its grandeur?"

TOP: *"The Battle of Antietam,"* Harper's Weekly, *October 4, 1862*
BOTTOM: *"Scenes on the Battlefield of Antietam,"* Harper's Weekly,
October 18, 1862.

In a broad sense, Gardner's photographs easily complement this patriotic Romanticism. Most of his dead troops are Confederates; displaying their bodies invokes the same triumphal revenge as the grave marker for "sixty rebels" that Lincoln encountered on his visit—"The wages of sin is death!" The line of civilians and soldiers gathered on the lip of the ditch in the middle left picture on page 38 look directly at the camera, inviting us to witness with them just such wages. Another photograph offers a more explicit lesson in the cause of right by presenting a hatted civilian gazing at a wooden marker to a hastily made grave while all but ignoring the unburied Confederate body (see plate 7): "A Contrast: Federal Buried, Confederate Unburied." Gardner composed the caption himself, making particularly pointed use of popular imagery of sentimental graveside mourning, itself the Victorian manifestation of the older tradition of memento mori ("remember [your own] death")—to make clear whose death deserves remembrance.

But there is something about the image that pushes against the strictly partisan reading suggested by the caption. While the man seems genuinely drawn to the headboard, *our* eyes are drawn to the pathos of the body in the foreground, which seems to clamor for attention, preventing us from joining the mourner's contemplation. If we draw close enough and the print is clear enough, we can make out "J. A. Clark" on the marker, but it is the anonymous face of the unburied body—by all appearances barely more than a youth—that most speaks of the pathos of an individual life lost too soon to war.

Harper's prominently featured a woodcut of the photograph in the top center of the magazine's pictorial spread of Gardner's pictures, but the artist made a few changes that suggest he understood where the photograph directed our attention (detail on page 66). First, he cast the grave in shadow, making it much less prominent. Then he turned the man's gaze ever so slightly away from the grave and toward the exposed Confederate. Perhaps this was done to blunt the partisan tenor of the caption; more likely it was meant to invite us to witness the wages, if not of sin, then of battle, much like the reproduction of the ditch image (on page 38) in the lower right of the spread and that of Hagerstown Pike (on page 38) in the upper left.

In doing so, however, the woodcut misses the critical tension that runs through Gardner's original photographs of Antietam's casualties, which are endowed with a moral complexity about the wages of war and what it means to look on them. That the civilian gazes at the headboard while ignoring the body is a provocation. It seems premature for him to indulge in mourning until both bodies, Union and Confederate, are properly buried. Moreover, his

Detail, "Scenes on the Battlefield of Antietam," Harper's Weekly, *October 18, 1862*

attention provokes us to question our own fascination with what the *Times* called "dead men's eyes" and to attend to the solemn labor of memorializing the fallen, named or anonymous. This photograph is no memento: it seems clear that Gardner staged the mourner (Gibson? another assistant?) and carefully organized the image around interlocking diagonals, lights and darks. Most provocatively, he anticipates his viewers' responses—those in Brady's gallery, ours today, perhaps his own—in order to shake up settled notions about the exceptional tragedy, or glory, of war. No wonder the New York crowd was hushed.

This provocation, and the unsettling questions it raises about what the living owe the dead, hovers around many of Gardner's images, especially the surprising number that include military burial details. Even as they document the shock and violence of battle, they show men who must nonetheless negotiate the stench, the flies, and the gore to finish their assigned job, happy perhaps to break and have their picture taken, but also impatient to finish their disagreeable labor (page 40). Taken together, their poses speak of a slumping weariness and boredom. Those who look at the bodies reflect none of the horror of other witnesses, only the prospect of more digging, lifting, moving, and digging again. This divided sense of detachment and obligation to the dead arises most starkly in the photograph on plate 6, where the men posed as

sentries are flanked on the left by two men who take advantage of the exposure time to stretch out on the ground and another in the right distance who simply slumps against his rifle.

While the *New York Times* equated Brady's exhibit to leaving dripping bodies on the streets of New York, Gardner's photographs suggest that he saw a better analogy between his work as an operator and that of the burial details. True, in order to get his "fine pictures" he had to race against them to find his bodies. But just as they interred the dead in their rightful place in the ground—no matter how hastily it was prepared—Gardner put the dead in the public's consciousness. In effect, he expanded the community of witnesses beyond those who fought in the battle or walked the battlefield, inviting all of us to "see what a victory costs." For some, as the *Times* reporter noted at Brady's gallery, the pictures provoked little more than sheer fascination with violent death. For others, like the reporter, they inspired sympathy for the widows and orphans on both sides of the Mason-Dixon Line. For still others, they tallied the necessary price for a just cause. For everyone, Gardner's images helped the country understand what it was facing.

The following summer, Gardner would again document the casualties of war—after the battle of Gettysburg. Over the years, those images have come to eclipse the collection from Antietam. Gardner had much to do with this: he featured the Gettysburg photographs prominently in his *Sketch Book*, while including none of the dead from Antietam, though this was likely a decision of format—the Antietam negatives were about the size of a postcard and would have been difficult to enlarge to fill an album page. But we should not let the popularity of the Gettysburg pictures diminish the importance of Gardner's visit to Antietam. Not only did he introduce the country to a new way of seeing war; he also discovered for himself what would become a compelling theme throughout his war career: the profound social and psychic disruptions of death and the labor of healing. Not only would this structure the themes of his *Sketch Book*; it would animate his coverage of Lincoln's death, and the capture, trial, and execution of the conspirators. Moreover, the emergence of this grand theme would coincide with his decision, well under way by the time he returned to Washington after McClellan stepped down, to leave Brady's employ and establish his own studio, to forge his own vision of how to run a business and of what the war meant for the country.

Lincoln's visit to Antietam offers a useful marker for his own renewed sense of direction. While he would leave McClellan in command for several more weeks, he would do so with a clear expectation of what he wanted from

his ideal military commander. On a bigger plane, he would return to the White House as the leader of the Union effort not just to defeat the rebellion and restore the Union, but to end the slavery that had precipitated the conflict and eroded the nation's ideals. The *New York Herald* sensed his new ascendancy: "President Lincoln himself is now the administration. He judges for himself, [and] acts upon his own counsels."

CHAPTER 3

1863: Gettysburg

ALEXANDER Gardner's most famous portrait of Lincoln, taken in his own studio on November 8, 1863, is known to the Lincoln community as the "Gettysburg Lincoln" (see plate 8). The name seems apt. The picture was made just eleven days before the president delivered what has come to be called the Gettysburg Address—brief, eloquent remarks dedicating the cemetery for soldiers fallen in the great battle fought five months earlier. Received respectfully when it was delivered, Lincoln's speech has come to be one of our few texts of national scripture. Its phrases have so thoroughly infused our culture that they live on in public life like strands of the national DNA, so recognizable and powerful—almost radioactive—it is difficult even to allude to them for fear of being compared to their maker.

The photograph shows us the kind of man capable of delivering such a visionary speech: forthright, decisive—in a word, "presidential." The original imperial-size print shows Lincoln seated in a chair from the midsection up, but the version we see most often today is cropped tightly in a way that brings us close to his face (see page 82). In both it is hard to miss the paperlike quality of Lincoln's skin, with its wrinkles and imperfections, or the touches of gray in his beard and hair that shine in the light. Most compelling, though, are the eyes, which fix us in their stare. Lincoln's eyes were gray-blue, a color that collodion photographs were most sensitive to (skies came out blank in landscapes). In some photographs, Lincoln's eyes have a disconcerting transparency, but here they are shaded dark by his brow. Still, Gardner lets us see the striations in the iris radiating from the pupil, even the curved blocks of light that reflect the skylighted room behind the camera. Lincoln sits with an almost military posture—a far cry from the figure who slouched with his hand on a chair in Antietam just over a year earlier. It's as if he has absorbed into his very expression and posture the full authority

of his office and the command he has come to exercise over the fate of the nation. This is the Lincoln who went to Gettysburg, the Lincoln who saved the Union.

Today the photograph and the speech are connected literally in stone. The address is engraved on the south wall of the Lincoln Memorial, directly opposite his other great speech, the second inaugural. In between them sits Daniel Chester French's monumental sculpture of Lincoln, enthroned in our national temple of freedom. Working over four years in bronze and plaster before carving the nineteen-foot-high sculpture from separate blocks of Georgia granite, French consulted all kinds of models, including life masks of Lincoln's face and hands and a number of photographs. Prominent among these was Gardner's full-frontal photograph, which is recognizable from the base of the statue looking up directly into Lincoln's face.

Image and speech were linked even earlier. In 1895, twenty-seven years before the memorial opened, the journalist and writer Noah Brooks published a memoir of his time in Washington as a member of Lincoln's inner circle. Brooks had known the Lincolns (he was a favorite of Mary's) since his days in the mid-1850s as a political operative and reporter (the two roles often coincided) in Illinois. He revived his friendship with the family when he found his way to Washington in 1862 as a correspondent for the *Sacramento Daily Union*. For the next three years, he was a regular guest in both wings of the White House, access that made the 258 dispatches he delivered during the war, and his reminiscences afterward, a generally reliable—if at times sentimental and always partisan—window into the president's wartime life.

Brooks published *Washington in Lincoln's Time* in 1895, on the first swells of a tide of Lincoln revivalism that would crest with the Lincoln Memorial. Lincoln's two White House secretaries, John Nicolay and John Hay, had just released the last of their ten-volume biography of Lincoln, much of which had run serially in the nationally preeminent *Century* magazine. The year before Brooks's book, *Century* published two articles on Lincoln in its February issue. The first, "Lincoln's Place in History," pronounced him "easily...the greatest of Americans since Washington," while Nicolay offered the magazine's subscribers a detailed account of the composition, delivery, and reception of the Gettysburg Address, complete with parallel texts that allowed the reader to graphically tease out textual variants of different drafts, the kind of exegesis normally reserved for the Bible and Shakespeare's plays.

This new attention to Lincoln and the address no doubt inspired Brooks to add his own memories to the story. He and Lincoln, he recalled, had visited

"Gardner, the photographer," on the Sunday before the Gettysburg ceremonies, so as not to disrupt Gardner's regular business and to avoid the "curiosity-seekers" and petitioners who so plagued the president. Just as they were about to leave the White House, Lincoln hurried back to his office to retrieve an advance copy of the speech that Edward Everett, the featured orator that Thursday in Gettysburg, was to deliver before the president's remarks. Perhaps he would have a chance to read it while waiting at Gardner's. Both men noted how long it was; Lincoln's remarks, which the president told him were written "but not finished," would be "short, short, short." As it turned out, Gardner was his usual efficient self, and Lincoln never had a chance to read Everett's speech at the gallery. It can be seen, according to Brooks, in the envelope on the table next to Lincoln's right hand in another photograph taken that same day—Brooks was fortunate to have a copy of the picture given him by the president to jog his memory (see pages 72 and 77).

It is a well-told story, full of the kind of lively detail characteristic of Brooks's dispatches. Everett's speech on the table makes palpable what must have been on Lincoln's mind as he posed for Gardner's photographs. The problem is that Brooks's account cannot be right because the envelope cannot be Everett's speech. John Hay's much more reliable diary entry (made that day as opposed to thirty years hence) makes it clear that the visit to Gardner's took place on November 8 (not November 15, as Brooks remembered)—more than a week before Everett's own diary records his still editing his speech. Hay also notes that it was Nicolay, not Brooks, who accompanied Lincoln to Gardner's. The diary never mentions Brooks, whom Hay knew. In all likelihood, whatever was in the envelope had nothing to do with Gettysburg.

As far as lapses of memory go, Brooks's errors about events thirty years earlier need little explanation. Still, they show that by the 1890s the Gettysburg Address had come to exercise a powerful gravitational effect on the way that the events surrounding it and the man who delivered it were remembered and understood. It was strong enough for Brooks to place himself somewhere he wasn't and to see in the picture he said Lincoln gave him something that was not there. It continues to exercise its force: in Gardner's photograph, we see the kind of president we want to have delivered the speech that only after his death became the sacred document we know it today.

All that said, though Lincoln's expression *does* command attention, it is also a bit of a puzzle. His right eye, with its enlarged pupil, certainly looks directly into the camera lens and hence at us, giving his face a frank, sternly challenging look. His left eye, however, while it seems to make contact with

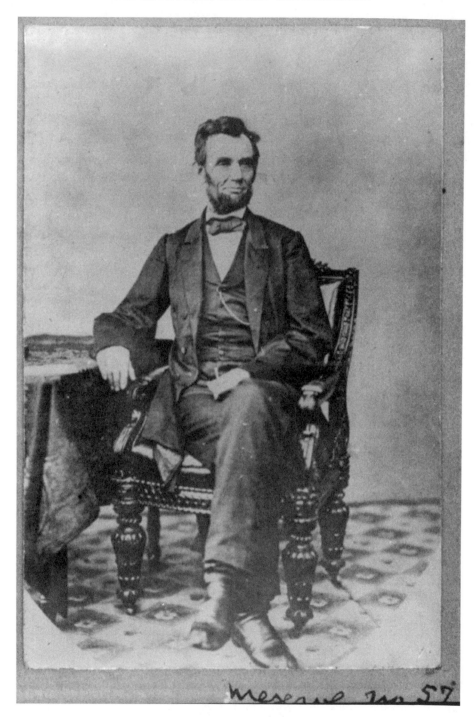

Abraham Lincoln, by Alexander Gardner, November 8, 1863

us, rises into its lid. In fact, the whole left side of his face looks oddly diminished and slightly out of kilter—from the cowlick tuft of hair above the part, the shadow that runs along his temple and cheekbone, and the crosshatch of wrinkles beneath his eye to the thinness of his left lower lip and his crooked tie and collar.

Lincoln's sagging left side is just one of a number of peculiarities about his face that have attracted attention, along with its long thin shape, his wandering left eye, his large ears, his bushy eyebrows, and his impressive beak of a nose. (The working title for Alfred Hitchcock's film *Notorious*, which ends with a climactic scramble across the presidential faces of Mount Rushmore, was "The Man in Lincoln's Nose.") More recently it has prompted medical diagnoses about whether he suffered from craniofacial microsomia or left synostotic frontal plagiocephaly—or from the aftereffects of being kicked by a horse while a child.

When photographing a subject, Gardner generally angled the sitter's head to emphasize the more attractive half of the face—in Lincoln's case, the right half—though obviously Lincoln was amenable to turning his head whichever way an artist suggested. By the conventions of the times, the angled pose gave a sitter dignity and character and made the photograph look more painterly. Conversely, most nineteenth-century Americans would have associated the full-frontal pose with the bread and butter of cheap operators who hurried their clientele through their photographic emporiums. Even by our aesthetic standards today, the photograph resembles a mug shot—especially when cropped tightly. The classic criminal photograph—with its full-frontal and profile views of the face—wasn't systematized until the 1880s, but by the Civil War, legal authorities were well versed in the use of photographs to record telltale idiosyncrasies of an individual's face. Scientists were using photographs to catalog the height and slope of the forehead, the relative fullness of the lips, and the set of the eyes in the effort to categorize the physiognomy and thereby predict the behavior of such "types" as "the habitual criminal," "the hysteric," "the Irish," or "the negro." As early as the 1840s, Mathew Brady himself supplied photographic studies of inmates of Blackwell's Island in New York for a book applying phrenology to the "rationale of crime." After the war, Gardner would help Washington's Metropolitan Police update its "rogue's gallery" designed to help officers and citizens identify criminals.

Gardner's photograph breaks with fine-portraiture convention by showing the president in a pose reserved for outcasts and criminals. Shooting directly from the front allowed him once again to emphasize Lincoln's physical

peculiarities, just as he had at Antietam by photographing him towering over the diminutive General McClellan. As in that picture, Gardner uses Lincoln's physical features to suggest a narrative, though this time it unfolds more as a psychological drama than a political intrigue. The Lincoln we see here offers himself up to the cold eye of the camera with a "take me as I am" confidence, marked not just by his direct look into the lens, but as well by his inexpertly knotted tie and cowlick. At the same time his personality seems to recede behind the mask he habitually presented to portrait artists in any medium. In effect, with the full frontal pose, Gardner stages a very modern-looking confrontation between sitter and camera, a pose that became a staple of the great photographic portraitists who followed him many decades later—Paul Strand, Walker Evans, Diane Arbus, Robert Mapplethorpe, and most recently Platon.

There are problems, however, with drawing too direct an art historical line from his picture to the present. Gardner may well have recognized that he had something special when he printed the image; he certainly held on to the negative after he made it. But he seems never to have published it. He did publish other pictures from the November session, and he made good commercial use of the six photographs he took of Lincoln in his newly opened studio in August. The "Gettysburg Lincoln," however, did not appear to the public until 1891, in the midst of the Lincoln revival and nearly a decade after Gardner's death. There could be any number of reasons for this, but the most likely one is that, like another picture taken that day of Lincoln's left profile (his bad side), it was the property of the sculptor Sarah Fisher Ames, who had arranged and paid for at least part of the sitting. In other words, Gardner really was taking a mug shot of sorts.

Ames was in the studio that day, having arrived with Hay. It made sense that the Princeton-educated Hay—who flourished as much in the drawing rooms of Washington society as he did in the hurly-burly of politics—would escort Mrs. Ames to Gardner's gallery. Renowned for her poise and beauty, she was also known for her social polish, honed amid the elite art circles of Boston and Rome, where she had lived for a time with her husband, the painter Joseph Ames, who had himself built a professional reputation on a steady stream of popular portraits and genre studies. By 1862 she was serving in Washington as a volunteer nurse in one of the dozens of military hospitals spread throughout the city, often taking over buildings like the Patent Office, just up the street from Gardner's gallery, and even the U.S. Capitol. Ames may have met Lincoln on one of his and Mary's hospital visits, a habit they had taken up after the death of their son Willie. She may also have met him in the course of

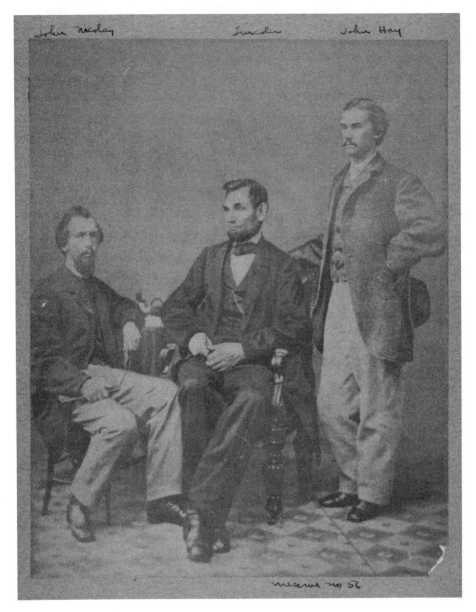

Abraham Lincoln with John Nicolay and John Hay,
by Alexander Gardner, November 8, 1863

her antislavery activism. In any case, sometime in 1863, Sarah Fisher Ames got to know the president well enough to ask if she could do a portrait bust of him.

When Lincoln arrived with Nicolay, they made a relaxed party. Lincoln knew Gardner, of course, but he was particularly close to his two young secretaries—Nicolay was thirty-one, while Hay was merely twenty-five. He had hired Nicolay as his private secretary in Springfield; Nicolay's friend Hay was brought on as assistant secretary as the workload grew (a third, William Stoddard, was added later). Over the course of Lincoln's presidency, the two men became indispensable to their employer, doing everything from handling his voluminous correspondence and vetting the crush of visitors to serving as his unofficial envoy to politicians and the press throughout the country and even working with Mrs. Lincoln as social secretaries. They also gave Lincoln an appreciative sounding board for anything from war strategy and politics to the droll stories he so enjoyed telling. Lincoln grew especially close to Hay, whom he treated almost as a son. Over the summer of 1863, while all of Washington, including the Lincoln family, had fled the heat—even Nicolay managed to find business out west—Hay had remained behind with the president. The two had bonded, sharing their love of Shakespeare and the poets and a weakness for jokes, humorists, and bad puns.

The bonhomie among the visitors can be seen in Gardner's other photographs from that session, some of which, noted Hay, were "the best I have seen." One shows the two secretaries "immortalized" (Hay again) with the president. Nicolay's look at the camera suggests he is all business. He balances a notebook on his thigh and clutches his glasses as if he can barely wait through the exposure before returning to pressing matters. Lincoln, looking neatly groomed, turns toward his senior secretary, awaiting a report or giving instructions, while the nattily dressed Hay stands behind him, resting his hand with an easy familiarity on the back of his boss's chair. This affability carries over to the images of the president alone. In one he appears seated at a table, his crossed legs extended to the left of the picture while he turns to look past the camera to the right (exposing his "good" side). His posture is as relaxed as it has ever been in a formal photograph, but what is most remarkable is the trace of a smile.

Lincoln's animation continues in a photograph of his left profile made for Mrs. Ames. As erect as his posture is, his raised eyebrows suggest a touch of amusement—perhaps at posing, maybe at Hay's wit. Only when the camera comes face-to-face with him does the president grow more formal. Posing for a bust, even for a picture that Ames would use to model her bust, was serious business.

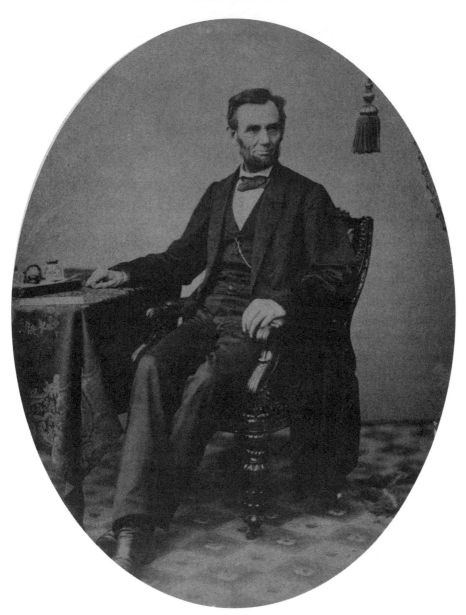

Abraham Lincoln, by Alexander Gardner, November 8, 1863

American culture in the 1860s had yet to organize itself into the hierarchies of taste that would come to dominate the Gilded Age, when curators, critics, and directors in institutions like New York's Metropolitan Museum of Art (founded 1870) and the Metropolitan Opera (1880) sought to educate the public in aesthetic discrimination. Still, there were plenty of distinctions between the arts that generally elevated sculpture (and painting) above the mechanical art of photography. While Victorian Americans popularly embraced photography for its startling detail, they admired sculptures especially for how they idealized the human form, transforming the features of people into types that embodied higher standards of nobility, heroism, or sentimental purity. The point of reference for much of this kind of art was Rome, which, along with ancient Greece, also supplied much of the architectural language for buildings like the U.S. Capitol, with its colonnades and impressive (if unfinished) dome.

Things could be taken too far. When Congress commissioned Horatio Greenough for a statue of George Washington for the centennial of his birthday, he delivered a larger-than-life statue of Washington seated on a throne in a style recalling the colossal Greek statue of Zeus at Olympia by Phidias that was counted as one of the lost seven wonders of the ancient world. However, it was Washington's bare chest that most caught nineteenth-century eyes; the president, commented one critic, looked "undressed, with a napkin lying in his lap." Responses like this caused it to be moved from the Capitol Rotunda to the east lawn of the Capitol, where it would distract fewer people (it can now be found inside the Smithsonian Museum of American History).

Busts, of course, were more modest in their ambition, but they were equally treasured for quoting classicism and ennobling the sitter. Ames's request for the president's time may well have appealed to his sense that he had indeed accomplished something on history's stage that was worth memorializing. This was not the Gettysburg Address; rather it was its much maligned sibling document, signed more than ten months earlier on New Year's Day: the Emancipation Proclamation. While today it is often derided as the weakly legalistic gesture of a reluctant abolitionist, Lincoln and his peers saw it in much different terms. Lincoln himself declared it not only "the central act of my administration" but "the great event of the nineteenth century." "I know very well," he told Senator Charles Sumner, "that the name which is connected to this act will never be forgotten."

Even as Lincoln was poised to sign the document into effect on January 1, 1863, he paused with what he later described as "a superstitious feeling," as if under the weight of history. He had spent the last several hours at the annual

White House New Year's reception, greeting "surging" crowds of "persons, high or low, civil, uncivil, or otherwise...who were all forcing their way" to meet the president. Now sitting at his desk, he looked at his friend, Secretary of State William Seward. "I have been shaking hands since nine o'clock this morning, and my right arm is almost paralyzed. If my name ever goes into history it will be for this act, and my whole soul is in it. If my hand trembles when I sign the Proclamation, all who examine the document hereafter will say, 'He hesitated.'" Lincoln spoke as a veteran of two years' living in the public echo chamber of the presidency, where the most innocuous rumor could become an accepted fact of huge significance. Signing the proclamation would not only change the purpose of the war; it would make Lincoln a lightning rod for controversy—both the champion of abolition and the bogeyman of federal overreaching and despotic ambition. He waited until his hand stilled before signing the document. "That will do," he said with a smile.

Ames's proposal to do a bust seemed just the vehicle to represent the man whose signature had made history. It also would have appealed to Lincoln's more earthly concerns with party politics. Once modeled, busts could easily be mass-produced for a wide domestic market: fashioned in plaster in a cabinet size that sold for a few dollars, they fit nicely on a mantel or shelf, edifying a room with Lincoln's face and perhaps reminding those who saw it of the nobility of next year's candidate for reelection. And yet he also had to balance these advantages against what he already knew to be the time-consuming and even arduous work of posing.

In 1860, just before he was nominated for president, Lincoln had been persuaded by the Chicago sculptor Leonard Volk to sit for a bust. The ordeal involved seven straight days of posing, breathing through straws while a plaster cast of his face hardened into a mold that tore his hair from his temples when it was removed, and finally stripping to the waist so that Volk could "represent his breast and brawny shoulders as nature presented them"—a pose that so flustered Lincoln that only when he reached the street after the session did he discover his long-john sleeves dangling beneath his coat. The resulting clay model of the bust impressed the Lincolns enough to allow Volk to make a cast of Lincoln's hands, but the overall impression of the experience was "anything but agreeable."

By the time Ames requested a sitting, Lincoln knew well what to do. History may beckon, but his busy schedule would not allow any extended sittings. And certainly, with his deeply Victorian sense of propriety, he was not going to sit for a woman sketching him as "nature presented." Instead, he

consented at least to pose for Gardner (it's not clear if Ames had any more access than that), who produced the mug shots for Ames. Front and side from the waist up, they would have supplied in a general way some of the same information about the power of Lincoln's shoulders and chest, about his face and the shape of his head, that Volk had acquired with his casts and sketches.

Ames made good use of her opportunity. By November 1865, some months after Lincoln's death, she offered a cabinet-size plaster bust for sale as a memento; all profits, she announced, went to support orphans of Union soldiers and sailors. Its popularity led to commissions for busts in bronze and marble, the most lucrative of which came from the U.S. Senate in 1866. Today the marble bust stands outside the Senate chambers.

Ames's presence in the studio that November does nothing to diminish the power of the image we know today, but it does complicate how we think about Gardner's intentions. In effect, the session recalls Gardner's first studio session with Lincoln, in which he relied on the guidance of the artist George Henry Story to obtain images for *Harper's Weekly*. However, what he captured with his camera is very different from what Ames carved into stone. She worked to idealize her subject in a classical style, most notably by draping a toga around the shoulders, but also by making his features more regular. The face of her Lincoln is almost symmetrical: the sag in the left side of his face is only suggested; the eyes are balanced, and the lips are touched with a faint suggestion of a smile. And while she certainly incorporates lines on his face, the smooth marble conveys little of the texture of Lincoln's skin. Gardner, on the other hand, highlights the very features Ames diminishes. Lincoln's face is bathed in light, but the strongest source comes from above right—raking across the president's face, it highlights the lined texture of his skin and adds a touch of shadow to the left side. Most striking is Gardner's narrow depth of field. The plane that includes Lincoln's forehead, cheekbone, lips, and chin stands out in crisp focus, while his sideburns and ears on the one hand, and the tip of his nose on the other, are slightly blurred. The effect is hardly useful to a sculptor with little access to her subject. For a photographer, however, it works to bring Lincoln close to us.

Ames and Gardner, of course, worked in different media—stone renders human forms differently than photo chemicals. But that is just the point: the two artists saw Lincoln differently. Ames's classical style lifted her subject out of history, idealizing him as a type and endowing him with the fame of a Caesar, or at least a Washington. For his part, Gardner fulfilled his task for her (and indirectly for Daniel Chester French), but he did so in a way that drew

Abraham Lincoln, by Sarah Fisher Ames, 1866

on the idiosyncrasies of his medium to emphasize those of a specific man. The spray of hair, the etched face, the lights in Lincoln's eyes: these details relentlessly hold Lincoln in a moment in time. In offering him up for our inspection, the photograph ultimately makes him part of *our* past, discrete from the timeless connotations of classical antiquity.

This uncanny sense of a past presence is most powerfully evoked when the image is cropped tightly, but it may be that Gardner didn't see the potential in his own photograph. It was not he, but one Moses P. Rice, who in 1891 copyrighted the photograph as we know it today. Rice may well have worked for Gardner as

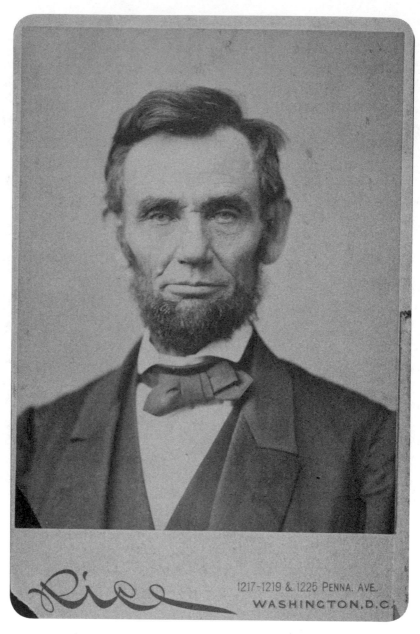

1217-1219 & 1225 PENNA. AVE.
WASHINGTON. D.C.

Photograph of Abraham Lincoln, copyrighted by Moses P. Rice, 1891

an assistant at one point, but by the 1890s, he was operating a jack-of-all-trades portrait gallery on Pennsylvania Avenue that offered "Fine Portraits in Crayon, Water Colors, India Ink and Oil." He promised "Special Attention Given to the Reproduction of Old Pictures"—a line he most likely developed to refer to his growing collection of glass negatives by both Brady and Gardner. When Rice published the "Gettysburg Lincoln," he also released Gardner's 1865 portrait of Ulysses Grant; the following year he published Gardner's photograph of General Sheridan and his staff. Rice attributed the latter to Gardner, but he claimed the Lincoln and Grant photographs as his own, dating their genesis to 1864, to commemorate Grant's being commissioned as lieutenant general of all the Union armies.

Rice was clearly marketing the Grant and Lincoln portraits as a pair to take advantage of the same tide of Lincoln revision and Civil War nostalgia that Brooks, Hay, and Nicolay participated in. His claim to having taken the photographs in 1864 is clearly wrong, but according to the laws and practice of the time, if he possessed Gardner's negatives, he was certainly free to make use of them as he wished. In the end, though, whatever rights Rice had to appropriate the image are less important than what he saw in it. It is *his* cropping, not Gardner's, that we see today as the "Gettysburg Lincoln."

What we see in any photograph is a complex amalgam of the intentions of the photographer and the sitter, the circumstances that brought them together, the expectations and understanding we bring to the picture, and the circumstances of our looking at it. In most cases, these factors fit together rather snugly, held in place by the conventions of looking that we take for granted. We have a good sense of what is important in our family albums, in browsing social media, in walking through art galleries, and in examining news and media images. Even debates over the meaning of certain pictures—as around questions of obscenity or exploitation—take place within a confined space of uncertainty bracketed by our shared understanding about what a photograph represents.

The process becomes more complicated when we look at photographs of places, people, times, and situations we know little about. Seeing is particularly challenging when we look at pictures from a historical moment that has taken on an epic life of its own beyond the realm of documented facts and verifiable circumstances. By many standards, the "Gettysburg Lincoln" is aptly named: we do see the man who would eleven days later deliver the remarks that have come to be called the Gettysburg Address. In Lincoln's mind, however, as well as in the mind of the sculptor who commissioned the photograph, the

photograph would be better identified as the "Emancipation Proclamation Lincoln." Gardner, too, may well have been satisfied with that caption, but he also would have thought of the photograph as "Mrs. Ames's Lincoln" or even "What My Photography Can Do Better Than Mrs. Ames's Sculpture." They may all have seen the image as an arresting addendum to a relaxed session of picture taking that produced exceptionally fine studies of the president. Gardner would have compared it to his portraits of Lincoln he had made in Brady's Washington studio in 1861, at Antietam in 1862, and in his own studio just months earlier, on August 9. Surely he would have realized that with this session he was establishing himself as the preeminent photographer of the president.

Gardner's "Gettysburg Lincoln" exposes a perfect storm of mixed artistic intentions, political ambition, and historical accident, all framed by the anachronistic power of the Gettysburg Address to pull history into its orbit. To see the photograph clearly, to understand what it shows about Lincoln, we have to make it part of a history of how the Emancipation Proclamation made the Gettysburg Address necessary. To grasp what it tells us about Gardner, we have to see it as one exposure among many he made that year. We also need to understand what Gettysburg meant to both men, as a military victory for the Union but for Gardner the battlefield where he'd make his mark as the nation's foremost war photographer. The "Gettysburg Lincoln" stands at the center of what was for both the president and the photographer one of the most momentous years of their lives and one of the watershed years of the nation's history.

LINCOLN and Hay had first visited Gardner's new gallery on an exceptionally fine Sunday morning in early August, when he and Hay—his companion for much of a summer that Hay called "as dismal as a defaced tombstone"—walked the mile from the White House to the corner of Seventh and D streets, where Gardner had installed his new business above Shepherd & Riley's bookstore. No doubt the break in the heat that morning had something to do with what Hay recorded in his diary as his boss's "very good spirits," but there was more to Lincoln's mood than the weather. Since early July, after two years of often disheartening and increasingly bloody conflict, the fortunes of war seemed finally to have turned the Union's way. In what felt to all like a significant conjunction, the day after Independence Day, Washington had received news of a major victory at Gettysburg, where the Army of the Potomac had turned

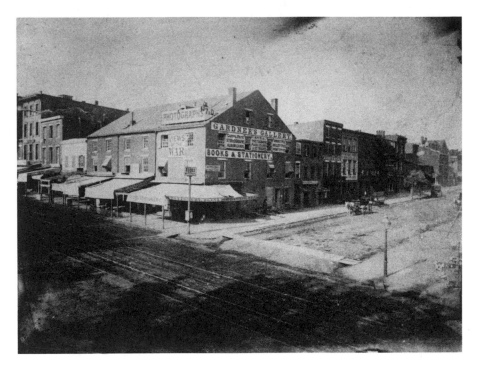

Alexander Gardner's Photographic Gallery, Seventh and D Streets, 1863

back Lee's invasion of the North, inflicting heavy casualties and sending the rebels in retreat. Two days later, there arrived news of an even more significant victory: General Grant's army had taken Vicksburg, Mississippi, accepting the surrender of nearly thirty thousand Confederates, effectively cutting the Confederacy in two and opening the Mississippi River to the free flow of Union forces and commercial traffic. News of the two victories set off celebrations all over the city, which for weeks had suffered under the not unreasonable fear of falling to Lee's invading forces.

The night Grant's victory was announced, revelers arrived at the White House and began to serenade the president and his family. The moment was giddy enough to tempt even Lincoln to join the fun and break his long-standing rule against speaking off the cuff in public. Inspired by the coincidence of the Fourth of July and the twin victories, he mused aloud to the crowd. "How long ago is it?—eighty odd years—since on the Fourth of July for the first time in the history of the world a nation by representatives, assembled and declared as self-evident truth that 'all men are created equal.'" He went on in an uncharacteristic ramble. "When we have a gigantic Rebellion,

at the bottom of which is an effort to overthrow the principle that all men were created equal, we [also] have the surrender of a most powerful position and army on that very day," and another "great battle" in which "the cohorts of those who opposed the declaration that all men are created equal, [have] 'turned tail' and run." The remarks brought sustained cheering, but Lincoln had had enough of thinking out loud in public. "Gentleman, this is glorious theme, and the occasion for a speech, but I am not prepared to make one worthy of the occasion." He concluded, "I will now take the music."

It is easy to hear echoes in his remarks here of what would become Lincoln's most famous phrases: "eighty odd" would become the more biblical (and precise) "four score and seven years ago"; "gigantic Rebellion" becomes "a great civil war"; the colloquially gloating "turned tail and run" would yield to the resonant cadences of "of the people, by the people, for the people." When he pronounces all this a "glorious theme" for a speech, it as if he is discovering on the spot the inspiration for what would become the Gettysburg Address. In fact, he had been working over these same ideas and phrases for some time. Lincoln's repeating "all men are created equal" gives a good idea of how the Declaration of Independence had long captivated his imagination. As president he turned to it often to give voice to the fundamental conviction that, as he put it in 1861, the "leading object" of government "is to elevate the condition of men." The South's great transgression for him was to overthrow these ideals by rebellion.

Lincoln's impromptu remarks anticipate the Gettysburg Address because the phrases and ideas they share were ones Lincoln turned to a number of times when he sought conceptual high ground. Still, as he fumbled for words on the White House balcony, perhaps he recognized in the twin victories that the days of the rebellion were numbered and that realizing the ideals of the Founding Fathers was suddenly possible. Lincoln was not alone in his optimism. Over the next months, much of Washington—in the halls of Congress, in the hotels and drinking clubs, in the drawing rooms, and on street corners—dared to think of victory as graspable, even imminent. For many, peace promised a return to normalcy—business as usual. Lincoln, however, was one of a few who anticipated the nation enduring on *new* grounds brought about chiefly by the sweeping changes his Emancipation Proclamation had set in motion six months earlier. In 1861, when Lincoln had elaborated to Congress on the "leading object" of government—"to afford all an unfettered start, and a fair chance, in the race of life"—he may or may not have had in mind the millions of blacks fettered by slavery. On the balcony, however, after months of public upheaval, there was no doubt that any "glorious theme" would include

free black people. Military victories had created the conditions for a speech, but the "occasion" would have to come later. That occasion would be at the dedication of a national cemetery on the battlefield in Pennsylvania where one of the victories the revelers were celebrating had just been gained.

By August the buoyancy of military victory had dissipated, but Lincoln had other reasons to be in good spirits. He was also enjoying a season of confidence and authority in his exercise of the presidency. Hay, impressed with this development, began privately to refer to Lincoln as the Tycoon—a Westernized reference to the Japanese shogun made popular by the diplomatic visit from the newly opened nation that Brady and Gardner had documented. With a puckish mix of slang and acuity, he wrote Nicolay just two days before visiting Gardner's. "The Tycoon is in fine whack. I have rarely seen him more serene & busy. He is managing his war, the draft, foreign relations, and planning a reconstruction of the Union, all at once. I never knew with what tyrannous authority he rules the Cabinet, till now. The most important things he decides & there is no cavil." Command suited Lincoln well.

His decisions in the weeks surrounding the August 9 session were bringing profound changes not only to how the war was waged, but to the social life and political landscape of the Union. He pressed General Grant to accelerate the recruitment of black soldiers into the military. Raising "colored troops," Lincoln wrote, "is a resource which, if vigorously applied now, will soon close the contest. It works doubly, weakening the enemy and strengthening us." To General Nathaniel Banks, he urged that Louisiana, under consideration to rejoin the Union, be required to "adopt some practical system by which the two races could gradually live themselves out of their old relation to each other, and both come out better prepared for the new." To Horatio Seymour, the Democratic governor of New York, who had written requesting that the newly mandated registration for the national draft be suspended until the courts ruled on its constitutionality, Lincoln insisted that the draft would go forward with all due speed—this despite the devastating riots that had brought New York City to its knees just weeks before.

Together, these mandates pointed the nation toward a not too distant future of new relations between the federal government and the states, the North and the South, and between the races. All of this suited the president's ambitions just fine. When he arrived at Gardner's that August 9 morning, he brought with him a healthy sense of change and optimism: "The rebel power is at last beginning to disintegrate," he told Hay. "They will break to pieces if we only stand firm now."

They were met by an equally upbeat Gardner, newly ensconced in his own photography studio. The nine months since Antietam had been transformative ones for the artist. Though his post with the Topographical Engineers had came to an end with McClellan's ousting in November 1862, Gardner had continued to travel intermittently with the army, taking pictures of the staff and headquarters of McClellan's successor, General Ambrose Burnside (whose extravagant facial hair brought him more fame than his generalship), and later, in February 1863, documenting the army outside Fredericksburg under the command of *his* successor, Joseph Hooker. Gardner had already closed his home in Kendall Green for what would turn out to be at least a year and installed himself closer in town as a boarder on North F Street, not far from his gallery. Most of his family had moved to Iowa to live near the remnants of the utopian community, while his fifteen-year-old son enrolled in a boarding school in Maryland just below the Pennsylvania state line. It may have been that, following the Union debacle at Fredericksburg, the Gardners were no longer comfortable in a city so close to the front lines.

He had also begun to release *cartes de visite* under the imprint of the Metropolitan Gallery, which was owned by Philp & Solomons, a well-connected and well-financed local firm that served as Gardner's publisher for the rest of his career. It is not clear how closely attached he was to the gallery. According to the historian and collector of Lincoln images Lloyd Ostendorf, at some point early in the war, Gardner and his brother James worked out of "a small building on the White House grounds," perhaps using it as their production studio for printing and copying. By summer, Gardner's itinerancy had come to an end. In May he announced the impending opening of his new gallery, "stocked with the newest and most improved apparatus, [with] every arrangement...[to] facilitate the production of 'Beautiful Pictures.'" Indeed, his *Catalogue of Photographic Incidents of the War* was slated to be published in September, including not only his own photographs, but virtually all of the Civil War images that Brady had circulated under his own imprint. Photographic rights were not all that Gardner had left Brady's with: he soon employed Brady's best operators, including his brother James, Timothy O'Sullivan, George Barnard, John Reekie, David Knox, and even his former distribution partner, James Gibson—litigation forgotten or forgiven (Gibson would later return to Brady's as manager and then partner; that relationship, too, would end in lawsuits).

Gardner's appropriation of so many of Brady's assets certainly suggests a tough breakup, but there is nothing in their subsequent dealings that indicates

anything but mutual respect, despite keen competition. In fact, Josephine Cobb tells us that Gardner continued to provide Brady with war photographs for his catalogs. Perhaps Gardner received rights to the photographs to settle debts or back pay; Brady's difficulties with managing money and Gardner's reputation for paying well could alone explain the exodus of the operators. Perhaps for many at Brady's gallery in Washington, it was Gardner, and not the often absent owner, who had become the face of the business.

The clearest sign of Gardner's respect for his former employer is seen in how closely he followed the Brady model for marketing his new business. He had certainly learned the importance of location: his gallery was only a couple of blocks around the corner from Brady's, on the city's only other paved street. And Gardner advertised with the same Barnumesque enthusiasm as Brady. Banners hung from the building announcing Gardner's gallery with its photographs and views of the war to both streets. Gardner advertised himself as a high-quality full-service photographer. His newspaper ads headlined his imperial photographs as "Having all the delicacy of the Album Card" and claimed that the "cartes de visite Produced at this Gallery are pronounced by all to be the finest they have ever had taken. No Pictures allowed to leave the Room unless meeting with the fullest approval." Over the following years, Gardner would regularly take out full-page ads in *Boyd's Directory* for Washington—an ante-telephone version of the Yellow Pages—perhaps at a discount rate from the directory's publisher, Philp & Solomons.

But it was the president's August 1863 visit that certified his reputation as a portraitist to be reckoned with. According to Ostendorf, the sitting fulfilled a promise Lincoln had made earlier to be the first patron of the new gallery. Whether or not he was Gardner's first patron, both men knew he would be his most famous.

Lincoln sat for seven photographs. One surviving print vignettes Lincoln's head and shoulders. In another he stands at a table, held steady by a head clamp and his hand resting on a stack of books. The other five show him sitting at the same table in various poses—in several he holds a newspaper in one hand and his spectacles in the other; in another he leans his head on his hand while resting his elbow on one of the table's books. In all of these, his long legs cross in front of him and he looks at the camera; in one he looks sharply at the viewer; in another he shows the trace of a smile.

At first glance, it is hard to find the "whack" in the pictures. By and large they hew closely to the conventional poses that made the images of Lincoln's 1861 sitting with Gardner so dreary. In several his face takes on its typical

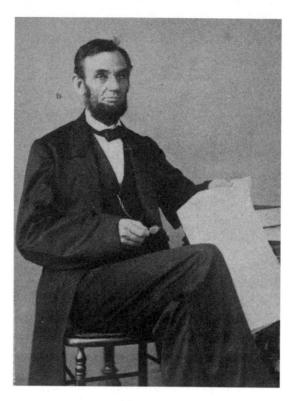

ABOVE AND OPPOSITE: *Abraham Lincoln, by Alexander Gardner, August 9, 1863*

masklike blankness. Compare the results of the two sittings, however, and it is clear that the 1863 images work much better as photographs, not least because in most of them Lincoln engages the camera. His look helps give them a staged quality. He may re-create a classic, if awkward, pose of poetic reverie by resting his head on his hand, but the alert look of his pale eyes and the enigmatic extension of the index finger on his thigh add an aura of veiled intention to his pose (see plate 9). The air of artifice is most palpable in the images of Lincoln with the newspaper. Holding his glasses in one hand and the unfolded paper in the other effectively suspends him in time: has he just finished reading the paper, or is he about to put on his glasses before turning to the news? One photograph seems to catch the president in motion, holding his glasses above his leg on their way either up to his face or down to his thigh. He looks expectantly at the camera as if we have interrupted him.

As an avid theatergoer who appreciated the stage as much as anyone, Lincoln very well may have found satisfaction in posing for such dramatic

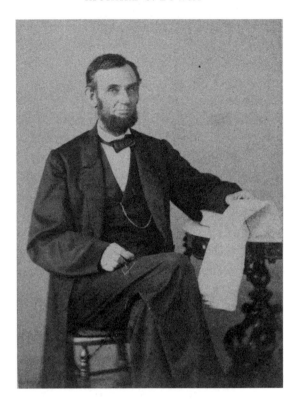

tableaux. Photographs of him up until that August include a number of images that invite us to notice a certain stagecraft, including one made that year by Lewis Walker, who was employed by the Treasury Department, that shows the president seated with his arms crossed on his chest, his hair askew, beaming at the camera (see page 92). More interesting is an earlier one taken at Brady's Washington gallery in April 1861, very likely by Gardner, just weeks after the *Harper's*-commissioned session that had yielded such lifeless depictions of the president-elect (see plate 1 and page 11). Here Lincoln leans forward in his chair with his hand poised at his mouth as if captured in mid-thought—it would have served as a fine publicity still for any stage actor (see page 93).

Gardner's August 1863 photographs do not so much represent Lincoln's good mood as stage a relaxed confidence in his willingness to give himself to the pleasures of picture taking. When afterward Gardner sent prints of the session to the White House, Lincoln was impressed enough to write back

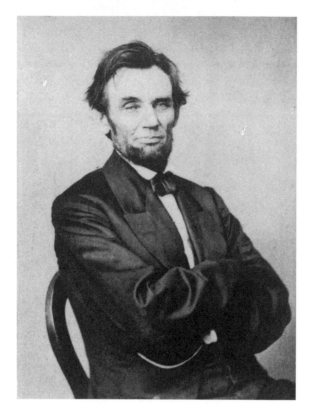

Abraham Lincoln, by Lewis Walker, circa 1863

praising them as "generally very successful." One picture in particular caught his eye: "The imperial photograph in which the head leans upon the hand I regard as the best that I have yet seen" (see plate 9). It was by far the most theatrical of the lot.

The photographs are replete with books, newspapers, pens, and other bookish objects, but Gardner's choice of props was not in and of itself particularly innovative. He was following a convention of presidential portraiture that reached back to 1796, when Gilbert Stuart painted his iconic "Landsdowne Portrait" of George Washington showing one hand on his sword, the other gesturing to a table cluttered with books, an elaborate silver inkwell, and a manuscript. In the 1850s, Currier & Ives sold a print of Franklin Pierce with quill pen in hand, while rival engraver John Sartain marketed one of Millard Fillmore standing at a table with books and paper. Brady photographed Lincoln's predecessor, James Buchanan, with a table of books, inkwell, and

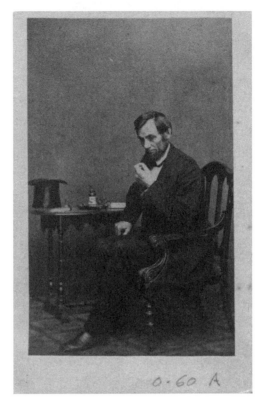

Abraham Lincoln, by Mathew Brady Studio (likely Gardner), April 6, 1861

quill at his elbow. Such props spoke more symbolically than expressively: presidents were at their most presidential when at work in the world of ideas. Their pen was their sword: Congress could pass laws, but it was only the president's signature that put them in effect.

The right circumstances, though, can breathe new life into even the most ossified conventions. For two autodidacts like Lincoln and Gardner, books and writing carried great personal significance. As a member of the Glasgow Athenaeum and as a newspaper publisher, Gardner had long believed that universal education and the free flow of ideas was the bedrock foundation of participatory democracy. Lincoln felt much the same. What made "Young America" unique, he argued in 1859, what made possible its energetic pursuit of "Discoveries, Inventions, and Improvements," was its near-universal embrace of writing and printing. It was in the United States that conditions were ripe to realize the full possibility of Gutenberg's

invention to "immancipate [*sic*] the mind from…slavery" and help establish "the habit of freedom of thought."

Personal convictions aside, a more particular antecedent would have framed Gardner's 1863 pictures for many viewers. By August, Lincoln had made himself known as the author of the Emancipation Proclamation, which from the moment it went into effect was itself a national symbol. There appeared dozens of reproductions and elaborately calligraphic renderings of the document, some with Lincoln's signature or a vignette of his head. Even before he had signed the final proclamation, representatives of the Great Northwestern Sanitary Fair requested Lincoln's original manuscript so they could auction it off to raise money for the care of wounded soldiers. Reluctant at first to part with the draft, Lincoln felt better when he found it had sold for $3,000 and was delighted when he received the prize for donating the most valuable contribution to the fair—an elegant gold watch that he wore for the rest of his life. Later, Lincoln parted with his draft of the preliminary version of the proclamation for another fair. Even the steel-nibbed pen Lincoln used to sign the proclamation attracted interest. When George Livermore, a Massachusetts abolitionist, managed to talk Senator Charles Sumner into procuring it for him, he was ecstatic: it "will forever be associated with the greatest event of our country and our age & with the honored names and services of the President of the United States."

The document and its author began to be rendered together as well. Sometime in the spring, the Pennsylvania artist David Gilmour Blythe painted an imaginary scene of a disheveled Lincoln in shirt and slippers penning the proclamation in a study cluttered nearly to the ceiling with maps, books, and manuscripts; it was later reproduced as a print for public sale. More successful was a painting by another Pennsylvanian, Edward Marchant, who spent several months at the White House working on an idealized image of the president at a desk, dressed not in an open-collared shirt, but in formal white tie and jacket, quill in hand, about to sign the document.

If Ostendorf is right and Gardner and his brother worked for a time on the White House grounds, perhaps they encountered Marchant and viewed his work in progress. But we don't need the connection to see in these August photographs an explicit reference to what was widely regarded as Lincoln's signature moment as president. Far from elevating Lincoln to the realm of the ideal, Gardner's August photographs grounded Lincoln and his proclamation in the midst of democratic politics. Books, pen and ink, the newspaper: these are tools of the presidential trade. Indeed, what was to prevent viewers from

seeing the document in his hands as the proclamation itself? Newspaper or document, Lincoln sits in a bentwood chair—the furniture of the common citizen—ready to meet the eye of a virtual visitor and discuss the issues of the day (see page 90). The same quality can be seen in the November exposures, as well. At his writing table with paper and quill at hand, he looks away from the camera, but his posture is level and attentive, as if he is intent on following a conversation in the room, participating as an equal in the public discourse of democracy as it flows from print to talk and back again (see pages 72 and 77).

As president, Lincoln's participation in the print culture he had celebrated was complex. He rarely, in fact, read newspapers; he could not abide, in the words of Secretary Stoddard, "the tissue of insane contradictions which then made up the staple of the public press," even when it was abridged for his perusal. Lincoln enjoyed the company of editors and reporters, but he felt he found out more about the people he governed from the face-to-face encounters, which alternately plagued and energized him, than he did from the party spin that shaped most newspaper coverage. On the other hand, he did respect its power to cultivate and shape opinion. Even before he took office, he understood that for a politician, "public sentiment is every thing. With it, nothing can fail; against it, nothing can succeed." And the most effective route to the hearts of the public lay through the press. He may not have had the vast media machinery that today's presidents deploy, but his methods were no less sophisticated.

At its most heavy-handed, the wartime government occasionally went so far as to arrest editors and employ other forms of outright censorship; more often it controlled the news closer to its source. Even before the battle at Bull Run, the War Department made sure that all the main telegraph lines in the North ran through its offices; by early 1862, all lines by law were under military control. The military also worked with correspondents traveling with the troops, and on a broader level with the newly formed wire services like the New York Associated Press, to regulate what it considered sensitive information.

For his part, Lincoln spent a lot of time and energy cultivating relationships with editors and reporters. Correspondents who supported the administration were granted privileged access to the White House. Lincoln invited reporters to sit in on meetings with delegations such as the Chicago clergy who visited him in September 1862, urging him to free the slaves. Speaking after he had determined to issue his proclamation but before it was announced, Lincoln was able to make clear his personal objections to slavery, its importance to the South's military success, and the constitutional and practical

difficulties of abolishing it. In sessions like these, Lincoln responded at once to specific appeals and used the press to float ideas, nudge supporters, and flush out opposition, as well as manage his message.

Lincoln also turned to the time-honored vehicle of patronage to gain influence, bringing editors, reporters, and in some cases their relatives and in-laws under the umbrella of government employment. The Lincoln scholar Gabor Boritt gives a concise account of assistance Lincoln passed on to the editor who became the administration's most trustworthy mouthpiece in the press, John Forney. Forney came to Lincoln's attention in 1860 when his Philadelphia newspaper had helped deliver the crucial state of Pennsylvania to the Republican cause. Within a year, he had established himself as such an administration loyalist that he was known as "Lincoln's dog," a name he took pride in. Forney soon moved to Washington and established a weekly, then, with White House encouragement, the *Daily Morning Chronicle*, which became a vocal supporter of all things Lincoln. In turn, Lincoln did his best to support Forney. He helped him land the well-paying and well-connected position of secretary of the Senate, his son received a U.S. Marine commission, and his brother-in-law and a cousin found their ways to comfortable government positions. Forney was not alone. Lincoln rewarded with positions many of the newspapermen from Illinois who had supported him, including Nicolay, Hay, and Stoddard. When he arrived in Washington as a correspondent for the *Sacramento Daily Union*, Noah Brooks found ready access to the president; he was to succeed Nicolay in Lincoln's second term as the president's next head secretary.

Once in the White House, the secretaries kept their journalistic skills sharp with regular use. Hay and Nicolay in particular published regularly in newspapers around the country, often anonymously, giving their own partisan spin to events inside and outside the White House. Many times they served simply as the president's mouthpiece. Nicolay wrote the lead editorial in Forney's *Daily Morning Chronicle* the day after Lincoln signed the Emancipation Proclamation, trying to frame the discussion. "Slavery caused the war," he proclaimed bluntly. "It is with the sword of his war power under the Constitution that President Lincoln now destroys the right arm of the rebellion—African slavery." In one sentence, the loyal secretary justified Lincoln's actions on both military (if slavery caused the war, this will end it) and constitutional grounds.

These were arguments that the White House had made repeatedly since September 22, 1862, when the president had announced his intention to declare free all slaves held in states still in rebellion by January 1, 1863. At first

it seemed they had little effect. While abolitionists responded in support, the stock market declined and military recruitment dried up. The 1862 fall elections cost the Republicans thirty-one seats in Congress and a number of key governorships as the Democratic party gleefully seized on what one wag called the "Proclamation of ABE" as a wedge issue. The war was about restoring the Union, not freeing slaves; Lincoln's unconstitutional expansion of executive power would leave white war widows and orphans prey to roaming bands of ex-slaves.

Disappointed by the election setback, Lincoln later said he did not think "the people had been quite educated" enough to accept the new policy. It was a difficult argument to make. Not only did he have to convince the public that freeing slaves was the right thing to do, but he also had to justify both his use of executive authority to do so and the new relationship between the national government and its citizenry that his actions would lead to. Lincoln took up the challenge in his annual message to Congress at the end of 1862, when he mixed careful reasoning—freeing slaves would shorten the war—with a visionary rhetoric that linked emancipation with national ideals. "In *giving* freedom to the *slave*," he urged, "we *assure* freedom to the *free*—honorable alike in what we give, and what we preserve. We shall nobly save or meanly lose the last best hope of earth."

Lincoln did not include anything like this soaring language in the revised proclamation that he officially signed on New Year's Day 1863. Composed as it is in long sentences of clauses and subclauses linked with lawyerly "thenceforwards," "thereofs," and "aforesaids," the text reads like a mortgage agreement. Most disconcerting is how much it avoids the heavy lifting of universal abolition. Lincoln does declare that "all persons held as slaves...are, and henceforward shall be free," but only in those "States and parts of States wherein the people thereof respectively, are this day in rebellion against the United States." Slaves living in, say, Norfolk, Virginia, or Terrebonne Parish, Louisiana, as well as those in the border states that had remained in the Union, because they were that day under the control of Union forces, remain legal chattel.

As dissatisfying as the document's flat language is to our ears today, it gives a good indication of the tremendous difficulty Lincoln faced in doing anything at all about slavery. He wrote for several audiences at once, any one of which could, if provoked enough, stall and even end any hopes of emancipation. He gave Northern abolitionists just enough action to at least mute their impatience with his efforts to end slavery, even as it protected loyalists in the border states who did not want to give up their own slaves. He also wrote to keep at bay

white Northerners who had their doubts about fighting to free blacks, while giving blacks themselves the assurance that their efforts to free themselves would not be overturned. Beyond this, the audience that most concerned him was a legal community of all political stripes that evaluated critically Lincoln's interpretation of the Constitution. Overstep the limits of executive power (including his claim that the proclamation is "a fit and necessary war measure"), and the president would find himself facing insuperable legal battles.

When Lincoln finally signed the document late on New Year's Day of 1863, it sparked both celebration and censure. When news reached Boston, the stronghold of abolitionists, crowds who had been waiting in a snowstorm since morning erupted in joy. At the Music Hall, a gathering of the country's literati—John Greenleaf Whittier, Henry Wadsworth Longfellow, Oliver Wendell Holmes, Ralph Waldo Emerson, and Harriet Beecher Stowe—marked the event with speeches, recitations, and music, including the Hallelujah Chorus and Beethoven's Ode to Joy. Frederick Douglass joined antislavery advocates and much of the city's black community for a celebration at Tremont Temple filled with tears, shouts of joy, and passionately sung hymns and jubilee songs. In Philadelphia, churches were filled throughout the day with white and black parishioners in prayer meetings. Even in Norfolk, Virginia—one of the localities exempted from the proclamation—nearly twelve thousand blacks gathered to recognize the momentous occasion. The document did not apply to Washington blacks, either—they had been free since March—but this did not stop them from expressing joy in song and prayer or from visiting the White House that evening under torchlight and calling for the president. He merely appeared at the window for an instant before turning away.

Many of the celebrants that day recognized in the proclamation's dry fussy language the seeds for fundamental change. Particularly important was a clause Lincoln added to the final version, assuring that "such persons" who had been freed, really any black man "of suitable condition, will be received into the armed service of the United States." As word spread, North and South, East and West, blacks and whites acted anew in their own way. Emboldened by its promise that the government and military "will recognize and maintain the freedom" of any slave in the lands under rebellion, blacks walked away from generations of servitude, heading for Union lines. They also responded to calls for military service by the tens of thousands. And once they wore the uniform, asked Frederick Douglass, how could full citizenship be far behind? Once they fought for the Union cause, how could any form of slavery in any state, rebel or loyal, be justified? In their opposition and even outrage, many of Lincoln's

political opponents read the same implications in the document, though few managed invective as eloquent in its way as the *Chicago Times*, which called it "a wicked, atrocious and revolting deed for the liberation of three million negro barbarians and their enfranchisement as citizens."

Democrats voiced what everyone knew: in changing the purpose of the war, Lincoln had set in motion changes to the nation he sought to preserve. By the first week of March 1863, Congress matched the audacity of the proclamation when, in less than one week, it passed legislation authorizing the federal government, not the states, to regulate currency and to draft citizens into armed service. These measures, along with freeing and enlisting slaves, would corrode the Confederacy from within and build Northern military power. At the same time, each of these materially changed how Americans experienced and understood the relationship between individual freedom and national responsibility. These changes would play themselves out most loudly in party politics, but Lincoln also saw another way to shape his actions to a collective vision. Nearly four decades before Theodore Roosevelt would coin the phrase, Lincoln adopted the White House as a bully pulpit, issuing a series of four public letters that responded to his critics and political rivals and sought to shape the national debate over what the war was about and the duties and limits of government. Each of the four addressed a specific group but all were meant to be overheard by the public at large. All of them responded in some way to the issues set in motion by emancipation, but they also had the effect of humanizing the president through the press. They allowed common citizens to, as it were, overhear him respond to critics with, as one supporter put it, "skill, tact, and extreme moderation."

They were addressed to a wide range of recipients, from a Manchester, England, workingman's association to a meeting of Democrats and a mass gathering of Republicans. Taken together, they made a constitutional and moral case for the chief executive to take extraordinary measures—the Emancipation Proclamation, suspending habeas corpus, instituting a draft—in extraordinary times. The South, he insisted, was intent on attempting "to overthrow this government, which was built upon the foundation of human rights, and to substitute for it one which should result exclusively on the basis of human slavery." Given this "clear, flagrant, and gigantic case of rebellion," he has the right to suspend "the privilege of the writ of habeas corpus" and arrest those who, like one notorious agitator, had urged soldiers to desert in order to stop the war. "Must I shoot a simple-minded soldier boy who deserts, while I must not touch a hair of a wily agitator who induces him to desert?"

Lincoln saved his most powerful language for a 1,700-word letter for a Republican rally in his home state of Illinois justifying emancipation and the recruitment of black troops. If slaves are property like any other, they can be appropriated for military use. And what better use than to arm, train, and send those free slaves into battle? Lincoln then went further than a mere instrumental argument by challenging his audience to think anew. When Union victory finally brings peace, "there will be some black men who can remember that, with silent tongue, and clenched teeth, and steady eye, and well-poised bayonet, they have helped mankind on to this great consummation; while I fear, there will be some white ones, unable to forget that, with malignant heart, and deceitful speech, they have strove to hinder it."

When read aloud, the letter elicited cheers from the partisan crowd of up to seventy-five thousand and appeared widely in the national press, where it attracted very favorable reviews. Hay called the letter "a great thing...that takes its solid place in history, as a great utterance of a great man." He then added more colloquially, Lincoln "can snake a sophism out of its hole, better than all the trained logicians of all schools." The *New York Times* caught the blend of high and low in Lincoln's language, used with all the effect of a "consummate rhetorician" in a letter "familiar to the plainest plowman." Later the paper gathered all of Lincoln's public letters into a pamphlet published in 1864. Widely distributed and read by millions, *The Letters of President Lincoln on Questions of National Policy* showed the president as eloquent and forceful, making him what the *Chicago Tribune* called "the most popular man in the United States." The Tycoon was indeed in fine whack. This was the figure that Gardner pictured with spectacles in hand, looking at us with his eyebrows raised as if to challenge us to heed his words and follow his reasoning. The photograph also emphasizes the extent to which Lincoln had become the focus and the face of policies that both he and Congress had implemented. And the fact that Gardner picked up the motif again in November points to the continuity from the partisan president immersed in party politics to a man who had his eyes on the broader sweep of history. Out of the fog of party politics was emerging a moral vision of national purpose. As he was beginning to articulate in his public letters, and as he had brushed upon in his remarks to the serenaders celebrating the twin victories of Gettysburg and Vicksburg, Lincoln saw himself very much as a prominent player on history's stage. He was certainly earning his qualifications for a bust.

Lincoln was not the only one in the gallery that November grappling with big ideas. Gardner must have been pleased to have yet another set of

prints to sell to a public increasingly enamored of its president. He must have been struck by the power of the print he made for Ames—else why save the plate, and why allow, if the story is true, Rice to copy it for his own use the following year? He would have recognized it as no less a staged image than any of the others, but perhaps he also saw the power of its details—the lined skin, the sag of Lincoln's left side—to modify the pose's apparent hubris with a more complex touch of sadness, exhaustion even. For like the president, Gardner understood more than most the frightful cost to the nation that underwrote the changes Lincoln oversaw. By no accounts was Gardner a somber man, but several months earlier, in the same town of Gettysburg that had sparked such celebrations in July and to which Lincoln would travel in a week and a half, the photographer had once again found himself amid a nightmare of carnage even greater than the one he had walked amid at Antietam. Whatever future lay ahead for the nation, the present was still very much marked by loss and sorrow. The photographs that he and his team made in July would make clear his understanding of that loss.

DURING the first days of July 1863, news and rumors about the great battle in Pennsylvania had trickled into Washington. Many of the reports were promising, but nothing had been resolved by the morning of the Fourth, when the capital city made a determined effort to celebrate the nation's founding even as its fate seemed to hang in the balance. The holiday began at dawn with the noise of gunshots and rowdy noisemaking, but it opened officially when the morning's Independence Day Parade began its march up Pennsylvania Avenue toward the White House, led by the Marine Band and filled out by Masons, Knights Templar, Odd Fellows, various civic dignitaries, and a host of other bands. It was not until after one o'clock that General George Meade's telegraph to the War Department declaring victory had become public knowledge and the holiday turned into a general celebration.

Eighty odd miles north in Gettysburg, things were decidedly more subdued, despite the victory. The day before, when the last of Confederate general George Pickett's men had straggled back from their famous charge across open fields against the middle of the Union line, General Robert E. Lee had met them with somber anguish. "It's all my fault," he said as he rode trying to re-form the Confederate line. "It is I who have lost this fight, and you must help me out of it the best way you can." They spent their Fourth of July digging in and awaiting a Union counterattack, but it never came. After assessing

the situation, Meade had said simply to one officer, "We have done enough." That night, in a pounding rainstorm, Lee began his retreat.

Meade deployed cavalry and light infantry to harass the invaders but didn't begin his pursuit in earnest for another day—and even then took a longer route to the border. The sluggishness left Lincoln beside himself. Meade had a chance to pin the Army of Virginia against the Potomac River, too swollen with rain to ford, and force a surrender that could end the war. It was Antietam and McClellan all over again. When Lee was finally able to cross into Virginia, Lincoln rebuked his general in a letter. "I do not believe you appreciate the magnitude of the misfortune involved in Lee's escape. He was within your easy grasp, and to have closed upon him would...have ended the war....Your golden opportunity is gone." The letter was ungenerous and very possibly misinformed. Lincoln never sent it.

As the two armies lurched south and the rest of the North reveled in the astounding twin victories, at Gettysburg and Vicksburg, the residents of Gettysburg found themselves in a landscape ravaged by unprecedented fighting. Taken together, the two armies of just under 160,000 soldiers had waged war for three days in the July heat and suffered 51,000 casualties—more than a quarter of the Union forces and well over a third of the Confederate army, more than twice as many as at Antietam. Of these casualties, nearly 8,000 died outright; of the roughly 33,000 wounded, something like 10 percent would soon die from their wounds. Neither army had the medical resources to adequately handle such casualties. When the Confederates began their withdrawal, their train of wounded stretched more than fourteen miles along muddy roads, but even then they left to the mercy of their enemy thousands of soldiers too injured to move, as well as acres of partially buried and exposed bodies, and 5,000 dead horses.

The residents were not even remotely prepared to respond to what one observer described as "a scene of horror and desolation." Before the battle, Gettysburg had been a prosperous town of 2,400 with its own seminary and college, nestled in a rolling countryside of productive and beautiful farmland. After the battle, the farms were chewed up, fences splintered, barns and houses in a shambles, and filled with wounded soldiers. The railroad and telegraph had been torn up; roads and streets were barricaded and sticky with mud and blood. Living was hard. The Confederate army had taken everything from clothing to livestock to barrels of flour; neither army had left medical supplies, and there were only 35 surgeons to attend to more than 21,000 wounded men. As at Antietam, the stench and flies drove local residents to leave their homes

or close all their windows despite the summer heat and suffocating humidity. If they had to venture out, they resorted to all kinds of concoctions to try to mask the smell; a popular one called for using peppermint oil on the upper lip. A Union army chaplain described the stench as "fearful, almost intolerable. The bodies, some horribly mangled lay there five days exposed to the sun—black rotting, full of worms."

As Gardner made his way toward the scene, the community reacted to the devastation with the mix of opportunism, charity, and sacrifice that characterized the heart of Yankee resolve. Stories circulated in the press of locals charging Union soldiers exorbitant prices for bread, milk, even water, or trying to extract rent from a regiment camped on their land. One particularly damning account told of two men charging the wounded two dollars for transportation to a hospital. In contrast, many residents shared what provisions they had and opened their homes to the wounded and soon to the visitors who began arriving even as the two armies stared warily at each other across the battlefield. When the railroad was repaired enough to allow refrigerated rail cars within a mile of town, staples like bread, mutton, eggs, and vegetables began to appear, if hardly in enough quantities, along with clothing, sponges, bandages, and even delicacies like oysters and brandy peaches.

As days passed, more people descended on the little town; at night they occupied every square inch of interior space not devoted to the wounded, while some even braved the stench and the rain by camping outside. Some arrived searching for loved ones—one woman opened twenty graves before she found her husband. Scavengers gathered the guns, blankets, saddles, and haversacks scattered on the ground and even dug up bodies to rob them. Alongside them, though, came hosts of civilian volunteers. Two wagons of nuns from the Sisters of Charity of Saint Joseph in nearby Emmitsburg, Maryland, arrived on July 5, drawn by stories of suffering told by Confederate stragglers they had fed that morning. After battling standing water, mud, and Federal roadblocks for the several hours it took to travel the thirteen miles to Gettysburg, they reached the battlefield with their carriage wheels "rolling through blood." Wrote one sister, "Our horses could hardly be made to proceed on account of the horrid objects lying about them—dead men and horses here and there; men digging graves and others bringing the bodies to them!" Later that day, another traveler arrived along the same road. Charles Keener, an official in the US Christian Commission—which added spiritual comfort and religious education to a mission similar to that of the Sanitary Commission—had made it from Baltimore to Emmitsburg the day before. But that morning of the fifth

he had been awakened at his hotel to find himself "in the hands of Philistines": Confederate cavalry commanded by J.E.B. Stuart had arrived at dawn to capture medical supplies and, as it turned out, some unlucky Union soldiers. Stuart and his men left in the morning, but it was not until the afternoon that Keener was able to hitch a ride to Gettysburg with a man he referred to simply as "the army photographer"—Gardner.

Gardner had left Washington sometime on July 4, perhaps right after the parade had passed the corner near his gallery. He must have been following the news of the battle closely and kept his wagon stocked with chemicals, plates, and cameras, ready to go. Traveling with his two new employees, Gibson and O'Sullivan, Gardner would have needed every hour of the day to cover the seventy-five miles over muddy and traffic-filled roads to Emmitsburg, suffering through the same rainstorm as the Confederate caravan of wounded on a different route south. Once in town, Gardner arranged to visit his son Lawrence, who was enrolled at the local boarding school. The next morning, like Keener, Gardner found himself detained by Stuart's men, while Gibson and O'Sullivan were free enough to spend some time taking views of the town, including one of the inn "where," according to the picture's caption, "our special artist was captured." In any case, the party, joined by Keener, was able set out for Gettysburg only by midafternoon.

Traveling the same road as the nuns before them, they arrived in Gettysburg late in the day. "First we saw the smoking ruins of a house and barn," wrote Keener later. "Fences were all leveled; breastworks were thrown up on all sides; the road barricaded; dead horses laid about by dozens, and filled the road with a horrible stench." He doesn't mention the burial parties—in fact, they saw only one dead body—but they did encounter some wounded in a house near the Peach Orchard. After arranging to spend the night there, Keener left the photographers and headed for the local seminary, one of the makeshift hospitals, with baskets of provisions.

It was too late to take pictures that evening, but the next morning the photographers began in earnest. Over the next four days, they worked their way north along the battlefield's eastern front, ending on July 9 in the town of Gettysburg. For Gardner and Gibson in particular, the struggles of working on a battlefield must have had a ghastly familiarity. Once again they faced the clouds of flies, the smell, and the psychological strain of moving through a landscape of horror—this time on a vaster scale than Antietam. They also had to contend with new challenges, like summer heat and a humidity so palpable it draped the fields in mist, fed by intermittent and often soaking rains that

"Gettysburg Pennsylvania," by Timothy O'Sullivan, July 1863; plate 35, Sketch Book

threatened equipment, hampered the complex process of exposure and development, and left the fields a muddy and gory mess. Certainly the weather limited the kinds of views they could take. The rain and mists made long shots difficult, if not impossible; it also diffused the light, lengthened exposure times, and narrowed the contrast between lights and darks. In the prints, backgrounds tend not only to recede out of focus but to dissolve into a light haze.

Still, the three men worked doggedly, even brilliantly, to produce around sixty pictures with the same equipment they used at Antietam—a double-lens stereographic camera and another for larger plates. They operated something like a modern-day film crew, rotating from job to job so often that in September, when Gardner published his *Catalogue of Photographic Incidents of the War,* he seems to have simply assigned authorship of the stereo cards by rotating their three names down the list of titles. (He attributed the large-format photographs to O'Sullivan alone.) One acted as a director and location scout, looking for possible points of view. Another operated the camera, acting as a cinematographer, framing the picture, managing exposure time. A third would have worked with the negatives. If the collection at the Library of

Congress is any indication, the last assignment was the trickiest: many of the plates are cracked; others show chemical damage.

Gardner would not have known the battlefield as well as the one at Antietam, where he had watched the fighting from the same hill as McClellan and his staff. He arrived in Gettysburg traveling blind, relying on whatever information he could pick up locally about the lay of the land. The team did manage to find its way to Meade's headquarters and the breastworks on Little Round Top—two landmarks of the fighting—but in the end they made little effort to cover the battlefield comprehensively. Instead, they worked their way north along the road from Emmitsburg, which had the advantage of roughly following what had been the extended western line of the Union and Confederate forces. They concentrated on obtaining the kind of images of battlefield dead that had succeeded at Antietam. Nearly half of these were exposed at two locations, at the base of Big Round Top in and around the rocky area now known as Devil's Den, and in the fields of the Rose Farm. The team worked much as Gardner and Gibson had earlier, making multiple exposures of the same scene from different points of view in search of just the right composition.

As a group, the Gettysburg images probe many of the same themes as the earlier ones. In looking at dead bodies—alone, in groups as they fell, or awaiting burial in rows that mimic military formations—we once again confront the obligations of the living to the dead. Just beyond the fields of the Rose Farm, Gardner and O'Sullivan photographed several Confederate graves left half finished by the retreating army, bodies exposed and wooden headboards leaning out of them. Above them, two wagon teams seem ready to pull away, intent on other business. Elsewhere the team took several photographs of the large gated entrance to the local Evergreen Cemetery, suggesting an ironic juxtaposition of the orderly rituals of peacetime funerals with the careless haste of wartime burial. Another battlefield image, attributed to Gibson, shows several gravediggers standing in the misty background behind a loose arrangement of bodies, waiting for their turn to deal with the bodies on the ground. William Frassanito, who reconstructed the photography of Gettysburg with the same care he used at Antietam, identifies the bearded figure with a hat and notebook—in the far right of the photograph—as a rare appearance of Gardner himself. These ancillary figures, however, are the exception, not the rule in the Gettysburg images. There are no group portraits of gravediggers at rest like those at Antietam, nor do we find any figures inviting us to contemplate with them the wages of war or to meditate on the divide between the living and the dead (see plate 7). Instead of this pastoralism, most of the photographs emphasize blunt objectivity.

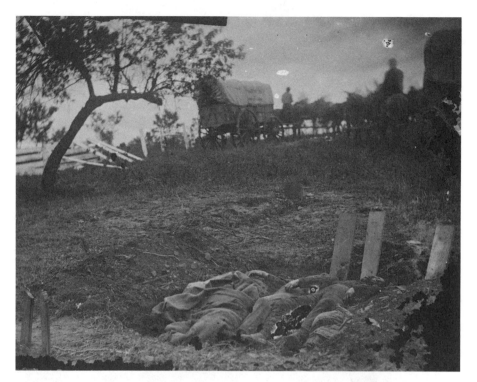

TOP: *"Unfinished Confederate Grave," by Timothy O'Sullivan, July 1863*
BOTTOM: *"Gateway of Cemetery, Gettysburg," by Timothy O'Sullivan, July 1863; plate 39,* Sketch Book

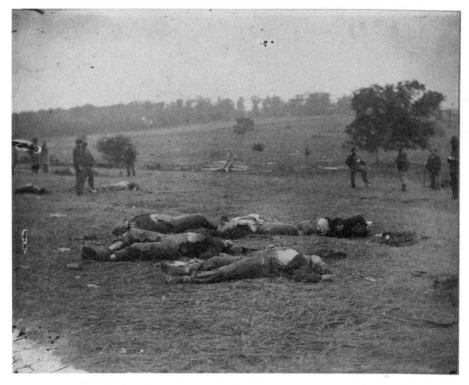

Union Dead, Gettysburg Battlefield, by James Gibson, July 1863

Whereas the stiff frozen gestures of the Antietam bodies spoke to the moment of violent death, of life abruptly interrupted, the Gettysburg figures show no trace of life at all; often grotesquely bloated and sprawled on their backs, at times they appear inhuman. One particularly disturbing photograph confronts us with an eviscerated body beneath what seems to be the goggle-eyed face of a ghoulish clown. In his catalog Gardner entitled this image "War Effect of a Shell on a Confederate Soldier, Battle of Gettysburg," but like many others he took at Gettysburg, it speaks more eloquently to the effects on the human body of prolonged exposure to the summer heat and rain. (Gardner may or may not have known that much of the damage in the picture was likely caused by pigs roaming the battlefield.) Repeatedly Gardner's images emphasize the passage of time after death—as a sign of neglect by the living, as a comment on the impossibility of recalling the once-living image of the dead. Bringing us face-to-face with bodies bloated and sodden, their pockets empty and their shoes missing, their faces monstrously swollen, these are less photographs of

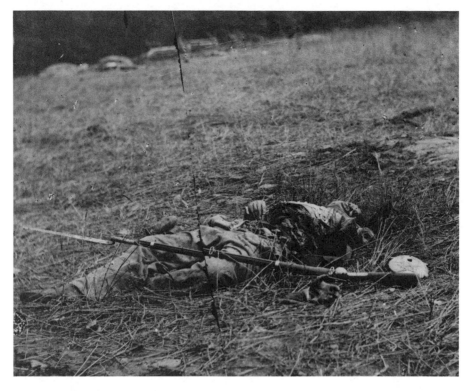

"War Effect of a Shell," by Alexander Gardner, Gettysburg, July 1863

violence than they are violent photographs. They offend our sense of propriety by insisting that we attend to the shocking moment of looking at the dead as they decompose into something inhuman, a process that is by rights left to happen underground after burial.

Most of Gardner's catalog captions, which were generally added later, prosaically match the scene in the photograph: "Scene near the woods on Confederate center," or "Interior view of Breastworks on the extreme left." In the case of "War," the caption ironically understates the power of the photograph. Gardner's words invite us to make an almost clinical inspection of cause and effect: this is the damage an artillery shell like the unexploded one on the left of the picture can inflict on a human body. One look at the image, though—the open severed hand, bulging eyes, and exposed viscera—short-circuits any pretense of objective looking. The effects of a shell and exposure are to transform a man into a thing. It is this process that leaves us caught between revulsion and morbid fascination.

With photographs like this, Gardner returned with a new urgency to the question he raised at Antietam: what are the living to do with the dead? Alongside these moral questions, he was also probing the capacity of photography to stimulate a new relationship to the world it recorded. For most of Gardner's contemporaries, the excitement of looking at photographs stemmed from how they "captured" reality so that it could be examined later. In fact, the majority of Gardner's battlefield images, including this one, were shot as stereographs, doubled exposures printed left and right on an oblong card. Looked at through a double-lens viewer, they gave the illusion of three-dimensionality so vivid that many people found it magical—a Victorian virtual reality. "War" heightens and exploits this quality by presenting something to the viewer that seems *un*real. The photograph may well document a Confederate soldier who died in the Battle of Gettysburg, as the caption tells us, but the vivid three-dimensionality transforms that body into a magical object—part fetish, part relic, part symbol of war.

A number of the Gettysburg pictures of the battlefield dead work this way, straining against the pitiless detail of the aftermath of the battle, trying to break away from the immediate contexts of there and then to produce a self-reflective, metaphorical representation of life, death, and war. No photograph, as Gardner well knew, could escape the circumstances of its making, but the tension between what a picture showed and what it could mean had the power to shake up the way his audience looked at the war and its world. With these possibilities in mind, as he walked the battlefield with his team, as he later printed the images and added captions to them, and finally, as he expanded some of those captions into full-page commentaries for his *Photographic Sketch Book of the War*, Gardner would create what would become among the best-known and most controversial photographs of war ever made.

The most complex and evocative image produced by Gardner and his team is the solemn photograph credited to O'Sullivan entitled "A Harvest of Death" (see plate 10). It offers a more expansive perspective than most of the other Gettysburg pictures, which allows O'Sullivan to incorporate the dim lighting conditions into a haunting image. Much of its effect comes from the haze, which seems to flatten the picture: while we know the field recedes into the distance, it also seems to rise up the picture plane above the more defined figures in the lower foreground. The scattered bodies in the distance seem to float in space—an effect reinforced by how they mimic the arched backs and raised knees of those nearest to the camera. The bloating—everywhere emphasized by the tight clothing and exposed shirts—gives a sense of ghastly uplift to

the horizon, or perhaps to the keeping of the mysterious figures, one on horseback, the other looking directly at us while standing next to—what? a wagon? a camera? Blurred as they are, they seem less to pose for the picture—which no doubt the actual people did—than to oversee whatever it is we look at.

There is another disorienting quality at work in the image. Virtually all of the details are out of focus, including the main figure in the foreground. O'Sullivan would go on to produce astonishing photographs that reproduced the monumental geography of the American West with the uncanny detail that only glass plate negatives can render. Here, however, he gives us only one slice of clarity located in the grass just above the arched chest of the front figure and extending right to include the two bodies. This depth of field creates a curious tension in the picture between what we want to look at and what we can see. O'Sullivan's composition directs our eye first to the front body, then to others in the group, and then upwards detail by detail as we sort out bodies from blankets and try to make out the other shapes floating in the picture plane. Only a patch of grass and the partially hidden bodies are clear: we look but cannot see.

In this case, Gardner's caption perfectly evokes O'Sullivan's image: death, not war, is the agent, harvesting souls in a field where crops once grew. He felt strongly enough about the power of the image to feature it in his *Photographic Sketch Book of the War*—the plate is the first to show dead bodies and the second in a ten-plate section about the battle of Gettysburg that makes up the emotional center of the two volumes. His commentary also emphasized the mythic quality of the scene on "the misty fields of Gettysburg": "A battle has been often the subject of elaborate description; but it can be described in one simple word, *devilish!* and the distorted dead recall the ancient legend of men torn in pieces by the savage wantonness of fiends."

In its impressionistic way, O'Sullivan's picture provokes the same challenges that "War" does with its brutal frankness. In the latter, it is hard to avoid a sense of violation, both in what war has done to this man and what our looking does to his body. In "Harvest" there are no open wounds or even blood on the sodden bodies in the foreground, but the image abounds with suggestions of violation. The open pockets, the shoeless feet of the left-center body, the barely discernible objects scattered across the landscape—bits of cloth, leather, paper; a cup and what looks like a paper card (a *carte de visite* of a loved one?) in the foreground—all suggest the postmortem scavenging of what was once personal to each of the men. The most unsettling sign of violence, though, can be found in the front figure's mouth. Open like a wound, it distends in a bellow of permanent protest to its fate.

"Harvest" is the most artistically ambitious and successful of the Gettysburg photographs, but it also may bear a trace of the controversy that has dogged these images for the past fifty years. It is very possible that the figure to the right on the horizon was none other than Gibson standing next to a stereopticon camera, which he used at least once that day to make an exposure of the same bodies from a position to the far right of that used for "Harvest" (see page 108). O'Sullivan would set up the large-format camera close to the same spot to produce a more formal version of Gibson's image and which is also very different from "Harvest." In this second shot (see plate 11), he arranges the bodies more tightly in a focal plane sharp enough to make out their faces. There is no horizon here, no sense of uplift—the trees, broken fencing, and contour lines in the landscape help, as it were, to hold the bodies in place. Altogether the image is more prosaic, less metaphorical than "Harvest."

When Gardner included O'Sullivan's large-format photograph in his *Sketch Book*, right after "Harvest," he titled the plate, "Field Where General Reynolds Fell." Reynolds was a popular and distinguished commander in the Union Army whom Gardner had photographed in late 1862 as a member of General Ambrose Burnside's staff. His death on the first day of battle had caught the public's imagination and would have attracted Gardner's attention as a useful subject. In fact, Reynolds fell in a wood west of town, far from where Gardner and his team took the vast majority of their photographs. In his studies of the photographic record of Gettysburg, William Frassanito is convinced that the photographers never reached that area—though to his great frustration, alone among all of Gardner's photographs, he never located where these two were exposed.

It is not, however, the location of the images that has caused the controversy, so much as the fact that Gardner repurposed the same bodies. In the *Sketch Book*, he refers to those in "Harvest" as "rebels," whereas those in "Reynolds" are "our own men"—Union soldiers (which, in fact, they were). This apparently deliberate misidentification seems part of a pattern of manipulation pervasive enough to challenge Gardner's documentary integrity. In "War" the rifle, the unexploded artillery shell just above the right knee, and the canteen are clearly props (see page 109). The same rifle appears sans bayonet in at least four other photographs the team took amid the boulders in the Devil's Den area. As the camera operator searched for the most dramatic perspective of a lone body, the rifle shifted places in each exposure with a tin cup, a forage cap, and other items of a soldier's kit. In all of these

photographs, Gardner was thinking theatrically, composing a scene that implies a larger story.

He later included one of these exposures in his *Sketch Book*, entitling it "A Sharpshooter's Last Sleep" (see plate 12). The body, the commentary tells us, was discovered by a burial party in just the same position as when "he fell when struck by the bullet." Gardner continues, "His cap and gun were evidently thrown behind him by the violence of the shock, and the blanket, partly shown, indicates that he had selected this as permanent position from which to annoy the enemy." Caption and image meld seamlessly into a narrative of sudden death, much of which is constructed by the photographer.

Gardner offers much the same story, with the same props, in the next *Sketch Book* plate (see plate 13). "Home of a Rebel Sharpshooter, Gettysburg" shows another lone figure, this time stretched on the ground in a rocky crevice between two boulders. Leaning against the rock wall above him is the same gun found in the other images; at his head is what seems the same cap; beneath it is the same blanket. But what has most caught the eye of critics is that the body in "Sleep" appears to be the same as that in "Home." Again Frassanito makes the best case. Comparing the pictures point by point, he concludes that Gardner and his team had carried the body from its original location in "Sleep" nearly seventy-five yards uphill over the rocky terrain to its more picturesque place among the boulders. The young dead man himself served as Gardner's prop.

There have been other explanations. Perhaps the two sharpshooters are different after all, as some dissenting voices have suggested. Maybe, as has been recently put forward, the body was moved *from* its home amid the boulders *to* the site of its last sleep, not by the photographers, but by a burial party looking for soil in which to inter the body. Still, there persists today an aura of scandal about the possibility of a move, mainly from discomfort with Gardner's apparent disregard of the ethics of photojournalism. As photography became a medium of social and even legal truth over much of the twentieth century and as its objectivity took on the weight of verified fact, even the slightest alteration of the scene or the image in production could represent a moral violation. Gardner worked nearly a generation before Jacob Riis used the documentary authority of photographs to expose the suffering in the New York slums in *How the Other Half Lives*. In the 1930s, the Farm Security Administration would employ photographers like Dorothea Lange and Walker Evans to bring the world face-to-face with the privations of the Depression and bravery of its victims. It says something about the staying

power of our expectations for photographic objectivity, even as digital imaging and computer graphics have eroded the importance of the moment of exposure, that Gardner's sharpshooter "fake," as well as his other manipulations, hold their grip on our popular memory of the war. His photograph and the controversy surrounding it have helped make Devil's Den one of the more popular sites on the Gettysburg battlefield.

Whether or not Gardner and his team endured the grisly work of moving the body, took advantage of its being moved, or simply found two similar-looking bodies, he very likely understood whatever he did with captions and props as permissible within the evolving conventions of photographic truth. He may have seen himself as working within the same rubrics that governed the illustrators he traveled with and befriended, who covered the war with pencil and paper for the national magazines. At Gettysburg, O'Sullivan took a stereograph of Alfred Waud, one of the most accomplished of these "special artists" working for *Harper's*. It was also the term Gardner used to identify himself in the caption to the photograph of the Farmer's Inn in Emmitsburg, where he had been "captured" by Stuart's cavalry. If photography had the advantage of recording what was in front of the camera's lens, why couldn't the photographer exercise the same artistic license as the illustrator in search of what he saw as the deeper truth of a scene?

What is clear about these two images is how important they were to Gardner's representation of Gettysburg. Certainly he was struck by the possibilities of the sharpshooter figure in general. As he and his crew moved across the rocky terrain, they photographed no fewer than five different bodies that Gardner labeled "Sharpshooter." It could be that the nooks and crannies of the rocky terrain suggested that many of the scattered bodies were indeed long-distance marksmen intent on harassing Union troops from cover. Maybe he was inspired by the Romantic rendering of a sharpshooter in *Harper's Weekly* eight months earlier by the young "special artist" Winslow Homer: precariously balanced on a tree branch, intent on aiming his rifle, he embodied the cool but deadly efficiency that Gardner emphasized in his extended caption to "Last Sleep." What likely most attracted his attention was the narrative possibility of picturing the death of a single soldier as a moving counterpoint to the mass killing many of their other photographs documented.

Gardner's search for pathos can be seen in the commentaries he wrote for the two sharpshooter images he included in the *Sketch Book*. After describing the circumstances that led to the "Sharpshooter's Last Sleep," he pauses to contemplate the implications of the image. "How many skeletons," he invites

us to wonder, "of such men are bleaching to-day in out of the way places no one can tell." Most of these will be found and buried, "but there are hundreds that will never be known of, and will moulder into nothingness among the rocks." He continues the theme of memento mori in his caption to "Home." This soldier, we are told, was wounded in the head, "and had laid down to await death." "Was he delirious with agony, or did death come slowly to his relief, while memories of home grew dearer as the field of carnage faded before him? What visions, of loved ones far away, may have hovered above his stony pillow!" The tone of Gardner's language takes us far from the gothic invocation of fiends accompanying "Harvest" (though to our ears all the captions can sound equally melodramatic). We are invited to empathize with the plight of the figure in the photograph, a connection made easier by the fact that the bodies are not bloated—nor do they appear even wet. In a turn of sentimental irony, both figures "sleep" in their final "homes," far from domestic happiness but without the frozen indignation of the bodies in "Harvest."

As they appeared in the *Sketch Book*, the sharpshooter images were the culmination of a long creative process. O'Sullivan's "Home," for instance, was identified on the negative sleeve as simply "Body of Dead Sharpshooter." The stereograph of the same scene was originally titled, with a touch of irony, "Rocks could not save him"—a caption that was retained in the catalog. When Gardner settled on "Home" as he later began to compose the commentaries for the *Sketch Book*, he transferred the title from another stereograph attributed to Gibson that showed a foreshortened and barely visible body next to a rude bunker under a boulder. He went further to find the title for "Sleep." The exposure was identified on the negative sleeve as simply "Dead sharpshooter," but when it came time to title it for his catalog, he reused the caption from an image of a solitary soldier taken at Antietam. All this mixing and matching suggests that his creative thinking about what his photographs were about continued from exposure to publication. With each step Gardner explored and tested narratives—of the newfound home of a young man far from home, of the dashed hope for safety behind rocks, of the release of death. Some of these were inspired by what he encountered on the battlefield; others, in a sense, were already formed, awaiting the right image; still others emerged as he worked with the photographs.

There are any number of explanations for Gardner's apparent shuffling of bodies, misidentifications, and liberal use of props. Many, including Frassanito, have suggested that Gardner's inventiveness was sparked by a rivalry with his former employer. Brady arrived late to the battlefield and so missed the chance

"The Harvest of Death," montage of photographs by Alexander Gardner,
Harper's Weekly, *July 22, 1865*

to capture any of the raw aftermath that Gardner's crew found, but he also had the benefit of having access to the increasingly accurate news accounts of the battle. And while he did try his hand at fabrication at least once by posing one of his assistants as a dead soldier in a woods, by and large the thirty-six images he and his team obtained pictured landmarks and views the public had read about. Eleven of these appeared in the August 22 issue of *Harper's Weekly*: a portrait of the sixty-nine-year-old War of 1812 veteran John Burns, who took up his gun to defend his land from Rebel invasion, pictures of Lee's and Meade's headquarters, and a panorama of the "Wheat-Field in Which General Reynolds Was Shot." Brady, too, got the general's death wrong (and may have led Gardner to think he had it right), and he photographed the wrong house as Meade's headquarters (Gardner got that right). But that didn't matter. He supplied the views that Northerners wanted to see.

Gardner's images of Gettysburg did not appear in *Harper's* until 1865, long after the battle was news. Even then, they appeared as a moody composite engraving using elements from at least five different photographs, titled by the magazine "The Harvest of Death." On the far right are stiff horses from "View around Abraham Trossel's House"; just to the left are the broken caisson and

horse from another exposure entitled "Unfit for Service." Much of the center and left middle ground draws from "General Reynolds," though the foreground is filled by the sharpshooter in his "Last Sleep." Only the background recalls O'Sullivan's "Harvest," with its scattered bodies and shadowy figures. It must have been galling for Gardner to see Brady trump him in 1863 with his timelier and fuller spread of pictures, but he would have found satisfaction in *Harper's* rendering of his images. In its way *Harper's* got things right. Gardner's photographs at Gettysburg may have been market driven ("get a picture that looks like a sharpshooter"), and they may or may not have stretched documentary codes to breaking. Nonetheless, they remain a powerful and moving record of three men endeavoring with their medium to represent the material violence of war in all its mystery and inscrutability.

LIKE the armies before them, Gardner and his team left behind the mayhem and suffering of the battlefield, but for the local residents, volunteers, and skeleton army medical staff, the ordeal was just beginning. Their efforts would find an element of closure in November's ceremonies dedicating Gettysburg's national cemetery, which Gardner and his team would document—but that was months away. After the battle, it was weeks before most of the wounded could be evacuated from the fields—or moved from homes, churches, and schools—to Camp Letterman, a vast military tent hospital a mile and a half east of the town. The dead were another matter altogether. When Pennsylvania governor Andrew Curtin visited the battlefield on July 10, he was appalled by what he saw: hundreds of unburied bodies lay scattered among the rocks and woods; many others "buried" in as little as eighteen inches of soil were already exposed by the rain. One report described skulls "kicked around like footballs."

Curtin acted quickly by empowering a local attorney, David Wills, to act as the state's agent in reburying the slain. Within two weeks, Wills had come up with an ambitious proposal to relocate them to a seventeen-acre plot just off the grounds of the Evergreen Cemetery—an ideal spot "for the honorable burial of the dead who have fallen in these fields." To do this, however, the state would have to purchase the land (at $200 an acre) and pay for the labor. In his letter to Curtin, Wills wrote with all the rhetorical wile of a good lawyer to convince the governor that the investment was worth it. First, of course, reinterring the slain was a matter of "humanity": how could they be left to the elements and "hogs...actually rooting out the bodies and devouring them"? The project was also a matter of state pride. The dead lay uncared

for "on Pennsylvania soil"; many of them "the patriotic soldiers of our state!" What better way to demonstrate "a proper mark of respect" to "soldiers in the field" and those at home than to have "their brave kindred...properly cared for by our Governor?" Wills also offered some practical incentives. He had already ascertained that the federal government would pay for coffins, and certainly the other states that had suffered casualties would "contribute towards defraying the expenses," and arrange to have "all the dead known & unknown" reburied. Given the potential cost sharing and the positive image building, how could Curtin—a Republican and staunch supporter of the president and the war—turn this down? He needed no more convincing. He gave Wills approval, and by mid-August the lawyer had pledges from all the states to participate in the project. He also hired one of the nation's preeminent landscape architects to develop a plan for what was to be known as the National Soldier's Cemetery: the Scottish-born William Saunders, who had made the Mount Auburn Cemetery in Massachusetts into a bucolic memorial to nature, life, and the dead so alluring that it had become a tourist destination.

Battlefield burial had posed a problem for the military long before Gettysburg. Early in the war, both sides had made field officers responsible for burying and recording the names of those killed in action. This plan quickly proved inadequate, and in early 1862, the Union army shifted responsibility up the chain of command, charging generals to designate a military cemetery in "some suitable spot near every battle field, so soon as it may be in their power." Despite these good intentions, the protocol never proved practical, particularly after large battles, when the need was most urgent. As the war escalated and casualties mounted, it was clear that it was rarely in the power of anyone with frontline duties to do much about the dead, no matter their rank. For much of the war, interment remained largely an ad hoc process. Often soldiers would seek out their comrades and relatives to give them a proper burial and grave marker. More commonly the task fell to prisoners or units forced into service for disciplinary reasons, because they had seen little action, or simply because they were there—a practice hardly conducive to careful work. At Antietam one officer got his men through the grisly work by requisitioning enough liquor to keep the detail drunk throughout the day.

Many of the gaps in the Union army's care for the wounded and dead were filled by the Sanitary Commission, which, besides providing medical personnel and supplies, made agents available to help families locate and return bodies home for burial. Some states also pledged to pay for the removal and reburial of their residents killed in battle. Still, even the vast resources of state

and philanthropic organizations were inadequate to the task, leaving many private citizens to retrieve bodies themselves. With little official support, they often had to turn for help to the undertakers, embalmers, and private agents who followed the armies, offering various services, from finding and exhuming a body to supplying a casket and shipping it home. Such arrangements left families vulnerable to price gouging, incompetence, and outright fraud, and even the honest businesses levied substantial fees. One entrepreneur at Gettysburg charged $50 for a zinc-lined metal coffin guaranteed not to emit odors even after transport. The Staunton Transportation Company offered its casket built as a "portable refrigerator" designed to allow the family at home to view the soldier's face in a "natural" condition. Most reliably for those who could afford it, the newly commercial process of embalming could preserve remains in a remarkably lifelike state. For many, such costs were prohibitive, which led to a de facto two-tiered system for the treatment of bodies (and when at all possible, officers routinely received special attention).

The whole process, with its exploitations and privileges, left many indignant. It seemed a sign of neglect and disrespect by the army and ultimately by the government not to treat all the fallen with dignity. As one Washington newspaper put it: "The first duty of a Government is to protect the life of a soldier; the second is to give him honorable burial when he has fought his last battle." Anything less than a decent burial for a man who has left his family to fight for his country, declared the chaplain of a Washington hospital, "is a disgrace to the nation." It was partly in response to such criticism that Congress in July 1862 authorized the president "to purchase...grounds...to be used as a national cemetery for the soldiers who shall die in the service of the country," but it would be eighteen months before the government appropriated the land around General Robert E. Lee's home in Arlington for the National Cemetery.

Wills's plan nicely filled the breach between personal need and national obligation. While technically not a federal project, the National Cemetery was supported by all the states that had lost soldiers in the battle. Location also helped. The cemetery resided in a solidly Union state, amid once pastoral landscape relatively accessible from the major cities of the North. Saunders's design for the cemetery elegantly tapped in to the implicit national symbolism of the project. Graves were sorted by state and marked by a simple gravestone engraved with the soldier's name; unknown graves were separately numbered. No one was given special treatment: officers were buried indiscriminately with enlisted men. All the graves were arranged in concentric semicircles around a dramatic monument to the fallen. All were equal in death, and all

states contributed to the larger unity of the nation. Curtin said the cemetery would be the "final resting place for the remains of our departed heroes, who nobly laid down their lives a sacrifice on their country's altar, for the sake of Universal Freedom and the preservation of the Union."

Plans for the cemetery formed alongside another initiative that came together to establish the battlefield as a commemorative site. Motivated in part by opportunistic boosterism and in part out of genuine recognition of the site's historical importance, planners modeled their idea on the antebellum effort to transform George Washington's Mount Vernon home into a national historical site. In early August, locals formed the Gettysburg Battlefield Memorial Association, led by businessman David McConaughy, who had already begun to buy large tracts of land to preserve the field of battle as a "standing memorial" to the events in July. He was soon joined by artist, photographer, entrepreneur, and promoter John Bachelder, who made the memorialization and history of the battle his life's work. Walking the terrain tirelessly, interviewing soldiers on both sides, sometimes even as they lay wounded in hospitals, he produced what he called an "isometric map"—an annotated panoramic view— of the battle that marked the three days of troop movements with an accuracy endorsed by no less than George Meade. Within months a nascent tourism industry had emerged; visitors could stay in hotels that advertised their battle damage, tour the battlefield with guides (including Bachelder himself), and return home with relics from America's Waterloo.

Once the cemetery site was laid out, Wills contracted with another local to transfer the Union dead from the battlefield to the cemetery, who in turn subcontracted the work to Basil Biggs, a black resident who owned horses and a wagon big enough to transport six coffins at a time. Biggs had arrived in Gettysburg in 1858 with a wife and family and soon made himself an important figure in the small black community, even harboring escaped slaves in his home on their way to Canada on the Underground Railroad. He and his team of local workers dug up the body of every Union soldier they could find, taking care to look for clues to the soldier's identity, then transferred it to a casket before reburying it in the cemetery. Needless to say it was tedious labor. It took until spring of 1864 before all 3,512 of the slain were properly interred; over a quarter of them would remain unidentified.

Wills, as ambitious as he was organized, also began to formulate plans for a dedication ceremony worthy of a national project. By the end of September, he had contracted with Edward Everett to give the centerpiece oration. It was a shrewd and popular choice. Former president of Harvard, governor of

Massachusetts, congressman, and ambassador, he was most beloved for his stirring orations in memory of Bunker Hill, Lexington, and Concord and in support of the Mount Vernon initiative. Wills also pursued the nation's best-known poets—Henry Wadsworth Longfellow, John Greenleaf Whittier, and William Cullen Bryant—to compose lyrics for a funeral dirge. Here he had less luck, finally settling for Benjamin Brown French, a lifetime bureaucrat who served as the Washington, D.C., commissioner of public buildings, overseeing, among other things, the completion of the U.S. Capitol and maintenance of the White House.

Wills probably found him through Ward Hill Lamon, whom Wills had appointed marshal of the dedication ceremony. As marshal of Washington, D.C., Lamon was certainly more qualified to manage the dedication ceremony than French was to write the dirge, but Lamon's best asset most likely was his relationship with Lincoln. Since early 1861, when he had accompanied the president-elect and detective Allan Pinkerton into Washington with his guns and knife to fend off a possible assassination attempt in Baltimore, Lamon had settled into a wide-ranging portfolio of official and unofficial duties in support of his longtime friend, the president. Wills would almost certainly have used Lamon as a conduit for sounding out Lincoln about attending the ceremony, but it was Governor Curtin who informally approached him sometime in August. The formal invitation did not arrive until November 2, though by then Wills would have been confident that Lincoln would accept. Still, he left nothing to chance, turning on the same persuasive charm as he had used with Curtin. The ceremony, he promised, "will doubtless be very imposing and solemnly impressive." Would Lincoln, "as Chief Executive of the Nation, formally set apart these grounds for their Sacred use by a few appropriate remarks"? He continued: "to have you here personally" would gratify "the many widows and orphans" of the battle, and inspire confidence in soldiers still fighting that "those highest in Authority" remember and care for "they who sleep in death on the Battle Field." He ended his appeal by inviting the president to stay at his home.

For Wills, it was Lincoln's presence that mattered most, not whatever "remarks" he might make. His participation would symbolize the nation's investment in the whole enterprise and make Gettysburg a place to visit. It would also, Wills cannily implied, play well politically for the president. Widows and orphans may not have been able to vote, but soldiers could, and so too could the men who attended the ceremony or read in the press about Father Abraham's compassionate attention to the nation's sacrifice.

Like Curtin, Lincoln knew a golden opportunity when he saw one, though he was more interested in the "remarks." Here was exactly the "occasion for a speech" about the "glorious theme" of war and national destiny that he had mused about months earlier on the White House balcony. Over the last several months, supporters had been urging him to build on the success of his public letter campaign by delivering a clear statement that, in the words of one correspondent, the North was "fighting for Democracy." The right remarks would add the poetry and vision missing from the Emancipation Proclamation. They might also serve to shape the discussion that had lately arisen about the end of the war and national reconstruction. On a more personal level, the solemnity of the occasion would allow Lincoln to speak to the deep losses he, his family, his friends, and much of the country had suffered during the war. And it didn't hurt that a rare journey out of Washington to a Republican state would provide a firm foundation for the next year's presidential election.

Few of these thoughts could have been uppermost in Lincoln's mind when he arrived at Gardner's studio to pose for Mrs. Ames's bust in November, six days after Wills's invitation. He may have begun working on his remarks, but he would not have been far along: he told a friend nine days later, the day before he was to leave, that they were only half finished. The Lincoln we see in Gardner's photographs that day was very much the one he photographed in a series of poses in August. Posed in the summer heat with a newspaper or in the fall with Gardner's new inkstand and the mysterious envelope at his elbow, the Tycoon is in fine whack. Then again, the remarks Lincoln would deliver at Gettysburg were themselves born of the political ambition that had led him to use the tools of the presidential trade by signing the Emancipation Proclamation and to guide the country through the political turbulence it precipitated. It is this ambition we see in the "Gettysburg Lincoln." Whether or not Ames or Gardner asked him to or he assumed the stern pose himself, he looked directly into the camera as his bust would into eternity. And whether or not Gardner followed Ames's directions in framing his shot, he heightened the peculiarities of Lincoln's asymmetrical face to express the effort behind that ambitious look.

As the day for the ceremony grew closer, Lincoln was having difficulty finding his way out of town. When he asked his Cabinet to accompany him to Gettysburg, all but three of them begged off, citing the end-of-the-year rush to prepare their annual reports for Congress. (Treasury Secretary Salmon Chase, who was scheming to challenge Lincoln for the Republican nomination for president, cited "imperative public duties" as his excuse.) Lincoln,

fretting about his own lack of time, was also distracted by the sudden illness of his son Tad, a disturbing replay of the illness that had claimed Willie the previous year. Despite all this, Lincoln managed to board his train for the six-hour trip to Gettysburg with Hay and Nicolay, the three Cabinet members (including his close friend Seward), the ambassadors from France and Italy, Everett's daughter, the Marine Corps Band, the disabled soldiers of the Invalid Corps who served as military escort, and Lincoln's valet, William Johnson, whom one scholar speculates was the only black on the train.

They were joined by a host of reporters, themselves but a small portion of the impressive contingent of the press from all over the North who would join the ten to fifteen thousand visitors who once again swamped the little town. Reporters were vital to both Wills's and Lincoln's interest in the proceedings; a number of them would sit on the speaker's platform with six governors and the president's distinguished entourage. Most of the crowd would come the day of the ceremony, but that evening there were visitors enough to give the town something of a celebratory atmosphere—a wakelike preamble to the "imposing and solemnly impressive" proceedings the next day. After finding their lodgings, Hay and Nicolay joined John Forney for a night of whiskey, carousing, speeches, and song. They had plenty of company. Well into the night, the public square in front of Wills's house was filled with a raucous crowd that "sang, & hallooed, and cheered," and at one point broke into a popular song written in response to Lincoln's call for troops, "We are coming Father Abra'am, 300,000 more."

Lincoln spent his evening more quietly, relieved by news that Tad was doing better. After dinner at the Wills's with Everett, he stepped outside to respond, with a brief greeting and some light banter, to early serenaders who called for a speech: "I must beg of you to excuse me from addressing you further." Back inside the house, he begged the same favor of his host before retiring to his room to finish his remarks. Later that night, he walked next door to consult with Seward, who had delivered his own (prepared) speech to the crowd and shared more than one whiskey with friends. After beginning the next day with an early-morning tour of the battlefield, the president emerged from the house by ten a.m. dressed in a new black suit and his stovepipe hat, still banded with black crepe in memory of his son Willie. He was greeted with such enthusiasm that he blushed. Mounted on horseback in the slow-moving procession to the platform, he was assailed by so many people wanting to shake his hand that the marshals had to intervene and cordon him off. Still the crowd cheered his every move. "Abraham Lincoln is the idol of

the American people at the moment," wrote French later in his diary. "Anyone who saw & heard as I did, the hurricane of applause that met his every movement at Gettysburg would know that he lived in every heart....It was the spontaneous outburst of heartfelt confidence in *their own* President."

The ceremony went smoothly and, notwithstanding the excesses of the night before, solemnly. After a dedication prayer "that thought it was an oration," according to Hay, Everett arose to deliver the real oration. Over the next two hours, without notes to guide him, he delivered the speech everyone wanted, moving many in his audience at times to tears as he transformed the Gettysburg campaign into a Greek epic, with all the rhetorical flourish of an American *Aeneid*. (Some press reports were less kind about its artistry.)

Lincoln's remarks were famously briefer. Under a beautiful and wonderfully mild fall sky, in a dry, high-pitched voice, bareheaded, with his spectacles on, he read his 270 words, according to Hay, "in a firm free way, with more grace than is his wont." While the brevity of the speech caught many off guard, it was interrupted several times by applause and received a warm response when it ended.

When Lincoln arose to deliver his remarks, surely he knew that much of what he wanted to accomplish was already done. His presence legitimated Wills's ambitions for the national cemetery, and his popularity with the crowd must have impressed upon not only the many correspondents in town, but also the governors (including New York's Seymour) that here was a formidable candidate for reelection to the presidency. His remarks were perfectly appropriate to the occasion, but they also expressed his keen ambition to seize the moment with eloquence. If Lincoln had exercised the full extent of his executive authority with the Emancipation Proclamation, with his address at Gettysburg he enlisted the people in the vision that document had put forward—that by extending liberty and equality to all individuals in the nation, the nation would begin anew to uphold its founding principles.

These were the ideas and phrases he had been working toward since the early days of the war. Decades later, Nicolay described Lincoln's "usual habit" of composition as a process of "great deliberation in arranging his thoughts, and molding his phrases mentally, waiting to reduce them to writing until they had taken satisfactory form." Lincoln was notorious for jotting notes on any handy piece of paper, slipping them into a pocket or even his hat, and then depositing them in the slots and drawers of his rolltop desk. We can hear these notes that were later molded and reduced to the Gettysburg Address in his response to the victory serenaders at the White House, and in the rhetoric in his public

letters over the past year. As early as Independence Day in 1861, two weeks before the debacle at Bull Run, Lincoln had insisted in his special message to Congress that the stakes in the rebellion were issues higher than the survival of the country. At hand was "the question, whether a constitutional republic, or a democracy—a government of the people, by the same people" can survive an attempt to "break up their Government, and thus practically put an end to free government upon the earth." The conflict "is essentially a People's contest"—"a struggle for maintaining in the world, that form, and substance of government, whose leading object is, to elevate the condition of men."

In molding his language, he also borrowed from other sources. His audiences in Congress and at Gettysburg would have recognized phrases like "a government of the people, by the same people," as variations on the conclusion to Daniel Webster's speech on the popular roots of federal government, itself a staple of countless school recitations. The music of his measured cadence and antique phrasing ("Four score and seven years") recall the language of the King James Bible (or that of King James's contemporary, Shakespeare), while his repetition—he uses some form of "dedicate" six times—evokes the ritual language of *The Book of Common Prayer*. With this language, Lincoln distilled years of deliberation into an eloquent argument for national renewal suitable both for the dedication of a cemetery and for a country weary of war. The nation, he declared, "conceived in Liberty, and dedicated to the proposition that all men are created equal," is now in the crisis of a civil war that is "testing" whether it can "endure." Those who died here did so in an effort to preserve that nation and those ideals; it is they, and not the living, who "dedicate," or "consecrate," or "hallow this ground." Therefore it is up to the living to carry on the task they began, to resolve ourselves to "a new birth of freedom—and that government of the people, by the people, for the people, shall not perish from the earth."

Lincoln's words would not be immortalized for several decades. In fact, there is evidence that Lincoln was disappointed with his performance. Years later, Ward Lamon recalled the president immediately afterward comparing his speech to a dull plow: "Lamon, that speech won't *scour!*" And when Everett wrote the next day complimenting Lincoln on his remarks, he humbly replied that he was pleased that "the little I did say was not entirely a failure." Beyond that, Lincoln said little about his speech—in part, perhaps, because he returned to Washington with a case of varioloid smallpox, a mild version of the disease that would nonetheless leave him quarantined in bed for much of the following week. Still, he thought highly enough of his work that, when asked

to submit copies in his own hand for auction at Sanitary Commission fairs, he meticulously edited his original version for style. He meant these words to stand for a long time. (It is his edited words that are carved on the wall of the Lincoln Memorial.)

The national press coverage gives a better measure of the effect of Lincoln's remarks. While Everett received close to twice the editorial attention as Lincoln—he was, after all, the featured speaker—Lincoln's brief speech allowed it to be reprinted in its entirety. Responses ran along party lines. Republican papers praised the "little speech" as "deep in feeling, compact in thought and expression, and tasteful and elegant in every word and comma." "The few words of the President," wrote *Harper's Weekly*, "were from the heart to the heart." Democratic papers, of course, begged to differ, faulting the president for his language and his ideas. Several papers objected to the poor taste of the birth imagery that he opened with: how dare he represent "the 'fathers' in stages of conception and parturition." The *Chicago Times*, a major Democratic newspaper, fulminated over what it called Lincoln's "perversion of history so flagrant that the most extended charity cannot regard it as otherwise than willful." Soldiers at Gettysburg, the paper thundered, died "to uphold this constitution, and the Union created by it," not to "dedicate the nation to 'the proposition that all men were created equal.'"

The *Times* put its finger on a dimension of Lincoln's address that has been lost under the shine of history's burnishing. The president was indeed making a historical argument: the nation's origins lay in the ideals of freedom and equality expressed in the Declaration of Independence, not in the legalities of the Constitution, which, for all of its brilliance—for all of Lincoln's careful adherence to its laws—was but the earthly, hence flawed, realization of universal ideals. To continue the work of the fallen, we must dedicate ourselves to realizing those ideals more perfectly. It is, of course, this vision that has invested Lincoln's words with what Garry Wills has called their "magical" power to transform the pressing issues of late 1863 into an enduring statement of national renewal.

The *Times*, however, along with many other Democratic papers, heard a more pointed argument. As they well knew, abolitionists had long preferred the Declaration's ideal of universal equality to the Constitution's endorsement of slavery; to their ears, when Lincoln called for dedication to "a new birth of freedom," he meant not just emancipation, but *racial equality*, as well. The Gettysburg Address worked as one more of Lincoln's public letters delivered to the sympathetic audience in front of him and to the vaster audience who

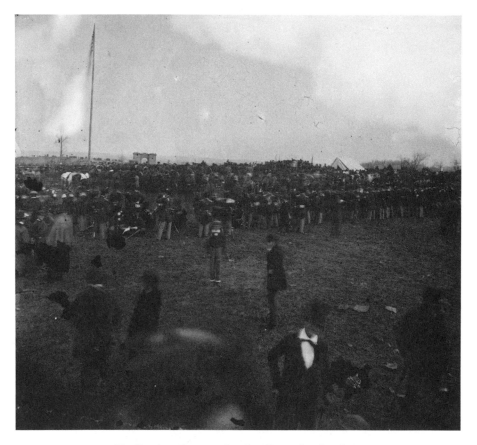

Dedication Ceremonies, by Alexander Gardner,
Gettysburg, November 19, 1863

read the newspapers. As the *Chicago Times* implicitly recognized, it did indeed fill out the vision so many found missing in the Emancipation Proclamation. The two documents—one overwhelmingly legal in tone, the other steeped in the rhythms of English that lay at the heart of the American popular idiom— were inseparable.

ONE account of Lincoln's speech tells of the crowd's distraction by a photographer hurrying to get his camera in place to capture the president, only to have the remarks end too soon. It is possible that the photographer was Gardner or one of his assistants, though likely not. The Library of Congress holds three stereo card negatives attributed to Gardner taken of the crowd at a distance

from some sort of platform. On the left horizon rises the gate to the Evergreen Cemetery; to the right is a tent where the sixty-nine-year-old Everett had rested before his oration. The speaker platform stood just to the left of the tent, about halfway between the tent and gateway. One of the negatives has received particular attention of late as scholars have debated whether one or neither of two figures in the picture is that of the president. Gardner was one of at least half a dozen photographers, including two from Brady's Washington gallery, who took pictures of the ceremony. Many of the images are since lost; only one, attributed most commonly to David Bachrach, shows Lincoln clearly, looking down and bareheaded while listening to Everett's speech.

It is not likely at that distance that Gardner would have bothered to photograph Lincoln; nor is he likely to have heard the president's words. If he did hear them or read the address later in the papers, they may well have struck a chord in him. The president and the photographer were thinking along similar lines. For Lincoln, Gettysburg represented the whole of "the great civil war," just as O'Sullivan's exposure of "A Harvest of Death" spoke to more than what happened on the Union right flank. More broadly, both of them put the relationship of the living to the battlefield dead at the crux of the nation's experience of war. In confronting his viewers with the uncanny ugliness of death, Gardner bore witness to the inexorable responsibility the living have to those who died. In word and deed, Lincoln gave direction to this responsibility. He urged that only by dedicating itself to its highest ideals can the nation properly value the fallen. And by participating in even just a symbolic way in the communal rite of burial at the ceremony, he inspired the thousands who had clogged the roads and railways to get there, many of whom, according to reporters, had lost sons and husbands and brothers and friends in the battle. His presence and his words bound their personal suffering to that of the soldiers in the field, forging the beginnings of a national community that looked to the future.

If he did read the address, Gardner may also have felt he had a small part in shaping Lincoln's vision. Among the many "VIEWS OF THE WAR" that Gardner advertised in his gallery would have been those freshly printed from Gettysburg. It is hard to imagine his not taking a few moments on at least one of Lincoln's visits to walk him through the gallery on the floor below his rooftop studio and show off his best work. The president might have seen himself for the first time towering over McClellan at Antietam, might have seen O'Sullivan's "A Harvest of Death" or "Home of a Rebel Sharpshooter."

There is no record of this having occurred during Lincoln's visits, but there does exist an account of a visit to Gardner's studio by another man who

"Headquarters Maj. Gen. George G. Meade, During the Battle of Gettysburg," by Timothy O'Sullivan, November 1863; plate 43 in Sketch Book

shared the platform with Lincoln as he delivered his remarks in Gettysburg. The president left town that evening around five p.m., but Benjamin French stayed the night. The next morning, he and the other marshals received an exclusive tour of the battlefield by none other than John Bachelder. At some point, French broke from the group and wandered away to find the house where General Meade had established his headquarters. There he met the son of the owner, who told French that he'd repaired the house and barn and burned fifteen of the dead horses on the property. Two still "very offensive" carcasses remained, too close to the house to burn safely. As French turned away, he encountered "two men with a camera down in the field"—Gardner and O'Sullivan, there to make a better print of the house than the one they'd made in July. Gardner posed French on the porch with two black children; he would later include that print in his *Sketch Book*.

Three weeks later, French stopped by Gardner's studio in Washington to sit for a *carte de visite* and perhaps to pick up his copy of Gardner's Gettysburg photograph "honored by my presence on the porch," which he would later

hang in his home. While at Gardner's, he took the time to look at the war photographs mounted on the walls of the gallery. "The carnage at Gettysburg," French wrote in his diary, "gave a most realizing sense of the concomitants of Battle. Oh the blood that has been needlessly shed during this awful war of rebellion!" French gives us no insight into how Lincoln responded to the photographs if he saw them—certainly the president didn't think the war "needless"—but his reaction testifies to how Gardner's images could provoke the same need to account for "this awful war" that the president made central to his remarks.

Meade's headquarters was not the only stop that Gardner made on the day after the dedication ceremony. At least as he tells it in the commentary for "Home of a Rebel Sharpshooter," he also returned to Devil's Den. "The musket," he tells us in the *Sketch Book*, "rusted by many storms, still leaned against the rock, and the skeleton of the soldier lay undisturbed within the mouldering uniform, as did the cold form of the seat four months before. None of those who went up and down the fields to bury the fallen, had found him." There is a lot of cause for skepticism here. It is true that human remains were discovered on the battlefield well past November—tour guides regularly led their more adventurous clients to where they could see skeletons—though it is hard to imagine that one would have remained exposed in Devil's Den, which was not particularly isolated. And certainly no rifle of any value would have remained uncollected for months, rusted or not. In an earlier version of the caption, written on the back of a print of the image, Gardner had written more plainly, "I took a friend to see the place and there the bones lay in the clothes he had evidently never been burried [*sic*]."

In the end, though, we can neither confirm nor dismiss Gardner's account; we can only ask how it frames the image. He ends the caption, in fact, by raising just the fears addressed by the president's words and by the whole enterprise of memorialization that founded the cemetery and would make Gettysburg into the symbolic site for the entire Civil War. "'Missing,'" he writes, "was all that could have been known of him at home, and some mother may yet be patiently watching for the return of her boy, whose bones lie bleaching, unrecognized and alone, between the rocks at Gettysburg." Out of whatever props and compositional liberties Gardner may have constructed his narrative, he too sought to make the dead part of a national community. To be sure, this was a Confederate soldier, one of those who fought against the ideals of democracy and equality; he would not be buried in the national cemetery. Gardner, however, published his caption after the war, when the

dedication Lincoln had called for would include all who fought, no matter their race or earlier allegiance.

The Library of Congress holds a print of "Home of a Rebel Sharpshooter" mounted on paper, most likely from an album. On the back is clipped an obituary for Reverend B. Lacy Hoge of Richmond, Virginia, from the 1925 issue of *Confederate Veteran*. The article, however, entitled "The Tragedy of Devil's Den," tells less about him than about his eldest son, Andrew, who had enlisted at the age of sixteen in the Confederate army, only to die at Gettysburg. It seems he had been resting with several friends there after the battle, "with their backs against the wall of stone, when a stray bomb fell and burst in his lap." The explosion killed all except a cousin, who "in danger to his own life, remained and cut the blanket from his shoulder and placed it under his head, brought water from a near-by stream and give him drink, then placed the canteen between his elbow and body, received his dying message, and closed for him his eyes." "For years," the article continues, echoing Gardners' words, "a father and mother wept and yearned and hoped, all in vain, that their boy might come up among the 'missing' of those times."

The article tells how, when it was moved years later with many of the Confederate dead to the Hollywood Cemetery in Richmond, Andrew's body was identified by papers still on his body, along with a daguerreotype "of his beautiful cousin, Helen Hoge." Sometime after that, a relative came across an advertising circular for Francis Trevelyan Miller's 1912 ten-volume set, *The Photographic History of the Civil War*. There, in a reproduction of Gardner's "Sharpshooter" photograph, he recognized his cousin Andrew with his canteen and blanket; as the obituary states, the photograph can be found in volume 9. Frassanito argues with good evidence that Gardner's soldier could not have been young Andrew Hoge—his unit fought on a different part of the battlefield. That said, accounts like this one give just the roughest measure of the power of his images to imaginatively respond, like Lincoln's words, to the nation's need, more than half a century after the fact, to bury the dead.

GARDNER'S gallery received another notable visitor sometime in late 1863 or early 1864. The forty-two-year-old poet Walt Whitman had come south from his home in Brooklyn in December 1862 after seeing his younger brother George listed as a casualty in the battle of Fredericksburg. His brother's wound proved to be minor (George would serve until the end of the war, fighting in more than twenty major battles), so Whitman stopped in Washington for a

brief visit on his way home, only to find himself drawn into the maelstrom of war. The city, which he would describe as "a great whited sepulchre" filled with "well-drest, rotten, meagre, nimble and impotent" politicians "full always of their thrice-accursed party," would become his home for nearly a decade.

By the time he arrived in the capital, Whitman had already made something of a name for himself in literary circles, though nothing like the fame the "Good Gray Poet" would realize near the end of his life in 1892. His reputation stemmed from *Leaves of Grass*, a sprawling visionary celebration of the poet as the representative American, realized most fully in his long poem *Song of Myself*. His poetry, however, was controversial—too sensuous and too innovative (no rhyme and little apparent meter). And in itself it did not pay well, so in the early months of 1863, Whitman had to settle for living on the meager salary of a part-time job as a copyist for the army paymaster (the best patronage job he could find). With the extra time on his hands, he was soon spending hours each day visiting the sick and wounded that flooded the city's hospitals. At times Whitman helped doctors and nurses care for patients—he would identify himself poetically as "The Wound-Dresser"—but more often he visited as a "sustainer of spirit and body" laden with gifts and supplies for the soldiers, from fruit and sweets to books and magazines and writing materials—even money, his own or funds he raised with public appeals. He sat at bedsides writing letters, reading, or simply holding hands and comforting the suffering. Looking back after the war, he estimated that he saw between eighty thousand and a hundred thousand soldiers—a self-appointed task that drained him emotionally and physically. Nonetheless, he considered his years in Washington "the greatest privilege and satisfaction" of his life. Despite "all their feverish excitements and physical deprivations and lamentable sights," his experiences brought him in touch with "those subtlest, rarest, divinest" qualities of humanity "laid bare in its inmost recesses."

By the time Whitman stopped by Gardner's, he was already an accomplished studio sitter. He had posed for only about a dozen images—several of which were taken at Brady's in New York—but in each of them he shows a relaxed sense of command in front of the camera. Over his lifetime, he would sit for at least 130 photographs by dozens of different operators, enough for him to claim rightfully to being, along with Lincoln, among the most photographed men of his generation. "I have been photographed, photographed, photographed," he joked later in life, "until the cameras themselves are tired of me." "I've been taken and taken beyond count," he said another time, "taken from every side—even from my blind side."

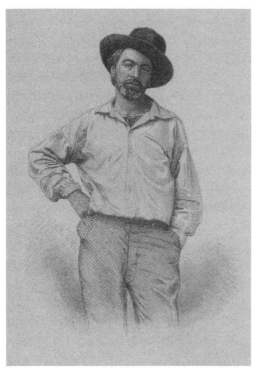

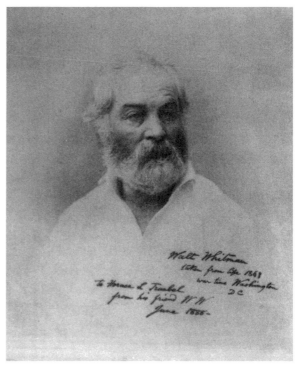

LEFT: *Engraving of Walt Whitman, by Samuel Hollyer, from the frontispiece of* Leaves of Grass, *1855*
BELOW: *Walt Whitman, by Alexander Gardner, circa 1863–64*

Despite all the sittings yet to come, by 1863 he had already posed for his most famous image. The first edition of *Leaves of Grass* had appeared anonymously in 1855; on one of the opening pages, where the author's name would normally appear, Whitman had substituted an engraving, taken from a photograph, of himself as a bearded young man standing with an open shirt, hand on hip, the other in his pocket, head tilted quizzically at the reader. It is a challenging, even arrogant pose of what would have been recognized as a common workingman, not a poet. For Whitman it served both as a picture of the author and as a fictional rendering of the "self" described in the poem: "Apart from the pulling and hauling stands what I am, ... / Looks with its sidecurved head curious what will come next, / Both in and out of the game, and watching and wondering at it."

Whitman showed up at Gardner's dressed much as he was in the image for the first edition of *Leaves*, though he wore a heavy coat over his shirt. He posed for one exposure wrapped in that coat, legs crossed, sitting pensively sideways in a chair. He wore only his open shirt for another one—a finely shaded portrait that depicts him looking into the distance to the right. Decades later, when his close friend and amanuensis, Horace Traubel, asked for the image, Whitman signed it "taken from life, 1863, war time, Washington D.C." and pronounced it "first rate—everybody at the time considered it capital." Even Whitman's close friend, the painter Thomas Eakins, "likes it—says it is the most powerful picture of me extant—always excepting his own, to be sure" (high praise from one of the great American painters of the century). Later Whitman would call it "the best picture of all." He then continued, "I remember well the afternoon that was taken. When a reporter saw it in the case by and bye he wrote that Walt Whitman had been photographed in his night-dress. The Gardner people were fiery mad over it—to me it seemed funny."

While it is hard to see what about the comment would have angered the Gardner studio, it is easy to understand why Whitman so admired the photograph. The poet in his "night-dress" revisits the "Walt Whitman" on the frontispiece of the original *Leaves of Grass* literally from a different angle, bringing us closer to the man in his open collar, his clear eyes facing out of a delicate cloud of hair that fades into a light background. The eyelids droop just a bit beneath his rising, even arched eyebrows—as if we have caught the poet in a visionary oxymoron of attentive reverie, "watching and wondering." A cropped version of the photograph gives a better sense of how Gardner worked with much the same visual vocabulary of selective focus and lighting as he did with his November 8 photograph of Lincoln (see plate 14).

With a narrow depth of field and diffuse lighting from his skylights above (and perhaps a mirror to Whitman's right), Gardner arranges the lights and darks to focus on the solemn clarity of the poet's eyes and on his mouth, wreathed with a beard rendered clearly enough to make out single hairs, while leaving much of the rest of his face, including even his eyebrows, slightly blurred. It is as if we see Whitman as a poet would, gathering together the luminous detail and suggestive atmosphere into a cohesive portrait.

Gardner seems to be working here with *Leaves of Grass* specifically in mind. While the image in the first edition showed the poet at the critical distance from the world he described, "in and out of the game," this one emphasizes a different aspect of his character in the poem. Here we certainly see the visionary, but by highlighting the beard and mouth as well as the eyes, Gardner emphasizes the bodily manliness of "Walt Whitman, an American, one of the roughs, a kosmos, / Disorderly, fleshy and sensual." This is a poet who considers "Washes and razor for foofoos...for me freckles and a bristling beard." His mouth is the organ of speaking and singing a song of himself in a voice "orotund, sweeping and final," that most represents his authority. "You there," he challenges the reader, "impotent, loose in the knees, open your scarfed chops till I blow grit within you." In his poem, there is no resisting the grit of poetry: "I am not to be denied...I compel...I have stores plenty and to spare...."

The extent to which Gardner's photograph seems so integrated with *Leaves of Grass* suggests that Whitman may have arrived with the intent of exploring a different side of his poetic self (though he never included this image in his book). By his own telling some twenty years later, however, he shared more of a collaborative relationship with Gardner, who, he said, "went strong for *Leaves of Grass*—believed in it, fought for it." Indeed, strength runs like a leitmotif through Whitman's recollections of the photographer. "Gardner was large, strong," he told Traubel, "a man with a big head full of ideas: a splendid neck: a man you would like to know, to meet." On another occasion, he used similar language, recalling him as "always a mighty fellow—also mightily my friend: he was always loving: I feel near to him—always—to this day: years, deaths, severances, don't seem to make much difference when you have once loved a man." Accompanying Whitman's affection was an abiding respect for his photography. Gardner was "a real artist—had the feel of his work—the inner feel, if I may say it so: he was not...only a workman...but he was also beyond his craft—saw farther than his camera—saw more: his pictures are an evidence of his endowment."

Whitman's enthusiasm for Gardner is palpable—unusually so, given that when he expressed it, he had almost certainly not seen him for fifteen years. His description matches those in the eulogies for Gardner at his death in 1882, which memorialized him as "a man of high impulses, warm affections, and strong feelings" who was "much esteemed for his...staunch friendship to those to whom he became attached." On Gardner's part, there is little direct evidence of his relationship with the poet. Ed Folsom's meticulously edited catalog of Whitman images attributes more than half a dozen possible photographs to Gardner, many of which show the poet in an open-collared shirt and one of which was a favorite of Whitman's mother: "She said to me often about it: 'When I look at this picture I feel like cheering thee with extra love.'" Gardner also sent a letter in 1866 to "My dear Whitman" telling of his receiving a letter from an "old friend," Robert Buchanan—whose father (of the same name) had edited the *Glasgow Sentinel* while Gardner owned it—asking for books by Whitman as well as photographs of him and Emerson. Gardner wrote to Whitman that he would "make a copy from each negative" of the poet, though he did not know where to get a good picture of Emerson. And he would send *Leaves of Grass* and *Drum Taps*, Whitman's collection of war poetry. Were there other works by Whitman, asked the photographer, that he should send on? Whitman fulfilled much of the request himself; Buchanan showed his thanks to both men by dedicating a 273-page poem about "the grandeur and charm of nature in the New World" to Whitman and Gardner.

There is also rich circumstantial evidence that the two men were kindred spirits. Whitman's recollections suggest that he found in his Scottish friend a figure who embodied the ideal American. "Large, strong," "a mighty fellow," a man with a "craft": Gardner is like the many inhabitants of the republic of labor that Whitman celebrated in his poetry and identified with throughout his life. He is also a man whose size and might reflect the visionary vigor of "a real artist"—an artist like, for instance, the Whitman on the title page of *Leaves of Grass* and in Gardner's photograph.

Whitman's embrace of democracy and free labor in his writing fit well with the Scotsman's socialist utopianism. Gardner's fighting for *Leaves of Grass* expressed his appreciation for the poetry, but Whitman may also have been referring to a more concrete form of support. One of the reasons Whitman lived so abstemiously during the war—moving about from one bare room to another—was that Treasury Secretary Chase, to whom Whitman brought several letters of introduction seeking a job (one from Emerson), refused to employ the author of "a very bad book." In 1865 Whitman was dismissed from

a full-time job at the Bureau of Indian Affairs at least in part because of *Leaves of Grass*. It is possible that Gardner, with his many friends, clients, and connections in the government, tried to intervene on Whitman's behalf.

There are signs that the two men shared an artistic kinship, as well. Besides apparently knowing Whitman's poetry, Gardner may also have read his correspondence about the war published in the *New York Weekly Graphic* and the *New York Times* (often reprinted, in the custom of the times, in local papers)— much of which Whitman would gather in 1876 into a slim memoir entitled *Memoranda During the War*. Even if he had simply spoken with Whitman, Gardner may well have heard about the poet's trip after visiting his brother from Fredericksburg to Washington, accompanying some of the wounded from the Union hospital at Lacy House near the battlefield. Whitman would have traveled by train to Aquia Creek, where he would have transferred to a boat that would have taken him up the Potomac. Later Whitman may have told him about visiting his brother while he was posted in Culpeper, Virginia. Gardner included photographs of all of these places in the *Sketch Book*, the perusal of which is like a re-creation of the landscape of his friend's experience.

The influence went both ways. Whitman saw more than his share of death and dying in the hospitals, but he saw little of the battlefield—though he listened to appalling stories of fighting from the soldiers he nursed. His best opportunity for encountering the dead would have come in Gardner's gallery of war images or in the gallery run by Gardner's publishers, Philp & Solomons, around the corner on Pennsylvania Avenue. Whatever their source, several of the war poems in *Drum Taps* resonate strongly with Gardner's photographs. One of his most haunting poems tells of a soldier spending a nightlong vigil with a son or comrade (Whitman keeps both possibilities in play) killed in battle; at dawn, "bathed by the rising sun," he buries him in "his rude-dug grave." In another, while wandering the woods in Virginia, he comes upon "at the foot of a tree the grave of a soldier; / Mortally wounded he and buried on the retreat." In both poems, the narrator contemplates death and burial much like the figure with the Rebel body and Union grave after Antietam (see plate 7); the tree in the latter poem, like the rising sun in the first, suggests nature's inexorable promise of life amid death, much like the leafless tree in another Antietam image (see plate 6).

Near the end of *Memoranda*, Whitman contemplates the scale of "the dead, the dead, the dead—*our* dead" scattered across the national landscape, in words that evoke the Gettysburg pictures Gardner included in the *Sketch Book*. One passage in particular recalls the caption to his controversial sharpshooter

image. "Some where they crawl'd to die, alone, in bushes, low gulleys, or on the sides of hills—(there, in secluded spots, their skeletons, bleach'd bones, tufts of hair, buttons, fragments of clothing, are occasionally found, yet)—our young men once so handsome and so joyous, taken from us." The land he imagines "saturated, perfumed with their impalpable ashes' exhalation," distilled in crops, flowers, "and every breath we draw."

It is impossible to know whether Gardner photographed Whitman before or after Lincoln's November 8 sitting with him, but it is clear that he worked with a similar photographic vocabulary in both sessions. He does for Whitman what the Gettysburg Lincoln does for the president. Both images render their subject as authoritatively embodying his office. Perhaps Gardner first developed his technique while working with the poet, perhaps while working with a sculptor. What matters is that the newly self-employed businessman emerged over this period as a newly confident photographer, willing to see "farther than his camera" in order to see better with it. No doubt his friendship with Whitman played a role in this developing artistry, though without any account by Gardner, it is difficult to know what that effect would have been. Perhaps it is reflected best in the enthusiasm with which Whitman remembered his friend Gardner and the admiration he expressed about his photography. Simply having someone like Whitman thinking of him as a fellow artist must surely have inspired Gardner to see what he had done to that point with new eyes and to approach, if not differently, then more expansively, more experimentally—and ultimately more creatively—the pictures he would make in the future.

A Portfolio of Photographs
by Alexander Gardner and His Operators

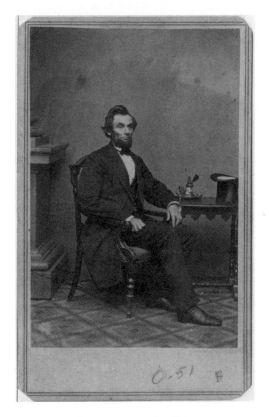

PLATE I: *Abraham Lincoln, February 24, 1861*

PLATE 2: *Alexander Gardner, Self–Portrait, circa 1863*

PLATE 3: *Alexander Gardner, Self-Portrait, circa 1864*

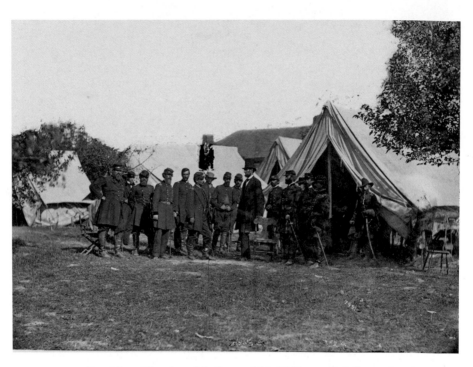

PLATE 4: *President Lincoln with General McClellan and Officers, October 1862*

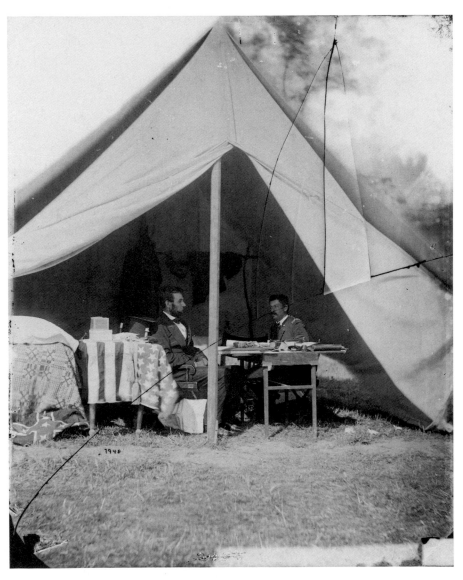

PLATE 5: *President Lincoln and General McClellan, October 1862*

PLATE 6: *A Lone Grave, Antietam Battlefield, September 1862*

PLATE 7: *"A Contrast: Federal Buried, Confederate Unburied,"*
Antietam Battlefield, September 1862

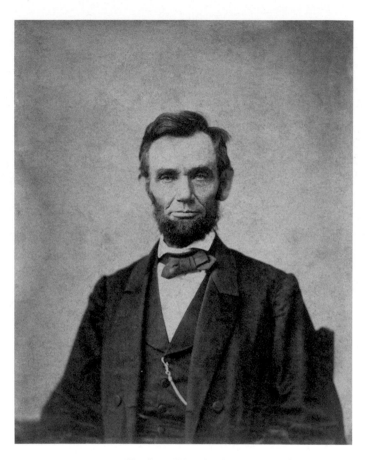

PLATE 8: *Abraham Lincoln, November 8, 1863*

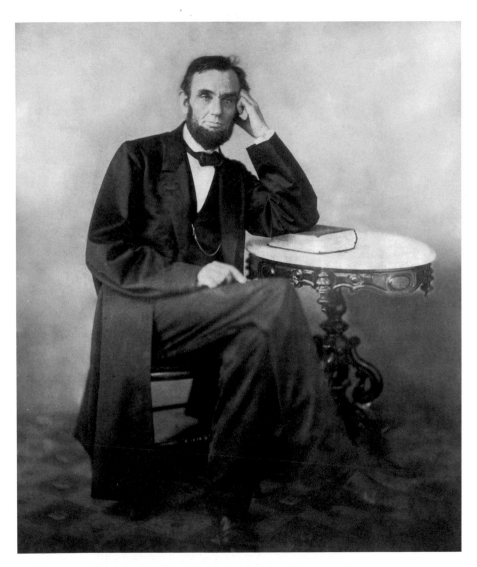

PLATE 9: *Abraham Lincoln, August 9, 1863*

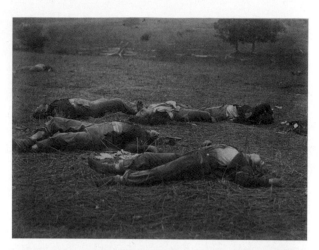

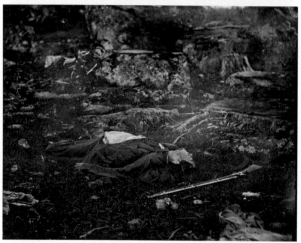

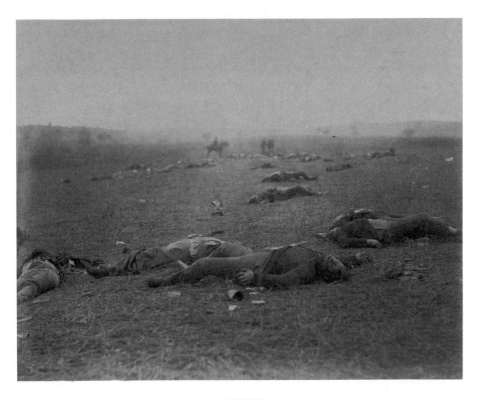

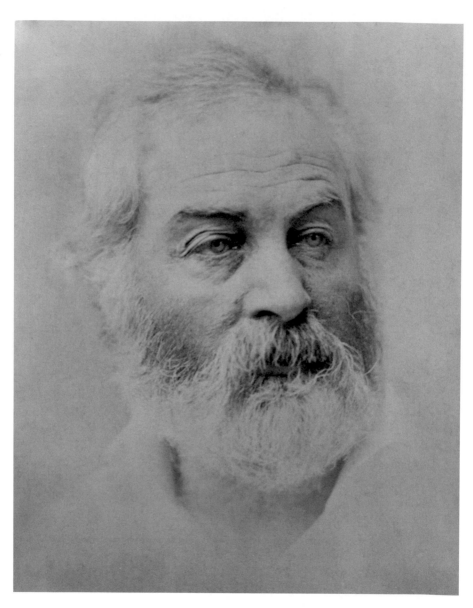

PLATE 14: *Walt Whitman (cropped), circa 1863–64*

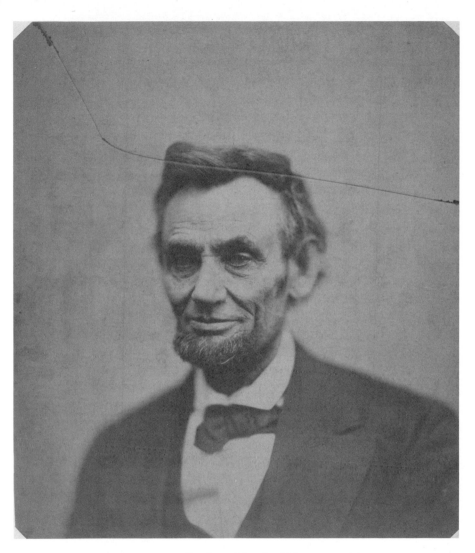

PLATE 15: *Abraham Lincoln, February 5, 1865*

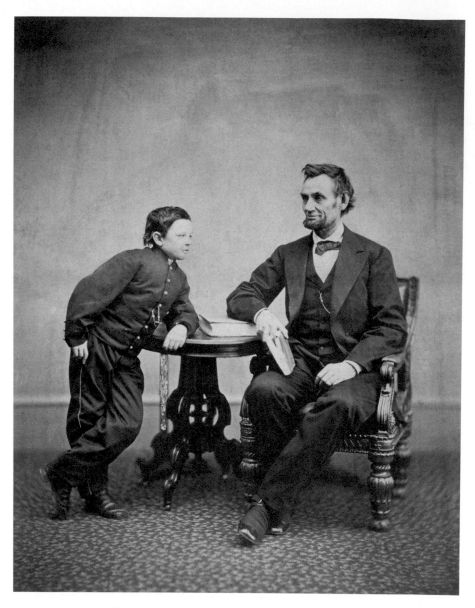

PLATE 16: *Abraham Lincoln and Thomas "Tad" Lincoln, February 5, 1865*

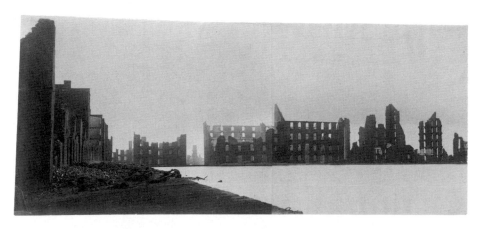

PLATE 17: *Ruins of Gallego Flour Mills, Richmond, April 1865*

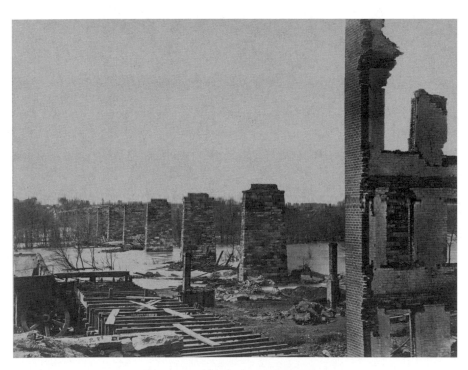

PLATE 18: *"Ruins of Richmond and Petersburg Railroad, Across the James,"*
Richmond, April 1865

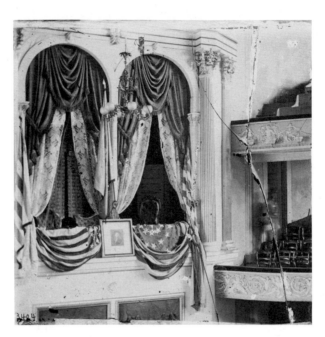

PLATE 19: *President's Box, Ford's Theater, April 1865*

CHAPTER 4

1864: Washington, D.C.

L INCOLN did not visit Gardner's studio again until February 5, 1865, nearly fifteen months after the Gettysburg Address. The longest break in their professional relationship was not the result of Lincoln's withdrawal from the visual record. He sat for Brady and his operators four times in the early months of 1864, visits that yielded some of the most popular and enduring images of a presidential Lincoln, including those used on the penny and the five-dollar bill, as well as the first-ever photo shoot inside the White House. Three of the sessions (including that in the White House) came at the request of the painter Francis Bicknell Carpenter, a friend of Brady's from New York who had managed through political connections to get himself invited to live and work in the White House for six months (with his studio in the State Dining Room) while he worked on a massive canvas featuring the president and his Cabinet discussing (contemplating, really—the painting is very static) the Emancipation Proclamation. Lincoln also posed for the Philadelphia photographers Wenderoth & Taylor and for a bust by William Swayne, who at the time worked for the Treasury Department. The round of sittings—none of them arranged by Lincoln—reflected a growing recognition of the historical importance of his presidency and the times everyone was living through, particularly in the lead-up to the 1864 election.

Gardner, meanwhile, had devoted much of 1864 to building his business both as portrait photographer and, as he advertised himself, "Photographer to the Army of the Potomac." While his days of traveling with the military were largely behind him, he continued to support Timothy O'Sullivan and at times other photographers, including his brother James, in the field. O'Sullivan alone furnished Gardner's catalog with several hundred images as he followed newly appointed Lieutenant General Ulysses Grant's Virginia campaign and siege of Petersburg. Gardner arranged to publish the photographs with Philp &

Solomons in Washington, and at some point contracted with E. & H. T. Anthony of New York—the firm he had used while managing Brady's gallery—to distribute them nationally. He made other efforts to expand his market. In June he spent a week in New York City exhibiting his war photographs to enthusiastic audiences with a special stereopticon slide projector, invented by the chemist John Fallon, that could throw images onto a screen that were up to twenty-five feet square. Gardner's local advertising emphasized the artistic quality of his prints and portraits, while Philp & Solomons advertised the war material out of their Metropolitan Gallery just around the corner on Pennsylvania Avenue.

Like a good businessman, Gardner also immersed himself in the civic and social life of Washington, building relationships with the local businessmen who called the capital their permanent home. While his publisher, Franklin Philp, hosted the likes of John Hay at his regular Sunday soirees, Gardner's networks were more deeply rooted in the doings of the city and more grounded in formal associations like the Washington chapter of Saint Andrew's Society, a men-only group celebrating all things Scottish with "mirth, music, and good fellowship" at regular meetings held at some of the more fashionable restaurants in town. Its members included James McGuire, a local patron of the arts, who with his brother owned one of Washington's finer furniture warehouses, located at Tenth and D streets near Gardner's gallery. Other members included Joseph Wilson, who managed a wholesale wine business on Pennsylvania Avenue a few blocks from Joseph Nairn's drugstore, as well as real estate and insurance agents, boilermakers, salesmen, and the superintendent of the United States Botanic Garden. It was through the society that Gardner likely met new colleagues like stonecutter-turned-photographer John Reekie and his fellow operator David Knox, as well as John Cameron, who served as one of Gardner's printers. Because of connections like these, the year 1864 was a resounding success for Gardner despite Lincoln's absence from his studio.

On that cold Sunday in February 1865 when the president and the photographer took up where they'd left off, they ended up producing their most distinctive lot of images. For three of the exposures, Gardner stuck with much the same approach he had used in 1863, picturing a seated Lincoln from the waist up, his longer hair still rumpled, a crooked tie, and the familiar dark suit and vest with watch chain. He also took one of the president with his son Tad at a table. In all of them, we see the familiar play of formal reserve and engagement with the camera, though this time in several images Lincoln's mouth and raised eyebrows hint strongly at an expressive openness, even a smile. Manner

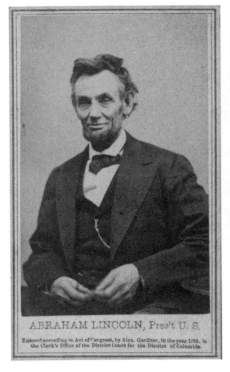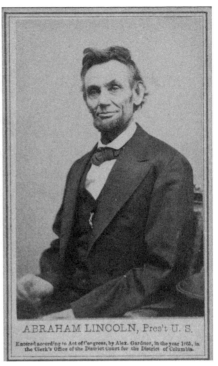

Abraham Lincoln, by Alexander Gardner, February 5, 1865

aside, what is most striking about all the photographs made that day is how thin, even haggard, the president looks. Compare these images to those in 1863 or even to Brady's in 1864, and his face shows clear signs of attrition, which Gardner highlights with his characteristically diffuse lighting from the sky lights above. We see the familiar lines and dry texture of Lincoln's skin, while the cheekbones and eyebrows are more prominent than ever before, and the flesh beneath his eyes bags loosely, belying the fact that he is still just one week from his fifty-sixth birthday.

This tension between the president's alert expression and his bodily weariness comes together in another photograph made that day, an imperial-size portrait popularly known as the "cracked-plate Lincoln" (see plate 15). The vivid fracture that cuts from the upper left of the picture through Lincoln's hairline occurred while the image was being developed; working quickly and carefully, Gardner was able to salvage just one print before the negative broke apart. It is clear why he made the effort to save it: the photograph is one of

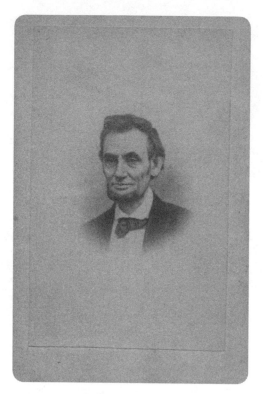

"Mr. Lincoln's Last Sitting," by Alexander Gardner,
published by Philp & Solomons, 1865

the most compelling images of the era, almost unprecedented by any of his previous work. As he did in the 1863 "Gettysburg Lincoln," Gardner narrows his depth of field, but here the effect is so tight and shallow that it throws much of the image out of focus. It brings into stark clarity the age lines around Lincoln's eyes, cheekbones, and mouth, as well as the hairs on his chin, while leaving not just his shoulders, but even his sideburns and ears in a soft blur. It imparts an uncanny sense of motion to the image. Lincoln's face looms toward us from some undefined space, moving through a plane of clarity before continuing on its journey beyond the picture's frame. More than in any of the other pictures, in this one Lincoln does seem to smile, which helps foster an aura of intimacy, but his eyes—one of which is recessed in shadow—gaze just past us, as if he sees something that we cannot see or is simply preoccupied. Mysteriously, provocatively, Lincoln is both "here," with us, and somewhere else.

For more than a century, it was thought that Lincoln's last session with Gardner had taken place two months later, on April 10. In a lot of ways, the mistake makes sense. The date follows the day Lee surrendered to Grant at Appomattox Court House, effectively ending the war, and comes five days before Lincoln was assassinated. Sandwiching the photographs between these two historic events makes Lincoln's enigmatic expression more legible. The weary smile seems to express the mixture of relief and sorrow appropriate to the man who in his second inaugural address suggested that the "terrible war" might, in fact, be the nation's debt due to God, by North and South, for "the wealth piled by the bond-man's two hundred and fifty years of unrequited toil." The ghostlike quality of the cracked-plate image also seems to uncannily anticipate Lincoln's imminent death. In the wake of the assassination, Gardner and his publisher saw some of the same possibilities in all the photographs from that day. Philp & Solomons rushed to publish them as pictures from "Mr. Lincoln's last sitting" in time for his funeral. One of the most popular of these was the cracked-plate portrait, though it was cropped and heavily retouched to remove age lines and the break, and framed as a ghostly vignette.

Today we prefer the original print, but it is difficult to shake off the April aura of Lincoln's Janus-like vision between the end of war and his future death. The National Portrait Gallery, which owns the print, of course uses the right date, and even highlights the break in the negative, but its entry in the online Catalog of Portraits frames the image as if caught on April's cusp of history. "Inadvertent, the crack nonetheless symbolizes the division of the Union that Lincoln dedicated himself to prevent. Looking forward, the line of fracture seems almost to presage the path of the bullet that John Wilkes Booth would fire on April 14." Perhaps the best-known and most eloquent modern reading of the photograph appeared in *Time* magazine in 2005 in a brief essay by then senator Barack Obama, who had mounted a copy of Gardner's cracked-plate photograph on the wall of his office, alongside images of Mohandas Gandhi and Martin Luther King Jr. Obama describes Lincoln's face as being "as finely lined as a pressed flower," balancing a "heartbreaking melancholy" with a smile that "alters tragedy into grace." But what most moves him are Lincoln's eyes. On one hand, he looks back in time, seeing "before him what the nation had so recently endured." On the other, "this rough-faced, aging man has cast his gaze toward eternity and yet still cherishes his memories—of an imperfect world and its fleeting, sometimes terrible beauty."

Both descriptions impart a mythic, almost mystical quality to the picture; Obama's beautiful language in particular represents Lincoln as an

oracle right out of a Greek tragedy, looking over history from a vantage outside of time. Such language indulges in the near deification of Lincoln that is now part of our history of him, but it also responds to the allusive quality of Gardner's image. Nothing about the photograph is presidential. There are no books or pens as props, no background, no ornate chair, no hint in his posture or expression that refers to the ideals and authority that associated him with the office. In this and the other images from that day, his thin neck barely fills his collar, as if the formality of his position is too big for him. Stripped of the signs of the presidency, Gardner's Lincoln here looms as an enigma endowed with the same uncanny mystery as the bellowing figure in O'Sullivan's "Harvest": just as we can only guess at what it tries to say, we can only wonder at what provoked what may or may not be Lincoln's smile.

Still, the Lincoln who sat for the photograph was very much immersed in his job. And in early February, while he certainly had good reasons, as he would put it a month later at his inauguration, for "high hope for the future" and the war's end, he knew all too well to venture "no prediction in regard to it." In his speeches and his statements both public and private, the man we look at saw more ahead of him than behind.

Harold Holzer discovered the correct date of Lincoln's sitting for Gardner in the diary of the painter Matthew Wilson, an English-born society portraitist whom Navy Secretary Gideon Welles had commissioned to do a portrait of Lincoln. Gardner was enlisted to make some Lincoln images for Wilson's reference. Because the painter specialized in life-size oval portraits of the head and upper chest of his subject, the format of a standard photographic portrait would give him just what he needed.

Wilson may have used all five images Gardner made that day to guide him, including the cracked-plate portrait, but even the quickest glance at his painting shows that he relied most on the photographs of Lincoln seated in his chair. Once he had his prints, he went quickly to work, using the photographs as models and adding touches from at least one sitting with the president. By February 22, the portrait hung in Lincoln's White House office. With good humor, Lincoln pronounced it "horridly like" the original, though Welles considered it successful enough to later order a copy for the Navy Department. After the president's death, the portrait also caught the eye of the editor and political operator John Forney and Lincoln's longtime friend Joshua Speed, both of whom commissioned copies. The image achieved its greatest renown when Louis Prang and Company reproduced it as a chromolithograph for mass distribution after Lincoln's death.

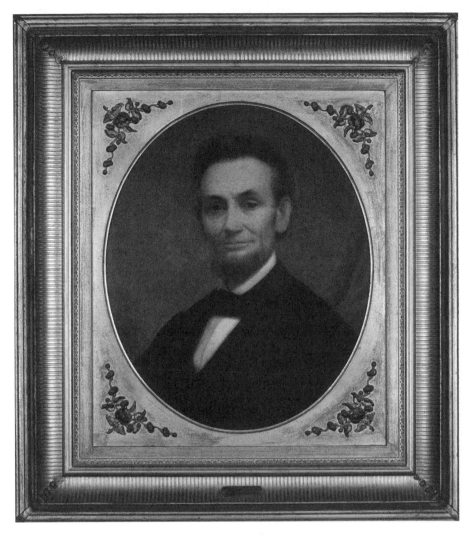

Abraham Lincoln, *by Matthew Wilson, 1865*

Comparing Wilson's painting to Gardner's photographs brings to the forefront many of the same differences in medium and artistry as those pertaining to Sarah Ames's marble bust. Wilson's portrait captures the almost smiling quality of Lincoln's expression that runs through all of that day's pictures, but the lines of fatigue in Gardner's images are replaced with a healthy, even rosy glow in the president's cheeks, while the angles and shadows of the cheekbones and deep eyes are softened. The most suggestive difference, however, comes from the framing: while Wilson vignettes Lincoln's head and

shoulders, Gardner hardly crops his negative, showing the president from the waist up, including his hands. The image that most resembles Wilson's painting exposes Lincoln's large, deeply veined left hand at the bottom of the image, suggesting the strength and power still present in his chest and shoulders. In the other two, Lincoln holds his reading spectacles; in one of them he also holds a pencil (see page 141).

Both of these standard props suggest a statesmanlike life of the mind, but unlike those in Gardner's August 1863 photographs, these hands are blurred—clearly Lincoln fiddled with them throughout the exposure. None of this was a problem for Wilson, obviously, nor apparently for Gardner, who included them as is in the *cartes de visite* he published for the funeral. Perhaps there had been no time to find a good retouching artist—in his encyclopedic *Lincoln's Photographs*, Lloyd Ostendorf includes two variants in which the hands and objects are retouched to show Lincoln holding a pocket knife. It is possible that Gardner later produced these retouched versions himself, but given that he prided himself as an artist of what he called "pure photographs...pictures which do not depend for their effect upon artistic skill in retouching," they are likely the work of another studio. In any case, the accident of motion in Gardner's original exposures speaks of a nervous energy, a distraction, that qualifies the sentimental openness that made Wilson's portrait so successful a keepsake after Lincoln's death. Lincoln may smile in relief or reflection, but he also has things on his mind. Perhaps the blur of energy betrays that the latent smile in all the images, including the cracked-plate portrait, expresses an impatience—a pursed-lip tolerance for one more portrait before he can return to his duties. His attention may be on the next day, not eternity.

Lincoln's day-to-day schedule was not as hectic as it had been four years earlier, when he arrived in Washington as first-time president-elect. From our perspective 150 years later, it's too easy to see the crises as almost resolved by 1865, but to those in the middle of events, things felt far from settled. Even all the victories and accomplishments of the past year had brought Lincoln their own measure of strife and tension. A month after his sitting with Gardner, on the eve of his inauguration, Mary Lincoln had commented, "Poor Mr. Lincoln is looking so broken-hearted, so completely worn out, I fear he will not get through the next four years."

A year earlier, in January 1864, there seemed little prospect for such weariness. The Tycoon, indeed all of Washington, was in fine whack. The fall 1863 midterm elections had affirmed widespread support for the administration's

policies on civil rights, emancipation, and enrolling blacks in the military, while Lincoln's personal popularity grew increasingly widespread after the dedication at Gettysburg. Washington's mood was also helped by the late-November 1863 rout of Confederate forces outside of Chattanooga, Tennessee, which had given rise to more talk in the press and Congress about reconstruction. That winter, the president's receptions on Tuesdays, the First Lady's matinees on Saturday afternoons, and the more exclusive soirees at the homes of Secretary of State Seward and Secretary of the Treasury Chase were all especially brilliant, reminding some observers of life before the war. Above the festivities rose the newly finished Capitol dome, topped with Thomas Crawford's nineteen-foot bronze statue of Freedom.

In late February 1864, Lincoln promoted Ulysses Grant, the unassuming cigar-smoking hero of Vicksburg and Chattanooga, to lieutenant general and commander of all military forces—a rank previously held only by George Washington himself. When Grant left Washington a few days later to join the Army of the Potomac, he left behind a public buoyed by his no-nonsense confidence. His West Point pedigree notwithstanding, like the president, he seemed closer in temperament and carriage to the common soldiers of a citizen army than most generals, and in particular McClellan, who had last held such supreme authority (though not the rank). Certainly the comparison was in the back of Lincoln's mind when later he wrote Grant, "The particulars of your plans I neither know, or seek to know. You are vigilant and self-reliant; and pleased with this I wish not to obtrude any constraints or restraints upon you." The president was at last free to leave fighting to his general.

By early May, the only resemblance between Grant and McClellan was height. Until then, the armies of the Potomac and Northern Virginia had met in set-piece battles, after which the opponents would disengage and regroup, sometimes for months at a time. Grant would have none of that. It was Lee who attacked the day after Union forces crossed the Rapidan River on May 4, but it was Grant who remained on the offensive. For three days, the two armies traded assaults and counterattacks just outside of Chancellorsville in what came to be known as the Battle of the Wilderness, named for the scrub-pine forest and overgrown farmland that hindered troop movements. When the battle ended indecisively with heavy casualties, rather than backing off, Grant turned south, hoping to outflank the Confederates. By the next day, the armies were locked in another major battle, at Spotsylvania Court House, which would last until rains intervened nearly a week later. So it continued for more than a month, as Grant carried on his campaign with flanking maneuvers

and brutal clashes that kept the two armies in constant conflict. Lee responded at times brilliantly and always quickly, but by June the Army of the Potomac had pinned down the Confederates in a siege of Petersburg, Virginia, the railroad center for Richmond just south of the capital.

Throughout the campaign, Lincoln remained confident in his general. "The great thing about Grant," he told a visitor, "is his perfect coolness and persistency of purpose...he is not easily excited...and he has the grit of a bulldog! Once let him get his 'teeth' in, and nothing can shake him off." When in the midst of the Battle of Spotsylvania Court House, Grant cabled the War Department that he proposed "to fight it out on this line if it takes all summer," Lincoln was pleased enough to quote the phrase in a speech a month later. Surely Richmond would soon fall to "the dogged pertinacity" of "Unconditional Surrender" Grant.

The excitement, however, turned to somber dismay as the human cost of the campaign became evident. Despite the War Department's attempts to control the news by denying newspaper correspondents access to the telegraph, it could not suppress the reports of dead, wounded, and missing that began to fill newspapers throughout the North. Nor could it stanch the flow of wounded that soon overwhelmed the hospitals in Washington. Noah Brooks found it "inexpressibly sad to see so much pain and waste of life" as each night "boatloads of wounded soldiers arrive at the Washington wharves" in the midst of a beautiful spring. Crowds gathered searching for sons, husbands, and fathers amid more than 10,000 wounded who arrived during the first two weeks of Grant's campaign. Casualty estimates for the North vary widely for the six weeks of the terrible offensive—historian James McPherson sets them at 65,000—but there is little disagreement over the effect of the losses on the North, Washington in particular.

As Grant's campaign stalled and losses mounted, Lincoln took to pacing the White House in the middle of the night—sometimes in his office, other times in a passageway, where painter-in-residence Carpenter encountered him one night "clad in a long morning wrapper, pacing back and forth...his hands behind him, great black rings under his eyes, his head bent forward upon his breast,—altogether such a picture of the effects of sorrow, care, and anxiety." On passing a line of ambulances filled with wounded, Lincoln turned to a friend: "Look yonder at those poor fellows. I cannot bear it. This suffering, this loss of life is dreadful." Mary Lincoln—a regular visitor to the wounded—was particularly appalled. Grant, she pronounced, "is a butcher and is not fit to be at the head of an army." Her opinion of Grant was not widely shared around

the White House, but everyone labored under a miasma of unease. Doris Kearns Goodwin describes how members of the Cabinet suffered from worry about family members fighting at the front. Gideon Welles, whose eighteen-year-old son was with Grant, admitted privately to an "intense anxiety" so "oppressive" it "almost unfits the mind for mental activity." Even White House secretary John Nicolay, with no loved one at the front, found himself "nervous and anxious" during the weeks of spring.

Within the government, the tension reached its peak in July, when ten thousand Confederate soldiers led by Jubal Early crossed into Maryland and threatened Washington's heavily engineered but meagerly manned defenses at Fort Stevens, north of the city. With virtually all the troops outside Petersburg, the capital reacted with an edge of panic. The Treasury Department prepared to transfer all the money in its vaults to a tugboat; Secretary of War Stanton had his personal money removed from a safe at the War Department and hidden under his mattress. He also ordered a carriage to take Lincoln and his family from their summer residence at the Soldier's Home in northern Washington, while arrangements were also made for a boat on the Potomac to be waiting if the president needed to escape. Improvising in a hurry, Stanton organized a force of home militia, government clerks newly armed with muskets, along with "all convalescents capable of defending the forts and rifle-pits," and deployed them to Fort Stevens. By the time Early's weary riders were ready to attack, reinforcements arrived from the Army of the Potomac; after some spirited skirmishing, he withdrew and, much to Lincoln's disgust, returned unscathed across the Potomac.

The fighting outside Washington was just one of a number of affronts inflicted by Early to the safety and pride of the North that summer of 1864. As he moved toward Washington, he extracted ransoms from several towns, including $200,000 from Frederick, Maryland; one contingent of his force burned Chambersburg, Pennsylvania, when it could not come up with its ransom. On the heels of Early's raids came a costly blunder outside Petersburg, where Union engineers had tunneled under Confederate trenches and planted a mine of eight thousand pounds of gunpowder. When it exploded just before dawn on July 30, Union forces rushed into the breach, only to seek shelter in the newly formed crater rather than bypassing it and pressing into the Confederate lines. The mistake turned into disaster as the crater became a killing field from which the troops could not escape. Neither of these conflicts materially altered the war, but they had a large impact on a public that had grown weary, even impatient with the fighting. Nor did it help when in the

middle of the month Lincoln issued a call for five hundred thousand more volunteers; if quotas were not filled by September, officials were to institute a draft. The call to arms did not provoke the kind of rioting that had taken place in New York a year earlier, but nonetheless it increased public unease.

Much of this unrest was fanned by the Democratic Party, eager to replace the tyrant Lincoln with its own president—most likely McClellan. Divided between those who wanted peace immediately and those who supported war to preserve the Union, Democrats found their rallying point when a confidential memo by Lincoln was leaked to press. In it he outlined his terms for peace with the Confederates: he would meet "any proposition which embraces the restoration of peace, the integrity of the whole Union, and the abandonment of slavery" with "liberal terms on other substantial and collateral points."

Democrats seized on the abolition requirement, which, of course, the South would never accept, as a sign that Lincoln was extending the war for his own political reasons. They were in some ways right; as Lincoln wrote later, even a temporary "armistice—a cessation of hostilities—is the end of the struggle, and the insurgents would be in peaceable possession of all that has been struggled for." In the midst of a particularly vicious political campaign and amid military embarrassments, the memo played powerfully with the press. The country was, according to one of Lincoln's political advisers, "wild for Peace," and willing to settle for an armistice that would uphold emancipation in the North and concede to the South slavery and secession. On August 22, Henry Raymond of the *New York Times* wrote the president that his network of political correspondents, including Lincoln's "staunchest friends," reported, "The tide is setting strongly against us." It seems impossible, he wrote, that Lincoln would win the election.

If anything, in the face of travail, Lincoln grew all the more adamant about fighting the war until the end of slavery was assured. To Frederick Douglass, whom he met in the White House on August 19, Lincoln emphasized his moral and political commitment to emancipation. That evening he spoke more bluntly and passionately to summer visitors at the Soldier's Home. "There have been men who have proposed to me to return to slavery the black warriors of Port Hudson" in order to conciliate the South and end the war. "I should be damned in time & in eternity for so doing. The world shall know that I will keep my faith to friends & enemies, come what will." On the day Raymond sent his letter, Lincoln told an Ohio regiment returning home after its enlistment that the nation was at war "in order that each of you may have through this free government which we have enjoyed, an open field and a fair chance for

your industry, enterprise and intelligence; that you may all have equal privileges in the race of life, with all its desirable human limitations." They had fought, in short, for equality for all.

The next day, Lincoln wrote a memo voicing what seemed at that moment to be the bitter truth about what lay ahead. "This morning, as for some days past, it seems exceedingly probable that this Administration will not be re-elected. Then it will be my duty to so co-operate with the President elect, as to save the Union between the election and the inauguration; as he will have secured his election on such ground that he can not possibly save it afterwards." The memo blends a palpable sense of defeat with determination. Once the Democratic candidate was elected—Lincoln assumed it would be McClellan—his own administration would have less than five months "between the election and the inauguration" to save the Union and end slavery before the next administration would settle for an honorable peace that would concede the issue to a new Confederacy. With a curious sense of ritual, he asked his Cabinet to pledge its faith in him by signing the memo sight unseen. Weeks later, he revealed its contents, explaining that his plan had been to enlist McClellan to recruit the manpower to force a conclusion to the war. (Seward quipped that the master of the slows would have agreed, "Yes, Yes" and then done nothing.)

From this nadir things turned slowly and then emphatically for the better. The Democrats did nominate McClellan, but the convention split and left him saddled as a War Democrat with a peace platform. At least as helpful were two military victories far away from the trenches outside Petersburg. In early August, Admiral David Farragut led his fleet into Mobile Bay past Confederate forts and tethered mines ("torpedoes") with his famous order "Damn the torpedoes," thus capturing the last major port on the Gulf of Mexico. A more dramatic victory came just days after the Democratic convention, when Union forces led by William Tecumseh Sherman captured Atlanta, the heart of the Confederacy. Buoyed by disunited opponents and military victory, Lincoln's reelection was an electoral swamping, though McClellan did receive 45 percent of the popular vote.

There was, however, no rest with victory. After following the returns at the War Department telegraph office until two a.m. on election night, Lincoln was soon caught up in the whirl of presidential business. Despite his efforts to shorten the lines of office seekers who had plagued his first months in the White House, he found himself so harassed that it felt as if each visitor "darted at him, and with thumb and finger carried off a portion of his vitality." He

also worked at restructuring his Cabinet, while also consulting with Grant and his staff on a hasty visit to Washington. His annual message to Congress, to the lame-duck session on December 6, included a plea that the House of Representatives reconsider a resolution to pass on to the states the Thirteenth Amendment ending slavery in the United States altogether.

The Senate had already done so the previous April, but Democrats had blocked the amendment from receiving the required two-thirds majority in the House. In the fall election, Republicans had won enough seats to impose their will in the next Congress, but Lincoln was eager to send the amendment to the states for ratification, thereby removing for good the legal and practical difficulties of the Emancipation Proclamation. Passage would also settle any questions of executive overreaching by taking the question of slavery off the negotiating table and putting it in the hands of the states. "May we not agree," he asked Congress, that when it comes to such an important piece of legislation, "the sooner the better?" During the next few weeks, political allies, lobbyists, newspaper editors, and even the president immersed themselves in the vital, often personal, and perhaps even shady politics of vote getting, but even then nothing was assured until the final ballot on the last day of January 1865 sent the Thirteenth Amendment to the states by two votes. When officially told the news, Lincoln was deeply pleased; as one observer understood, the votes pointed the way to "the complete consummation of his own work, the emancipation proclamation."

The next day, Lincoln followed up in a brief prepared speech to White House serenaders. Although his proclamation had begun the work imperfectly, the amendment promised to root out "the original disturbing cause" of the war. There was, of course, work ahead, he warned: three-quarters of the states had to ratify the amendment before it would go into effect, a process that was already well begun by his home state of Illinois, voting for the amendment that very day. Still, he concluded, congratulations were due to "the country and the whole world upon this great moral victory."

Amid the celebration, Lincoln had already immersed himself in another initiative that had threatened to derail the amendment. On the morning of the vote, word had reached Congress that several representatives from the Confederate government had crossed Union lines outside Richmond and were headed for Washington to discuss the possibility of peace. If it were true, the few Democrats who had broken ranks to join the majority would drop their support for the amendment for fear that federal legislation abolishing slavery would prove an insurmountable obstacle in negotiations. When queried

point-blank about whether negotiators were in Washington, Lincoln replied strictly to the letter: "So far as I know there are no peace commissioners in the city, or likely to be in it." The Congressmen had their answer, and went ahead and voted in support.

Lincoln could be certain there were no peace commissioners in Washington because on that day he had dispatched Secretary of State William Seward to meet them in Hampton Roads, Virginia. The meeting was the outcome of weeks of negotiation between Washington and Richmond, made all the more delicate by Lincoln's refusal to recognize the Confederate government. When in December Jefferson Davis had forwarded a letter signifying his willingness to entertain a cease-fire and engage in talks leading to peace between the "two countries," Lincoln addressed his response to his emissary, not Davis. Tell him, wrote the President, that he would be willing "to receive any agent" representing those "resisting the national authority...with the view to securing peace to the people of our one common country." Lincoln was not interested in negotiating over Confederate independence, which he also made clear in his instructions to Seward: no peace without a single national government and the end of slavery, no cease-fire without "the disbanding of all forces hostile to the government."

The House's authorization of the Thirteenth Amendment strengthened Lincoln's hand. On February 1, when Henry Ward Beecher visited the White House, the president told him that he had no faith in anything to do with the peace initiative but was happy to let it bubble along to see what could happen. The abolitionist Beecher was reassured by his statement but was also struck by how disheveled Lincoln looked in his slippers and open vest, his hair "like an abandoned stubble-field. He looked wearied, and when he sat down in a chair, looked as though every limb wanted to drop off his body." Neither his weariness nor his professed lack of interest prevented the turn of events the next morning. General Grant, who had spoken with the commissioners, telegraphed urging the president to meet with them at least out of respect for their honorable intentions. Two hours later, Lincoln boarded a train to Annapolis, Maryland, where he met a steamer that took him through the ice of Chesapeake Bay to Seward and the commissioners.

The conference the next morning unfolded as a mixture of reminiscence, jokes, stories, and hard bargaining. When Lincoln got down to business, though, he remained adamant. No peace without "those resisting the laws of the Union" laying down their arms. No cease-fire, no treaties, no agreements of any kind could be made, because they would recognize the legitimacy of the rebellion. The Thirteenth Amendment would soon be the law of the land—no

discussion could change that. When one of the negotiators suggested that even Charles I of England had met with Parliamentarian rebels during the English Civil War, Lincoln deflected the analogy with a joke. He did not "profess to be posted in history. All I distinctly recollect about the case of Charles I, is, that he lost his head in the end." Nevertheless, on almost all other issues— possible compensation to owners for lost slaves, reseating state representatives in Congress, pardons—Lincoln was open to exercising his authority "with the utmost liberality."

As a peace conference, the meeting was a failure, but for Lincoln it was a small success in his ongoing effort to manage the end of the war. From our perspective today, it seems little more than a footnote to the inevitable end of the war—after all, Lee would surrender to Grant in less than ten weeks. Lincoln saw things differently. Soon afterward he followed up his suggestion at the peace conference by proposing to the Cabinet that the government compensate Southern slaveholders for freeing their slaves. The Cabinet flatly refused to endorse the plan. Lincoln's disappointment can be gauged by his argument for it: payments would amount to no more expense than waging two hundred days of war—perhaps a conservatively realistic estimate of how long he thought the war would continue. Certainly the expense was worth that.

Gardner took his photographs of Lincoln the day after he returned from Hampton Roads and hours before he would make his proposal to the Cabinet. The president we see is wearied by all that had been accomplished but confident in his political strength and prepared for at least six more months of fighting. After that there would be more ahead. A month later, in the famous final paragraph of his second inaugural address, Lincoln would urge his listeners to "strive on to finish the work we are in; to bind up the nation's wounds; to care for him who shall have borne the battle, and for his widow, and his orphan—to do all which may achieve and cherish a just, and a lasting peace, among ourselves, and with all nations."

LINCOLN may have been caught up in the crises of this time, but Gardner's portrait is so powerful because it lifts Lincoln's face out of history. In his 2005 *Time* essay, Barack Obama asks, with a heavy dose of political calculation as he tries to connect his aspirations with those of his model, "What is it about this man that can move us so profoundly?" Pay attention to how he answers the question, however, and it emerges that what he really asks is, What is it about

Gardner's *photograph* that can move us so? To be sure, he is moved by Lincoln's rise from poverty and "his capacity to overcome personal loss and remain determined in the face of repeated defeat." In the end, though, it is the portrait on his office wall, not the man in history, that "soothes" him; it is the portrait that "asks me questions." And it is what he sees in the photograph, "the painful self-awareness of those failings etched in every crease of his face and reflected in those haunted eyes," that so compels him.

More than any of his other photographs of Lincoln, Gardner's cracked-plate portrait makes looking at Lincoln as much its subject as it does Lincoln himself. This aesthetic self-consciousness may well have been provoked by the deepening understanding of photography's capacity for creating meaning in the picture, discovered on the Gettysburg battlefield. It may also have arisen after a year and a half of learning to trust his own eye in his own studio. It may have been provoked at the moment by exposing yet another negative of a man who had sat for him more times than he had for anyone else, and more often than anyone else Gardner photographed, and who happened at that moment to be the most widely recognized, most widely reviled, and most widely admired figure in the country. But there is another reason Gardner may have looked anew at a familiar subject: his friendship with Walt Whitman, who during his time in Washington had made something of an art of watching Lincoln.

When Whitman moved to Washington, he had glimpsed Lincoln only once before amid the crowds in New York City where the president-elect had stopped on his way to Washington. Once in the capital, however, the poet soon found himself both a supporter and an admirer of the president. He especially appreciated the quality of Lincoln's leadership and his ability to steer clear of the petty infighting of party politics. Alongside this, however, in his letters, journals, and published works from the period, there runs a curiously intense vein of feelings about Lincoln that seem like those of an obsessed fan. "I see the President almost every day" he wrote in the midst of the stifling heat of August of 1863 about Lincoln's riding past Whitman's boarding room on his way to and from the Soldier's Home. "We have got so that we always exchange bows, and very cordial ones." Oddly, this was as close as Whitman ever came to Lincoln. The two men never spoke to each other; instead the poet simply watched the president—on horseback or in a carriage, speaking with Seward on the street, at the inauguration and the ball afterward, at a White House levee. In sum, Whitman's encounters with the president were no more familiar or frequent than those of the many residents of Washington who met Lincoln regularly walking and riding the streets of the city.

It could be that the author of *Leaves of Grass* was content with "watching and wondering" at the game without entering it. He certainly made the president the subject of study. Lincoln, he wrote to friends, "has a face like a hoosier Michael Angelo, so awful ugly it becomes beautiful, with its strange mouth, its deep cut, criss-cross lines, and its doughnut complexion." A number of times he recorded his fascination with the president's "dark brown face, with the deep cut lines" that both expressed the burdens of office—"vast responsibilities, intricate questions, and demands of life and death"—and masked something hidden, a "latent sadness," a "tinge of weird melancholy," or more expansively "goodness, tenderness, sadness, and canny shrewdness." Years later he speculated further about how what he called "the radical element in Lincoln"—"sadness bordering on melancholy, touched by a philosophy, and that philosophy touched again by a humor"—made Lincoln a better president. But his interest reached deeper than aesthetics and politics. After watching Lincoln in his barouche after the inauguration, Whitman admitted, "I never see that man without feeling that he is one to become personally attach'd to." In his diary after watching Lincoln speak with a friend at an 1863 White House reception, Whitman wrote, "His face & manner...are inexpressibly sweet—one hand on his friend's shoulder, the other holds his hand. I love the President personally."

The bittersweet combination of Whitman's envy (of the friend) and longing (for the president) here is the plaintive sigh of the unrequited—a common enough experience for a man who expressed unmistakably erotic longing for other men at a time when acting on it was outside the lines of ordinary expression. And there is no doubt that at least some of Whitman's attachment to Lincoln grew out of his sexuality. But the poet in Whitman built on his personal feelings to come to a broader understanding of the charisma of Lincoln's "ugly," "strange," and "weird" face. In his *Memoranda*, Whitman tells of encountering Lincoln early in the summer of 1863 out with the First Lady, "on a pleasure ride through the city." "They pass'd me once very close," he wrote, "and I saw the President in the face fully, as they were moving slow, and his look, though abstracted, happen'd to be directed steadily in my eye. He bow'd and smiled, but far beneath his smile I noticed well the expression I have alluded to. None of the artists or pictures have caught the deep, though subtle and indirect expression of this man's face. There is something else there."

In his introduction to *Memoranda*, the literary critic Peter Coviello compares this encounter with those of Whitman's with men about whom he expressed a recognizably "ardent love," and concluded that they all "veritably

shimmer with erotic portent." The exchange of looks with Lincoln certainly recalls a number of Whitman's *Calamus* poems—the openly homoerotic group he added to the 1860 edition of *Leaves of Grass*. "Are you the new person drawn toward me," he writes in one of them, "and asking something significant from me?" Another opens with his calling out, "passing stranger! you do not know how longingly I look upon you." This is the poetry of "something else," where what is "subtle or indirect," or latent in a stranger's face can trigger a dream of sexual liaison or the possibility of lifelong intimacy. But it is also a poetry of the sudden look, the glimpse, the glance taking in a face on the fly—the kind of visual encounter that had become commonplace in crowds of strangers that filled cities like New York and wartime Washington. As erotically charged as Whitman's exchange of glances with Lincoln may have been, they remained just glances, their delicious intimation of secret sharing kept inviolate by the distance of the encounter. In those moments, Whitman expresses the excitement that would come to be associated with the photographic: the flash of apparent intimacy was over the instant it happened, preserved by Whitman's imagination like a snapshot for later scrutiny.

It is impossible to say how much of his thoughts and feelings about the president Whitman may have shared with the "mighty" Gardner. And no matter what he expressed, it is a losing game to look in the cracked-plate portrait for any kind of strict analogy to Whitman's imaginative and wide-ranging ideas about the subject. Still, the picture gives evidence of a Whitmanesque vision. The lighting enhances the "deep cut lines" the poet noted, while the selective focus highlights the "strange mouth" and the manly beard of the "hoosier Michael Angelo." Gardner tightens the depth-of-field more than in any of his other photographs, save perhaps that of Whitman—the deep blur of much of the images lends it the glimpselike quality of a momentary encounter. But what most recalls the poet's eye is the enigmatic fragility of Lincoln's face, the bare trace of a smile, and the fixed stare past us. There is, as Whitman understood, "something else" in Lincoln's expression, perhaps a surprising intimacy in his full lips and the individual hairs of his beard, or perhaps in a secret knowledge of "sadness bordering on melancholy, touched by a philosophy, and that philosophy touched again by a humor."

Whitman never recognized his Lincoln in Gardner's Lincoln. It could be that he never saw the unretouched version of the cracked-plate portrait. It could also be that no artist could catch the abstracted, "subtle and indirect" look of Lincoln's face—its secrets belonged to Whitman. That, however, did not stop him from complaining about artists' failures. In his memoir of his war

years in Washington, *Memoranda During the War*, he declared emphatically, there was "No good Portrait of Abraham Lincoln.... The current portraits are all failures—most of them caricatures." Nearly fifteen years later, he returned to the issue with his friend Traubel. "But there never has been a portrait," he insisted, "never a real portrait" of Lincoln. Even photographs missed the "wonderful reserve, restraint, of expression—fine nobility staring at you out of all that ruggedness." Traubel's record goes on. "He did not know why his friend Alexander Gardner 'did not try his hands at it,' for G. was 'very successful: I have often thought him the best.'"

AT first glance, the final photograph Gardner took that day in February 1865 of Lincoln and his son Tad seems as far away as it could be from enigma and mystery (see plate 16). It was his most calculated. In it, Lincoln sits erect in his chair, the formality of his alert posture softened a bit by his disheveled hair. His pose recalls those in the August 1863 sittings, though he has put away his reading spectacles, and his right hand holds his place in a book, spine down on his thigh, while his elbow rests on another volume on the table; no newspapers in sight. Nonetheless, much the same narrative holds here: either Lincoln's reading has been interrupted, or he is about to open his book either to read to his son Tad or himself. Tad leans across the table between them—to listen to his father? or has he interrupted him? It is difficult to tell because of the image's posed quality. Father and son turn toward each other, but their lines of sight miss—Lincoln fixes his gaze above his son, while Tad stares at a point directly past his father's tie. The scene looks contrived to modern eyes, but like the other photographs from that session, this one circulated widely as the last studio photograph of the president—unretouched, with the plain background visible behind father and son.

Gardner's was only the second most popular photograph of Tad and his father. A year earlier, during the extensive gallery sessions sponsored by the painter Carpenter, Brady happened upon Lincoln and his son gazing at an album of his photographs. "So impressed was Brady by the pose," recalled Lincoln's oldest son, Robert, "that he induced them to remain as they were while he [or rather his very able operator Anthony Berger] took their picture." The picture is disarmingly intimate; both a spectacled Lincoln with his eyebrows raised in nearsighted concentration, and Tad, with his head tilted and his arm reaching behind his father, are absorbed in their own world as they gaze at the open book. This rare glimpse of filial tenderness touched

Abraham Lincoln and Thomas "Tad" Lincoln,
by Mathew Brady, February 9, 1864

a sentimental nerve in the public in a way that made it, especially follow
ing Lincoln's death, the most widely sold of all Lincoln photographs. *Harper's*
Weekly featured it on its cover two weeks after the assassination; over the years,
it circulated in countless vignettes and engravings, some of which retouched
the book as a Bible.

It is easy to recognize Gardner's photograph as an effort to tap the same
market as Brady's, but the two pictures differ so widely in tone that it is better
to see it as an explicit revision. Gardner in effect quotes the earlier picture
by arranging his subjects around a book, though this one appears to be some
kind of heavy tome—a law book, perhaps—and of course it is closed. Both
pictures suggest "like father, like son" by highlighting their matching watch
fobs against similar dark clothes. Gardner goes further along these lines: Tad

stands, but like his father his elbow rests on the table, and his left leg crosses over his right. Beyond that, however, Gardner's image suggests an altogether different relationship. Brady emphasizes Lincoln's paternal authority: he holds the open book while Tad looks on at what his father shows him. In Gardner's image, despite the size difference between him and his father, Tad fills his portion of the image's space, hand partly in his pocket, leaning in to engage his father with an insouciant gentleman-about-town confidence beyond his age (he is eleven years old in the picture). Brady implies that the father guides the son; Gardner shows the boy arresting his father's attention, either by interrupting or waiting for his action.

After Willie Lincoln died, in early 1862, the grief-stricken Lincoln had grown very close to his remaining son at home (Robert, to whom Lincoln was never particularly close, was away at Harvard). Tad had virtually free access to his father, at times sitting on his knee as Lincoln met visitors and conducted Cabinet meetings. Because of a speech impediment that made Tad's words difficult for visitors to understand, it seemed as if father and son shared a secret language. They did share a bed, to which John Hay recalled Lincoln carrying the young boy after he had fallen asleep on the floor of the Executive Office.

Hay's account of Tad's days in the White House is generously affectionate, but in his understated way, he also offers a critical assessment of the Lincoln family life. The boy may have been "truthful and generous," but he showed the "insubordination and reckless mischief" of a "spoiled child." Tad "had a very bad opinion of books and no opinion of discipline," both of which his father indulged. "Let him run," he told visitors. "He has time enough left to learn his letters and get poky." (Despite having a tutor, Tad was virtually illiterate until his brother Robert took his education in hand after they left the White House.) Lincoln generally enjoyed, and almost always tolerated, Tad's pranks and interruptions. He also valued his bluntly commonsensical and at times surprising observations: turkeys, explained Tad to his father on election day in 1864, could not vote because they were too young. Still, the president might well have agreed with his secretary about his lax parenting. Hay tells of Lincoln having to interrupt a late-night meeting to put an unruly son to bed by announcing, "I must go and suppress Tad." When he returned, he joked, "I don't know but I may succeed in governing the nation, but I do believe I shall fail in ruling my own household."

Lincoln's jest betrays the self-consciousness of any parent when a child misbehaves in public (even when, as in the White House, home is public). But it also points to where Gardner's image parts company with Brady's. The latter

Secret Service Department Headquarters, by Alexander Gardner, October 1862

blends paternal and presidential authority into one comforting image of care; Gardner's photograph disrupts the connection. Tad's relaxed confidence and cool look comically presumes his equality with, even his independence from, his father, the president. If this is governing, then the table between them serves less as the family table than the cracker barrel or country-store counter, props from the world of local politics that Lincoln—a former store owner himself—knew well. Most Americans would have recognized the humor: equality and democracy are all fine and good in national politics, but there is little place for it in what advice writers called "family government." The intimacy between father and son lies in the dry humor they share in pulling off the joke.

Though Gardner was known more for his earnestness than his humor, there is good evidence that with his camera he had always been willing at least to participate in the bonhomie of his sitters. Consider, for instance, his photograph of Allan Pinkerton and some of his Secret Service agents made at Antietam in October 1862 during the same outing on which he photographed Lincoln and McClellan. In his photographs of generals and their staffs,

Gardner regularly arranged the men to emphasize the primacy of rank—high-lighting commanders above, in front, or in the center of the group. Here, while he uses the tent to organize the exposure—Pinkerton in his checked shirt leans against the tent pole and scowls at the camera—any of several men, including the man in the white coat or the one with crossed boots in the chair (or none of them) could stand as the figure of authority. The motley crew of military men and civilians—who seem to spill out of the tent to find their own space of comfort and visibility, spread loosely across the picture, some standing, some sitting, others lounging in the grass—present a study in the language of manliness. Of the fifteen men in the picture, ten sport a beard, five smoke cigars, and all but one of them look directly at the camera to claim our attention (the figure in the coat does so in profile). With his hat tilted back and a cigar clamped in his mouth, Pinkerton may exude the most confidence, but he is not alone. The aura of manliness is as thick as tobacco smoke, giving a hint of the kind of men who made it their job to work outside the boundaries of military protocol.

It is impossible to say how much of a hand Gardner had in arranging the group, though the formal organization beneath the apparently casual poses suggests at least some of what goes on in the image is his work. And at the very least, his allowing the men the latitude to strut for the camera points to his own participation in the group's lighthearted posing. Nowhere is this more evident than in the two men in officer's coats who sit to Pinkerton's right, one in the other's lap, who beneath his beard seems to wear a waggish smile.

The most elaborate instance of such photographic jest can be found on plate 45 of the *Sketch Book*, in an image he titled "Studying the Art of War." Once again we see men sprawled on the grass beneath a spreading tree; the ubiquitous tents hover in the deep background, giving the setting a pastoral air. The prominent markers of virile manliness are largely military: uniforms, hats, boots, swords, and two lighted cigars. These are officers studying, as the title of the photograph tells us, the art of war. Their poses, however, suggest something closer to Romantic young men contemplating the art of love. The supine figure in the center, with his straw hat and open jacket, reaches with the pinkie of his cigar-holding hand, as if toying with what could equally be a report or a book of poetry. Weapons may be nearby—the man on the right holds his—but their languid attention has led them far away from the battle-field they only pretend to study. Art of War indeed.

In the *Sketch Book*, there is an odd sort of disconnect between the image with its ironic title and the accompanying commentary that suggests something

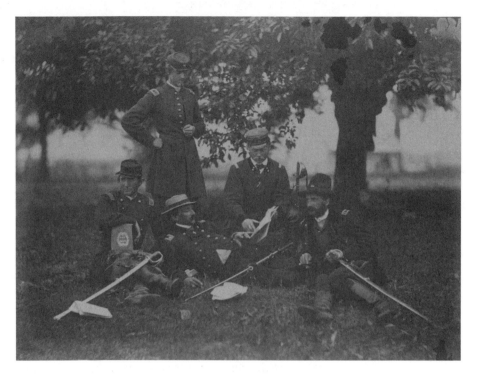

"Studying the Art of War," by Alexander Gardner,
June 1863; plate 45, Sketch Book

wistful about Gardner's sense of humor. In his exposition, he writes with great feeling about the standing figure, Ulric Dahlgren, son of Admiral John Dahlgren, and, at the time the photograph was taken, in April 1863, a rising star in the military. Just three months after posing for the photograph, he would lose a leg in leading a daring attack during the Gettysburg campaign that would gain him promotion as the youngest full colonel in the army. In the *Sketch Book* commentary, however, Gardner focuses his attention on the controversial circumstances of Dahlgren's death in 1864. He was killed leading a contingent of cavalry on a daring raid on Richmond to free Union prisoners from the notorious Belle Isle Prison. On his body, Confederates claimed to find a letter with orders to free the prisoners, burn the capital, and kill "the rebel leader Davis and his hateful crew." Outraged, Richmond leaders published the letter (Union officials denied its authenticity), and refused to give Dahlgren an honorable burial. Gardner's caption insists that "so noble a man" would never perpetrate such a deed. The document, he insists, was false: "No ruthless raid was his, but a Christian effort to help the despairing Union prisoners."

Dahlgren does look "noble" in the photograph, but the urgency of the commentary jars with the whimsy of the image and title. What does connect the two is how both make claim to Gardner's place in the world he represents. The narrative tells us that "the writer narrowly escaped" witnessing Dahlgren's end, "having been invited to accompany...that ill-starred expedition." Gardner, of course, is not in the photograph (nor was he invited to be), but with his camera still plays a crucial part in the picture's understated, whimsical, and ultimately ironic humor. Group portraits like these do not simply document the jocular fraternity among men at war; they attest to Gardner's own appreciation of the manly art of play.

Two years later, in 1865, as he set up the image between the president and his son, Gardner may have had his own private joke in mind. With his bent leg and confident lean forward, Tad recalls General McClellan's defiant posture as he cocked his head toward Lincoln at his headquarters at Antietam (see plate 4). And as in that 1862 image, in this one Lincoln looks over and past the shorter appeal. The table between the boy and his father, as well as their divergent lines of sight, likewise recall Lincoln and his general sitting inside the tent (see plate 5). In those images, the tight quarters and height disparity provoked physical expressions of the tensions between them. Here they give room for a relaxed affection between a distracted president with his books and his independent but attentive son.

Lincoln's sense of humor is as legendary as it was complex, as Benjamin Thomas makes abundantly clear in his classic 1935 essay, "Lincoln's Humor," which gives a good idea of just how deeply jokes, puns, other wordplay, and humorous stories especially were woven into Lincoln's life and psyche. As a young man, he was well known for his homespun wit and storytelling, which he put to good use both in the state legislature and on the political stump. His wit and humor played a role, along with his intellectual tenacity, in bringing him fame during his debates with Stephen Douglas. As a circuit lawyer in Illinois—a life of poor food, cramped sleeping arrangements, muddy roads, and one-horse towns relieved in the evenings by books, cards, whiskey, even pillow fights—Lincoln gained a reputation for storytelling strong enough to attract crowds of up to two hundred listeners. Drawing on a seemingly endless reservoir of tales, anecdotes, and quips, he could hold an audience spellbound as he worked his way to "the pith or point of the joke or the story." Recalled his friend and law partner, William Herndon, when it arrived, "no one's laugh was heartier than his." Lincoln's storytelling at once brought together a community built on the pleasure of laughter and distinguished him within that group.

As president, Lincoln could still entertain an audience, especially a military one, but generally he was more discerning than earlier, with both his stories and his company. As Thomas points out, Lincoln the president employed humor as a social tool—to deflect aggression or deflate tension, for example, or to illustrate a difficult point. Even his funniest stories were delivered with a motive. One he related a number of times featured a man who approached Lincoln on a train to say he seemed to have something that rightfully belonged to him. When Lincoln asked what it was, the man told him he had been given a jackknife with the injunction to keep it until he found someone uglier than he was. "Allow me now to say, sir, that I think you are fairly entitled to it." The joke may have been self-deprecating, but it also disarmed his listener with sympathy and laughter. It was a tactic Herndon well understood: when Lincoln told a story, he wrote, "it gave him, in some mysterious way, a singularly firm hold on...people." It could also give him relief from grief and anxiety. After news of the crushing Union defeat at Fredericksburg, Lincoln's good friend Isaac Arnold was appalled at finding the president, "with the whole land bowed in sorrow," enjoying the writings of the dialect humorist Artemus Ward ("I hiv no politics. Nary a one. I'm not in the bisniss"). Lincoln replied, "Mr. Arnold, if I could not get momentary respite from the crushing burden I am constantly carrying, my heart would break!" Arnold was moved by Lincoln's response, but Edwin Stanton was enraged by Lincoln's reading aloud from another comic as he nervously awaited the presidential election returns at the War Department telegraph office in 1864. "God damn it to hell," he exploded. "Was there ever such nonsense? Here is the fate of the whole republic at stake, and here is the man around whom it all centers, on whom it all depends, turning aside from this monumental issue to read the God damned trash of a silly mountebank!"

Even though humor served Lincoln as therapy, as Thomas understood and even Stanton touched on, it expressed something deeper in him. Telling his own jokes and stories and reciting those of others allowed Lincoln to find a distance from the center, a sense of perspective on the monumental issues that shared much with irony but expressed more accurately his deep appreciation for the absurd and the ridiculous—or the "ludicrous," as one friend put it—in even the most trying times. His oldest friends understood it as arising from the same mysterious inner sources as Lincoln's melancholy. David Davis, the brawny and charismatic judge who traveled the circuit with Lincoln, managed his first presidential campaign, served as Supreme Court justice on his nomination, and administered his estate on his death, admitted he never knew the

president. "Mr. Lincoln was not a social man by any means," he declared. "His Stories—jokes &c. which were done to whistle off sadness are not evidences of sociality." Herndon, who devoted much of his life after Lincoln's death to a "true" biography of his friend, admitted near its end that Lincoln "never revealed himself entirely to any one man." He continues in a tone of bewilderment, "I always believed I could read him as thoroughly as any man, and yet he was so different in many respects from any other one I ever met before or since his time that I cannot say I comprehend him."

Lincoln would have appreciated the gentle humor at the heart of Gardner's photograph of him with Tad, both for what it reveals, and for what it leaves unsaid. He might have appreciated how the cracked-plate portrait suggests a private joke or an obscure irony between sitter and operator about the eerie sense of isolation in his distant eyes and the tantalizing "something else" that lurks in his soft smile. Perhaps it would have reminded him of a man he met on the train one day.

CHAPTER 5

1865: Ruins and Memorials

WHEN the news reached Washington on April 3, 1865, that Union troops had entered Richmond, Virginia, the capital of the Confederacy, the entire city broke into celebration. Beginning with "a grand salute of eight hundred guns," the streets, in Noah Brooks's account, filled "with hosts of people, talking, laughing, hurrahing, and shouting in the fullness of their joy." Bands "paraded...and boomed and blared from every public place," while "any man...who could make a speech, or who thought he could make a speech," did so. Celebrations ran into the night as people flocked to the saloons and soberer residents illuminated their homes with lights, candles, even fireworks. Gardner, however, was soon busy with other plans. Even as Washington prepared for a second day of festivities, the photographer loaded his wagon and headed south to Richmond, likely accompanied by his Scottish friend John Reekie.

Gardner traveled well stocked, taking with him enough chemicals and glass plates for fifty to a hundred exposures. They began working on April 6, with Gardner making all the exposures through April 10 before returning home. Afterward Reekie took over as operator, adding his own exposures of the city and then working his way through some of the many battlefields and landmarks around Richmond. They were not alone in the Confederate capital. E. & H. T. Anthony's had their own photographers at work; also active was the army's official photographer, Captain A. J. Russell. Mathew Brady showed up sometime after April 12, late enough to photograph both Grant and Robert E. Lee just after the Appomattox surrender. These photographers worked along-side special artists from *Harper's Weekly* and *Frank Leslie's*, as well as the many journalists who converged on the city. After all, public interest was high. As George Alfred Townsend wrote in the *New York Herald*, "This town is the Rebellion; it is all that we have directly striven for....Its history is the epitome

of the whole contest, and to us, shivering our thunderbolts against it for more than four years, Richmond is still a mystery." People wanted to see it.

Certainly Lincoln did. He heard the news at City Point, some twenty-five miles down the James River from Richmond, where General Grant had established his headquarters. Lincoln had spent the last nine days consulting with the general and his staff, reviewing the troops and visiting the front lines, while using the *River Queen*, the same steamboat that had accommodated the Hampton Roads peace conference in February, as a hotel. That afternoon, on the third, Lincoln had visited Grant in Petersburg, the vital railroad nexus that the Confederate army had finally abandoned to Union forces after months of siege. Grant had hoped to deliver tidings of Richmond personally to Lincoln that afternoon, but that had to wait until the evening, with the president at City Point and Grant in pursuit of Lee. Even though the news was expected, Lincoln was still deeply satisfied. Writing years later, Admiral David Dixon Porter, who was with the president, recalled his response. "Thank God that I have lived to see this!" said the man who had at times despaired about the many men who had died to make it possible. "It seems to me that I have been dreaming a horrid dream for four years, and now the nightmare is gone. I want to see Richmond."

At Gettysburg and Antietam, Gardner had arrived at the battlefield ahead of Lincoln; this time Lincoln entered the scene first, on the heels of the army. The order of their arrival, however, did nothing to change their similar responses to what they encountered. Lincoln's visit to the Confederate capital especially risked looking like the hubris of a conquering ruler, and no doubt many in the South saw it as just that. There certainly had been an air of elation among the Union forces who raced into the city. One infantryman reveled that his unit's entrance was "grander and more exultant than even a Roman emperor." Lincoln was in no mood for triumph. During his time in Virginia, he had twice walked battlefields strewn with the dead and once with the wounded as well, leaving him in tears. He made clear to his generals he wanted victory, yes, but he most yearned for an end to the bloodshed. His instructions to Grant about how to treat the rebel soldiers were clear. "Let them all go, officers and all," he insisted. "Let them have their horses to plow with, and, if you like, their guns to shoot crows with. I want no one punished; treat them liberally." Roman celebrations did not suit his mood or his agenda.

Though Gardner's time in Richmond came on the heels of the president's, the views depicted in his photographs offer us a vital backdrop to the myriad written accounts of Lincoln's visit to the fallen Confederate capital. Gardner's

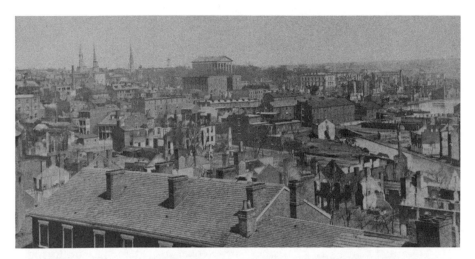

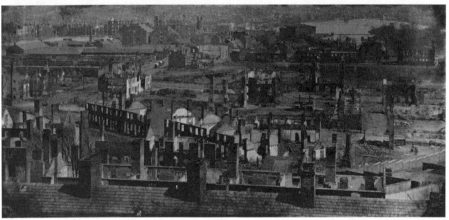

Panorama of Richmond, Virginia, by Alexander Gardner, April 1865

photographs of Richmond show no trace of the revelry of Washington or the triumph of victory. Instead, taken together, they evoke a reflective meditation on the transformational power of war's destruction.

By the time he began work on April 6, Gardner would have known that on the morning Union troops had entered Richmond three days earlier, much of the city was already in flames. The fire had been self-inflicted by a badly managed effort to destroy stores of tobacco and burn the bridges behind the retreating Confederate army and its government. During the night of April 2 and into the early morning, mobs of residents, starved and desperate after months of privation, many of them drunk from liquor flowing

down the gutters from broken hogsheads, turned to looting stores and warehouses. Around dawn of April 3, following orders of the Confederate army, the city's provost marshal set fire to the tobacco warehouses and the bridges. Augmented by those set by pillagers, as well as by embers from the bonfires set the previous day to burn official papers, the fire soon grew into a conflagration that reduced the city's entire commercial district to shells and rubble. Consumed in the morning flames were the city's two largest flour mills, every bank, two major hotels, and the State Court House, as well as countless small businesses. When the fire reached the armory later in the morning, ordnance exploded with booms that shook the earth and broke windows. Union soldiers, working with virtually no firefighting equipment, didn't bring the fire under control until it had destroyed more than forty blocks of the city.

One of the first tasks Gardner and Reekie turned to was producing a sweeping panorama of the city from the top of Gamble's Hill. To get a clear field, they climbed to the roof of what was known as Pratt's Castle, a mansion-size folly with secret passageways, stained-glass windows, and outer walls of rolled iron scored and painted to look like stone. One view toward the northeast takes in many of the sites that had symbolized Richmond's renown before the war as a cosmopolitan and prosperous city with a vigorous literary culture, fine hotels, and thriving industry. Rising above the city is the State House designed by Thomas Jefferson; the elegant Custom House sits directly down the hill; beneath the churches to the left is the Spotswood Hotel. Just peeking over the horizon to the right of the churches appears the head of the monumental statue of George Washington on his horse.

Over the next few days, Gardner and Reekie would take separate photographs of many of these sites, as well as historic buildings and the residences of Lee and Davis. But a large part of their attention would be devoted to what became known as the Burnt District, visible in the middle foreground and running to the right of the frame. It fills virtually all the frame in the next image in Gardner's panoramic series. Here we see only the shells of what was once a living city—the architectural equivalent of the bodies at Antietam snatched from life in mid-gesture. Commerce, society, and domesticity—the sheer plenitude of activity that makes cities so invigorating—are now replaced by an uncanny emptiness. Open spaces of dirt and rubble stand inside walls of empty windows; a lone fireplace and chimney in the lower right is all that remains of what?—a home? a store? Scattered across the unreal space are its only inhabitants—horses hitched to caissons, broken artillery, two white covered wagons moving away in left middle distance.

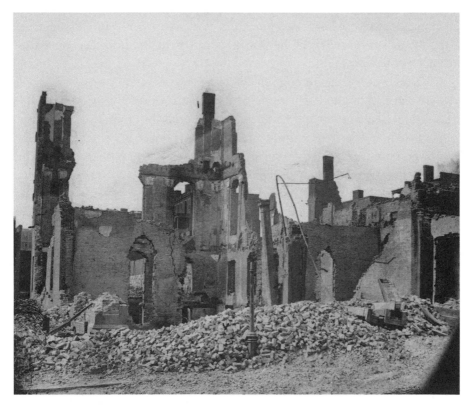

Richmond, Virginia, by Alexander Gardner, April 1865

Later the two men carried their cameras into the district. The photographs from street level take on an almost abstract quality, emphasizing monumental forms rising above the rubble. The corner of the building, with its now exposed faux interior columns, arches, and cracked walls, its doorway opening to a largely intact building front behind it, and its chimney rising into an empty white space, at once seems abstractly sculptural and evocative of Romantic paintings of the ruins of Pompeii or the aftermath of the sack of Rome that invited viewers to contemplate the passing of empire. Perhaps they recalled for Gardner the ruins of Bothwell Castle outside of Glasgow, or Stanely Castle near his hometown of Paisley. For nineteenth-century travelers, such ruins evoked the romance of histories both legendary and long forgotten. Richmond's ruins, however, had more immediate antecedents in other cities put to the torch—Norfolk and Hampton, Virginia; Atlanta, Georgia; and most notoriously and devastatingly, Columbia, South Carolina. Any viewer

North or South would have recognized in Richmond's ruins the fearful capability of war's power to reach beyond the battlefield and into the homes and businesses of civilian life.

Virtually all of the photographers active in Richmond during the weeks after its fall took photographs in the Burnt District, often of the same buildings, bridges, and landscape features. It is conceivable they may even have worked side by side, here lending a hand to each other and there competing for the best point of view in the right light. Taken as a group, all of the pictures testify to the destructive potential of war and perhaps even the price of victory. In many cases it would be difficult to attribute any single picture to any one of the more accomplished photographers. Gather together the pictures of any of them, however, as Gardner did when he published a catalog of his and Reekie's stereographs as "Memories of the War," and compare them to each other and to earlier work, and we can begin to see Richmond through Gardner's distinctive eye.

Among the more suggestive characteristics of Gardner's collection of about fifty photographs is how little attention he paid to the occupying army. Reekie produced some images that show troops sprawled in the grass with their laundry hanging over a fence, but in Gardner's work, beyond the wagons and horses in the panorama, there are as few signs of Union troops as there are of white residents. At times he turns this emptiness into images of great, terrible beauty, as in his composite image of two photographs showing the Gallego Flour Mills spread along the edge of the Richmond Canal (see plate 17). The light rakes in from the upper right, illuminating the haze or smoke inside the buildings, which combines with the bright gray sky and the luminous sheet of brilliance of the overexposed canal to give the scene a sense of ethereal sublimity and wonder.

Gardner did take one photograph that comments sardonically or whimsically—its tone is hard to gauge—on the insignificance of the military in the face of ruination. Directly in the middle of this visually prosaic image—dominated by jagged walls and piles of rubble spilling over the curb into the cobblestone street—sits a Union soldier whose bayoneted rifle and upper-body posture suggest a half-hearted gesture at presenting arms. Almost lost in rubble next to him crouches a boy with what could be a shovel, a pry bar, or simply a stick slung over his shoulder. The two figures raise a host of questions, all of which emphasize their inadequacy to the situation they find themselves in. Why a fixed bayonet—why in fact a weapon at all? Does the soldier protect the ruins? Has he captured the boy—looting perhaps—or does he protect him?

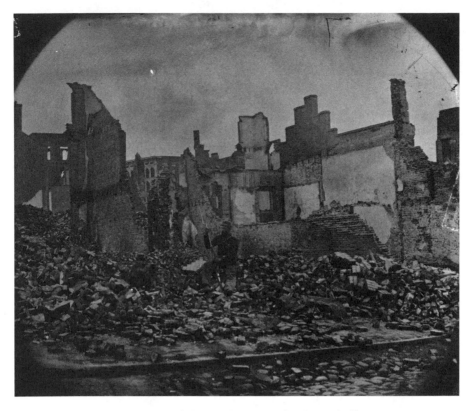

Richmond, Virginia, by Alexander Gardner, April 1865

What exactly is there to defend, guard, or attack? Is the boy there to search the ruins? To protect them himself? To begin rebuilding the city? Whatever their relationship, it is diminished by the sheer size of the pile of rubble.

Running alongside images that stress the finality of the devastation are those that gesture toward a future after war. One such image looks into the Burnt District from behind the fence surrounding Capitol Square, the civic center of the city (see page 174). Gardner has turned his back to Jefferson's (and the Confederacy's) State House to look into the same field of endless ruins he photographed off the canal. Here, however, he uses the fence to mark the limits, symbolic and actual, of the devastation. The bare trees recall the tree blasted of its leaves by the shattering force of Antietam's fighting (see plate 6), but they also anticipate the spring that lies ahead.

Later Gardner would develop this optimism more fully in his commentary on one of the four images from Richmond he included in his *Sketch Book*. Accompanying his arresting photograph of stone piers reaching across the

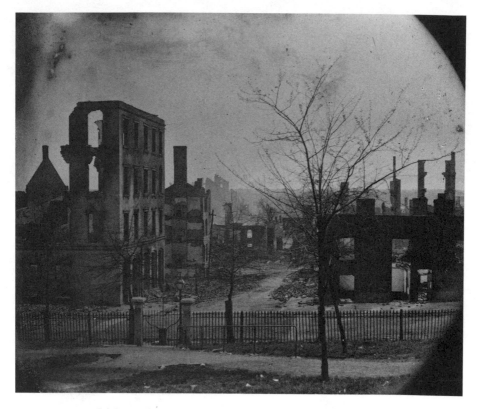

Richmond, Virginia, by Alexander Gardner, April 1865

James (see plate 18), we are told how the largely wooden bridge they supported was burned by the evacuating Confederate army. The piers, however, do not look like ruins. Even with the gutted building on the far right and the debris piled at their feet, the formal order of the receding forms and the gentle arc described by their top seems less to document destruction than invite completion. Gardner's commentary confirms the potential implied by the image: today, he tells us, the piers support a new bridge, "and the trains now cross regularly." In fact, all along the river, new buildings have replaced ruins, and the cities in the area "are resuming their bustle of trade and improvement." Out of the wreckage of the old Confederate capital, out of the devastation of war, grow the reconstructive energies of industry and trade.

*

WITH these views of Gardner's in mind, we can return to April 3, when the president's plans to visit the fallen Confederate capital were put in motion. When Lincoln announced to Admiral David Dixon Porter his intention to visit Richmond, he told the right man. It was Admiral Porter's ironclads that had kept the Confederate navy bottled up during the siege. The Rebels had done their best to keep his navy out of their capital by mining the James River with torpedoes and by sinking ships and pilings as barriers. In order to give the president the kind of entrance appropriate to the victory, Porter ordered the mines to be cleared and assembled a small squadron of three gunboats and his flagship to accompany the *River Queen* up the James from Grant's headquarters at City Point. Things, however, did not go smoothly. One after another, the steamboat, the gunboats—one of which transported the president's cavalry escort—and the flagship ran afoul of the obstacles or ran aground. In the end, the presidential armada had dwindled to a single barge, shorn of its tugboat by yet another obstacle and buffeted by the current, which pulled into Rocketts Landing, about two miles from the central Courthouse Square in Richmond: no bands, no official escort, no flags waving, no cheering soldiers.

When Lincoln disembarked late in the morning on April 4, the air was still heavy with smoke and ashes from the day before (fires would break out sporadically for days). The Union military commander was expecting the president, but not so far from the center of town (and the fire damage). His officers would soon be able to locate him by the sound of the crowds that gathered around the president, who, hand in hand with Tad and accompanied by something like a dozen armed marines, Porter, and a few other officers, walked up the hill from the river, sweating in the unseasonably warm morning.

The many accounts of Lincoln's walk into Richmond—by newspapermen, by Porter, and by others with him—agree that by the time he arrived at Capitol Square, his party had attracted the attention of what grew into a large and enthusiastic crowd of up to three thousand mainly black residents. A couple of accounts mention that things grew intense enough for his escorts to grow concerned for the president's safety—one marine, in fact, was injured. But what is most noticeable about the accounts is the same mixture of wonder and condescension at the response of the newly free black residents. "The joy of the negro knew no bounds," wrote the special correspondent for the *New York Tribune*. "It found expression in whoops, in contortions [and in] in prayerful ejaculations." In his journal, Porter represented the words of the workman at the riverside who first recognized Lincoln with all the biblical naïveté and dialect inflections that whites regularly used to signal a speaker's ignorance:

"Bress de Lord, dere come de Messiah! Dar is Mass Abram Linkum sure enuff!" Improbably, he tells of the man kissing the feet of the president, who looked "down upon the poor creatures" and pronounced himself "but God's humble instrument."

Condescension aside, the accounts make clear just how remarkable Lincoln's lightly guarded walk up the hill into Richmond was for everyone involved. Whatever the blacks who gathered may or may not have felt or known about Lincoln—Porter suggests they recognized him from photographs—his mere presence signaled the freedom they had long hoped for and worked toward. And what better way to claim that freedom than by raising their voices in shouts and songs loud enough to be heard by the very white residents of Richmond who had sacrificed to keep them enslaved? Why not pay their respects to the man who made the end of slavery a fundamental goal of the war? For his part, as he clutched his son's hand, Lincoln must surely have been moved by the historic celebrations his efforts had helped make possible. He also could not have helped but be aware of the symbolic weight of his encounter and self-conscious of his role not as a liberator but as the representative of the democratic forces that brought about the moment. One white correspondent captured this awareness for the *Atlantic* magazine in an account about Lincoln's exchanging a formal greeting with an older black resident. After the local man doffed his hat and bowed, tears in his eyes, "The President removed his own hat, and bowed in silence." Recalling the moment, the reporter continued, "it was a blow which upset the forms, laws, customs, and ceremonies of centuries. It was a death-shock to chivalry, and a mortal wound to caste."

Eventually Lincoln and Tad found their way to Davis's White House, where the president sat in his counterpart's reception chair and asked for a glass of water. Later, in Courthouse Square near the monumental sculpture of Washington on his horse, he spoke to another gathering of mainly black residents (many of Richmond's large foreign-born white population were also among those to see the president), confirming that they were indeed free ("free as air" by one account). He then visited the State House before riding with Tad through the Burnt District two days before Gardner began work on the same streets, past the notorious Libby Prison for Union officers, which was now filled with Rebel prisoners. After initially considering an overnight stay in the still elegant Spotswood Hotel, he was persuaded for safety's sake to spend the night on Porter's flagship, the USS *Malvern*, which had found its way through the river's obstacles.

Lincoln's walk to Court House Square that warm April morning expressed his profoundly democratic understanding of the office he occupied. As when he shook countless hands at White House levees, and greeted thousands of soldiers in camp, on review, or in hospitals, Lincoln acted on the conviction that the president was obligated to put himself before the public as their representative. Democrat or Republican, Union or Rebel, man or woman, white or black, voter or not, all were part of the body politic. For those who gathered around him that day, especially for the newly free blacks, like the countless reunions and conflicts that took place throughout the South, Lincoln's walk offered just a glimmer of what would prove to be a heartbreakingly distant future of racial equality.

There were other encounters those first few days after the opening of Richmond that put the accounts of Lincoln's walk and his measured behavior in the wider perspective of anger, joy, and sadness that accompanied the freedom brought by the end of fighting. Among the reporters in the city was Thomas Morris Chester, the black son of an escaped slave who worked as a war correspondent for the *Philadelphia Press*—the only black to do so for a major newspaper. He had entered Richmond with a unit of the colored troops the day before; he was not with Lincoln when he arrived. Nor was he with Lincoln when he sat in Davis's chair, though he would have appreciated the gesture. For as he told his readers, he had chosen to write his first article in the State House, "seated in the Speaker's chair, so long dedicated to treason." While he was enjoying the reversal, according to the *Tribune* correspondent, an indignant white man ordered him out of the chair. When Chester refused, the man seized hold of him. "Then Chester planted a black fist and left a black eye and a prostrate Rebel."

Reverend Garland White, chaplain of the Twenty-Eighth US Colored Troops, had a very different but equally significant encounter. White had been born in Richmond, where he had been sold as a boy to Robert Toombs, who would later become Davis's secretary of state. Long before then, White had run away and finally settled in Ohio. After the Emancipation Proclamation, he had helped recruit a number of black regiments before finally enlisting as a chaplain. As one of the first Union units in the city, the Twenty-Eighth attracted much the same response as Lincoln. Black residents cheered and embraced them as they marched in formation; White felt as if "all the colored people had collected" in the street. After they arrived at camp, like Lincoln at Capital Square, he was asked to give a speech. His remarks were briefer than the president's: after proclaiming "for the first time in that city freedom to all

mankind," his feelings overcame him and he could go no further. There was more emotion in store for him when later a woman began to sharply quiz him about his place of birth, mother's name, and his owner's name. When she had enough, she announced, "This is your mother, Garland, whom you are now talking to, who has spent twenty years of grief about her son."

IN his visit to the city several days later, Gardner photographed two of his own encounters with new members of the body politic, neither of which touches on the frenzied excitement the journalists described in the crowd greeting Lincoln. One photograph presents four black women sitting on rocks above a pool of water. Behind them are a stand of trees and vines just beginning to bud; above them arises one of the piers of the destroyed railroad bridge. With them on the rocks sit two children at least one of which looks white (Tad-like, he wears a military cap, and perhaps he also appears amid the rubble with the soldier in the photograph on page 173). The other younger child, too restless to hold still, is dressed in white, as is the woman on the far right. Three of the women clearly wear aprons, and one of them rests her elbow on a large wicker basket, suggesting some sort of domestic labor, whether for themselves or for someone else. It would not be too much of a leap to presume that at least one of them cares as a servant for the children. Gardner's photograph, however, draws less attention to their relation to whites than to the dignity expressed by their formal poses and direct looks to the camera. Unlike the Union soldier in the rubble, these women claim ownership of themselves and the pastoral world they have made their own far from war.

A similar kind of self-possession is visible in the photograph of black men taken along the Richmond Canal, beneath the ruins of the Haxal Flour Mill. Again, virtually everyone in the image directly addresses the camera, except the children and the young man who deliberately turns his back to it. The figures in the foreground, ranging in age from young child to adult, arrange themselves around a man who could be taken as a pipe-smoking patriarch of his largely male family. At the same time, the figures of young men arrayed across the background—who pose, especially those on the fence, with the same confidence as Pinkerton's agents at Antietam—suggest a wider fraternal network of extended kinship and comradeship. Several of the men seem to wear pieces of Confederate uniforms—the hat and pants of the figure to the left of the patriarch, the coat of the figure on the far right. Perhaps they are from stores left behind by the evacuation, or perhaps the men had served in

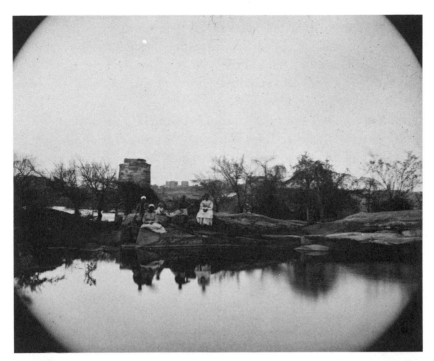

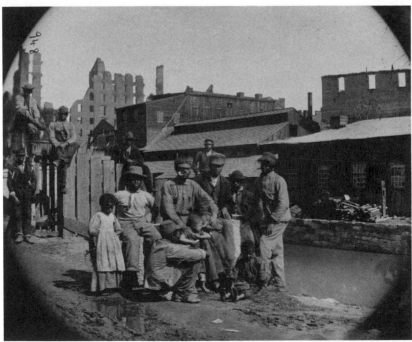

Richmond, Virginia, by Alexander Gardner, April 1865

return for their freedom in one of the three regiments raised in the last days of the siege. Again, it is not their relationship to white culture, in ruin all about them, that Gardner calls attention to. As with the women, we can only guess at their lives, but we can be certain that they gather in relaxed, even confident ownership of what may one day be their city.

As Gardner worked in Richmond, news trickled in of Grant's pursuit of Lee's army and finally of Lee's surrender on April 9 at Appomattox. He may have felt mixed emotions about the end of the war. Relief, even a touch of joy and peace—but also perhaps some of the somberness reflected in his photographs as he realized that the grand enterprise of documenting the war was coming to an end. Whatever his state of mind, when he returned home sometime after April 10, he could not have helped but notice the contrast in mood between the old Confederate capital he left and the swooning euphoria of Washington.

LINCOLN left City Point for Washington aboard the *River Queen* near midnight on April 9, the day before Gardner finished his work in Richmond. The president spent much of the next day in a reflective mood, reminiscing about his administration and reading passages out loud from *Macbeth* to whomever would listen. He read several times from one passage in particular, which had always fascinated him, concerning Macbeth's guilt about murdering his cousin. Perhaps it sounded right after witnessing the collapse of a fraternal rebellion. Or perhaps he simply felt free to indulge his love for Shakespeare's powerful language and tragic vision. Over the past two and a half weeks, he had been touched by the pain of the wounded and grief for the dead, and seen the fruits of emancipation on the streets of Richmond both in the residents and the colored troops who served in the finest military force in the world. As Lincoln read *Macbeth*, he did not know for certain that Lee was surrendering to Grant and that the war that had so worn him down and so defined his leadership was soon to end. Still, he could not have been surprised when later that night he received the news.

The morning after Lincoln returned, Washington reacted to Lee's surrender with yet more celebration. Yet another cannonade resounded, and once again the streets, this time "horribly muddy, were all alive with people, cheering and singing, carrying flags and saluting everybody, hungering and thirsting for speeches." The crowd in front of the White House was "wild," even "mad" when Lincoln came to the window, spurred in part by Tad's earlier

appearance waving the same captured rebel flag for which Lincoln's friend Elmer Ellsworth had given his life four years earlier. Lincoln, however, disappointed them, promising to deliver the next night an address proper to the occasion. He retired after asking the band to play "Dixie"—"our lawful prize," he quipped to the crowd, for winning the war.

Naturally Lincoln was relieved and deeply moved by recent events. Secretary of War Stanton recalled his time the next day with the president as "some of the happiest moments of my life; our hearts beat with exultation at the victories." Characteristically, though, the president kept his feelings largely to himself. Four days later—on the last day of his life—Mary, who knew her husband better than anyone, remarked on his mood during a carriage ride: "Dear Husband, you almost startle me by your great cheerfulness." Lincoln responded, "And well I may feel so, Mary. I consider *this day*, the war has come to a close." He then spoke about returning to Springfield after the end of his term.

Retirement was far from his mind on the evening of April 11 when he delivered his promised speech from a White House window. The president spoke about the country's future in a tone of sober satisfaction without a trace of triumph. "We meet this evening," he began, "in gladness of heart" that would best be expressed later in a formal day of "national thanksgiving" that he would proclaim. For now all gratitude and honor were due to "General Grant, his skillful officers, and brave men." Then he turned to an almost lawyerly discussion of Louisiana as a test case for the larger task of "restoring the proper practical relations between the states [that had rebelled] and the Union." Stay focused, he urged, on the matters of governing; be flexible in addressing issues as they arise. In particular, he mentioned, he would favor giving the vote to those blacks who are "very intelligent," and to "those who serve our cause as soldiers." Lincoln was back in the political saddle, addressing his listeners, but also speaking to the Democrats and Radical Republicans, who were already at loggerheads about how to manage the house newly reunited.

Standing at the White House windows during the speech, both Noah Brooks and Elizabeth Keckley, Mary Lincoln's modiste, were struck by the almost threatening power of the crowd. Brooks found "something terrible about the enthusiasm with which the beloved chief Magistrate was received—cheers upon cheers, wave after wave of applause." Keckley, too, compared the crowd to the sea, but was also struck by the "weird, spectral beauty of the scene" and "the confused hum of voices that rose above the sea of forms, sounding like the subdued, sullied roar of an ocean storm, or the wind soughing through

the dark lonely forest." Lincoln, lighted by just a candle to help him read his remarks, "looked more like a demi-god than a man." For both, there was something troubling, even haunting, in the urgency of the crowd's expectations of the president.

At the very front of the crowd that night stood the actor John Wilkes Booth, there not to celebrate, but to feed his rage and stanch the despair that had overtaken him with the fall of Richmond and the Appomattox surrender. He loathed the president and had long targeted him for violence, going so far as to consult with Confederate spies and sympathizers from Canada to Virginia. Twice he and his irregular gang of conspirators had come close to acting on plans to kidnap Lincoln, smuggle him into the Confederacy, and hold him for ransom. Kidnapping now would be useless with nowhere to take him, so Booth had formulated a scheme to throw the government in disarray by assassinating the president, the vice president, and the secretary of state.

When he heard Lincoln's words about limited black suffrage, Booth had had enough. "That means nigger citizenship," he told a conspirator standing with him. "Now by God I'll put him through!" Booth did not have to wait long for the right opportunity. When three days later he read in the paper that Lincoln and Grant would attend that evening's performance of *Our American Cousin* at Ford's Theater, he put his plan into motion. With his fellow conspirators in place, his escape route mapped out, and a horse waiting in the alley, Booth slipped into the presidential box in the middle of the third act of the play, put a derringer to Lincoln's head, and shot him. Lincoln never regained consciousness. He died the next morning at 7:22.

ALEXANDER Gardner's photograph of the presidential box in Ford's Theater, made shortly after Lincoln's assassination on Good Friday, April 14, 1865, captures perfectly both the scene of the murder and its forlorn aftermath (see plate 19). The flags hanging on either side and over the balustrade of the double-wide box, as well as the elaborate drapery and the framed portrait of George Washington, evoke the patriotic festivity of the evening, coming as it did at the end of nearly a week of celebrations over the victories in Virginia. When on Friday morning the White House had sent notice to Ford's that the president would be attending that night's performance in the company of General Grant, owner John T. Ford had gone right to work. In short order, he had festooned the box with flags and furnished it with a comfortable couch,

two chairs, and a padded rocker for the president set back in the box as he liked it, where he could partially shield himself from the audience. After placing notices in the papers about the night's guests, he had been rewarded with a sharp rise in reservations—the price of a ticket was well worth the chance to see the general, who was the nation's new hero. The Grants bowed out at the last minute, and the Lincolns appeared after the play had begun with just a young couple—Major Henry Rathbone and his fiancée, Clara Harris—but the audience still halted the play with an enthusiastic cheer for the president.

The photograph organizes the theater's ornamentation with strong horizontal and vertical lines, but what really draws attention is the dark triangle filling much of the image's center, with its eerily lighted chair and the door looming behind it in the darkness. As anyone at the time would have known, John Wilkes Booth had come through that door and shot the president in that chair. He had then swung his leg over the railing and dropped to the stage some twelve feet below, catching his spur on a flag as he went, perhaps also pulling loose the bunting hanging on the right. Waving a dagger (with which he had slashed Rathbone's arm to the bone from elbow to shoulder) he called out the Latin motto of Virginia, *Sic semper tyrannis*, Thus always to tyrants, and then dashed offstage and out of the theater to a waiting horse in the alley.

The very theatricality of Booth's leap and exit, leaving very little doubt about who he was, left everyone in the theater stunned and confused, including the dozens of armed officers in the audience who could not process what they saw fast enough to react. In fact, very few of the perhaps one thousand witnesses made reliable sense of what happened in front of them—there was even disagreement about what Booth said and when, or whether he spoke at all. What was generally agreed on was the piercing anguish of Mary Lincoln's screams, powerful enough to be heard outside the theater and across the street. A call for doctors brought several volunteers forward, two of whom managed with the aid of the crowd to enter the box by clambering over the same railing Booth had used for his exit minutes earlier. As doctors did what they could to treat the president, and later moved him across the street to the boardinghouse of William Petersen, the scene in Ford's and the street outside devolved into chaos. "The seats, aisles, galleries, and stage," recalled one witness, "were filled with shouting, frenzied men and women, many running aimlessly over one another; a chaos of disorder beyond control." As the audience moved outside, a crowd gathered, drawn by the commotion. Some people went to the police station to report the killing; one person ran to the nearby Grover's Theater and shouted the news to the audience there, which included Lincoln's son Tad and

his tutor enjoying *Aladdin; or, The Wonderful Lamp*. The shaken boy and his guardian immediately returned to the White House.

News that night traveled by happenstance, almost virally. "From lip to lip the tale of horror flew," wrote Noah Brooks, "men and women went weeping about the streets; no loud voice was anywhere heard." If most audience members found their way home, others went to report the murder to the police. Those who had heard the news went to rouse members of the Cabinet, including Secretary of War Edwin Stanton, who at first was skeptical about what he was told. When one of his messengers also mentioned a rumor about the murder of Secretary of State William Seward, Stanton finally reacted and announced he was heading for Seward's home.

The rumor was false, but not by much. Seward, still in bed with his injuries from a carriage accident, had been assaulted by a knife- and pistol-wielding assailant who had fought his way upstairs past a servant and Seward's son, whom the intruder had beaten senseless with his gun after it jammed. He had then leaped at the helpless Seward with a bowie knife, stabbing repeatedly at the jugular vein in his neck. A metal collar supporting the Secretary's neck deflected the blade, but the attack had nearly severed his cheek, spilling enough blood that the man had left him for dead. He and his son would both survive, though Frances Seward, wife to the father and mother to the son, would die of a heart attack precipitated, many believed, by the stress of caring for her loved ones.

The audacity of the coordinated assaults sent shock waves through the government and streets of Washington. The friend who awoke Vice President Andrew Johnson was relieved to find him unharmed, but there was no reason not to expect more attacks on anyone at the head of the government or military. Rumors—of General Grant killed in his rail car on the way to New Jersey, of escaped Confederate prisoners prowling the city—made the uncertainty worse. As the night wore on and rain began to fall, silence in many parts of the city gave way to mobs of men wielding their own knives and guns and threatening anyone who might be disloyal to the Union cause. At one point two thousand angry citizens marched on the Old Capitol Prison, which held a number of the very Confederate prisoners said to be on the loose. They were turned away only by the inspired intervention of a Kentucky Congressmen who spoke to the crowd until troops arrived. Another mob threatened to burn down Ford's Theater.

After making sure Seward was alive, Stanton, along with Secretary of the Navy Gideon Welles, found his way to the bedroom at the Petersen

house where Lincoln's six-four frame was stretched diagonally across a bed. Doctors had treated the president as best they could but held out no hope. Known for his gruff, even overbearing manner, Stanton shocked the room when he broke down sobbing for the man he had grown close to over their three and a half years together. He would share his grief that night in the cramped room with, among others, Robert Lincoln, Senator Charles Sumner, and Mary, whose anguish left her alternately wailing and prostrate despite the ministrations of Welles's wife. For his part, Stanton spent the night moving between the deathbed and another room, where he and others had set up a command post to bring order to the night's chaos—sealing off the city, alerting the military, and composing official updates for the press, sent via military telegraph. By midnight all traffic in and out of the capital had halted and the White House and Cabinet members' homes were placed under guard. An hour later, Stanton wired local police to send "three or four of your best detectives" to investigate the assaults on Lincoln and Seward. By three a.m., he had arranged for David Cartter, chief justice of the D.C. Supreme Court, to take evidence, and instructed military units to patrol "every avenue leading into Baltimore" for Booth (who was, in fact, heading for southern Maryland). Stanton was certain that regardless of who would be captured, the investigation would ultimately lead to Jefferson Davis and his renegade Confederate government.

There was, of course, a plot, but it had really begun and ended with Booth and reached no further past Lincoln than attempting to kill Seward and, as it turned out, Johnson (George Atzerodt, who was likely assigned to carry out that murder, abandoned the plan). Still, the possibility of a larger conspiracy, even an insurrection, loomed large in those opening hours and continued to worry all of Washington in the days and weeks ahead. At the moment it had won the war and ended the rebellion, the national house, no longer divided, seemed on the verge of crumbling.

By the next morning, the news out of Washington had reached the papers in the major cities, precipitating many of the same public spectacles of shock, fear, grief, and rage played out in Washington. At home in Brooklyn, Walt Whitman spent the Saturday at home with his family reading every edition of every paper they could get their hands on. "Black clouds driving overhead," he wrote with a sense of grief and foreboding. "Lincoln's death—black, black, black—as you look toward the sky—long broad black like great serpents." Violence erupted throughout the North, from Maryland to Iowa to Maine, as people impulsively turned sorrow to rage, assaulting and at times killing

anyone who voiced a disloyal opinion about Lincoln's death. Where there were no Confederates to target, Southern sympathizers and even loyal but outspoken Copperhead Democrats, who had opposed both the war and the president, were a ready target. In Cincinnati, mobs still drunk from the previous night's celebration of Union victory turned ugly, attacking suspected enemies and looting homes and businesses.

Union troops in the South responded in much the same way. Whole regiments broke down in tears; others suffered in woeful silence. When news found its way to General Sherman's army, still facing a Confederate foe in North Carolina, part of the force reacted by marching on the unprotected city of Raleigh looking for vengeance. They backed down only when threatened by their own artillery. There was no such discipline in Nashville, where troops shot citizens for voicing any kind of disloyal sentiments. After sacking and burning homes through the night, the next day the military issued a general order mandating public displays of mourning.

None of this anguish, chaos, and violence precipitated by Lincoln's death is explicit in Gardner's photograph. The primal darkness of the president's side of the box is much subtler and more portentous, like the black serpents Whitman saw in the sky. Nor is there any such commotion visible in his photographs documenting other sites of Lincoln's murder: the front of Ford's draped in the black crepe of mourning, the stable where Booth kept his horse, the telegraph office from which the news was broadcast to the nation. Particularly poignant is a curiously blurred photograph, attributed to Gardner, of the rocking chair Lincoln sat in when he was shot. Richly upholstered and well padded, the chair leans back with the promise of an inviting, even domestic comfort. There are no stains or other signs of assault (unattributed photographs of the chair held at the Library of Congress, possibly by Gardner, or by one of Brady's operators, show what looks like blood on the floor). Though it is elaborate, the chair is less a throne than Gardner's last studio prop for the president; both here and in the image of the presidential box, the chair is simply and irretrievably empty.

Gardner's battlefield photographs had shocked viewers by showing anonymous bodies hastily or casually buried, or left to putrefy in the field. These two photographs appeal to the same sensibilities that made the "good death" so important to nineteenth-century rituals of domestic mourning, but in a different way. By the time Gardner took the images, the president's body was being prepared for what would be the largest funeral in the nation's history. Countless sermons and eulogies would memorialize Lincoln as the nation's

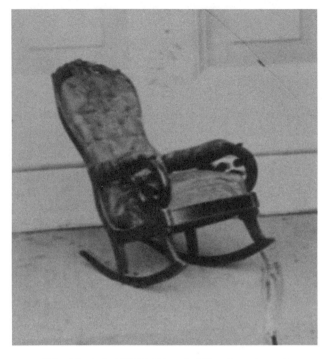

The Chair in Which Lincoln Was Assassinated,
by Alexander Gardner, April 1865

martyr. Gardner's photographs remind his viewers that despite the rituals and ceremonies, the man who once sat in the chair is gone.

There is a way, of course, that Gardner's pictures offer the chair, or the box, or even the physical print itself, as mementos of the president. (The chair is now a prize piece, along with the John F. Kennedy limousine, in the collection of the Henry Ford Museum.) In fact, given people's passion for appropriating souvenirs of the assassination, it was likely only its size that prevented the chair from being carried away in the confusion afterward. It took only an hour for the box to be stripped of anything that might be of interest: Lincoln's playbill, his collar, his blood-stained cravat, the wooden board Booth had used to jam the door shut behind him (oddly, Booth's revolver was found later under a chair). Later souvenir hunters would peel off the wallpaper and cut pieces of the curtains. When Lincoln's body was removed from the Petersen house, his shirt, the sheets of his bed, and towels—dark with blood—were cut up and divided, along with strands of his hair, among those in the Petersen house. Someone even managed to unseat a few of the screws in Lincoln's casket.

Gardner sold his assassination photographs much as he did those of Lincoln's February sitting—to capitalize on the public's need to hold on to what was lost. But if we look closely at the photograph of the president's box, we can sense another purpose at work. Like the images that he had made a week earlier in the ruins of Richmond, the power in the photograph of the presidential box derives from the way it represents emptiness as the result of violence. In the captions he later wrote for the *Sketch Book*, Gardner qualified the melancholy of those ruins with a narrative of commerce and rebuilding. Here there is no caption, but the photograph itself nonetheless offers the possibility of a national future. Just as it had after the death of George Washington, whose portrait still hangs between the flags, the country will move on without Lincoln.

MANY in Washington wanted Lincoln buried there in a manner fit for a national martyr, but Mary Lincoln resisted. For her the death of her husband was personal, and she wanted to bury him with their son Willie, who would be disinterred from his tomb in Washington and moved with his father to Springfield, where the Lincolns had shared eighteen years of marriage. Her insistence led to an ambitious plan for what in effect became a national funeral intended, in the words of one Congressman, to "arouse the patriotism of the people." The president and his son would return home on a special train that would retrace in reverse the journey the president-elect had made in 1861. When Mary grudgingly acquiesced, plans began for Lincoln's last campaign.

The ceremonies, which began on April 18 in Washington, were impressive enough. Thirty thousand visitors passed through the White House Green Room to view the president's body, preserved by the latest techniques in embalming, in an open casket. The next day, following a brief funeral service in the White House, the casket was borne to a waiting hearse, which to the boom of cannon and the sound of funeral dirges took its place in an enormous procession that Gardner photographed from high above Pennsylvania Avenue as it moved to the Capitol in front of thousands of residents. Once again the casket remained open for the public.

By any measure, the 1,654-mile funeral procession across the North that departed Washington on the twenty-first was a success whose magnitude astounded even its planners. In Philadelphia nearly a quarter of a million people lined the streets for the funeral cortege from the railway station to Independence Hall, where three hundred thousand mourners paid their

last respects. In New York City, between six hundred thousand and a million people watched the miles-long procession. In Chicago, according to one estimate, nearly 80 percent of the city gathered for or participated in the procession. Even more impressive, in their way, were the fifteen thousand people in Richmond, Indiana, who met the train as it passed through at three a.m. or the continuous line of torches and fires of mourners gathered along the route at night from New York City to Albany.

Once the funeral train left Washington, public attention returned to tracking down the conspiracy that had killed the president and threatened the government. On April 24, the same day all New York gathered to pay its respects to Lincoln, the *Washington Chronicle* voiced what was on many people's minds in the capital. "The thugs of the Confederacy are among us, and nothing can surely protect us from the assassin's knife but the wholesale terror inspired by a stern and strict execution of the law.... The satisfaction of seeing [the assassins] dangling at the end of a rope would be a sorry compensation for the great grief they have caused the nation." The reporter's impatience would soon be rewarded.

Only two days later, a squad of cavalry cornered John Wilkes Booth in a burning barn just south of the Rappahannock River in Virginia, where he was shot after refusing to give himself up. His accomplice David Herold chose otherwise, which meant that all eight of the conspirators who would ultimately be put on trial were in custody. In fact, the investigation had proceeded with reasonable efficiency. Five of the eight conspirators, including Lewis Powell (who used the alias Lewis Payne, or Paine), the man who had attacked Seward, had been arrested on April 17, just three days after the assassination. Three days after that, Atzerodt was arrested at his cousin's home. By then the military and police dragnet had hauled in hundreds of suspects and witnesses; it was time for the government to mount its case.

The military trial didn't begin until May 10, but Washington didn't have to wait that long to see evidence of the "stern and strict execution of the law" in the way the prisoners were treated. By modern standards, their incarceration was inhumane. Conditions in the Old Capital Prison, where Surratt, Ford, and others were held were bad enough. But Powell, Atzerodt, Herold, and others deemed more dangerous suffered under outright torturous conditions while they were held aboard the ironclad monitors *Saugus* and *Montauk*, moored in the Navy Yard. Each prisoner was isolated from virtually all human contact in a cell too small to lie down in. The prisoners were also bound by handcuffs, procured from a nearby asylum, that joined the wrists with an iron

bar instead of a chain, locking the hands in a single position. Their legs were chained as well; Powell's chains had an iron ball attached. After only five days in these conditions, on what was his twenty-first birthday, Powell tried to kill himself by smashing his head against the bulkhead. The War Department responded by requiring all prisoners to wear hoods with only a small flap for their mouths. Powell's was padded to prevent self-injury. In the close, fetid air, they were intolerably hot.

Some five days after his attempted suicide, Powell and the other prisoners were brought one by one to the deck of their ship, where they were relieved of their hoods, chains, and even cuffs. There waiting for them was Gardner, an assistant, and his camera. It must have been a strange experience to be in the open air after ten days in an iron hole and then be asked to sit for a portrait. Gardner, too, would have marveled at the peculiarity of the situation. He had come aboard at the behest of the investigation to produce a photograph of John Wilkes Booth, whose body had been hurried overnight to Washington for an autopsy. No doubt the authorities wanted a clear record that it was indeed the actor who had been shot. The photograph has never turned up; it's likely Gardner never took it. Booth's face was already too disfigured to recognize. Other marks on the body, a scar and a tattoo, confirmed his identity.

It is not clear whether the sittings took place that day, another day, or over the course of two days, but at some point Gardner photographed each of the primary suspects at least twice, face forward and in a relaxed profile, some in front of a canvas background that Mark Katz identifies as being on the *Montauk*, others in front of a metal gun turret that he identifies as being on the *Saugus*. Given the format, it seems likely they served as mug shots for government records, though Gardner was free after fulfilling his assignment to use the negatives as he wished. As a group, the photographs have an eerie quality to them, especially those posed on the *Saugus*. Most of the prisoners, like Michael O'Laughlin, barely respond to the camera. But his faraway look speaks to a profound isolation made palpable by the jarring contrast between his fashionable street clothes (including a collar and tie) and the medieval-looking cuffs and the pitted iron wall with its massive rivets. Whatever his appearance may tell us about a past life, the photograph emphasizes that he now belongs to the unyielding justice of the law.

Gardner was especially interested in Powell, taking ten different photographs of him. Of these, six would be the only ones from his onboard session he would take the trouble to copyright. Of the ten, six show Powell standing in front of a canvas screen dressed in a light-colored overcoat, sometimes with a hat

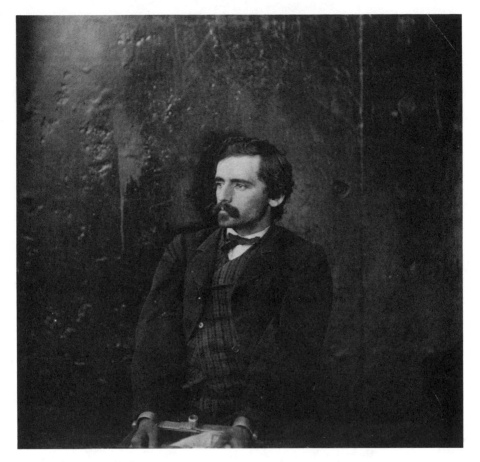

Michael O'Laughlin, by Alexander Gardner, April 1865

on, sometimes with one hand or both in a pocket, at times glaring at the camera (see pages 192 and 193). Throughout the sequence, his feet barely shift on the floor, as if he is simply waiting for Gardner to expose the plate, perhaps turning his head as instructed. Again, the poses likely served the government's uses by showing Powell dressed as he was on the night of his attack; he does, in fact, wear the hat he left behind at the scene. In one image, however, Powell "breaks the fourth wall" (the imaginary wall between stage and audience, or photograph and viewer): shifting his weight to his left leg and tilting his head forward until the rim of the hat shades his eyes, he glares at the camera. Perhaps he was asked to do it; perhaps he allowed himself to express impatience or distrust. Whatever the cause, his figure takes on a veiled sense of power as he seems to step out of the photograph, past the bayoneted guard to the left, and back to Seward's door.

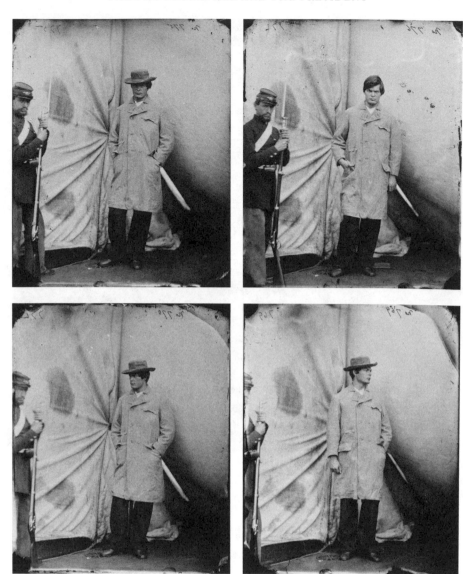

ABOVE AND OPPOSITE:
Lewis Powell (alias "Payne"), by Alexander Gardner, April 1865

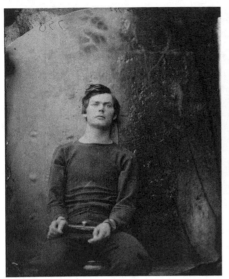

Powell's challenge to the camera is uncannily disconcerting in Gardner's photograph of him sitting in front of the turret. Unlike those of O'Laughlin, Powell's clothes offer no clues to a social identity. In fact, in his dark clothes, leaning back against the iron wall behind him, with his hands at ease in his lap, Powell seems to have taken possession of his environment. He looks at us as a man who knows he is condemned; the cold appeal of his stern look not so much threatens us as challenges us to explain our interest in him, even as his calm face refuses access. It has become one of Gardner's most haunting photographs.

Once the trial was under way, in the second week of May, Powell—or "Payne," as he was known—fascinated the public because of the same qualities visible in Gardner's photographs. Reporters covering the proceedings devoted a lot of attention to characterizing the conspirators, and most of these descriptions were written in terms that presupposed their guilt. Noah Brooks described David Herold as "a small dark man…with a low, receding forehead, scanty black hair and whiskers,…and a vulgar face." "I think I would not have passed Harold [*sic*] on the street," wrote the reporter Jane Swisshelm, "without mentally exclaiming 'ape.'" Brooks found Atzerodt "the completest personification of a low and cunning scoundrel," and his fellow defendant O'Laughlin looked like "a traditional stage villain," the kind of man a "California vigilance committee in 1849…would have hanged…'on general principles.'" Because she was most often veiled, and because of her sex, Mary Surratt was more of a

cipher. Brooks found her "matronly"; another observer, "rather pretty"; and still another, "Amazonian...masculine."

Like other reporters, Brooks also noted how the accused suffered as the machinery of justice moved inexorably to decide their fates. The chains on O'Laughlin's feet clanked as he shifted them. Of Edward Spangler, an employee of Ford's who had held Booth's horse for him, Brooks wrote, "The poor creature, more than any other [of the accused], appeared under the influence of bodily fear." But Powell frustrated all these conventions of characterization. Brooks saw "a good face" that defied "the ordinary physiognomist." Bound in chains and cuffs, he nonetheless "sat bolt upright against the wall, looming up like a young giant above all the others....His brawny, muscular chest, which was covered only by a dark, close-fitting 'sweater,' was that of an athlete." "Who is Payne?" mused the correspondent for the *New York World* late in the trial. "The mystery enshrouding [him], instead of being cleared up, is growing deeper." With language that could easily refer to Gardner's photograph, he continues: "His fortitude is wonderful. Heat, chains, handcuffs, and the awful presence of death, the constant gaze of the eager and curious crowd...neither appal [*sic*] or terrify him in the least."

The military commissioners reached a verdict on June 30. Four conspirators received prison sentences, while Powell, Atzerodt, Herold, and Surratt were condemned to hang. The report of their findings and verdicts was forwarded to President Johnson, along with a recommendation for clemency for Mary Surratt. Five days later, Johnson signed the report, authorizing the sentences but not the recommendation. He later claimed he never saw it; Judge Joseph Holt insisted he had given it to him. The four conspirators to be hanged learned of their fate on July 6, the day before they were to be executed (the four others would wait weeks to learn of their sentences). Soon after they were told, the prisoners in their cells could hear the carpenters sawing and hammering into place a large scaffold in the arsenal courtyard. The construction continued into the night, punctuated several times by loud creaks as workers tested the trapdoors that would swing from beneath the feet of the condemned.

The press followed every moment of the prisoners' final hours. All of them took the news of their sentence calmly at first, but Surratt, Atzerodt, and Herold soon broke down in grief and despair. Surratt, a Catholic, received visits from two priests and her daughter, Anna; Atzerodt spent time with his mother and common-law wife; and Herold was visited by his sisters. With no family close, Powell expressed his remorse to a minister and insisted to his jailer that

Mrs. Surratt should not hang. The next morning, reporters described the wait-
ing crowd in the courtyard heat—it would reach 100 degrees that day—and
gave details of the choreographed proceedings. Just before one o'clock, four
chairs were placed on the deck of the massive scaffold; just past the hour, the
condemned appeared one by one behind General John Hartranft, a Medal of
Honor recipient who served as provost marshal. First came Surratt, supported
by two priests, then Atzerodt and Herold, and finally Powell. After climbing
the stairs and taking a seat in each of the chairs placed beneath the nooses, the
four listened as Hartranft read the order for execution. Next came the actual
preparations. The legs and arms of each were bound with linen strips, hoods
were pulled over their heads, and the nooses were fitted. As they stood in the
heat, Hartranft clapped his hands three times.

An hour earlier, as one of the newspaper correspondents waited for the
proceedings to begin, he heard "the click of hammer" high above the court-
yard. "Presently a window was raised, and forth with was seen protruding the
familiar snout of the camera, showing that the inevitable photographer was
on hand. Gardner's good-humored face presently was seen over the camera,
as he took 'a sight' at the gallows, to see that it was focused properly." As he
had on the *Montauk* and the *Saugus*, Gardner had obtained exclusive access
to the government-controlled event. He and an assistant worked that day
with at least two cameras, a single-lens and a stereo, producing just over a
dozen images.

Eight of them compose a chilling sequence of the execution. Unfolding
with almost stop-action precision, everything about the photographs empha-
sizes the ritualism of the spectacle. To the disappointment of the people who
had crowded the rail stations, roads, and saloons the night before and stood
before the gates at the arsenal that morning, attendance was strictly limited to
officials, press, and military, all of whom can be clearly seen gathering in the
courtyard below the camera, and along the top of the wall above the scaffold. In
the first image, the scaffold is bare except for the four empty chairs; in the next, it
is filled with more than twenty figures standing around the four sitting prisoners.
An umbrella protects Surratt from the sun. In the next image, four umbrellas are
open; beneath one of them is a brilliant patch of white—the order of execution
(see page 196). The next image shows three of the prisoners standing (Surratt,
partially hidden, still sits); one man adjusts Powell's hood, another Herold's
noose. Beneath the scaffold wait the four soldiers charged with knocking out
the supports for the trapdoors at the signal. One of them hangs on a support,
having just vomited from the heat and the tension (see page 197).

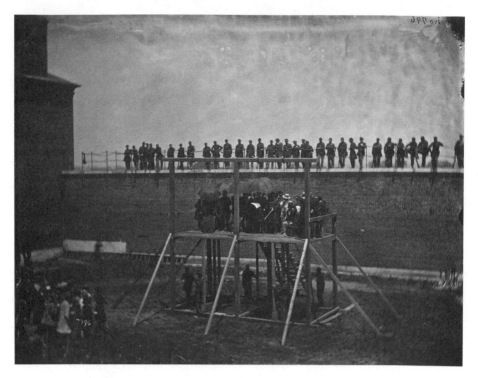

Reading the Death Warrant, by Alexander Gardner

A different camera caught the grimmest moment of the sequence. On Hartranft's third hand clap, the four men below knocked out the supports, the trapdoors dropped, and the four bodies fell into the space below. In the image, the soldiers on the wall, as well as the crowd on the platform, stand transfixed as they watch the bodies, blurred in the film, fall. Gardner waited until the bodies stopped moving (Powell had struggled for some minutes) before taking the final two images in the sequence. In the earlier one, the crowd has already turned away; a soldier just below turns his head to the camera. In the other one, most of the civilians are out of the picture, and most of the soldiers on the wall have gone on to other duties.

Gardner took several more photographs that day, including one of the rifle boxes that served as coffins stacked in front of the rude graves dug just to the right of the scaffold. At some point (likely before), he also posed the officers in charge of the execution for a group portrait in the arsenal yard; four of them apparently sit in the same chairs used on the scaffold. After over three years on the battlefield and in the studio producing images of the terrible reality of war, that day for the

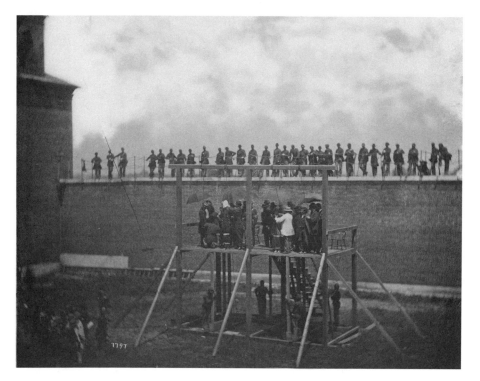

Adjusting the Ropes, by Alexander Gardner

first and only time, he recorded the moment of death and the men who made it happen. With this awful form of clarity, he took his last photographs having to do with Abraham Lincoln and ended his career as a war photographer.

JUST over two weeks later, a number of Gardner's photographs of the execution were published as engravings in the July 22 issue of *Harper's Weekly*. The first image appeared midway through the issue as a full-page composite of two photographs, with the bodies hanging in the scaffold next to their caskets and freshly dug graves (see page 198). The next page includes two more illustrations from Gardner's sequence, as well as vignettes from his portraits of the three men who were hanged (Mrs. Surratt is represented by an image of her home in the lower right) (see page 199). The editors chose to work from a photograph of Powell showing him looking away from the camera— the spread and the accompanying article emphasize closure, not unsettling endings. The written account goes through many of the same details as the

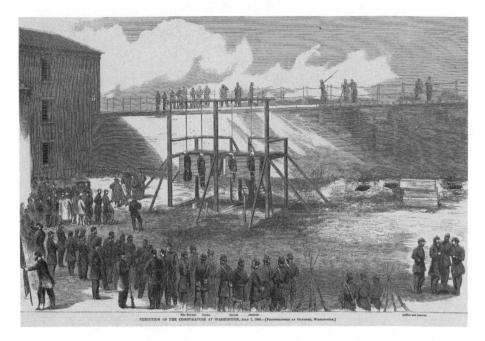

"Execution of the Conspirators at Washington," Harper's Weekly, *July 22, 1865*

newspapers. On the stand, Atzerodt "quaked with fear." After the drop, with "Mrs. Surratt, there was no struggle....Payne lived six minutes and a half." The article ends matter-of-factly: "Thus was completed the memorable history of that conspiracy which three months ago plunged our people into the lowest depths of grief."

The conspiracy is not the only ending marked in that issue. A few pages after Gardner's images, the magazine offers a full-page picture of Fort Sumter "After its Evacuation by the Rebels" from a photograph taken by George Barnard—a former employee of Brady's and colleague of Gardner's. A few pages before the execution images appears the woodcut collage from the Gardner photographs of the Gettysburg dead (see page 116), reprinted as part of the magazine's extensive coverage of the July 4 ceremonies for laying the cornerstone to the Soldier's Monument at the cemetery that Lincoln had dedicated less than two years earlier. The collage appears beneath Gardner's portrait of Major-General Oliver O. Howard, a military hero who gave the monument's dedication address. In words that only distantly recall Lincoln's brilliantly compact eloquence, he links the president's death to those on the battlefield. "These grounds have been already consecrated, and are doubly

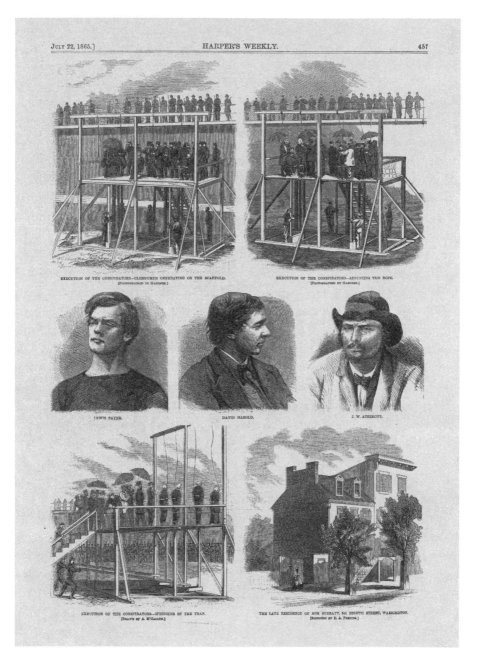

"*The Conspirators and Their Execution,*" Harper's Weekly, *July 22, 1865*

sacred from the memory of our brethren who lie here, and from the association with those remarkable men, Mr. Everett and Mr. Lincoln, who gave tone to the exercises of consecration two years ago, whose own bodies are now resting beneath the sod, but whose spirit is still living and unmistakably animating every true American heart this day."

The coincidence of memorialization and execution brought together by Gardner's images—and the *Harper's* editors who arranged them—makes clear how tied together in the public mind was the "memorable history" of the conspiracy and that of the war. Many have come to understand Lincoln's death as the war's last casualty, but it was only with the death of the conspirators that he could be psychically as well as literally buried and the nation could move on. This tension between looking back and moving forward runs throughout the issue. On the second page, a poetic "Hymn to Peace" is featured next to an article on the economics of "Railroads in Peace Time." Elsewhere the magazine tells of the Army of the Tennessee's being "reduced by 15,000 men," of the Confederate governor of Virginia's being released on parole from the Old Capital Prison, and all "the rebel prisoners'" being released from Point Lookout prison in Maryland. Above the twenty-fifth and twenty-sixth chapters of Amelia D. Edwards's serialized novel, *Half a Million Dollars*, appears a sentimental ode to "A Soldier's Burial" (the man being "left to slumber / In his grave on the wooded hill"). In the final pages, after Barnard's image and a generous spread of pictures and text about the Soldier's Home in New York City, notices for Ann S. Stephens's *Pictorial History of the Civil War for the Union* and E. and H. T. Anthony's "Stereoscopic Views of the War" jockey for attention with ads touting investment opportunities, "Sheep Wash Tobacco," and "J. Havens Patent Mosquito Shield." Each ad testifies to the "final harvest" reaped and society's finally moving forward to embrace, in Gardner's words describing the ruins of Richmond, "the bustle of trade and improvement."

The issue also gives evidence of Gardner's moving on, even at what must have been near the pinnacle of his national reputation. "During the war, now happily ended," the editors write, "we have been in the daily receipt of the greatest variety of views and portraits from all the armies and from every part of the country....Among our photographic friends and allies none have been more constant and serviceable than Mr. Alaxander [*sic*] Gardner, of Washington." Gardner, we are told, has his sights on new projects—a book of photographs about South America and, closer to home, a volume tentatively titled "Memories of the Rebellion" with "a striking series of War Views." For Gardner as for the nation, Abraham Lincoln, his assassination, and the Civil War were now history.

*

DURING a dinner for the Saint Andrews Society at the height of the war in 1863, the furniture merchant James McGuire proposed a toast to Alexander Gardner's contributions to "Art and her handmaid Photography." No one else in the country, he stated, had done more for the profession, and "when this desolating and fratricidal war is over and we return again to the pleasant paths of peace, his collection of Photographic Incidents of the War will be about the only source from which artists for all time will find material to illustrate almost any inspiration." By mid-1865, McGuire's hopes for peace were fulfilled, but he may have thought that his praise for Gardner had fallen short. By the end of the summer, the photographs from Gardner's trip to Richmond in April, combined with his coverage of the assassination and the conspirators, had brought him a national reputation that rivaled Brady's. That fall, his status brought him one more grim high-profile assignment from the government—to photograph the hanging of Captain Henry Wirz, the Confederate commandant of the notorious Andersonville prison. More palatable, and prestigious in a different way, had been his publisher Franklin Philp's sponsorship of one of his pictures, "Colored Photograph of a Lady," in the first annual art show of Washington's exclusive Metropolitan Club, where it hung alongside works by such well-known painters as John Frederick Kensett, Emanuel Leutze, and Albert Bierstadt. He was also engaged to produce forty stereocard views of George Washington's estate for the Mount Vernon Preservation Organization. His one setback came near the end of September, when a fire broke out in his studio, causing nearly $5,000 in damages. Except for one broken negative, all of his pictures were saved, however, and he was able to reopen for business nine days later.

One press account reports that some of the damages were covered by insurance, but had the fire been worse, no amount of money would have reimbursed him for the already considerable work he had put into preparing *Gardner's Photographic Sketch Book of the War*, which would appear in early 1866. Gardner had been intrigued by the possibility of publishing a book of photographs for quite some time. Earlier, in his 1863 *Catalogue of Photographic Incidents of the War*, Gardner had offered his own gallery's photographs bound in a folio of fifty plates for $75. Later, as *Harper's Weekly* had reported in its July 1865 issue, Gardner was indeed working with views of "guano islands" and cathedrals—though they were exclusively of Peru, not all of South America, and his "corps" of operators consisted only of one Henry Moulton, whose fifty (not two hundred) negatives Gardner's studio had simply printed and mounted for binding by Philp & Solomons as a book, *Rays of Sunlight from South America*.

Cover, Gardner's Photographic Sketch Book of the War

The *Sketch Book* was far more ambitious than any of these projects. The production alone asked readers to take it seriously as a work of art. Philp & Solomons offered the two-volume set by subscription, which meant they could fill individual orders with any of a number of different leather bindings and gilding. The volumes themselves are large and unwieldy—seventeen inches wide by twelve inches high. Inside, each photograph, a substantial nine by seven inches, was tipped in on its own page facing a blank one on the left. There is little to distract the eye from the picture except small type identifying operator and printer (Gardner), and a caption. Gardner's commentary precedes each photograph with a page of its own, letterpressed in elaborate type. There is a museum-like quality to the experience of paging through the two volumes from text to image, each by itself inviting a slow, deliberate viewing.

If the books themselves say "art," the progression of the commentary and pictures works more like an idiosyncratic guidebook. The plates begin with a photograph of the Marshall House in Alexandria, where Lincoln's friend Elmer Ellsworth became the symbolic first casualty of the war after capturing the Rebel flag that Tad later waved from the White House. Gardner

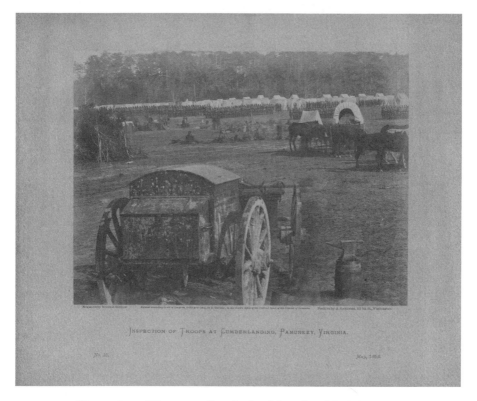

*"Inspection of Troops at Cumberland Landing," by John Wood
and James Gibson; plate 16,* Sketch Book

then leads us through the major campaigns and battles of the Army of the
Potomac, while making little pretense of offering a comprehensive overview
of the war—no images of and virtually no mention of the campaigns in the
West or of Sherman's march through the South. We do see scenes of many
of the major eastern battlefields—Fredericksburg, Antietam, Gettysburg, the
Petersburg trenches—but the images and the commentary make little effort to
map the course of battle or the movement of armies. Still, the last of the one
hundred plates brings us to, if not quite where we began, then close enough to
suggest closure at the dedication ceremonies in 1865 for the monument to the
dead at Bull Run battlefield. As Lincoln had urged in his Gettysburg Address,
the fallen from first to last have been honored.

Gardner's commentary expresses a vigorous Union partisanship: the
Chesterfield Bridge remained under fire as long as "we" held possession, "the
rebels were driven [back], and our cavalry left masters of the field." But there is

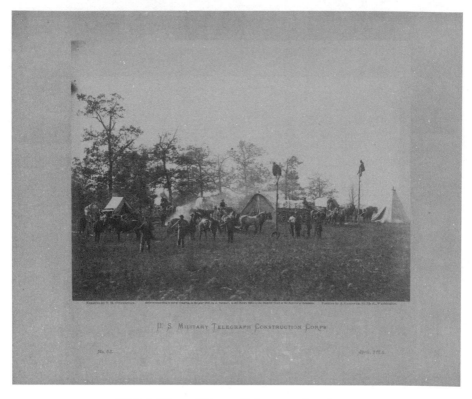

"U.S. Military Telegraph Construction Corps,"
by Timothy O'Sullivan; plate 62, Sketch Book

hardly any mention of the larger issues at stake, preservation of the Union and emancipation. While we see McClellan and Lincoln in their awkward tête-à-tête, there are no photographs of the heroes and generals so widely celebrated in the press, whose *cartes de visite* provided such a steady income for all photographers during the war. Grant is mentioned ten times in the commentary, but nowhere is he pictured; Meade is represented only by Gardner's November photograph of the "humble dwelling" that served as his headquarters at Gettysburg.

Instead, Gardner pictures war as a relentless process of organization, transportation, construction, and destruction pursued not by generals and politicians but by skilled laborers. He does include a number of images that, like the battlefield scenes of Gettysburg, emphasize the human toll of war, and others that document the harrowed and denuded landscapes of violence. But a preponderance of images documents the engineering and mechanics of moving tens of thousands of men and tons of military matériel from one location

Title page, by A. R. Waud (misspelled "Ward"); Sketch Book

to another: railway bridges and pontoon bridges; canals and railroads; engines, ships, and barges. We see the Commissary Department ("nothing less than an immense grocery establishment"), and the provost marshal's office, a field hospital, a wagon park, a portable field battery, and a forge on wheels. Many of these images are filled with men posing in the setting of their work: workmen stringing nearly invisible telegraph wire from pole to pole, "lusty artificers" posed in their field shop working at an anvil or repairing a wagon wheel, and a contingent of soldiers occupying the newly captured Fort Fisher in North Carolina. Gardner does not quite call these men heroes, though his commentary does emphasize their hard work despite privation and danger. Rather, these are the men who make the military go.

That said, it overstates the thematic unity and understates the experimental, even unfinished quality of the whole enterprise to say that the *Sketch Book* is "about," for instance, the common soldier. Gardner takes very seriously his title: what we look at is less a formal work of art than a book of sketches much like the notational drawings made in the field by his friend Alfred Waud, the *Harper's Weekly* special artist who supplied the title page. In addition, Elizabeth Young has made a good case for Gardner's having in mind the literary tradition of the sketchbook made popular by Charles Dickens's *Sketches by Boz*, or Louisa May Alcott's *Hospital Sketches*—works that offer vivid slices of life in personal, reflective pieces that express the sensibility of the author.

For Gardner, the artistry of the book lay less in what he did with a camera—after all, he includes only seventeen of his own photographs (O'Sullivan is credited with forty-three)—than what he does with the pictures. "During the four years of the war," he writes in his introduction, "almost every point of importance has been photographed." He himself has gone through "nearly three thousand" to select the images he wants to gather as "mementos" of "enduring interest." Perhaps the best way to think about the *Sketch Book* is as a family album, meant to document the war but selected and ordered to reflect what he and his family of operators encountered in the field with their cameras. His commentaries often help us see what he finds important in the image, but in them he is prone to using the image as a pretext for writing a narrative about a sharpshooter's dying far from home, or burrowing into military policies concerning the questionable burning of the Norfolk shipyards, or restoring Ulric Dahlgren's integrity, or finding out which fortification soldiers called Fort Hell and which one Fort Damnation and why. Gardner's *Sketch Book* does not show us what happened; it shows us what war looked like in photographs. In exposing some of those pictures, then in selecting, ordering, printing, and mounting them, and then in commenting on them with a mix of imagination, reflection, and research, Gardner offers a self-conscious lesson in the power and limits of photography to make sense of the world, a model for the kind of looking it takes to find history in pictures.

The *Sketch Book* is a lasting contribution to the history of photography, but as a business venture, it was a disappointment. While an advertising notice promised that the volumes, bound in "magnificent style," were "destined to have an immense sale," Gardner must have known that, at $150 a set, he was catering to an exclusive market. Surely, though, given the labor of preparing each volume, he hoped to reach more buyers than the fewer than two hundred he apparently found. The *Sketch Book*, however, was but one of a number of photographic projects that Gardner pursued during the next few years. In 1866 the *National Intelligencer* in Washington, with which for a period Gardner shared a building, declared his recent portfolio of photographs of Washington's public buildings—the Capitol, the Treasury, the White House, and the like—examples of the "photographic art, in its highest development and its richest finish." A year later, he garnered even more effusion from another local paper, which praised his three-foot-by-four-foot photograph of the Capitol "the most magnificent production of artistic skill in photography that has yet been realized either in Europe or America." Gardner, pronounced the writer, was simply "the legitimate king of photography." These are hardly objective

critiques—in fact, there is a good chance that Gardner may have placed them himself, either with a reporter willing to "puff" his work or in his own hand. But they give an idea of the ambition with which he pursued his craft and its marketing in the years after the war.

In 1867 that ambition took Gardner to Kansas as chief photographer of the Union Pacific Railway Eastern Division (later renamed the Kansas Pacific Railroad). There he joined a survey team that explored a possible route for a transcontinental railroad roughly along the thirty-fifth parallel to the Pacific Ocean. His job as photographer was to document the topography and features of the land, its habitat, and its inhabitants in such a way as to attract investors and government support—which he did successfully enough for the survey's final report in 1869 to include a number of his pictures. Alongside those he also produced an extensive series of more than 150 stereographs of Kansas, along with a portfolio of 127 full-plate prints. He returned to the West again in April and May 1868, this time employed by the government to document its negotiation at Fort Laramie, Wyoming, of major peace treaties with a number of the northern Indian nations. He returned at the end of May with something like two hundred negatives of the negotiations, including the only period photograph of the ritual smoking of a pipe, as well as images documenting the camp life of Indians visiting the area for the proceedings. In Washington, Gardner continued to photograph members of Indian delegations, especially when in 1872 he was named the official photographer for the Bureau of Indian Affairs. Many of his portraits present their subjects, some dressed traditionally, others in European clothes, with the same dignity and nuance as those of Lincoln.

Gardner's national reputation as a photographer grew. In 1874 he would be elected, along with the great portraitist Albert Sands Southworth, to the Committee on the Progress of Photography for the National Photographic Association. Even so, he began devoting more of his energy to the civic and business life of Washington. By the end of the war, he had grown increasingly active in real-estate investment; over the next decade, he would serve as president of the Equitable Co-operative Building Association and trustee for the Union Town Building Association and the Equitable Democratic Association. He also served for several years on the Levy Court of Washington, until it was dissolved in 1871, as well as on the Washington Board of Trade and the General Committee for bringing a "Grand International Industrial Exposition" to Washington.

In 1868, in a move that must have been tantamount to declaring US citizenship, Gardner switched his Masonic affiliation from Scotland, the home

of Freemasonry. By then American Freemasonry had long ago shed its notorious reputation as a secret society of intrigue and power, emerging as a stolid middle-class fraternal organization that brought men together for benevolence, philanthropy, moral uplift, and self-improvement. In the years following the war, it was the largest of a number of organizations that offered urban men a blend of brotherhood and civic engagement. In Washington by the late 1870s, listings in the city directory for "Secret and Benefit Societies" took more space than churches and served much the same social purpose. Once Gardner became affiliated with a local lodge in Washington, he threw himself into the fraternity with gusto. Aside from community projects, Masons were expected to work their way up through "degrees," or ranks, by participating in elaborate rituals, complete with costumes, scripts, and arcane symbologies of ancient wisdom. Gardner was enthusiastic enough about the whole process to pose in a buckskin costume as a stout bearded American Indian complete with bow and moccasins. During the next decade, he would work his way through the degrees until he achieved the highest rank, Knight Templar, the year before he died.

Ultimately, it was Freemasonry that drew him out of photography and into the profession he was best known for when he died in 1882. A common expectation of Masonic brothers was a commitment to helping those in need, both in the fraternity and outside of it. Gardner was very active in organizing this kind of charitable giving, going so far as to help found the Saint John's Mite Association. Later he was a key organizer in an effort to aid victims of a "great plague" (likely influenza) that was sweeping the South. It is also likely that the goal of at least some of the building associations he involved himself with was to make inexpensive and fair mortgages available to those who normally could not buy property. Within the Masons, Gardner grew increasingly active in organizing the charitable distribution of death benefits to family members, going so far as to devise a system for regularizing cash reserves and covering costs. When the fraternity founded its own independent life insurance company, Gardner soon joined the board. By the late 1870s, he had emerged as a national voice for insurance reform.

Josephine Cobb suggests that, at some point after the war, Gardner was able to live off income from his real-estate investments. However he lived, his interest in photography dwindled in the last decade of his life. In 1869 Gardner and Brady separately petitioned Congress to purchase their collections of Civil War images, but nothing came of the idea. (The government would later purchase a sizable collection of Brady's images at bankruptcy auction.) Sometime

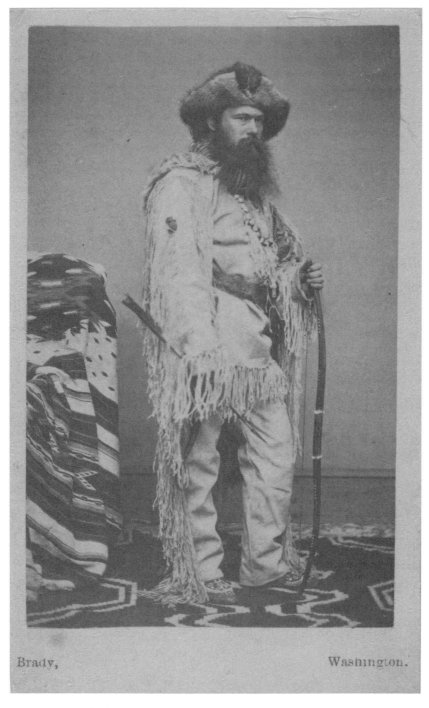

Brady, Washington.

Self-Portrait in Buckskin, by Alexander Gardner

after 1875, Gardner sold a large number of his negatives to Moses Rice, who would later copyright them, including the Gettysburg Lincoln, as his own. (Another sizable part of Gardner's negatives languished under a stairway and between the floors of a building on Pennsylvania Avenue, near where he had last listed his gallery's address, until they were discovered in 1893.) By the late 1870s, Gardner's interests lay primarily in his duties as secretary of the Washington Beneficial Endowment Association, and as secretary—and finally, on November 22, 1882, as president—of the Masonic Mutual Relief Association of the District of Columbia. He would occupy the office for only eighteen days before succumbing to a sudden illness on December 10, 1882.

His death merited a headline obituary in the *Washington Post*: "Alexander Gardner Dead: A Prominent Figure in Masonic and Other Circles Passes Away." To be sure, the article acknowledges Gardner's "national reputation as a photographer" and goes on to note that "his pictures of the campaigns in Virginia are preserved as the only worthy representations of any of the scenes of the war taken on the spot." But the bulk of the notice focuses on his "busy life...done in connection with the Masonic and other mutual assessment relief associations." His loss to "the cause...of life assurance will be well nigh irreparable." The directors of the Masonic Mutual Relief Association passed a resolution recognizing, among other things, "his unblemished integrity," and pledged to "drape the office in mourning for thirty days." In January, Joseph Wilson delivered a formal eulogy of Gardner, praising him as an experimentalist in photography, an abolitionist and "enemy of slavery," and a philanthropist "deeply interested in all plans to encourage self-reliance among the poor and lowly and to recognize the common brotherhood of man." Later the *Philadelphia Photographer* reprinted Wilson's remarks, while adding a few of its own: "Who, in photography, has not heard of Alexander Gardner? He was one of our veterans—one of photography's staunchest friends...We all feel his loss, and regret that we shall never again see his genial face or grasp his hand."

Like many of the men whose bodies he photographed on the battlefields and like the president he photographed in the studio and out, Gardner died, as it were, in mid-stride, eager to begin a new project in a "busy life."

SELECTED BIBLIOGRAPHY

A WORD ABOUT SOURCES

A bibliography reflects the intellectual scope of any work of research, and mine certainly does that. In fact, I include more sources than those I cite in the notes, in the hope that readers might find material that rewards their curiosity as much as it did mine.

It does not, however, represent sufficiently the experience of entering the rich and daunting field of Lincoln studies for the first time or show the debt I owe to a number of exceptional scholars who have brought Lincoln and his world alive with an enviable combination of graceful writing and challenging scholarship. Three biographies, in particular, guided me through Lincoln's presidency and a continent of Lincoln scholarship. I have cited and quoted liberally from Michael Burlingame's *Abraham Lincoln*, David Herbert Donald's *Lincoln*, and Doris Kearns Goodwin's *Team of Rivals*. I also learned much from the work of Eric Foner, Allen Guelzo, Harold Holzer, and Ronald White. Finally, I want to mention three short works that went a long way toward inspiring this book: Alan Trachtenberg's essay "Lincoln's Smile," Alan Gurganus's meditation "The Ramada Inn at Shiloh," and Adam Gopnik's *Angels and Ages*. One could hardly do better than begin an intellectual journey with such imaginative and thought-provoking touchstones.

One last word: Scholarship hardly goes anywhere without the help of digital collections. First and foremost among these is the Prints and Photographs Online Collection at the Library of Congress. We are only beginning to see how it will transform research in visual culture. Another site I have mined much from is the Internet Archive at www.archive.org, which hosts a rich collection of popular nineteenth-century texts. The Abraham Lincoln Association maintains Lincoln's Collected Works online, while the Lincoln Log offers a thorough chronology of every day of Lincoln's life. I am also fortunate to have access to extraordinary digital research resources through the College of William & Mary. These are only a few of the many online collections and archives that helped make this book possible.

Adams, John Coleman. "Lincoln's Place in History." *Century* 47 (1894): 590–95.

Anderson, Elbert. *The Sky-Light and the Dark Room: A Complete Text-Book on Portrait Photography*. Philadelphia: Benerman & Wilson, 1872.

Barr, John McKee. *Loathing Lincoln: An American Tradition from the Civil War to the Present* (in series Conflicting Worlds: New Dimensions of the American Civil War). Baton Rouge: Louisiana State University Press, 2014.

Blake, David Haven. *Walt Whitman and the Culture of American Celebrity*. New Haven, CT: Yale University Press, 2006.

Blight, David. *Race and Reunion: The Civil War in American Memory*. Cambridge, MA: Harvard University Press, 2001.

Blodgett, Harold. "Whitman and Buchanan." *American Literature* 2, no. 2 (1930): 131–40.

Blondheim, Menahem. "'Public Sentiment Is Everything': The Union's Public Communications Strategy and the Bogus Proclamation of 1864." *Journal of American History* 89, no. 3 (Dec. 2002): 869–99.

Blue, Frederick J. "The Poet and the Reformer: Longfellow, Sumner, and the Bonds of Male Friendship, 1837–1874." *Journal of the Early Republic* 15, no. 2 (Winter 1995): 273–97.

Boritt, Gabor. *The Gettysburg Gospel: The Lincoln Speech That Nobody Knows*. New York: Simon & Schuster, 2006.

Borreson, Ralph. *When Lincoln Died*. New York: Appleton-Century, 1965.

Boykin, Edward M. *The Falling Flag: Evacuation of Richmond, Retreat and Surrender at Appomattox*. New York: E. T. Hale & Son, 1874.

Brake, Laurel, and Marysa Demoor. *Dictionary of Nineteenth-Century Journalism in Great Britain and Ireland*. Ghent, Belgium: Academia Press, 2009.

Bray, Robert. *Reading with Lincoln*. Carbondale: Southern Illinois University Press, 2010.

Brooks, Noah. *Lincoln Observed: Civil War Dispatches of Noah Brooks*. Baltimore: Johns Hopkins University Press, 1998.

———. *Mr. Lincoln's Washington: Selections from the Writings of Noah Brooks, Civil War Correspondent*. New York: Thomas Yoseloff, 1967.

Brooks, Noah, and Herbert Mitgang. *Washington, D.C., in Lincoln's Time*. Athens: University of Georgia Press, 1989.

Brown, Clarence A. "Walt Whitman and Lincoln." *Journal of the Illinois State Historical Society* 47 (1954): 176–84.

Bunker, Gary L. *From Rail-Splitter to Icon: Lincoln's Image in Illustrated Periodicals, 1860–1865*. Kent, OH: Kent State University Press, 2001.

Burlingame, Michael. *Abraham Lincoln: A Life*. Baltimore, MD: Johns Hopkins University Press, 2008.

———. *The Inner World of Abraham Lincoln*. Urbana: University of Illinois Press, 1994.

Byrd, Cecil. "Some Notes on Thomas D. Jones, Sculptor of Lincoln." *Indiana University Bookman* 2 (1957): 26–37.

Byrd, Cecil K., and Ward W. Moore. *Abraham Lincoln in Print and Photograph: A Picture History from the Lilly Library*. Mineola, NY: Dover, 1997.

Carpenter, Francis Bicknell. *The Inner Life of Abraham Lincoln: Six Months at the White House*. New York: Hurd & Houghton, 1867.

Carwardine, Richard. "Abraham Lincoln and the Fourth Estate: The White House and the Press during the American Civil War." *American Nineteenth Century History* 7, no. 1 (2006): 1–27.

Cobb, Josephine. "Alexander Gardner." *Image* 62 (1958): 124–36.

———. "Mathew B. Brady's Photographic Gallery in Washington." *Records of the Columbia Historical Society, Washington, D.C.* 53/56 (1953): 28–69.

Coddington, Ronald S. *African American Faces of the Civil War: An Album*. Baltimore: Johns Hopkins University Press, 2012.

Colman, George W. "Assassination of the President: A Discourse on the Death of Abraham Lincoln, President of the United States," delivered at Acton, MA, Apr. 16, 1865; repeated in the Baptist Church, West Acton, June 1, 1865. Boston: S. Chism, 1865.

Crane, Cephas B. "Sermon on the Occasion of the Death of President Lincoln," preached in the South Baptist Church, Hartford, CT, Sunday, Apr. 16, 1865. Hartford: Press of Case, Lockwood & Co., 1865.

Crary, Jonathan. *Suspensions of Perception: Attention, Spectacle, and Modern Culture* (October Books). Cambridge, MA: MIT Press, 2001.

———. *Techniques of the Observer: On Vision and Modernity in the Nineteenth Century* (October Books). Cambridge, MA: MIT Press, 1992.

Dabakis, Melissa. "Sculpting Lincoln: Vinnie Ream, Sarah Fisher Ames, and the Equal Rights Movement." *American Art* 22, no. 1 (Spring 2008): 78–101.

Davis, Keith F. *The Origins of American Photography: From Daguerreotype to Dry-Plate, 1839–1885, the Hallmark Photographic Collection at the Nelson-Atkins Museum of Art.* Kansas City, MO: Nelson Atkins, 2007.

———. "'A Terrible Distinctness': Photography of the Civil War Era," in *Photography in Nineteenth-Century America*, ed. Martha Sandweiss, 130–79. Fort Worth, TX: Amon Carter Museum, 1991.

Davis, William C. *Lincoln's Men: How President Lincoln Became Father to an Army and a Nation.* New York: Free Press, 1999.

Dawley, Thomas Robinson. *Old Abe's Jokes, Fresh from Abraham's Bosom, Containing All His Issues, Excepting the "Greenbacks," to Call in Some of Which, This Work Is Issued.* New York: T. R. Dawley, 1864.

Desjardin, Thomas A. *These Honored Dead: How the Story of Gettysburg Shaped American Memory.* Cambridge, MA: Da Capo Press, 2003.

Dirck, Brian. *Lincoln the Lawyer.* Urbana and Chicago: University of Illinois Press, 2007.

Donald, David Herbert. *Lincoln.* New York: Simon & Schuster, 1996.

Dreese, Michael A. *The Hospital on Seminary Ridge at the Battle of Gettysburg.* Jefferson, NC: McFarland & Co., 2005.

Eaton, Edward Bailey. *Original Photographs Taken on the Battlefields During the Civil War of the United States.* Hartford, CT: E. B. Eaton, 1907.

Epstein, Daniel Mark. *Lincoln's Men: The President and His Private Secretaries.* New York: Smithsonian Books/Collins, 2009.

Fahs, Alice. *The Imagined Civil War: Popular Literature of the North & South, 1861–1865.* Chapel Hill: University of North Carolina Press, 2001.

Faust, Drew Gilpin. *This Republic of Suffering: Death and the American Civil War.* New York: Knopf, 2008.

Fehrenbacher, Don, and Virginia Fehrenbacher. *Recollected Words of Abraham Lincoln.* Palo Alto, CA: Stanford University Press, 1996.

Folsom, Ed. "'This Heart's Geography Map': The Photographs of Walt Whitman." The Walt Whitman Archive, http://whitmanarchive.org/multimedia/gallery/introduction.html (accessed Apr. 13, 2013).

———. *Walt Whitman: The Centennial Essays.* Iowa City: University of Iowa Press, 1994.

Folsom, Ed, and Kenneth M. Price. The Walt Whitman Archive, www.whitmanarchive.org.

Foner, Eric. *The Fiery Trial: Abraham Lincoln and American Slavery.* New York: Norton, 2010.

———, ed. *Our Lincoln: New Perspectives on Lincoln and His World.* New York: Norton, 2008.

Forney, John Wien. *Anecdotes of Public Men.* New York: Harper & Brothers, 1877.

Fox, Richard Wightman. "'A Death-Shock to Chivalry, and a Mortal Wound to Caste': The Story of Tad and Abraham Lincoln in Richmond." *Journal of the Abraham Lincoln Association* 33, no. 2 (Summer 2012): 1–19.

Frassanito, William A. *Antietam: The Photographic Legacy of America's Bloodiest Day.* New York: Charles Scribner's Sons, 1978.

———. *Early Photography at Gettysburg.* Gettysburg, PA: Thomas Publications, 1995.

———. *Gettysburg: A Journey in Time.* New York: Charles Scribner's Sons, 1975.

———. *Grant and Lee: The Virginia Campaigns, 1864–1865.* New York: Charles Scribner's Sons, 1983.

Freedman, Russell. *Lincoln: A Photobiography.* Boston: Sandpiper, 1989.

French, Benjamin Brown. *Witness to the Young Republic: A Yankee's Journal, 1828–1870.* Hanover, NH: University Press of New England, 1989.

Furgurson, Ernest B. *Ashes of Glory: Richmond at War.* New York: Knopf, 1996.

———. *Freedom Rising: Washington in the Civil War.* New York: Vintage, 2005.

Gallagher, Gary. *Causes Won, Lost, and Forgotten: How Hollywood and Popular Art Shape What We Know About the Civil War.* Chapel Hill: University of North Carolina Press, 2008.

Gardner, Alexander. *Gardner's Photographic Sketch Book of the War*. Washington, D.C.: Philp & Solomons, 1866.

———. *Incidents of the War: Alexander Gardner's Antietam Photographs*. Daytona Beach, FL: Southeast Museum of Photography, 1994.

Gardner, Alexander, the George Eastman House, and Mulvane Art Center. *Alex. Gardner's Photographs Along the 35th Parallel*. Rochester, NY: George Eastman House, 1971.

Glover III, Charles C. "A Brief History of the Metropolitan Club." *Records of the Columbia Historical Society, Washington, D.C.* 60/62 (1960): 266–77.

Good, Timothy S. *We Saw Lincoln Shot: One Hundred Eyewitness Accounts*. Jackson: University Press of Mississippi, 1995.

Goodrich, Thomas. *The Darkest Dawn: Lincoln, Booth, and the Great American Tragedy*. Bloomington: Indiana University Press, 2005.

Goodwin, Doris Kearns. *Team of Rivals: The Political Genius of Abraham Lincoln*. New York: Simon & Schuster, 2005.

Gopnik, Adam. *Angels and Ages: A Short Book About Darwin, Lincoln, and Modern Life*. New York: Knopf, 2009.

Guelzo, Allen C. "Come-Outers and Community Men: Abraham Lincoln and the Idea of Community in Nineteenth-Century America." *Journal of the Abraham Lincoln Association* 21, no. 1 (Winter 2000): 1–29.

———. *Lincoln's Emancipation Proclamation: The End of Slavery in America*. New York: Simon & Schuster, 2006.

Gurganus, Allan. "The Ramada Inn at Shiloh." *Granta* 35 (Spring 1991), www.allangurganus.com/essays/first-essay-title (accessed Feb. 11, 2012).

Hannaford, Katharine W. "'Now He Belongs to the Ages': The Legacy of Abraham Lincoln, Abstract and Concrete." *American Quarterly* 51, no. 4 (1999): 871–81.

Harris, Maverick Marvin. "Democratic Party." *Walt Whitman: An Encyclopedia*, ed. J. R. LeMaster and Donald D. Kummings (New York: Garland, 1998), at the Walt Whitman Archive, www.whitmanarchive.org/criticism/current/encyclopedia/entry_5.html (accessed June 5, 2014).

Harris, William C. *Lincoln's Last Months*. Cambridge, MA: Harvard University Press, 2004.

Harvey, Eleanor Jones. *The Civil War and American Art*, exhibition catalog, Metropolitan Museum, New York. New Haven, CT: Yale University Press, 2012.

Hawthorne, Nathaniel. "Chiefly About War Matters by a Peaceable Man," in *Sketches and Studies*, 105–56. Boston: Houghton Mifflin, 1883.

Hay, John. "Life in the White House in the Time of Lincoln." *Century* 41 (1890): 33–37.

Hay, John, and Michael Burlingame. *At Lincoln's Side: John Hay's Civil War Correspondence and Selected Writings*. Carbondale: Southern Illinois University Press, 2000.

Hay, John, and Michael Burlingame. *Lincoln's Journalist: John Hay's Anonymous Writings for the Press, 1860–1864*. Carbondale: Southern Illinois University Press, 1998.

Hay, John, Michael Burlingame, and John R. Turner Ettlinger. *Inside Lincoln's White House: The Complete Civil War Diary of John Hay*. Carbondale: Southern Illinois University Press, 1997.

Herndon, William Henry, Jesse William Weik, Douglas L. Wilson, and Rodney O. Davis. *Herndon's Lincoln*. Urbana: Knox College Lincoln Studies Center and University of Illinois Press, 2006.

Holmes, Oliver Wendell. "Doings of the Sunbeam," in *Photography: Essays and Images*, ed. Beaumont Newhall, 63–77. New York: Metropolitan Museum of Art, 1980.

———. "My Hunt After the Captain." *Atlantic Monthly* 10, no. 62 (1862): 738–64.

———. "The Stereoscope and the Stereograph," in *Photography: Essays and Images*, ed. Beaumont Newhall, 53–61. New York: Metropolitan Museum of Art, 1980.

Holzer, Harold. "The Campaign of 1860: Cooper Union, Mathew Brady, and the Campaign of Words and Images," in *Lincoln Revisited: New Insights from the Lincoln Forum*, ed. John Simon, Harold Holzer, and Dawn Vogel, 57–80. New York: Fordham University Press, 2007.

———. *Emancipating Lincoln: The Proclamation in Text, Context, and Memory*. Cambridge, MA: Harvard University Press, 2012.

—. *Lincoln at Cooper Union: The Speech That Made Abraham Lincoln President*. New York: Simon & Schuster, 2006.

—. *Lincoln President-Elect: Abraham Lincoln and the Great Secession Winter 1860–1861*. New York: Simon & Schuster, 2008.

—. "Visualizing Lincoln: Abraham Lincoln as Student, Subject, and Patron of the Visual Arts," in *Our Lincoln: New Perspectives on Lincoln and His World*, ed. Eric Foner, 80–106. New York: Norton, 2008.

Holzer, Harold, G. S. Boritt, and Mark E. Neely. *The Lincoln Image: Abraham Lincoln and the Popular Print*. New York: Scribner Press, 1984.

Holzer, Harold, Edward Steers, and John F. Hartranft. *The Lincoln Assassination Conspirators: Their Confinement and Execution, as Recorded in the Letterbook of John Frederick Hartranft*. Baton Rouge: Louisiana State University Press, 2009.

Holzer, Harold, Craig L. Symonds, and Frank J. Williams. *The Lincoln Assassination: Crime and Punishment, Myth and Memory*. New York: Fordham University Press, 2010.

Hoobler, Dorothy. *Photographing History: The Career of Mathew Brady*. New York: Putnam, 1977.

Jay, Harriet. *Robert Buchanan, Some Account of His Life, His Life's Work, and His Literary Friendships*. London: T. Fisher Unwin, 1903.

Johnson, Brooks. *An Enduring Interest: The Photographs of Alexander Gardner*. Norfolk, VA: Chrysler Museum, 1991.

Johnson, Carla K.. "Lopsided Lincoln: Laser Scans Reveal Facial Defect." *USA Today*, Aug. 13, 2007, http://usatoday30.usatoday.com/tech/science/discoveries/2007-08-13-lincoln-facial-asymmetry_N.htm (accessed Mar. 18, 2014).

Johnson, William S. *Nineteenth-Century Photography: An Annotated Bibliography 1839–1879*. Boston: G. K. Hall, 1990.

Jones, Thomas. *Memories of Lincoln*. New York: Press of the Pioneers, 1934.

Katz, D. Mark. *Witness to an Era: The Life and Photographs of Alexander Gardner: The Civil War, Lincoln, and the West*. New York: Viking, 1991.

Kauffman, Michael W. *American Brutus: John Wilkes Booth and the Lincoln Conspiracies*. New York: Random House, 2004.

Keckley, Elizabeth. *Behind the Scenes in the Lincoln White House: Memoirs of an African-American Seamstress*. Mineola, NY: Dover, 2006.

Kelbaugh, Ross J. *Introduction to Civil War Photography*. Gettysburg, PA: Thomas Publications, 1991.

Kendall, Amos. *Letters on Our Country's Crisis*. Washington, D.C.: Constitutional Union, 1864.

Kunhardt, Philip B., Peter W. Kunhardt, and Peter W. Kunhardt Jr. *Lincoln, Life-Size*. New York: Knopf, 2009.

—. *Looking for Lincoln: The Making of an American Icon*. New York: Knopf, 2008.

Lamb, Brian, and Susan Swain, eds. *Abraham Lincoln: Great American Historians on Our Sixteenth President*. New York: PublicAffairs, 2010.

Lankford, Nelson. *Richmond Burning: The Last Days of the Confederate Capital*. New York: Viking, 2002.

Lee, Anthony W., and Elizabeth Young. *On Alexander Gardner's Photographic Sketch Book of the Civil War*. Berkeley: University of California Press, 2007.

Lee, Richard M. *Mr. Lincoln's City: An Illustrated Guide to the Civil War Sites of Washington*. McLean, VA: EPM Publications, 1981.

Leech, Margaret. *Reveille in Washington 1860–1865*. Simon Publications, 2001.

Lincoln, Abraham. *Speeches and Writings 1859–1865: Speeches, Letters, and Miscellaneous Writings; Presidential Messages and Proclamations*. New York: Library of America, 1989.

—. *Speeches and Writings: Speeches, Letters, and Miscellaneous Writings; The Lincoln-Douglas Debates*. New York: Library of America, 1989.

McClellan, George Brinton, and William Cowper Prime. *McClellan's Own Story: The War for the Union*. New York: C. L. Webster, 1886.

McCoo, Don K. "A Rare Specimen Found: Alexander Gardner, Scots Photographer, 1821–1892," diss., Glasgow School of Art, 1985.

McPherson, James M. *Abraham Lincoln*. New York: Oxford University Press, 2009.

———. *Battle Cry of Freedom: The Civil War Era* (Oxford History of the United States). New York: Oxford University Press, 2003.

———. *Crossroads of Freedom: Antietam* (Pivotal Moments in American History). New York: Oxford University Press, 2002.

———. *Tried by War: Abraham Lincoln as Commander in Chief*. New York: Penguin Press, 2008.

Markle, Donald E. *Spies and Spymasters of the Civil War*. New York: Hippocrene Books, 1999.

Marvel, William. *Lincoln's Darkest Year: The War in 1862*. Boston: Houghton Mifflin Harcourt, 2008.

Masur, Louis P. "'The Special Correspondent.'" *Opinionator* blog, Mar. 24, 2011, *New York Times*, http://opinionator.blogs.nytimes.com/2011/03/24/the-special-correspondent (accessed June 14, 2014).

Meehan, Sean Ross. *Mediating American Autobiography: Photography in Emerson, Thoreau, Douglass, and Whitman*. Columbia: University of Missouri Press, 2008.

Miller, Angela L., Janet C. Berlo, Bryan Wolf, and Jennifer L. Roberts. *American Encounters*. Upper Saddle River, NJ: Pearson, 2007.

Miller, Francis Trevelyan. *Portrait Life of Lincoln: Life of Abraham Lincoln, the Greatest American*. Springfield, MA: Patriot Pub. Co., 1910.

Mitchell, Alexander D. *Washington, D.C., Then and Now*. Charlotte, NC: Thunder Bay Press, 1999.

Morris, Errol. "The Interminable, Everlasting Lincolns," part 1. *Opinionator* blog, *New York Times*, http://opinionator.blogs.nytimes.com/2013/12/02/the-interminable-everlasting-lincolns-part-1/?_php=true&_type=blogs&_r=0 (accessed Dec. 3, 2013).

Morris, Roy. *The Better Angel: Walt Whitman in the Civil War*. New York: Oxford University Press, 2000.

National Portrait Gallery. *Faces of Discord: The Civil War Era at the National Portrait Gallery*. Washington, D.C.: Smithsonian, 2006.

Neely, Mark E. "The Last Life Portrait of Lincoln." *Lincoln Lore*, no. 1700 (1979): 1–2.

Neely, Mark E., and Harold Holzer. *The Lincoln Family Album*. Carbondale: Southern Illinois University Press, 1990.

Nelson, Megan Kate. *Ruin Nation: Destruction and the American Civil War*. Athens: University of Georgia Press, 2012.

Newhall, Beaumont. *The Daguerreotype in America*. New York: Dover, 1976.

———. *The History of Photography: From 1839 to the Present*. Boston: Little, Brown, 1988.

Newhall, Beaumont, ed. *Photography: Essays and Images*. New York: Metropolitan Museum of Art, 1980.

Nicolay, John. "Lincoln's Gettysburg Address." *Century* 47 (1894): 596–609.

———. "Lincoln's Personal Appearance." *Century* 42 (1891): 932–38.

Nudelman, Franny. *John Brown's Body: Slavery, Violence, and the Culture of War*. Chapel Hill: University of North Carolina Press, 2004.

Obama, Barack. "What I See in Lincoln's Eyes." *Time*, July 4, 2005: 74.

Ostendorf, Lloyd, and Charles Hamilton. *Lincoln's Photographs: A Complete Album*. Dayton, OH: Rockywood Press, 1998.

Panzer, Mary. *Mathew Brady and the Image of History*. Washington, D.C.: National Portrait Gallery and Smithsonian Institution Press, 1997.

Passonneau, Joseph. *Washington Through Two Centuries*. New York: Monacelli Press, 2004.

Perich, Shannon. *The Changing Face of Portrait Photography: From Daguerreotype to Digital*. Washington, D.C.: Smithsonian Books, 2011.

Peterson, Anne E. "Alexander Gardner in Review." *History of Photography* 34, no. 4 (Nov. 2010): 356–67.

Pollak, Vivian R. "Whitman Unperturbed: The Civil War and After," in *Walt Whitman: The Centennial Essays*, ed. Ed Folsom, 30–47. Iowa City: University of Iowa Press, 1994.

Porter, David D. *Incidents and Anecdotes of the Civil War*. New York: D. Appleton, 1885.

Porter, Horace. *Campaigning with Grant*. New York: Century, 1897.

Pritzker, Barry. *Mathew Brady*. East Bridgewater, MA: JG Press, 2003.

Reed, Robert. *Old Washington, D.C., in Early Photographs, 1846–1932*. Mineola, NY: Dover, 1980.

Reynolds, David S. *Walt Whitman's America: A Cultural Biography*. New York: Knopf, 1995.

Rice, Allen Thorndike, ed. *Reminiscences of Abraham Lincoln by Distinguished Men of His Time*. New York: North American Pub. Co., 1886.

Risley, Ford. "The President's Editor: John W. Forney of the Press and Morning Chronicle." *American Journalism* 26, no. 4 (Fall 2009): 63–85.

Rodgers, H. J. *Twenty-Three Years Under a Sky-Light; or, Life and Experiences of a Photographer*. H. J. Rodgers, 1872.

Roper, Robert. *Now the Drum of War: Walt Whitman and His Brothers in the Civil War*. New York: Walker & Co., 2008.

Rosenheim, Jeff. *Photography and the American Civil War*. New York: Metropolitan Museum of Art, 2013.

Rosenzweig, Roy. *The Presence of the Past: Popular Uses of History in American Life*. New York: Columbia University Press, 1998.

Russell, William Howard. *My Diary North and South*. Boston: T.O.H.P. Burnham, 1863.

Samuels, Shirley. *Facing America: Iconography and the Civil War*. New York: Oxford University Press, 2004.

Sandler, Martin W. *Lincoln Through the Lens: How Photography Revealed and Shaped an Extraordinary Life*. London: Walker Books for Young Readers, 2008.

Sandweiss, Martha, ed., and Carter Museum of Western Art. *Photography in Nineteenth-Century America*. Amon Carter Museum, Fort Worth, and Harry N. Abrams, New York, 1991.

Savas, Theodore P. *Brady's Civil War Journal: Photographing the War, 1861–65*. New York: Skyhorse Publishing, 2008.

Schwartz, Barry. *Abraham Lincoln and the Forge of National Memory*. Chicago: University of Chicago Press, 2000.

———. *Abraham Lincoln in the Post-Heroic Era: History and Memory in Late Twentieth-Century America*. Chicago: University of Chicago Press, 2008.

Sears, Stephen W. *The Civil War: The Second Year Told by Those Who Lived It*. New York: Library of America, 2012.

———. *George B. McClellan: The Young Napoleon*. New York: Da Capo Press, 1988.

———. *Gettysburg*. Boston: Houghton Mifflin, 2003.

Sears, Stephen W., ed. *Landscape Turned Red: The Battle of Antietam*. Boston: Mariner Books, 2003.

Sheldon, George. *When the Smoke Cleared at Gettysburg: The Tragic Aftermath of the Bloodiest Battle of the Civil War*. Naperville, IL: Cumberland House, 2003.

Simon, John, Harold Holzer, and Dawn Vogel. *Lincoln Revisited: New Insights from the Lincoln Forum*. New York: Fordham University Press, 2007.

Simpson, Brooks D., ed. *The Civil War: The Third Year Told by Those Who Lived It*. New York: Library of America, 2013.

Simpson, Brooks D., Stephen W. Sears, and Aaron Sheehan-Dean, eds. *The Civil War: The First Year Told by Those Who Lived It*. New York: Library of America, 2011.

Sims, William J. "Matthew Henry Wilson, 1814–1892." *Connecticut Historical Society Bulletin* 37, no. 4 (Oct. 1972): 97–136.

Skinner, David. "The Living and the Dead." *Humanities* 33, no. 5 (Sept.–Oct. 2012), www.neh.gov/humanities/2012/septemberoctober/feature/the-living-and-the-dead (accessed July 14, 2014).

Sotos, John G. *The Physical Lincoln Complete*. CreateSpace Independent Publishing Platform, 2008.

Steers, Edward. *Blood on the Moon: The Assassination of Abraham Lincoln*. Lexington: University Press of Kentucky, 2001.

Stevens, Joseph E. *1863: The Rebirth of a Nation*. New York: Bantam Books, 1999.

Stoddard, William O. *Inside the White House in War Times: Memoirs and Reports of Lincoln's Secretary*. Lincoln, NE: Bison Books, 2000.

Stump, Brice. "Lincoln Under Glass: Salisbury-Area Man Linked to Rare Photonegatives." *Delmarva Daily Times*, Salisbury, MD, Mar. 10, 2013, http://archive.delmarvanow.com/article/20130310/LIFESTYLE/303100030/Lincoln-Under-Glass.

———. "War on the Shore: Lincoln's Shore Legacy." (2014): *Delmarva Daily Times*, Salisbury, MD, Mar. 22, 2014, www.delmarvanow.com/story/news/war-on-the-shore/2014/03/22/war-on-the-shore-lincolns-shore-legacy/6754017 (accessed July 13, 2014).

Sullivan, George. *Mathew Brady: His Life and Photographs*. New York: Cobblehill Books, 1994.

———. *Picturing Lincoln: Famous Photographs That Popularized the President*. Boston: Houghton Mifflin Harcourt, 2000.

Swanson, James L., and Daniel R. Weinberg. *Lincoln's Assassins: Their Trial and Execution—an Illustrated History*. New York: William Morrow, 2006.

Sweet, Timothy. *Traces of War: Poetry, Photography, and the Crisis of the Union*. Baltimore: Johns Hopkins University Press, 1990.

Taft, Robert. *Photography and the American Scene: A Social History, 1839–1889*. New York: Dover, 1964.

Thomas, Andrew L. "Edward Dalton Marchant's *Abraham Lincoln*," in *Philadelphia's Cultural Landscape: The Sartain Family Legacy*, ed. Katherine Martinez, Page Talbott, and Elizabeth Johns, 62–71. Philadelphia: Temple University Press, 2000.

Thomas, Benjamin P., and Michael Burlingame. *"Lincoln's Humor" and Other Essays*. Urbana: University of Illinois Press, 2002.

Thompson, William Fletcher. *The Image of War: The Pictorial Reporting of the American Civil War*. Baton Rouge: Louisiana State University Press, 1994.

Townsend, George Alfred. "Brady, the Grand Old Man of American Photography," in *Photography: Essays and Images*, ed. Beaumont Newhall, 45–52. New York: Museum of Modern Art, 1980.

———. *The Life, Crime, and Capture of John Wilkes Booth, with a Full Sketch of the Conspiracy of Which He Was the Leader, and the Pursuit, Trial and Execution of His Accomplices*. New York: Dick & Fitzgerald, 1865.

Trachtenberg, Alan. "Lincoln's Smile: Ambiguities of the Face in Photography." *Social Research* (New York) 67, no. 1 (Spring 2000): 1–23.

———. *Lincoln's Smile and Other Enigmas*. New York: Hill & Wang, 2007.

———. *Reading American Photographs: Images as History, Mathew Brady to Walker Evans*. New York: Hill & Wang, 1990.

Traubel, Horace. *With Walt Whitman in Camden*. 9 vols. New York: Century, 1906–1996; available at the Walt Whitman Archive, www.whitmanarchive.org/criticism/disciples/traubel/WWWiC/1/whole.html (accessed Aug. 14, 2014).

Tripp, C. A. *The Intimate World of Abraham Lincoln*. New York: Basic Books, 2006.

Vermilyea, Peter C. "The Effect of the Confederate Invasion of Pennsylvania on Gettysburg's African American Community." *Gettysburg* 22 (2014), www.gdg.org/gettysburg%20magazine/gburgafrican.html (accessed May 18, 2014).

Villard, Henry. *Memoirs of Henry Villard, Journalist and Financier, 1835–1900*. Boston, New York: Houghton, Mifflin and Company, 1904.

Volk, Leonard W., Henry B. Bankin, and Charles C. Nott. "The Lincoln Life-Mask and How It Was Made," *Century*, Dec. 1881; repr. *Journal of the Illinois State Historical Society* 8, no. 2 (1915): 238–59.

Wallace, Maurice, and Shawn Michelle Smith. *Pictures and Progress: Early Photography and the Making of African American Identity*. Durham, NC: Duke University Press, 2012.

Walther, Susan Danly. *The Landscape Photographs of Alexander Gardner and Andrew Joseph Russell*. Providence, RI: Brown University Press, 1983.

Waugh, John C. *Lincoln and McClellan: The Troubled Partnership Between a President and His General*. New York: Palgrave Macmillan, 2010.

Weeks, Jim. "'A Disgrace That Can Never Be Washed Out': Gettysburg and the Lingering Stigma of 1863," in *Making and Remaking Pennsylvania's Civil War*, ed. William Blair, William Pencack, Henry Louis Gates, and Karen C. Dalton, 189–210. University Park: Pennsylvania State University Press, 2001.

———. *Gettysburg: Memory, Market, and an American Shrine*. Princeton, NJ: Princeton University Press, 2003.

Welling, William. *Collectors' Guide to Nineteenth-Century Photographs*. New York: Collier Books, 1976.

Werge, John. *The Evolution of Photography with a Chronological Record of Discoveries, Inventions, Etc., Contributions to Photographic Literature, and Personal Reminiscences Extending over Forty Years*. London: Piper & Carter, 1890.

White Jr., Ronald C. *A. Lincoln: A Biography*. New York: Random House, 2010.

Whitman, Walt. *Memoranda During the War*, ed. Peter Coviello. New York: Oxford University Press, 2004.

Whitman, Walt. *Poetry and Prose*. New York: Library of America, 1982.

Wiebe, Robert. "Lincoln's Fraternal Democracy," in *Abraham Lincoln and the American Political Tradition*, ed. John L. Thomas, 11–30. Amherst: University of Massachusetts Press, 1986.

Williams, George Forrester. *The Memorial War Book: As Drawn from Historical Records and Personal Narratives of the Men Who Served in the Great Struggle*. New York: Arno Press, 1979.

Willis, Deborah. *Envisioning Emancipation: Black Americans and the End of Slavery*. Philadelphia: Temple University Press, 2013.

Wills, Garry. *Lincoln at Gettysburg: The Words That Remade America*. New York: Simon & Schuster, 1992.

Wilson, Douglas L. *Lincoln's Sword: The Presidency and the Power of Words*. New York: Vintage, 2007.

Wilson, Joseph M. "A Eulogy on the Life and Character of Alexander Gardner," delivered at a stated communication of Lebanon Lodge, no. 7, F.a.a.m., Jan. 19, 1883. Washington, D.C.: R. Beresford, 1883.

Wilson, Robert. *Mathew Brady: Portraits of a Nation*. New York: Bloomsbury USA, 2013.

Wilson, Rufus Rockwell. *Intimate Memories of Lincoln*. Elmira, NY: Primavera Press, 1945.

———. *Lincoln in Portraiture*. New York: Press of the Pioneer, 1935.

Winkle, Kenneth J. *Lincoln's Citadel: The Civil War in Washington, DC*. New York: Norton, 2013.

Zeller, Bob. *The Blue and Gray in Black and White: A History of Civil War Photography*. Westport, CT: Praeger, 2005.

NOTES

My notes are written to help readers find citations for quotations and in a few instances to pursue further reading on a specific topic. Primary sources (printed material from the period, papers, and the like) receive full citations in the notes. I cite secondary sources with a short form that refers to the Selected Bibliography. For extended quotations by Lincoln, I use the widely available Library of America edition of Lincoln's *Speeches and Writings*.

CHAPTER I. 1861. PRESIDENT-ELECT

6 "a man who was overwhelmed": "Chance Created Best Photo Ever Taken of 'Abe' Lincoln," *New York Evening Telegram*, Mar. 6, 1921.

7 "honest as the sun": Donald, *Lincoln*, 281.

7 "idlers": Unattributed clipping, Mar. 6, 1858. Mathew Brady Scrapbooks and Clippings, Prints and Photographs Division, Library of Congress.

8 The main floor: Cobb, "Brady's Gallery in Washington," 41, 43.

9 In one exposure: Lloyd Ostendorf, *Lincoln's Photographs*, remains the standard reference for Lincoln photographs; see also Kunhardt, *Looking for Lincoln*.

9 "laughable" "bolt upright": "Chance Created Best Photo Ever Taken of 'Abe' Lincoln," *New York Evening Telegram*, Mar. 6, 1921.

12 "Promptly on the hour": Rufus Wilson, *Lincoln in Portraiture*, 123.

12 "reminds me of a rough block": Cecil Byrd, "Some Notes on Thomas D. Jones," 33.

15 Lincoln's unlikely route: Holzer, *Cooper Union*; the quotation appears on 219. See also Holzer, "The Campaign of 1860," and Donald, *Lincoln*, 237–40.

17 ten thousand copies: Ostendorf, *Lincoln's Photographs*, 49.

17 These images...were copied, edited, and freely interpreted: Byrd & Moore, *Lincoln in Print and Photograph*, 36; and Bunker, *From Rail-Splitter to Icon*.

18 "You would look a great deal better": Burlingame, *Abraham Lincoln*, vol. 2, 18.

18 Some thirty years later: Townsend, "Brady, The Grand Old Man," 48.

19 No single man: The best accounts of Brady's career are Mary Panzer, *Mathew Brady and the Image of History*, and Robert Wilson, *Mathew Brady: Portraits of a Nation*. Both are inspired by Alan Trachtenberg's *Reading American Photographs*; his work builds on Robert Taft, *Photography and the American Scene*.

20 "of a lady or a photographer": Townsend, "Mathew Brady," 46.

20 "a telegraph stretched": Ibid.

20 When they first appeared: Taft, *Photography and the American Scene*, 78, 98.

21 three million daguerreotypes: Panzer, *Mathew Brady*, 39.

21 "as fast as coining": John Werge, *The Evolution of Photography*, 200.

21 "It is my constant labor": Taft, *Photography and the American Scene*, 82.

24 "failing eyesight": Ibid., 466.

25 "daguerreotypers were afraid": Townsend, "Mathew Brady," 47, 48.

25 "a delicate person": Ibid., 48.

25 "a sort of dread": Rodgers, "Twenty-three Years,"140, 49, 141.

25 "bulky, grave, or abstract": Root, *The Camera and the Pencil*, 46, 47–48.

26 "I never had an excess of confidence": Townsend, "Mathew Brady," 47.

26 "urbanity and geniality": "M. B. Brady: Phrenological Character and Biography," Panzer, *Mathew Brady*, 217.

26 "getting the subjects to come to me": Townsend, "Mathew Brady," 49.

26 "seem almost to stand out of the plate": *New York Evening Post*, Aug. 7, 1848.

27 "Find the photographic emporium": Panzer, *Mathew Brady*, 28.

27 "those delicious lounging-places": Unattributed clipping, Mar. 6, 1858. Mathew Brady Scrapbooks and Clippings, Prints and Photographs Division, Library of Congress.

27 "In those days, a photographer ran his career": Townsend, "Mathew Brady," 48.

28 paid some of the best wages: On Gardner, see Mark Katz, *Witness to an Era*; Don McCoo, "A Rare Specimen Found"; Josephine Cobb, "Alexander Gardner," and "Mathew B. Brady's Photographic Gallery in Washington"; Brooks Johnson, *An Enduring Interest*; Anthony Lee and Elizabeth Young, *On Alexander Gardner's Photographic Sketch Book of the Civil War*; and Wilson, *Mathew Brady*.

29 "united capital and industry": McCoo, "The Years in Scotland," in Johnson, *Enduring Interest*, 12.

29 "as mere speculation": McCoo, "A Rare Specimen," 15.

30 "up a dingy street": Jay, *Robert Buchanan*, 17.

30 "the principle working-class": Brake, ed., *Dictionary of Nineteenth-Century Journalism*, 251.

30 "the necessity of improving dwellings": *Glasgow Sentinel*, Apr. 19, 1851.

30 "right of soil": *Glasgow Sentinel*, Apr. 5, 1851.

30 "Mr. Gardner is practicing": Katz, *Witness*, 7.

32 Coincidence or not: Taft, *Photography*,

130; Wilson, "A Eulogy," 9; see also Katz, *Witness to an Era*, and Cobb, "Alexander Gardner."

32 When Gardner arrived: Peterson, "Alexander Gardner in Review," 358.

32 "He makes money fast": Panzer, *Mathew Brady*, 15.

32 "a man of great system": Wilson, "Eulogy," 6.

33 He also arranged a contract: Cobb, " Alexander Gardner," 130.

33 Their break has invited speculation: Katz, *Witness to an Era*, 50–51, Cobb, "Mathew Brady," 52, and "Alexander Gardner," 130, and Wilson, *Mathew Brady*, 147–49, all offer explanations.

36 "You can read anything in him": Traubel, *Walt Whitman in Camden*, vol. 9, 59.

CHAPTER 2. 1862: ANTIETAM

39 On the Friday morning of September 19, 1862: William Frassanito's *Antietam* gives the best account of Gardner's time at Antietam. See also Bob Zeller, *The Blue and Gray in Black and White*, 65–82; and Mark Katz, *Witness to an Era*, 43–50; Anthony Lee and Elizabeth Young, *On Alexander Gardner's Photographic Sketchbook*; Keith Davis, "'A Terrible Distinctness'"; and Timothy Sweet, *Traces of War*.

41 But of course they had everything to do with each other: On the battle of Antietam, see McPherson, *Crossroads of Freedom* and *Battle Cry of Freedom*, 531–57; and Stephen Sears, *Landscape Turned Red*.

42 "the two most popular men": *New York Herald*, Oct. 7, 1862.

43 "forty fine negatives": Zeller, *The Blue and Grey*, and Katz, *Alexander Gardner*, both read the handwriting as "forty five."

43 "a few dripping bodies": "Brady's Photographs: Pictures of the Dead at Antietam," *New York Times*, Oct. 20, 1862.

44 "in the space of less than ten acres": McPherson, *Crossroads*, 4.

44 An exhausted Massachusetts captain: Ibid. See also Marvel, *Lincoln's Darkest Year*, 222, 225.

44 "The bloodiest single day": "Antietam,"
 Civil War Trust, www
 .civilwar.org/battlefields/antietam.html
 (accessed Sept. 30, 2014).

44 "In the bloodiest": "Antietam," Public
 Broadcasting Service, accessed July 9,
 2014, www.pbs.org
 /civilwar/classroom/lesson_antietam.
 html.

44 "The Bloodiest One Day Battle":
 "Antietam National Battlefield,"
 National Park Service, accessed July 9,
 2014, www.nps.gov/anti
 /index.htm.

44 "No tongue can tell": McPherson,
 Crossroads, 146.

45 "The real horror": Herald of Freedom &
 Torch Light (Hagerstown, MD), Sept.
 10–24, 1862.

45 "in every state of mutilation":
 McPherson Crossroads, 4, 5.

45 "To the feeling man": Ibid., 7; see also
 Zeller, 83.

45 "it seems almost nothing could justify":
 McPherson, Crossroads, 8, 5.

45 "hushed, reverend": "Brady's
 Photographs: Pictures of the Dead at
 Antietam," New York Times, Oct. 20,
 1862.

45 "of which are a number of dead bodies":
 Harper's Weekly, Oct. 18, 1862, 663.

46 "that all the emotions": Holmes,
 "Doings of the Sunbeam," 73.

46 The results were such firestorms:
 Frassanito, Antietam,190: on the Texas
 regiment, see "Battle of Antietam:
 Carnage in a Cornfield," www.history-
 net.com/battle-of-antietam-carnage-
 in-a-cornfield.htm (consulted June 14,
 2014).

46 Antietam's exceptional casualty rates:
 This is McPherson's argument in
 Crossroads of Freedom.

46 "Union soldier and Confederate":
 "Brady's Photographs: Pictures of the
 Dead at Antietam," New York Times,
 Oct. 20, 1862.

48 "gigantic stature": New York Herald, Oct.
 7, 1862.

50 "will be one of subjugation":
 McPherson, Battle Cry, 558.

51 Add to this an intellectual intensity: See
 Donald, Lincoln, 333.

51 "Is this the little woman": Annie Fields,
 "Days With Mrs. Stowe," Atlantic, Aug.
 1896, 148.

51 "It would be difficult": Burlingame,
 Abraham Lincoln, vol. 2, 288.

51 "of care and anxiety": Noah Brooks,
 Lincoln Observed, 13.

51 "physiognomy...as coarse": Hawthorne,
 "Chiefly About War Matters by a
 Peaceable Man," Sketches and Studies, 119.

51 "strange quaint face": Russell, My Diary
 North and South, 38, 39. See also Masur,
 "Special Correspondent."

52 "By some strange operation": Burlingame,
 Abraham Lincoln, vol. 2, 191, 195.

52 "crush the rebellion": Waugh, Lincoln
 and McClellan, 43.

53 "idiot": Ibid., 50.

53 "his Excellency": McPherson, Battle,
 364; See also Doris Kearns Goodwin,
 Team of Rivals, 383; Donald, Lincoln, 319,
 and Waugh, Lincoln and McClellan, 50.

53 "was destitute of refinement":
 Burlingame, Abraham Lincoln, vol. 2, 198.

53 "I will hold McClellan's horse":
 McPherson, Battle Cry, 365.

54 "The country will not fail to note":
 Lincoln to McClellan, April 9, 1862, in
 Speeches & Writings vol. 2, 314; see also
 Goodwin, Rivals, 432.

54 "liked me personally": McClellan,
 McClellan's Own Story, 160.

54 "seems to have a special talent": 54,
 Team of Rivals, 431.

54 "better remove as soon as possible":
 Lincoln to McClellan, July 4, 1862, in
 Speeches & Writings, vol. 2, 338, 339.

54 "too useful just now": Goodwin, Team of
 Rivals, 478.

54 "He was very affable": Burlingame,
 Abraham Lincoln, vol. 2, 426; see also
 Goodwin, Team of Rivals, 484.

55 "that he was entirely": McClellan,
 McClellan's Own Story, 627.

55 One early morning during: Burlingame,
 Abraham Lincoln, vol. 2, 426.

55 "the highest principles known": "Civil
 and Military Policy," July 1863, in Sears,
 ed., The Civil War: Second Year, 307.

56 "The character of the war": Henry W. Halleck to Ulysses S. Grant, Mar. 31, 1863, in Brooks Simpson, ed., *The Civil War: The Third Year*, 106.

56 "infamous": Goodwin, *Team of Rivals*, 484.

57 Overlooking a "splendid" view: *New York Herald*, Oct. 7, 1862.

57 "peculiar" interest: ibid.; see also the *National Republican*, Oct. 4, 1862.

57 "Here lies the bodies": Burlingame, *Abraham Lincoln*, vol. 2, 426.

58 "uncontrollable circumstances": Ibid., 425.

58 "thought they were merely a corporal's guard": Ibid.

58 "in the best of humors": *New York Herald*, Oct. 7, 1862.

58 "My boy! My boy!": Burlingame, *Abraham Lincoln*, vol. 2, 177.

58 "an affliction": Lincoln to Ephraim D. and Phoebe Ellsworth, May 25, 1861, in *Speeches & Writings*, vol. 2, 242.

58 "impetuous daring": Burlingame, *Abraham Lincoln*, vol. 2, 200.

59 "When will this terrible war": Ibid.

59 "There was no patriot": Ronald White, *A. Lincoln*, 457; see also Goodwin, *Team of Rivals*, 381.

59 "a gentle and amiable boy": Burlingame, *Abraham Lincoln*, vol. 2, 297.

59 "It showed me my weakness": Goodwin, *Team of Rivals*, 422–23.

59 "deeply affecting": *New York Herald*, Oct. 5, 1862.

60 "ungenerous": Burlingame, *Abraham Lincoln*, vol. 2, 323.

60 "I have seen too many dead": Ibid., 322.

60 "The glory you have achieved": Goodwin, *Team of Rivals*, 486.

60 traveling "around with Gardner": Zeller, *Blue and Gray*, 152.

60 "he was the photographer for the Union Army": Wilson, *Eulogy*, 9.

60 "We say of the great battle": *New York Herald*, Oct. 7 1862.

61 "fragments of clothing": Oliver Wendell Holmes, "My Hunt After the Captain," 34.

61 "a party, women among them": Ibid., 33.

61 "an intelligent guide": Ibid., 35.

61 "almost intolerable" stench: *Herald of Freedom & Torch Light*, Sept. 10–24, 1862.

61 "If I didn't": Zeller, *Blue and Gray*, 77.

63 "unyielding in purpose": *Harper's Weekly*, Oct. 4, 1862, 634

68 "President Lincoln himself": *New York Herald*, Oct. 7, 1862.

CHAPTER 3. 1863: GETTYSBURG

70 "greatest of Americans since Washington": "P Adams, Lincoln's Place in History," 590.

70 a detailed account of the composition: Nicolay, "Lincoln's Gettysburg Address."

71 "Gardner, the photographer": Brooks, *Washington in Lincoln's Time*, 252–53.

71 It is a well-told story: Boritt develops this point more fully in *The Gettysburg Gospel*, 81–83.

73 medical diagnoses: See, for instance, John Sotos, *The Physical Lincoln*. Carla Johnson, "Lopsided Lincoln" summarizes other investigations.

73 As early as the 1840s: Alan Trachtenberg, *Reading American Photographs*, 28.

74 Renowned for her poise: Melissa Dabakis, "Sculpting Lincoln," and Harold Holzer, "Visualizing Lincoln."

76 "the best I have seen": Hay, *Inside Lincoln's White House*, 109.

78 "undressed, with a napkin": Angela Miller, et. al., *American Encounters*, 144.

78 "the central act": Carpenter, *Inner Life*, 90.

78 "I know very well": Holzer, *Emancipating Lincoln*, 126; Burlingame, *Lincoln*, vol. 2, 473.

78 "a superstitious feeling": Burlingame, *Lincoln*, vol. 2, 469.

79 "surging" crowds: Brooks, *Lincoln Observed*, 15.

79 "I have been shaking hands": Carpenter, *Inner Life*, 269. See also Burlingame, *Lincoln*, vol. 2, 469, and Goodwin, *Team of Rivals*, 499.

79 "That will do": The signing is recounted in numerous texts; the quote is from Holzer, *Emancipating Lincoln*, 131, which offers one of the fullest accounts.

79 "represent his breast": Volk, "The Lincoln Life-Mask," 244.

80 Ames made good use: Dabakis, "Sculpting Lincoln," 82.

81 one Moses P. Rice: The information on Rice is scattered and vague. On his acquiring Gardner's negatives, see "War Time Photographs," *Washington Post*, Sept. 29, 1893.

84 "as dismal as a defaced tombstone": Epstein, *Lincoln's Men*, 157.

84 "very good spirits": Hay, *Inside the White House*, 70.

85 "How long ago is it?": Lincoln, "Response to Serenade, Washington, D.C.," July 7, 1863, *Speeches and Writings*, vol. 2, 475–76.

86 "leading object" of government: Lincoln, "Message to Congress in Special Session," July 4, 1861, *Speeches and Writings*, vol. 2, 259.

87 "The Tycoon is in fine whack": Goodwin, *Team of Rivals*, 545; Epstein, *Lincoln's Men*, 160.

87 Raising "colored troops": Lincoln to Ulysses S. Grant, Aug. 9, 1863, *Speeches and Writings*, vol. 2, 490.

87 "adopt some practical system": Lincoln to Nathaniel P. Banks, Aug. 5, 1863, *Speeches and Writings*, vol. 2, 486.

87 "the rebel power": Hay, *Inside Lincoln's White House*, 70.

88 The nine months: On Gardner's movements during this period, see Cobb, "Alexander Gardner," 132, and Katz, *Witness to an Era*, 51.

88 It is not clear: Lloyd Ostendorf, "President Lincoln," in Johnson, *An Enduring Interest*, 62.

88 "stocked with the newest": Katz, *Witness to an Era*, 51.

89 In fact, Josephine Cobb: Cobb, "Alexander Gardner," 132.

89 Gardner's reputation: Wilson, *Eulogy*, 19.

89 imperial photographs: *Daily National Intelligencer*. Feb. 29, 1864.

92 "generally very successful": Katz, *Witness to an Era*, 120.

94 "immancipate the mind": Lincoln, "Lecture on Discoveries and Inventions," Feb. 11, 1859, *Speeches and Writings*, vol. 2, 10.

94 "will forever be associated: Holzer, *Emancipating Lincoln*, 97. My discussion owes much to Holzer's book.

95 "the tissue of insane contradictions": Stoddard, *Inside the White House in War Times*, 148.

95 "public sentiment is every thing": Blondheim, "Public Sentiment," 869.

95 At its most heavy-handed: Carwardine, "Abraham Lincoln," 11.

95 Even before the battle at Bull Run: Ibid., and Blondheim, "Public Sentiment."

96 "Slavery caused the war": Guelzo, *Lincoln's Emancipation Proclamation*, 186.

97 "Proclamation of ABE": Guelzo, *Lincoln's Emancipation Proclamation*, 159.

97 "the people had been quite educated": Ibid., 160.

97 "In *giving* freedom": Lincoln, "Annual Message to Congress," Dec. 1, 1862, *Speeches and Writings*, vol. 2, 415.

98 once they wore the uniform: Guelzo, *Lincoln's Emancipation Proclamation*, 219.

99 "a wicked, atrocious and revolting": Holzer, *Emancipating Lincoln*, 104.

99 "skill, tact, and extreme moderation": Guelzo, *Lincoln's Emancipation Proclamation*, 204.

99 "to overthrow this government": Lincoln "To the Workingmen of Manchester, England," Jan. 19, 1863, *Speeches and Writings*, vol. 2, 432.

99 "clear, flagrant, and gigantic": Lincoln "To Erastus Corning and Others," *Speeches and Writings*, vol. 2, 457, 460.

100 "there will be some black men": Lincoln to James Conkling, *Speeches and Writings*, vol. 2, 499.

100 When read aloud: Donald, *Lincoln*, 457.

100 Hay called the letter "a great thing": Goodwin, *Team of Rivals*, 555.

100 "consummate rhetorician": Donald, *Lincoln*, 458.

101 "It's all my fault": McPherson, *Battle Cry of Freedom*, 663.

102 "We have done enough": Ibid.

102 "I do not believe": Lincoln to George G. Meade, July 14, 1863, *Speeches and Writings*, vol. 2, 479.

102 "a scene of horror": Boritt, *The Gettysburg Gospel*, 9.

103 If they had to venture out: Skinner, "The Living and the Dead."

103 "fearful, almost intolerable": Frassanito, *Early Photography*, 329.

103 Stories circulated: Weeks, "A Disgrace," 192–93.

103 When the railroad was repaired: Dreese, *Hospital on Seminary Ridge*, 124–25.

103 "rolling through blood": Sheldon, *When the Smoke Cleared*, 140.

104 "the army photographer": See the *Baltimore Sun*, July 10, 1863, for a note about Gardner's "capture."

104 "First we saw the smoking ruins": Frassanito, *Early Photography*, 21.

104 After arranging to spend the night: Dreese, *Hospital on Seminary Ridge*, 125.

106 William Frassanito: Frassanito, *Early Photography*, 318.

108 "War Effect of a Shell": Katz, *Eyewitness to an Era*, reproduces Gardner's catalogs, 279–94.

110 Looked at through a double-lens viewer: On stereo viewers, see Crary, *Suspensions of Perception* and *Techniques of the Observer*.

112 It is very possible: Frassanito discusses these images in detail in *Early Photography*, 316.

113 Perhaps the two sharpshooters: Desjardin, *These Honored Dead*, 186–87.

113 Maybe, as has been recently: Rosenheim, *Photography and the American Civil War*, 95–98.

115 As they appeared in the *Sketch Book*: For catalog titles, I draw on Katz, *Witness to an Era*, 285–89. Captions on negative sleeves are from the Library of Congress Prints and Photographs Online Catalog. See entries for images LC-DIG-cwpb-00874, LC-DIG-cwpb-00073, and LC-DIG-cwpb-00069.

117 "buried" "kicked around": Boritt, *Gettysburg Gospel*, 36.

117 "hogs...actually rooting": Sheldon, *When the Smoke Cleared*, 233.

118 "some suitable spot": Faust, *This Republic of Suffering*, 65.

118 At Antietam one officer: Ibid., 69.

119 "The first duty," "is a disgrace": Winkle, *Lincoln's Citadel*, 368.

120 "final resting place": Boritt, *Gettysburg Gospel*, 39.

120 commemorative site: On the transformation of Gettysburg into a memorial park, see Boritt, *Gettysburg Gospel*; Weeks, *Gettysburg*; Faust, *The Republic of Suffering*, 246–49; and Sheldon, *When the Smoke Cleared*.

120 Basil Biggs: Vermilyea, "Effect of the Confederate Invasion."

120 It took until spring: Sheldon, *When the Smoke Cleared*, 243.

121 it was Governor Curtin: Burlingame, *Abraham Lincoln*, vol. 2, 569, says Curtin "probably" approached Lincoln.

121 "will doubtless be very imposing": Sheldon, *When the Smoke Cleared*, 238.

122 "fighting for Democracy": Donald, *Lincoln*, 460.

122 He may have begun working: Nicolay, "Lincoln's Gettysburg Address," 597.

122 As the day for the ceremony: Goodwin, *Team of Rivals*, 583.

122 "imperative public duties": Boritt, *Gettysburg Gospel*, 55.

123 whom one scholar speculates: Ibid., 53.

123 "imposing and solemnly impressive": Sheldon *When the Smoke Cleared*, 238.

123 "sang, & hallooed, and cheered": French, *Witness to the Young Republic*, 434.

123 "I must beg of you": Burlingame, *Abraham Lincoln*, vol. 2, 571.

123 "Abraham Lincoln is the idol": French, *Witness to the Young Republic*, 435–36.

124 "that thought it was an oration": Donald, *Lincoln*, 464.

124 Over the next two hours: French, *Witness to the Young Republic*, 435; Burlingame, *Abraham Lincoln*, vol. 2, 573.

124 "in a firm free way": Burlingame, *Abraham Lincoln*, vol. 2, 574.

124 "usual habit": Nicolay, "Lincoln's Gettysburg Address," 597.

125 "the question, whether a constitutional republic": Lincoln, "Message to Congress in Special Session," July 4, 1861, *Speeches and Writings*, vol. 2, 250, 259.

125 "Lamon, that speech": Donald, *Lincoln*, 465.

125 "the little I did say": Lincoln to Edward Everett, November 20, 1863, *Speeches and Writings*, vol. 2, 537.

126 "little speech" "the few words": Donald, *Lincoln*, 465.

126 "the 'fathers' in stages of conception": Burlingame, *Abraham Lincoln*, 577.

126 "to uphold this constitution": Donald, *Lincoln*, 466.

126 "magical" power: Wills, *Lincoln at Gettysburg*, 89.

127 One account: Donald, *Lincoln*, 464.

129 "very offensive": French, *Witness to the Young Republic*, 437.

130 "The carnage at Gettysburg": Ibid., 441.

130 "I took a friend": Library of Congress, Prints and Photographs Online Catalog entry for LC-DIG-ppmsca-33067.

131 The Library of Congress: Library of Congress, Prints and Photographs Online Catalog entry for LC-DIG-ppmsca-31300.

132 "a great whited sepulchre": Whitman to Ralph Waldo Emerson, Jan. 17, 1863. Walt Whitman Archive.

132 "sustainer of spirit and body": Whitman, *Memoranda During the War*, 101. The poem "The Wound-Dresser" appeared in Whitman's book of war poetry, *Drum Taps*, which was later incorporated into *Leaves of Grass*. For accounts of Whitman's time in Washington, see Reynolds, *Walt Whitman*, 413–447; Roper, *Now the Drum of War*, and Morris, *Better Angel*.

132 "the greatest privilege": Whitman, *Memoranda During the War*, 101.

132 Over his lifetime: On Whitman's photographs, see Folsom, "'This Heart's Geography Map.'"

132 "I have been photographed"…"I've been taken": Traubel, *Walt Whitman in Camden*, vol. 1, 367; vol. 2, 45.

134 "Apart from the pulling": Whitman, *Poetry and Prose*, 30.

134 "first rate—everybody": Traubel, *Walt Whitman in Cambridge*, vol. 1, 390.

134 "I remember well": Traubel, *Walt Whitman in Cambridge*, vol. 2, 131.

135 "Walt Whitman, an American": Whitman, *Poetry and Prose*, 48, 50, 72.

135 "went strong for *Leaves of Grass*": Traubel, *Walt Whitman in Cambridge*, vol. 3: 234, 346.

136 "a man of high impulses"…"much esteemed": Wilson, "A Eulogy on the Life," 5–6; "Alexander Gardner Dead," *Washington Post*, Dec. 11, 1882.

136 "When I look at this": Traubel, *Walt Whitman in Cambridge*, vol. 3, 363; Folsom, "'This Heart's Geography Map.'"

136 "My dear Whitman"…"the grandeur and charm": Gardner to Walt Whitman, Nov. 26, 1866, Walt Whitman Archive; Review, "White Rose and Red," *Pall Mall Gazette*, Oct. 21, 1873.

136 "a very bad book": Reynolds, *Walt Whitman's America*, 412.

137 "bathed by the rising sun": Whitman, *Poetry and Prose*, 439, 441.

138 "Some where they crawl'd": Whitman, *Memoranda*, 102, 103.

CHAPTER 4. 1864: WASHINGTON, D.C.

139 While his days of traveling with the military: Frassanito, *Grant and Lee*, 15–16.

140 In June he spent a week in New York City: See notices in the *New York Herald*, June 26, 1864, and June 30, 1864. See also Harvey, *Civil War in American Art*, 92–94.

140 "mirth, music, and good fellowship": *National Intelligencer*, Dec. 9, 1863.

140 Its members included: Information about Gardner's friends comes from *Boyd's Directory of the District of Columbia*. On Cameron, see also Peterson, "Alexander Gardner in Review," 364.

141 The vivid fracture: Katz, *Witness to an Era*, 119.

143 "terrible war": Lincoln, "Second Inaugural Address," *Speeches and Writings*, vol. 2, 687.

143 "Mr. Lincoln's last sitting": Katz, *Witness to an Era*, 119.

143 "Inadvertent, the crack": National Portrait Gallery, CAP Search results for ObjectID 45439. Accessed August 30, 2014. http://npgportraits.si.edu/eMuseumNPG/code/emuseum.asp?rawsearch=ObjectID/,/is/,/45439/,/false/,/false&newprofile=CAP&newstyle=single.

143 "as finely lined": Obama, "What I See in Lincoln's Eyes." For a thoughtful and

inspiring essay on this issue, see Alan Trachtenberg, "Lincoln's Smile."

144 "high hope for the future": Lincoln "Second Inaugural Address," *Speeches and Writings*, vol. 2, 686.

144 Harold Holzer: Holzer, "Visualizing Lincoln," 105. He discusses his discovery in Morris, "Everlasting Lincolns." On Wilson, see also Sims, "Matthew Henry Wilson."

144 "horridly like": Carpenter, *Inner Life*, 233.

146 Lloyd Ostendorf: Ostendorf, *Lincoln's Photographs*, 226, 227.

146 "pure photographs": "Gardner's Photographs," *Daily National Intelligencer*, May 2 1864.

146 "Poor Mr. Lincoln": Donald, *Lincoln*, 568.

147 "The particulars of your plans": Lincoln to Ulysses S. Grant, Apr. 18, 1864, *Speeches and Writings*, vol. 2, 591.

148 "The great thing about Grant": Carpenter, *Inner Life*, 283.

148 "to fight it out on this line": Lincoln quotes Grant in "Speech at Great Central Sanitary Fair," *Speeches and Writings*, vol. 2, 601.

148 "the dogged pertinacity": Donald, *Lincoln*, 501.

148 "inexpressibly sad to see": Brooks, *Mr. Lincoln's Washington*, 323.

148 Casualty estimates for the North: McPherson, *Battle Cry of Freedom*, 742.

148 "clad in a long morning wrapper": Carpenter, *Inner Life*, 30–31.

148 "Look yonder at those poor fellows": Donald, *Lincoln*, 513.

148 Grant . . . "is a butcher": Ibid., 515.

149 "intense anxiety" so "oppressive": Goodwin, *Team of Rivals*, 619. See also 627–28.

149 The Treasury Department: Burlingame, *Abraham Lincoln*, vol. 2, 655; see also Goodwin, *Team of Rivals*, 642.

149 "all convalescents capable": Goodwin, *Team of Rivals*, 642.

150 "abandonment of slavery"…"liberal terms": Lincoln, "Offer of Safe Conduct for Peace Negotiations," July 18, 1864, *Speeches and Writings*, vol. 2, 611–12.

150 "armistice—a cessation": Lincoln, Draft Letter to Isaac M. Schermerhorn,

Sept. 12, 1864, *Speeches and Writings*, vol. 2, 631.

150 "wild for Peace": Burlingame, *Abraham Lincoln*, vol. 2, 669.

150 "staunchest friends": Ibid., 669.

150 "to return to slavery the black warriors": Pinsker, *Lincoln's Sanctuary*, 160.

150 "an open field and a fair chance": Lincoln "Speech to the 166th Ohio Regiment," August 22, 1864, *Speeches and Writings*, vol. 2, 624.

151 "This morning…save it afterwards": Lincoln, "Memorandum on Probable Failure of Re-election," Aug. 23, 1864, *Speeches and Writings*, vol. 2, 624.

151 "Yes, Yes,": Hay, *Inside Lincoln's White House*, 247–48.

151 "Damn the torpedoes": McPherson, for one, accepts the quote as genuine; *Battle Cry of Freedom*, 761.

151 "darted at him": Carpenter, *Inner Life*, 276.

152 "May we not agree": Lincoln, "Annual Message to Congress," Dec. 6, 1864, *Speeches and Writings*, vol. 2, 658.

152 "the complete consummation": Harris, *Lincoln's Last Months*, 133.

152 "the original disturbing cause": Lincoln, "Response to Serenaders," Feb. 1, 1865, *Speeches and Writings*, vol. 2, 670.

153 "So far as I know": Harris, *Lincoln's Last Months*, 132.

153 peace between the "two countries": Ibid., 113.

153 "the disbanding of all forces": Lincoln to William Seward, Jan. 31, 1865, *Speeches and Writings*, vol. 2, 678.

153 "like an abandoned stubble-field": Burlingame, *Abraham Lincoln*, 753.

153 "those resisting the laws of the Union": Burlingame, *Abraham Lincoln*, 756.

154 "profess to be posted": Goodwin, *Team of Rivals*, 693.

154 "with the utmost liberality": Harris, *Lincoln's Last Months*, 119.

154 "strive on to finish": Lincoln, *Speeches and Writings*, vol. 2, 687.

154 "What is it about": Obama, "What I See in Lincoln's Eyes."

155 "We have got so that we always exchange bows": Whitman, *Memoranda*, 39, 41.

156 "has a face like a hoosier": Whitman letter to Nathaniel Bloom and John F. S. Gray, Mar. 19–20, 1863; Walt Whitman Archive, www.whitmanarchive.org/biography/correspondence/cw/tei/uva.00345.html.

156 "dark brown face"..."tinge of weird"..."goodness": Whitman, Memoranda, 40, 5, 76.

156 "sadness bordering": Traubel, Walt Whitman in Camden, vol. 1, 4.

156 "I never see that man": Whitman, Memoranda, 76.

156 "His face & manner": Vivian Pollack, "Whitman Unperturbed," 31.

156 "on a pleasure ride": Whitman, Memoranda, 39, 41.

156 "ardent love": Coviello, "Introduction," in Whitman, Memoranda, xliii, xliv.

157 "Are you the new person": Whitman, Poetry and Prose, 277, 280..

157 But it is also a poetry: On the "glimpse," see Meehan, Mediating American Biography, 186–89.

158 "No good portrait": Whitman, Memoranda, 118.

158 "there never has been a portrait": Traubel, With Walt Whitman in Camden, vol. 3, 554.

158 "So impressed was Brady": Wilson, Lincoln in Portraiture, 213.

158 This rare glimpse of filial tenderness: Kunhardt, Lincoln Life-Size, 138.

160 They did share a bed: Hay, "Obituary of Tad Lincoln," At Lincoln's Side, 112.

160 "truthful and generous": Ibid.

160 "I must go and suppress": Burlingame, Abraham Lincoln, vol. 2, 261.

163 "the rebel leader Davis": Donald, Lincoln, 490.

164 Benjamin Thomas makes abundantly clear: Thomas, "Lincoln's Humor."

164 "the pith or point": Herndon, Herndon's Lincoln, 194–95.

165 "Allow me now to say": Thomas, "Lincoln's Humor," 12.

165 "it gave him": Herndon, Herdon's Lincoln, 195.

165 "with the whole land bowed in sorrow": Bray, Reading with Lincoln, 201.

165 "I hiv no politics": Artemus Ward, "Artemus Ward on His Visit to Abe Lincoln," in Holzer, ed., The Lincoln Anthology, 24.

165 "God damn it to hell": Ibid., 203; see also Burlingame, Lincoln, vol. 2, 720–21.

165 "ludicrous": Leonard Swett, in Herdon, Herdon's Lincoln, 320.

166 "Mr. Lincoln was not": Guelzo, "Come-outers," 9.

166 "never revealed himself": Herndon, Herndon's Lincoln, 349–50.

CHAPTER 5. 1865: RUINS AND MEMORIALS

167 "grand salute": Brooks, Washington in Lincoln's Time, 219, 221–22.

167 They began working on April 6: On the photography of Richmond during this period, including Gardner and Reekie's activity, see Frassanito, Grant and Lee, 378–421.

167 "This town is the Rebellion": Furgurson, Ashes of Glory, 348.

168 "Thank God that I have lived": Burlingame, Abraham Lincoln, vol. 2, 788.

168 "grander and more exultant": Furgurson, Ashes of Glory, 337.

168 "Let them all go": Harris, Lincoln's Last Months, 199.

171 Any viewer North or South: Nelson, Ruin Nation.

175 When Lincoln disembarked: Fox, "'A Death-Shock to Chivalry,'" offers an excellent overview of Lincoln and Tad's walk into Richmond.

175 "The joy of the negro": New York Tribune, Apr. 8, 1865.

176 "Bress de Lord": Porter, Incidents and Anecdotes, 295.

176 "The President removed his own hat": C. C. Coffin, "Late Scenes in Richmond," Atlantic Monthly 15 (June 1865): 753, 755.

176 "free as air": Burlingame, Abraham Lincoln, vol. 2, 791.

177 "seated in the Speaker's chair": Furgurson, Ashes of Glory, 349.

177 "Then Chester planted": New York Tribune, April 8, 1865.

177 "all the colored people": Lankford, Richmond Burning, 127; see also Furgurson, Ashes of Glory, 346.

180 "horribly muddy": Brooks, *Lincoln Observed*, 182.

181 "our lawful prize": Burlingame, *Abraham Lincoln*, vol. 2, 801.

181 "some of the happiest moments": Ibid., 800.

181 "Dear Husband": Harris, *Lincoln's Last Months*, 222.

181 "We meet this evening": Lincoln, "Speech on Reconstruction," *Speeches and Writings*, vol. 2, 697–701.

181 "something terrible": Brooks, *Lincoln Observed*, 183.

181 "weird, spectral beauty": Keckley, *Behind the Scenes*, 75.

182 "That means nigger citizenship": Burlingame, *Abraham Lincoln*, vol. 2, 811. See also, Kauffman, *American Brutus*, 210.

182 When on Friday morning: There are dozens of accounts of Lincoln's assassination and its aftermath. Of these, the best is Michael Kauffman, *American Brutus*. I have also drawn on Edward Steers, *Blood on the Moon*, and Thomas Goodrich, *The Darkest Dawn*.

183 In fact, very few: See Timothy Good, *We Saw Lincoln Shot*.

183 "The seats, aisles, galleries, and stage": Kauffman, *American Brutus*, 17.

184 "From lip to lip": Noah Brooks, *Lincoln Observed*, 192.

185 "three or four of your best detectives": Kauffman, *American Brutus*, 48, 68.

185 "Black clouds driving": Goodrich, *Darkest Dawn*, 131.

186 Union troops in the South: See Goodrich, *Darkest Dawn*, 160–65.

188 "arouse the patriotism": Burlingame, *Lincoln*, vol. 2, 822.

188 By any measure: The estimates and anecdotes come from Goodrich, *Darkest Dawn*, and Schwartz, *Abraham Lincoln*.

189 "The thugs of the Confederacy": Harris, *Lincoln's Last Months*, 226.

190 It is not clear: See Mark Katz, *Witness to an Era*, 164ff.

193 "a small dark man": Brooks, *Washington in Lincoln's Time*, 238.

193 "mentally exclaiming 'ape'": Kauffman, *American Brutus*, 348.

193 "the completest personification": Brooks, *Washington in Lincoln's Time*, 239, 238; Goodrich, *Darkest Dawn*, 261.

194 "The poor creature": Brooks, *Washington in Lincoln's Time*, 240, 238.

194 "Who is Payne?": *Wayne County Herald* (Honesdale, PA), June 15, 1865.

195 "Presently a window was raised": Swanson and Weinberg, *Lincoln's Assassins*, 25.

197 Just over two weeks: *Harper's Weekly*, July 22, 1865. The images discussed appear on 452, 453, 456, 457, 460. Quotations from 454, 451.

198 "These grounds have": "The Gettysburg Monument," *Harper's Weekly*, July 22, 1865, 454.

200 "During the war": "Alexander Gardner," *Harper's Weekly*, July 22, 1865, 451.

201 "when this desolating and fratricidal war": *National Intelligencer*, Dec. 9, 1863.

201 More palatable, and prestigious: *National Intelligencer*, Feb. 20, 1865.

201 to produce forty stereocard views: Katz, *Witness to an Era*, 208, 214.

201 His one setback: Ibid, 205–8.

201 *Gardner's Photographic Sketch Book*: For thematic discussions of the *Sketch Book*, see Lee and Young, *On Alexander Gardner's Photographic Sketch Book*; William F. Stapp, "'To...Arouse the Conscience, and Affect the Heart,'" in Johnson, *An Enduring Interest*, 17–58; Trachtenberg, *Reading American Photographs*, 93–111, Davis, "A Terrible Distinctness'"; and Sweet, *Traces of War*, 107–37.

201 in his 1863 *Catalogue*: Peterson, "Alexander Gardner in Review," 360. Peterson usefully sets the *Sketch Book* in context with other photographic publications and portfolios.

201 as *Harper's Weekly*: Ibid., 205.

203 "we" held possession: Gardner, *Sketch Book*, commentary to plate 66 and 34.

204 "humble dwelling": Gardner, *Sketch Book*, commentary to plate 43.

205 "nothing less than"..."lusty artificers": Gardner, *Sketch Book*, commentary to plates 61 and 70.

205 Elizabeth Young: Lee and Young, *On Alexander Gardner's Sketch Book*, 57–63.

206 an advertising notice: Peterson, "Alexander Gardner in Review," quotations on 363.

206 "photographic art, in its highest development": *Daily National Intelligencer*, Dec. 8, 1866.

206 "king of photography": *Daily Constitutional Union*, June 5, 1867.

207 In 1867: Susan Danly, "Across the Continent," in Johnson, *An Enduring Interest*, 84–93; Peterson, "Alexander Gardner in Review"; and Katz, *Witness to an Era*, 215–28. Katz argues that Gardner never left Kansas.

207 By the end of the war: Information is taken from city directories. See also the *Daily National Intelligencer*, May 16, 1869, and Oct. 13, 1869. On the Union Town Building Association, see William Jenkins, Deed of Trust, Archives and Manuscript Collection, Historical Society of Washington, D.C.

208 Later he was a key organizer: *Washington Post*, Aug. 24, 1878.

208 In 1869 Gardner: Cobb, "Alexander Gardner, 127; see also Cobb, "Brady's Photographic Gallery," 64.

208 Sometime after: *Washington Post*, Sept. 29, 1893.

210 "Alexander Gardner Dead": *Washington Post*, Dec. 11, 1882.

210 "his unblemished integrity": *Washington Post*, Dec. 12, 1882.

210 "enemy of slavery": Wilson, "Eulogy," 9.

210 "Who, in photography": "Obituary," *Philadelphia Photographer*, Jan. 1883, 92.

ACKNOWLEDGMENTS

As a friend, adviser, editor, and for a while unofficial agent, Paul Aron shepherded this book from it earliest stages. He also sat through more diner lunches than anyone should have to, listening patiently to all things Lincoln and Gardner. My agent, Doe Coover, showed me what was interesting about the project; she continues to give guidance and encouragement with intelligence and good cheer. Frank Goodyear, codirector of the Bowdoin College Museum of Art, opened the photographic riches of the National Portrait Gallery when he served as curator there. I learned much from his deep knowledge of nineteenth-century photography, which he shared with a generous enthusiasm.

I have been privileged to work with two very fine editors. From its early stages, Alessandra Lusardi guided the project with grace, vision, and encouragement. Liz Van Hoose brought sympathy and insight to her rigorous editing of the manuscript. Bob Scholnick and Simon Joyce read portions of the book, and shared their own work as members of our informal writing group. Robert Burgoyne read material as well; his writing and ideas continue to enrich my own. Ed Folsom and Kenneth Price helped focus my thinking about Walt Whitman. I am grateful to the St Andrews William & Mary Joint Degree Programme for giving me the opportunity to present an early version of chapter 2. Jennifer Blanchard, executive director of the Pejepscot Historical Society in Brunswick, Maine, offered a stimulating venue for presenting an early version of chapter 3.

Like anyone writing about the past, I owe debts to the staffs of a number of research institutions. Carol Johnson, curator of photography at the Prints and Photographs Division of the Library of Congress, offered early direction. The entire staff exemplifies the ideals of public

service and intellectual custodianship. Alex Mann, Brock Curator of American art, Chrysler Museum of Art, gave generous access to the museum's collection of Gardner images. Amy Barton, assistant curator of the U.S. Senate Commission on Art, supplemented a visit to Sarah Fisher Ames's bust of Lincoln with a behind-the-scenes tour that gave me valuable insight into the function of public art. I am also grateful to the staffs of the National Portrait Gallery, the National Gallery of Art, the U.S. Army Heritage and Education Center, the Lincoln Financial Foundation Collection, the Allen County Public Library and Indiana State Museum, and the still picture reference team at the National Archives and Records Administration. In countless ways, the librarians and staff of Swem Library at the College of William & Mary, and in particular in the Special Collections Research Center, have proved themselves valuable colleagues.

My mother, Eleanor, died just as my "Lincoln project" became a book; it is dedicated to her. It is also dedicated to my wife, Joyce Lowry, whose love, patience, and support made possible every word. Margaret Lowry provided able research assistance; she and her sister Elizabeth Lowry continue to show me what it means to engage the world we live in with energy, commitment, and imagination.

INDEX

Gardner refers to Alexander Gardner; Lincoln, to Abraham Lincoln; Brady, to Mathew Brady.

Page numbers in *italics* indicate illustrations; *PL* indicates insert plate number.